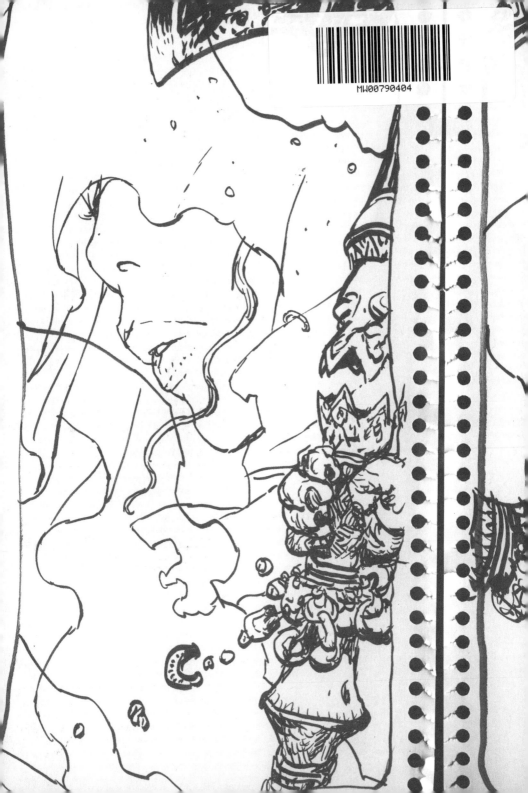

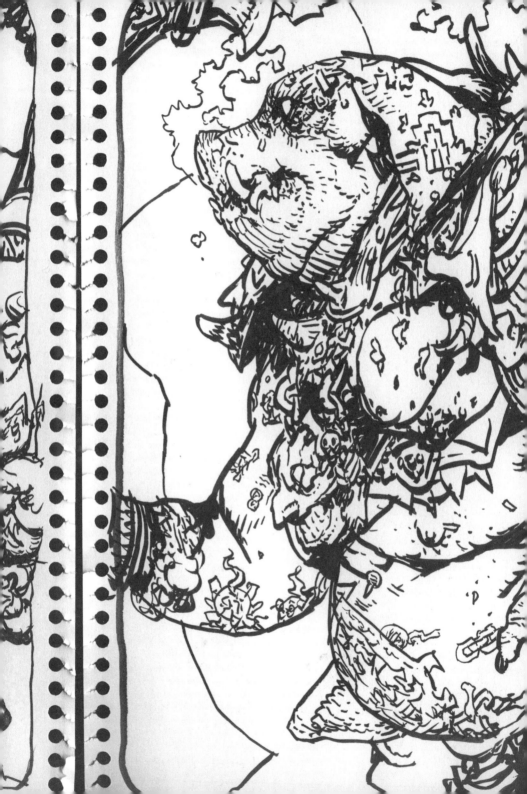

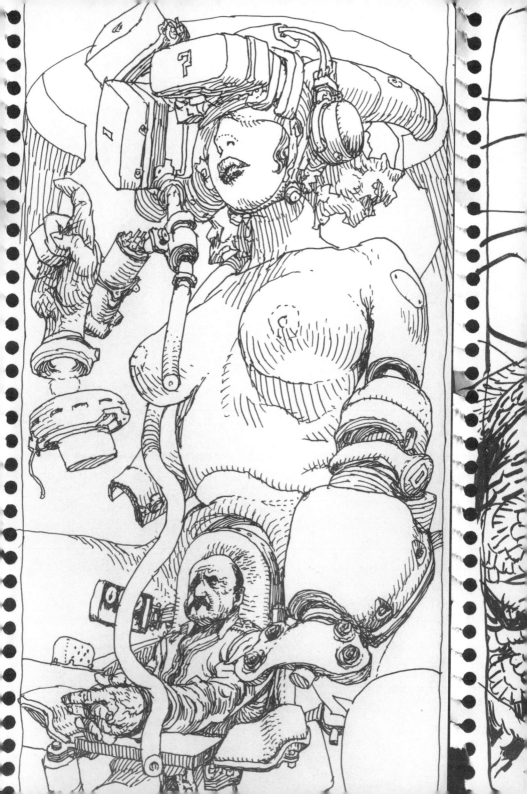

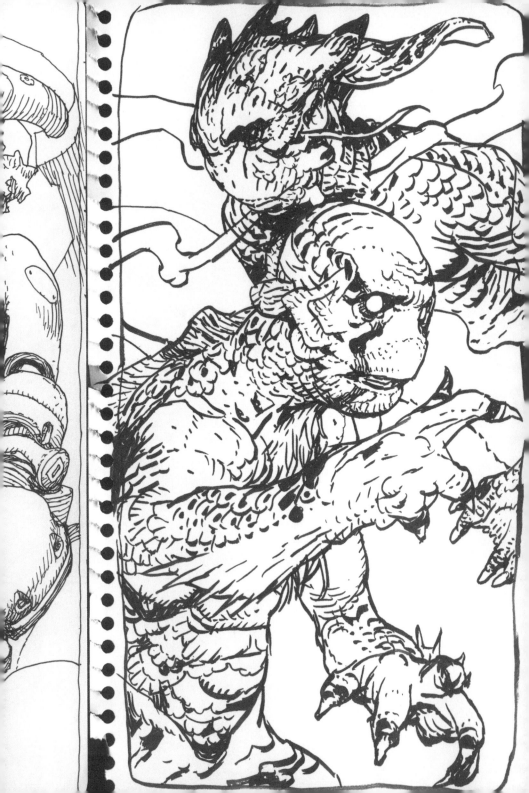

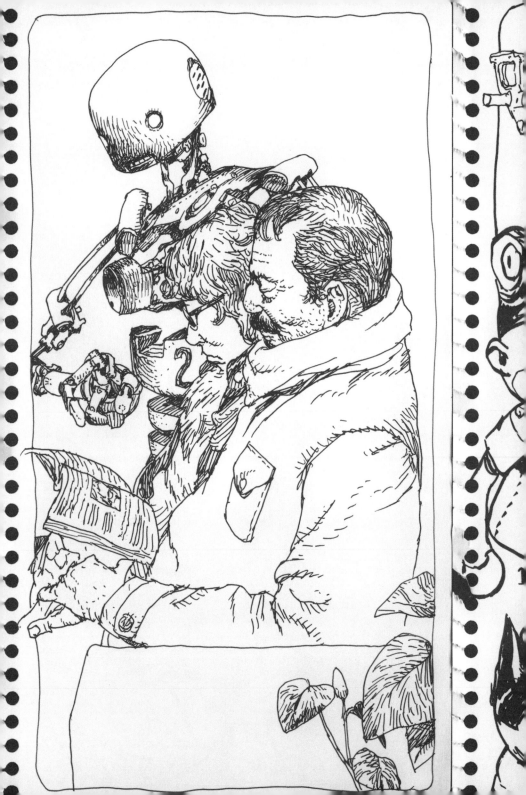

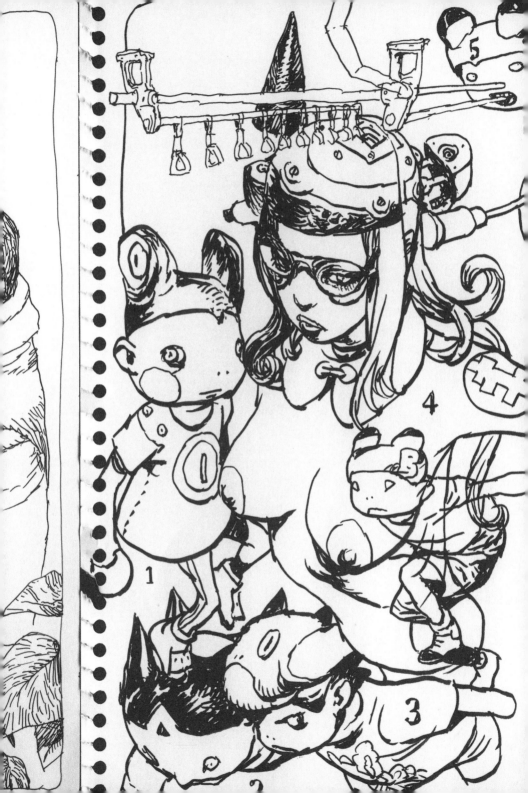

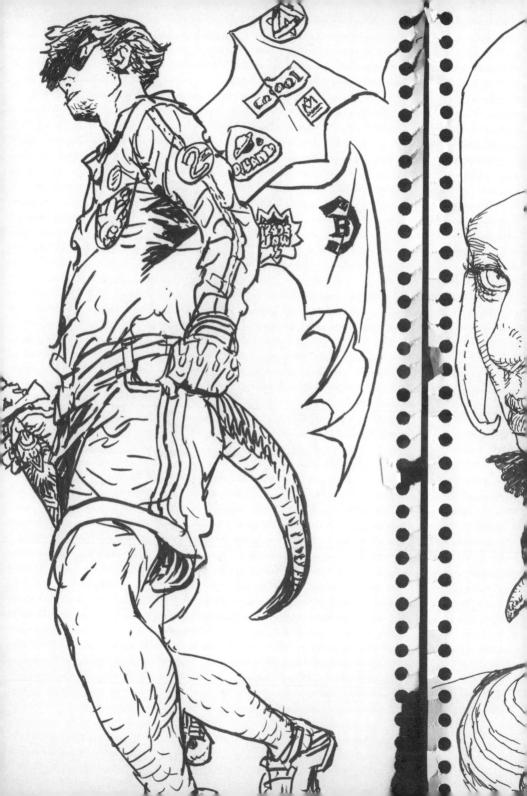

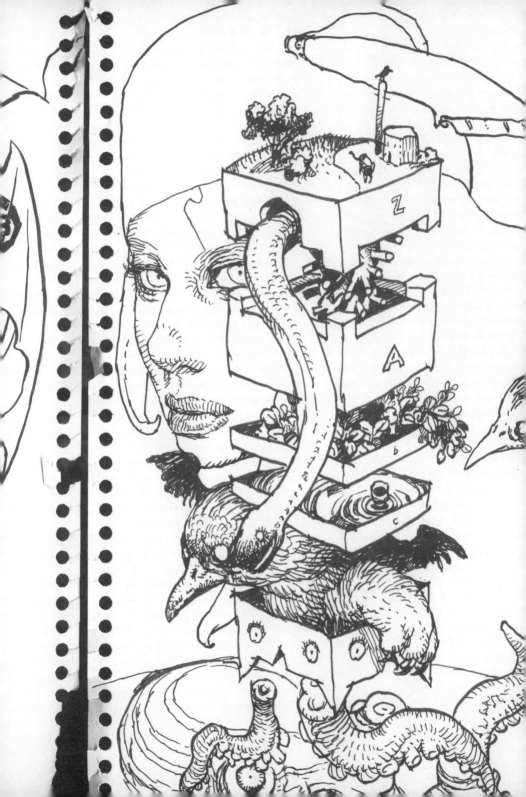

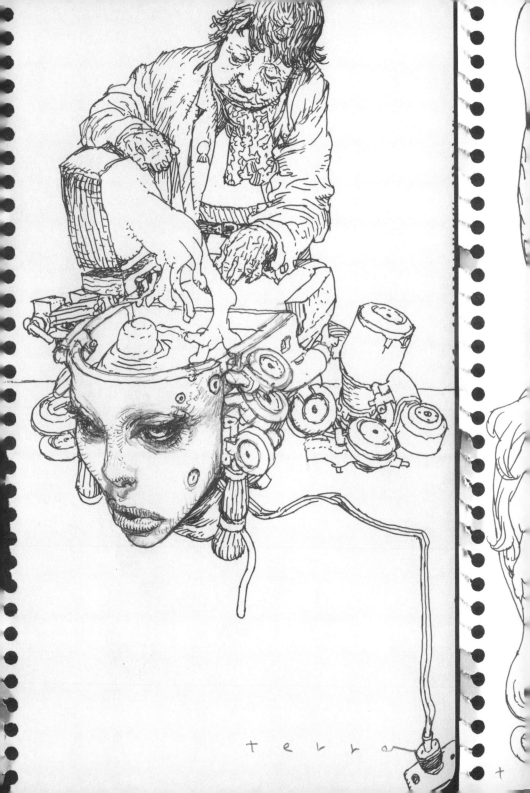

terra

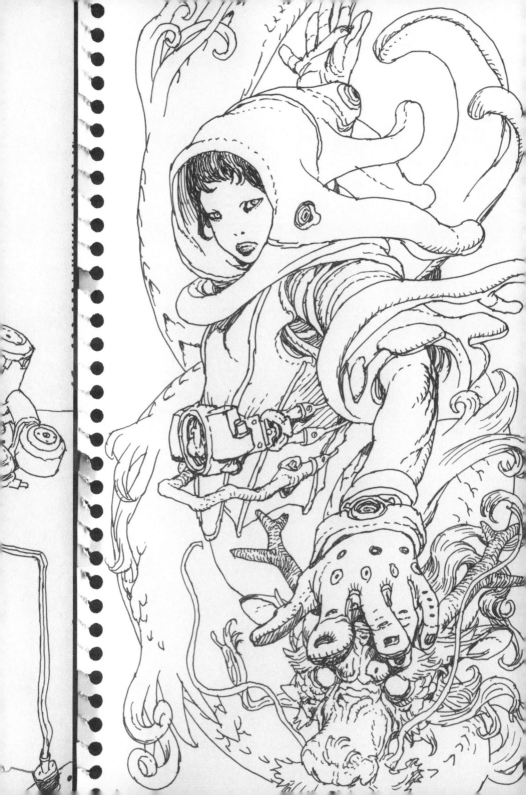

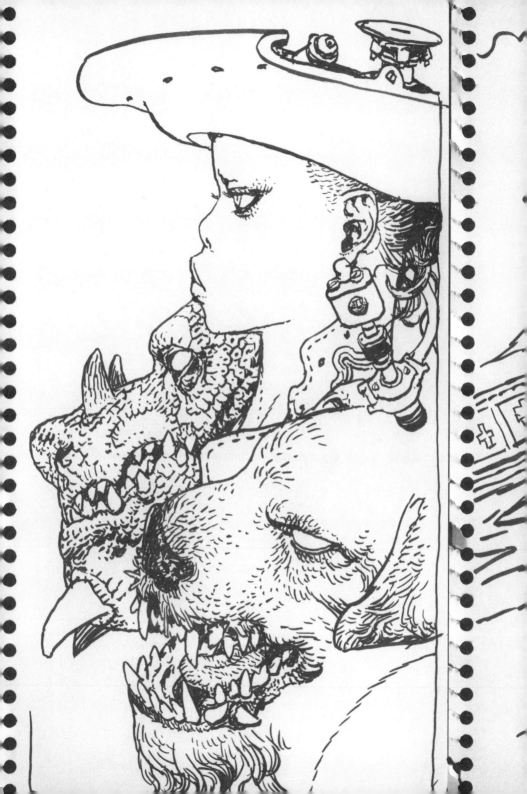

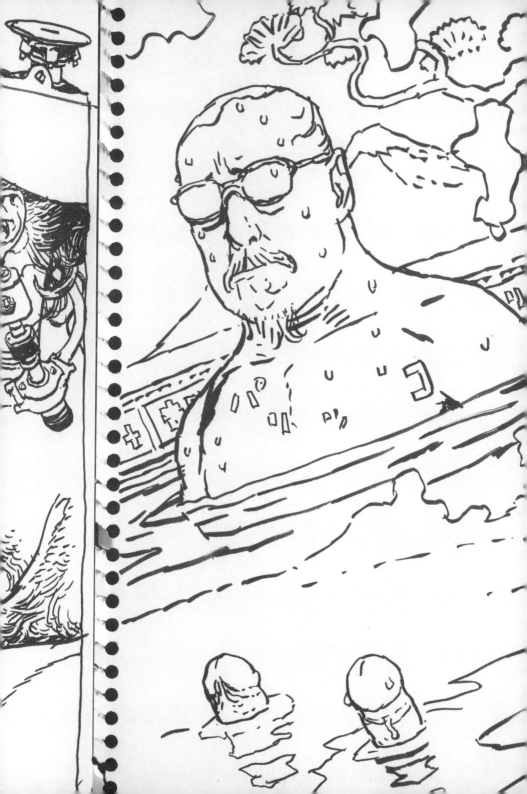

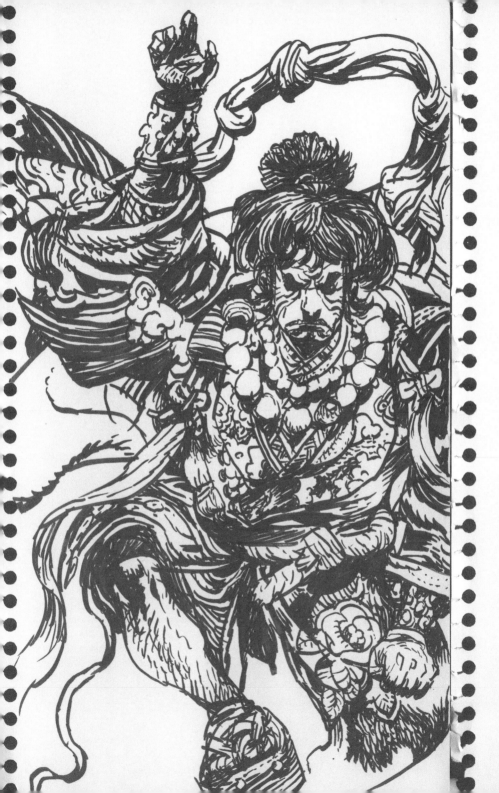

S K E

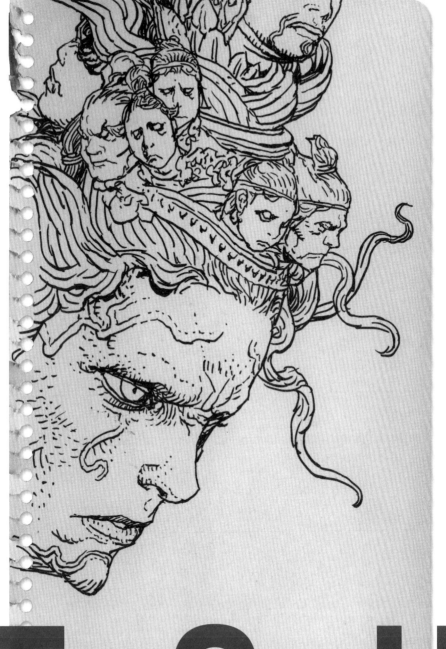

TCH

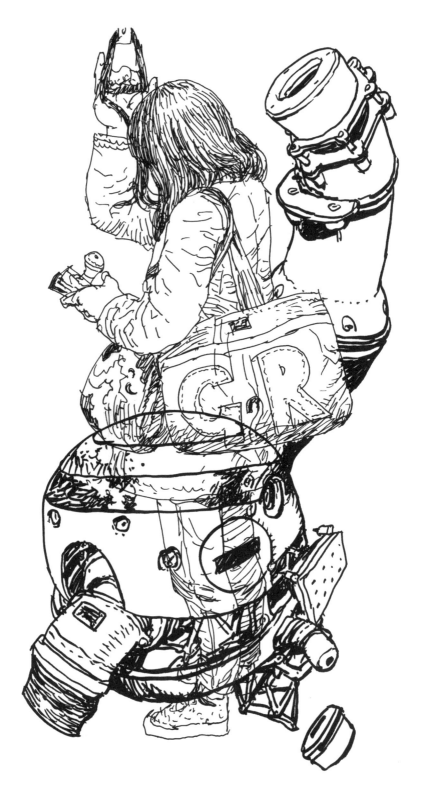

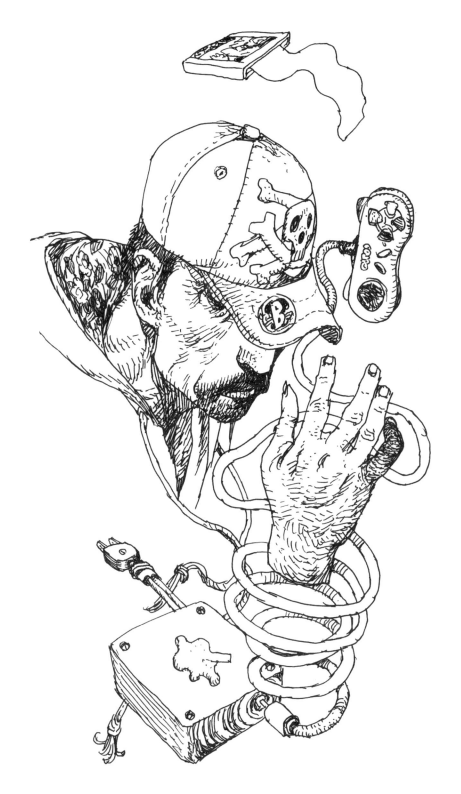

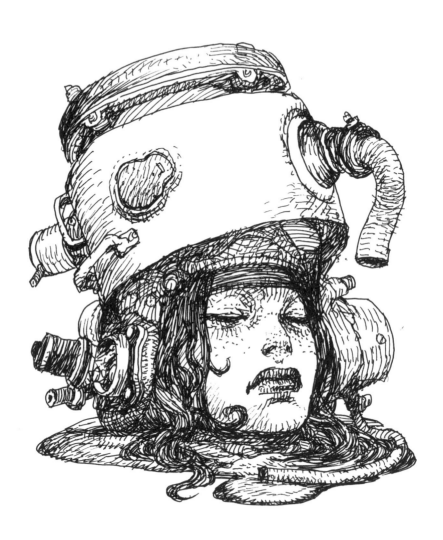

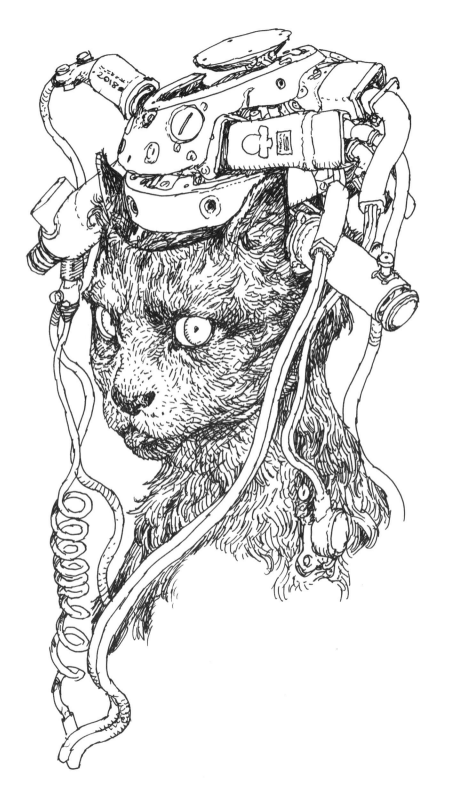

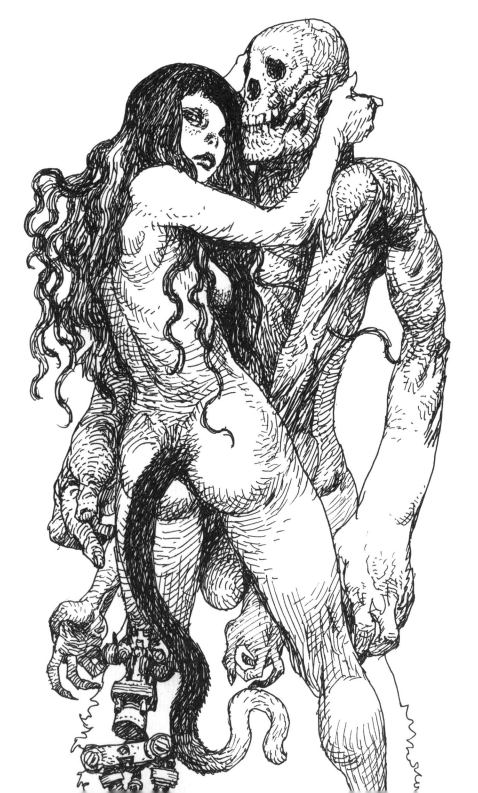

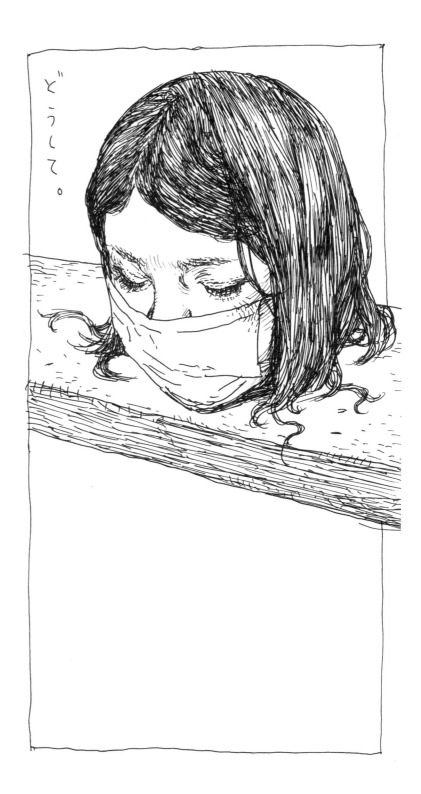

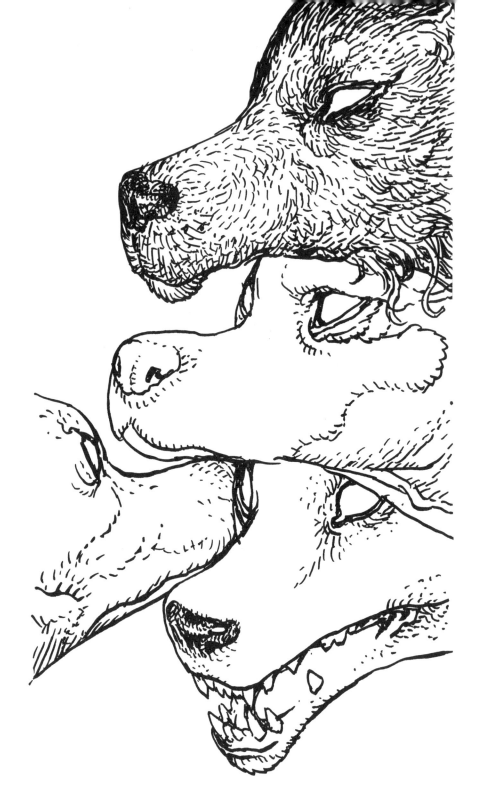

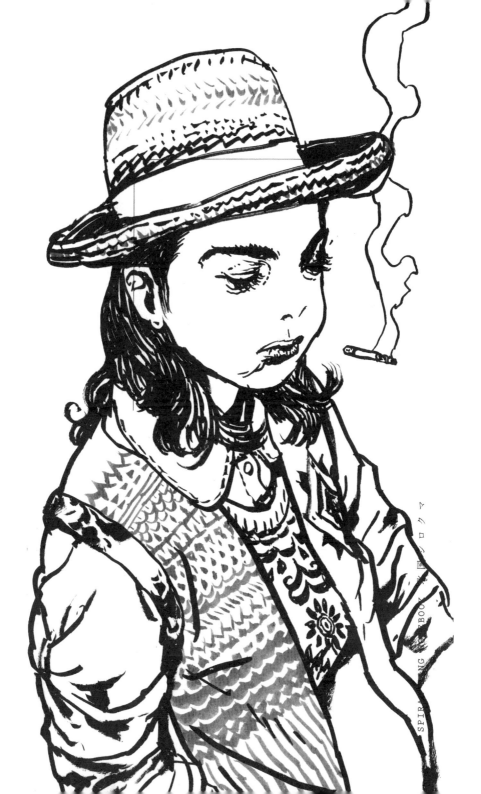

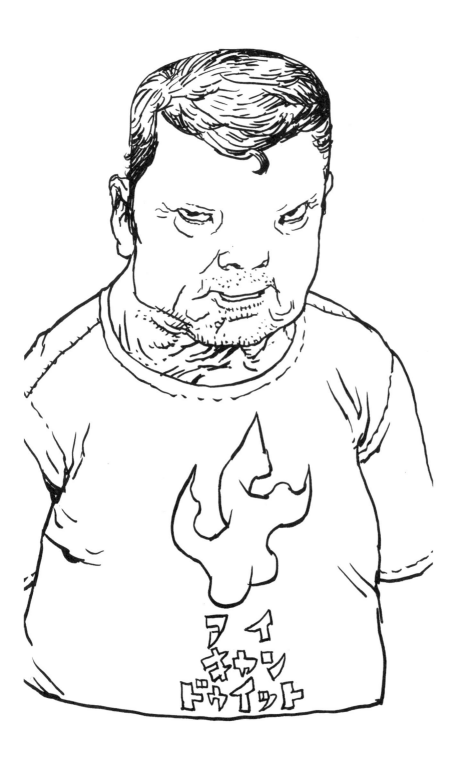

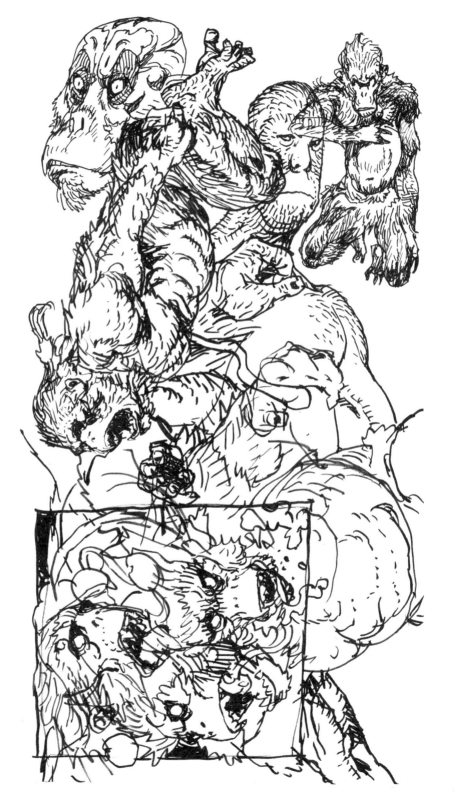

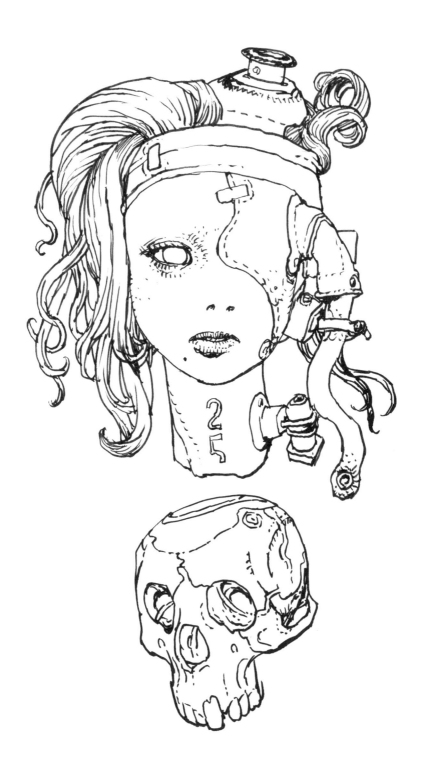

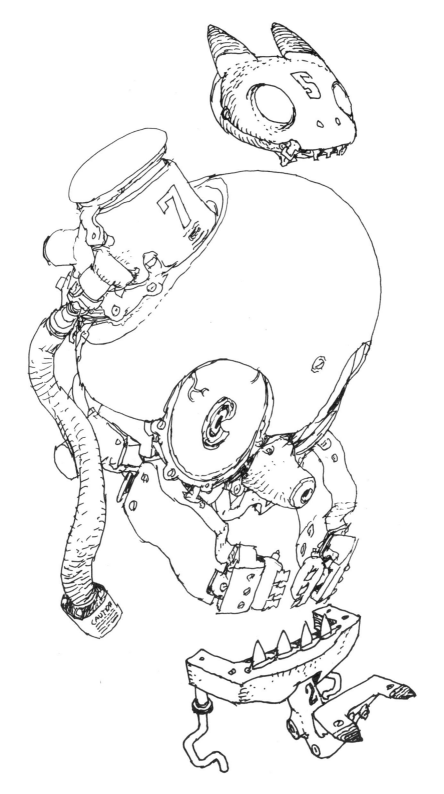

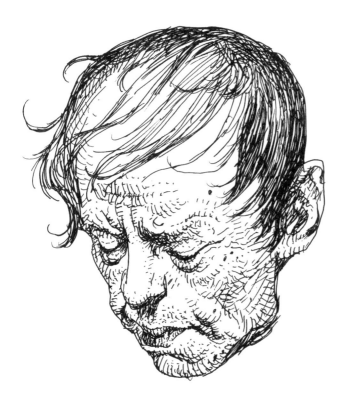

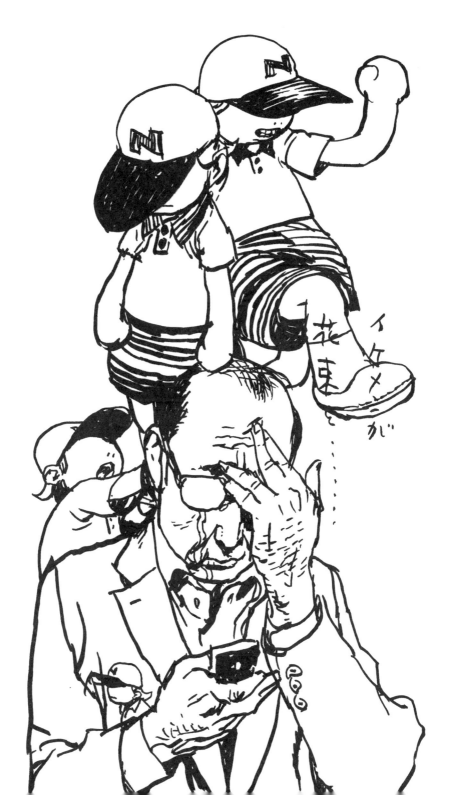

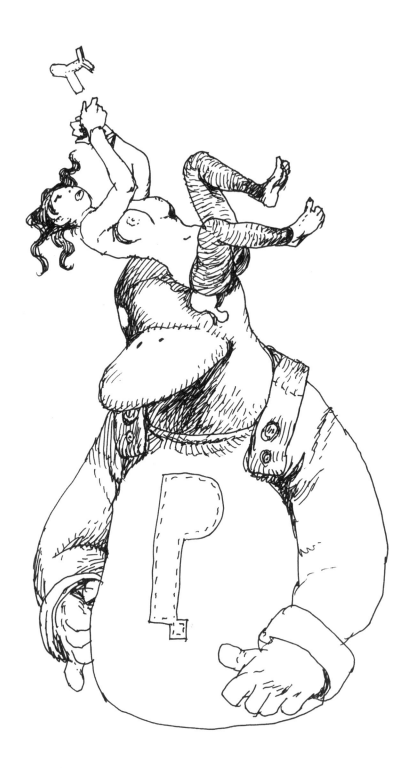

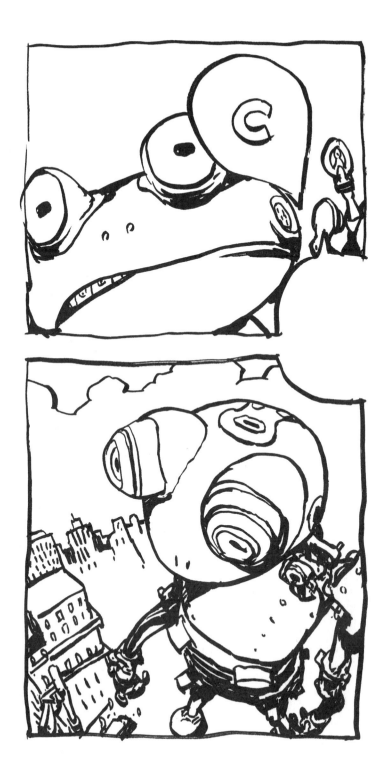

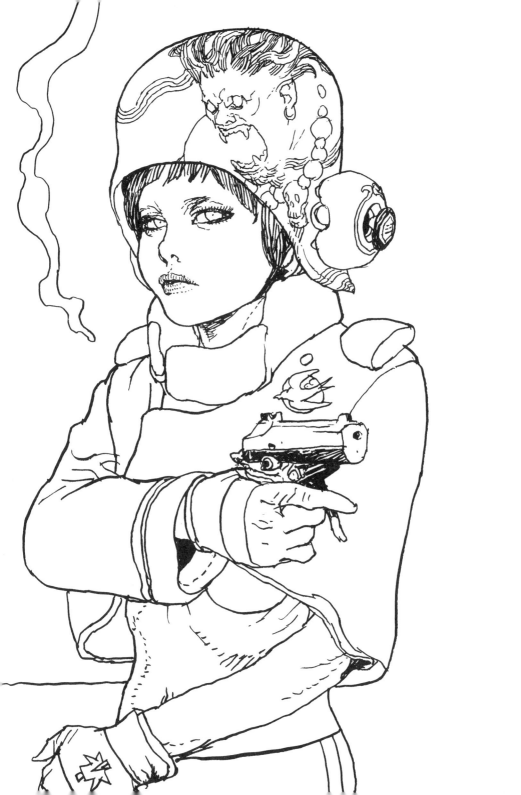

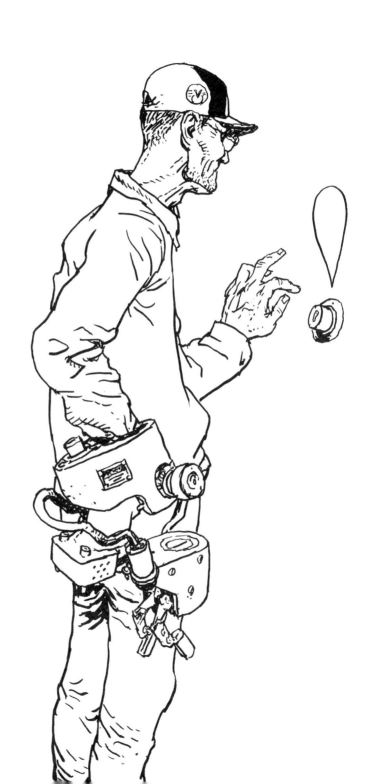

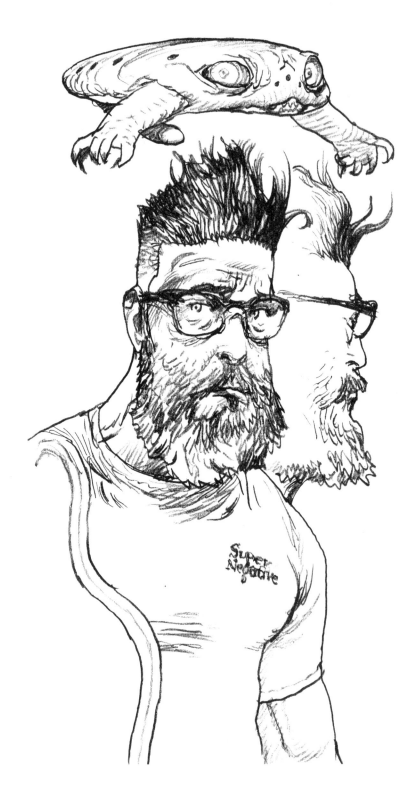

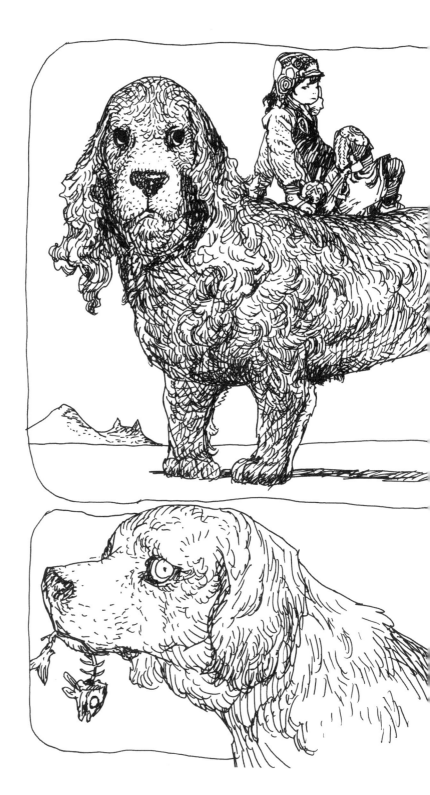

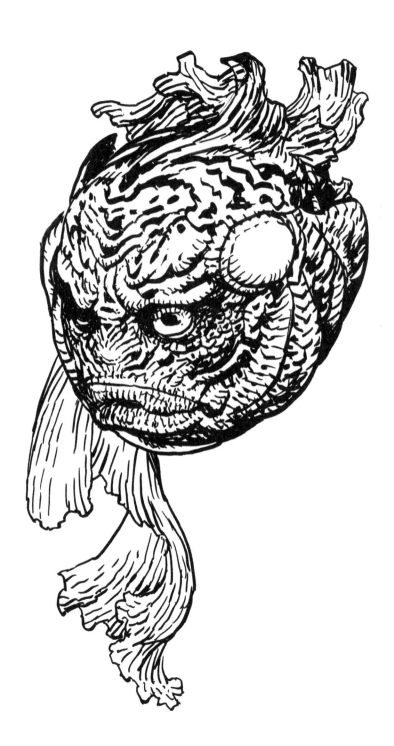

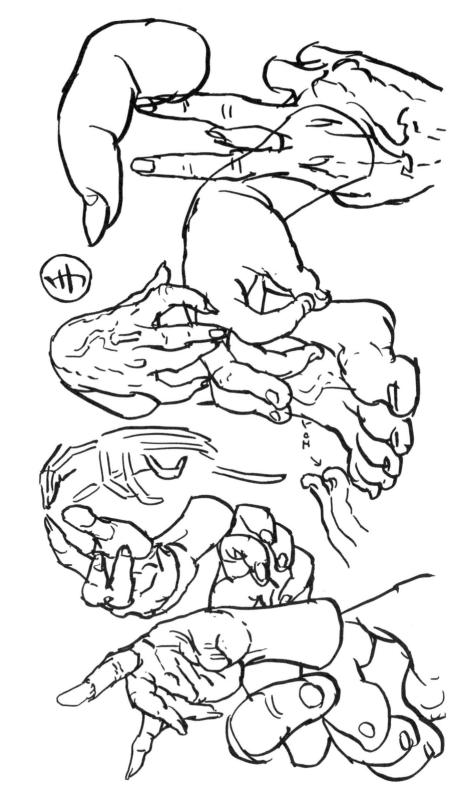

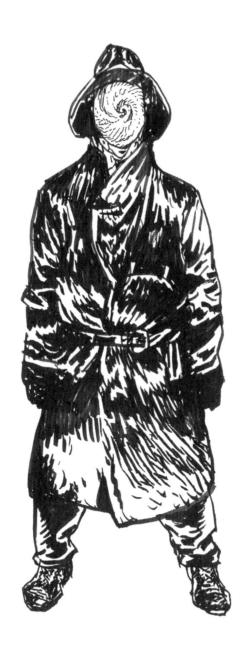

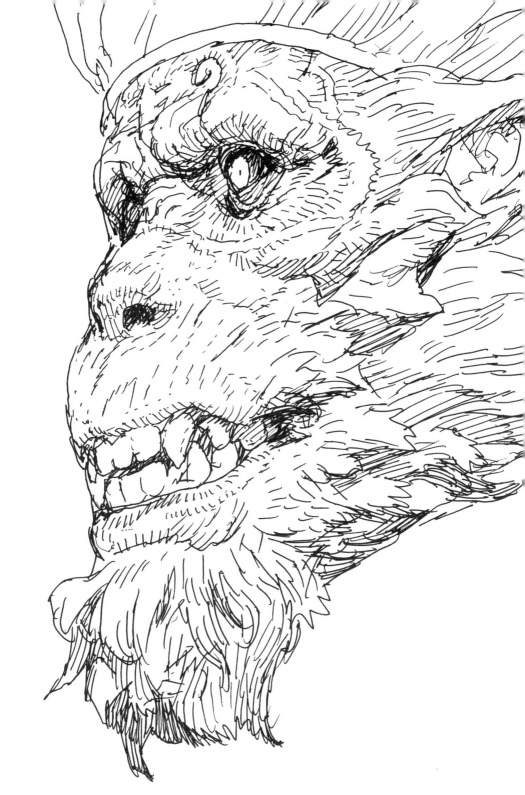

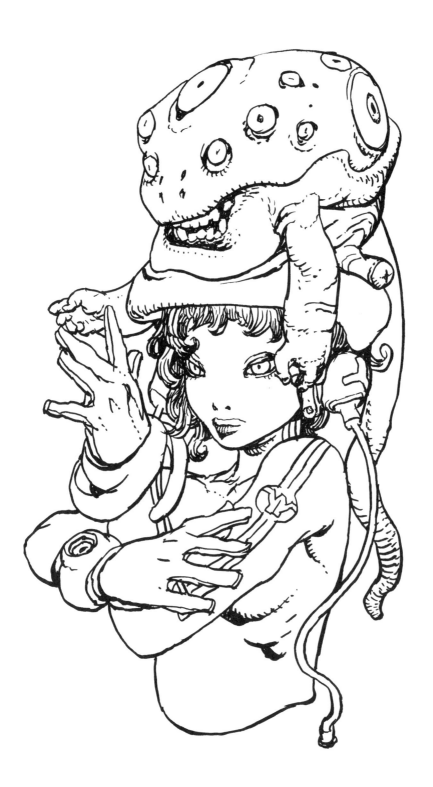

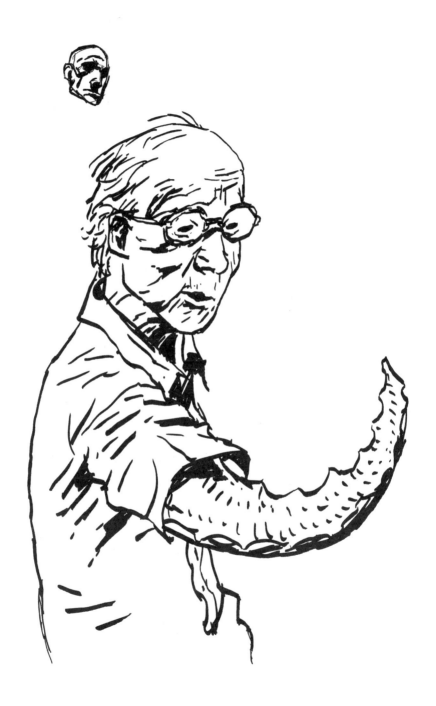

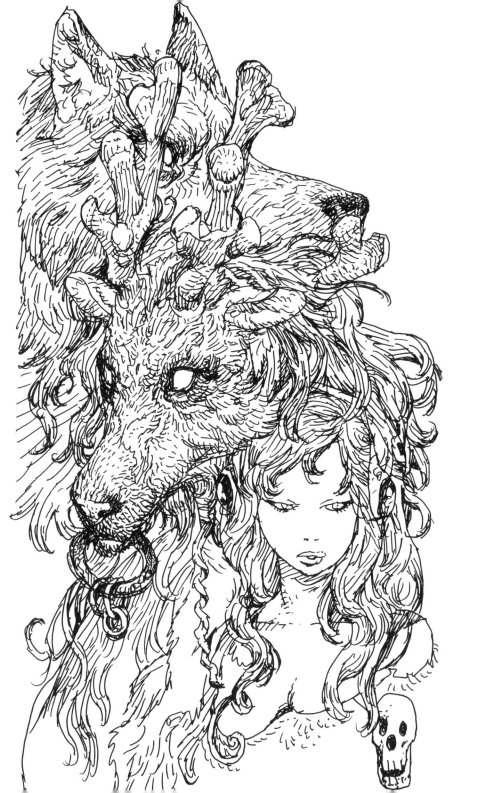

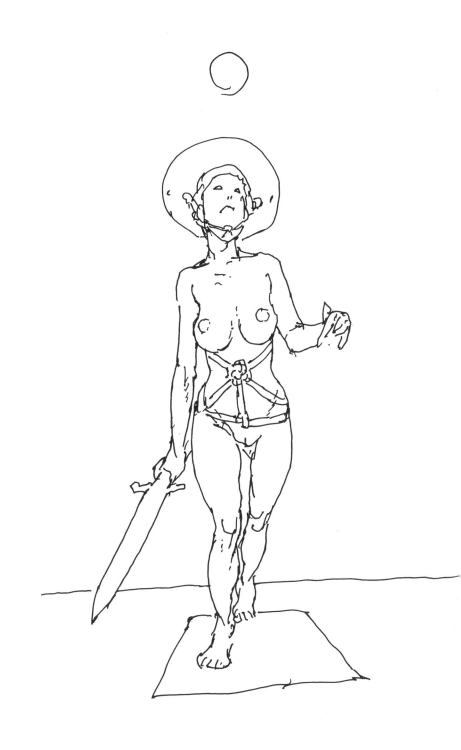

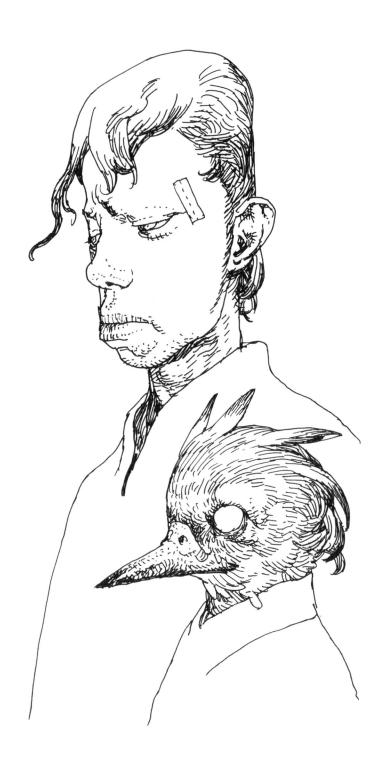

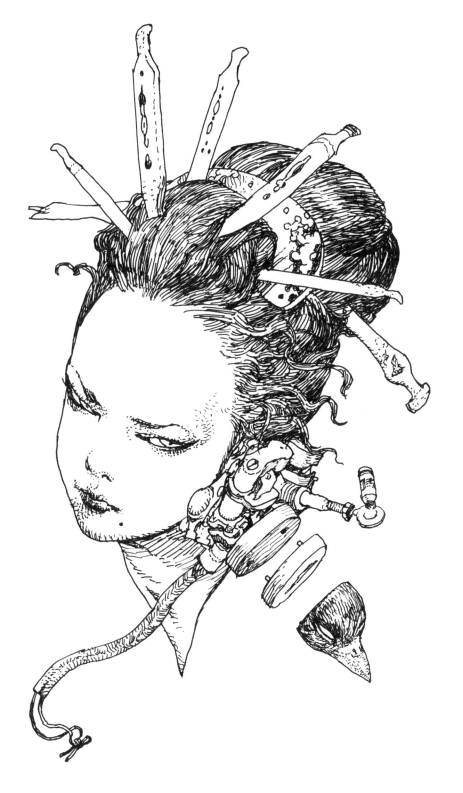

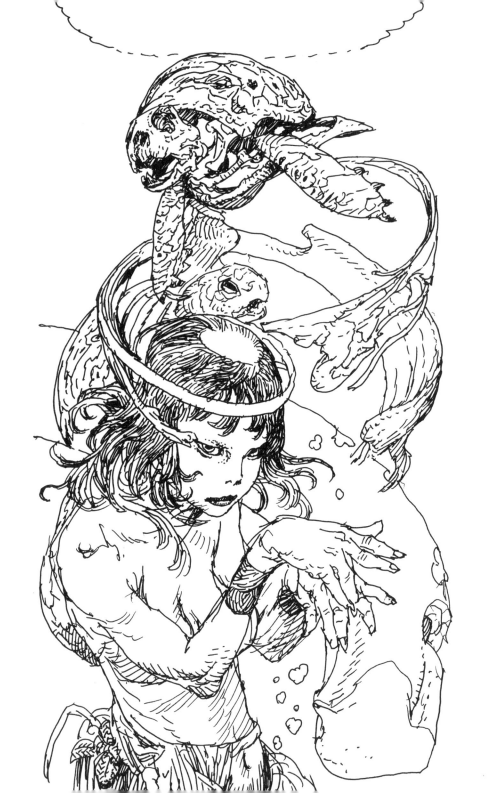

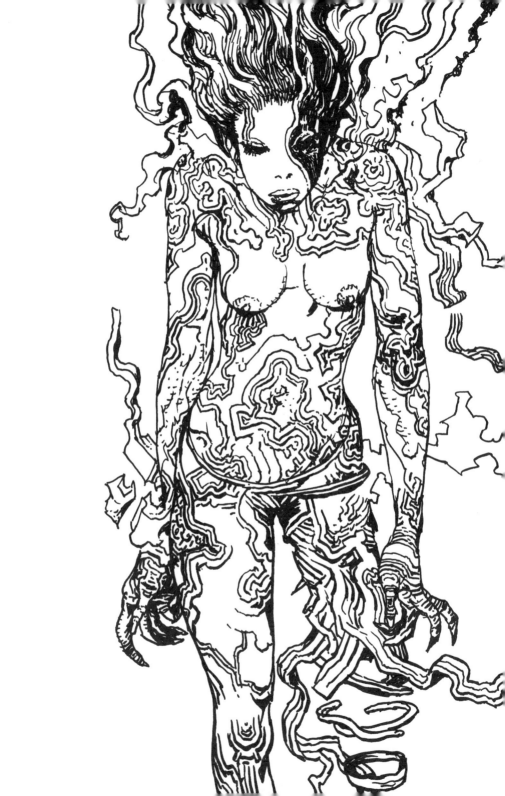

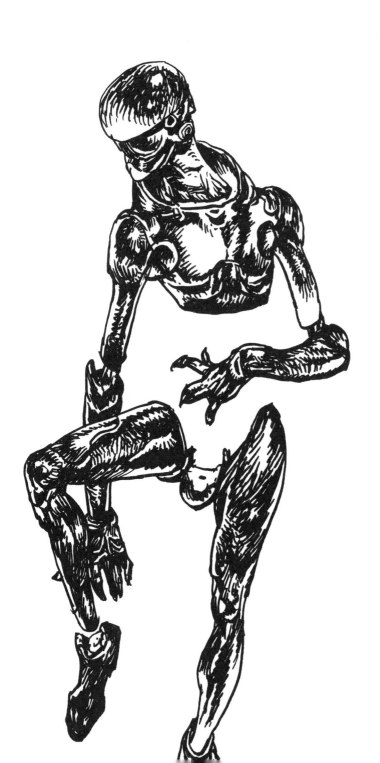

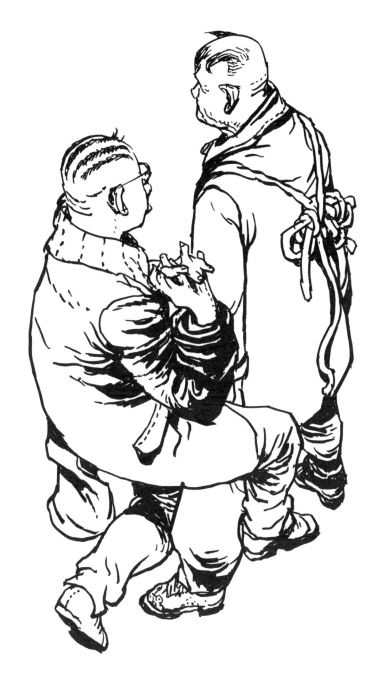

紅燒牛肉麵

粉蒸排骨

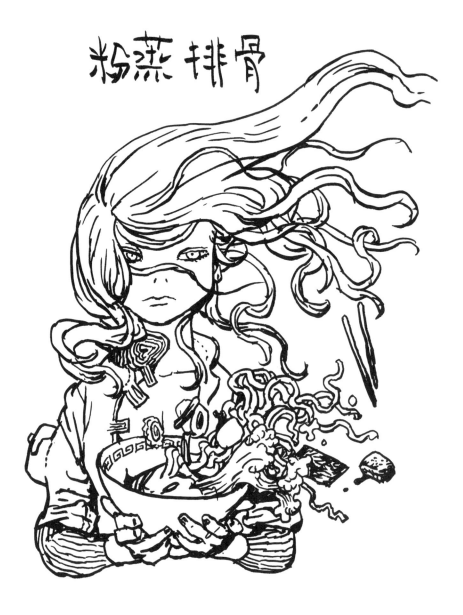

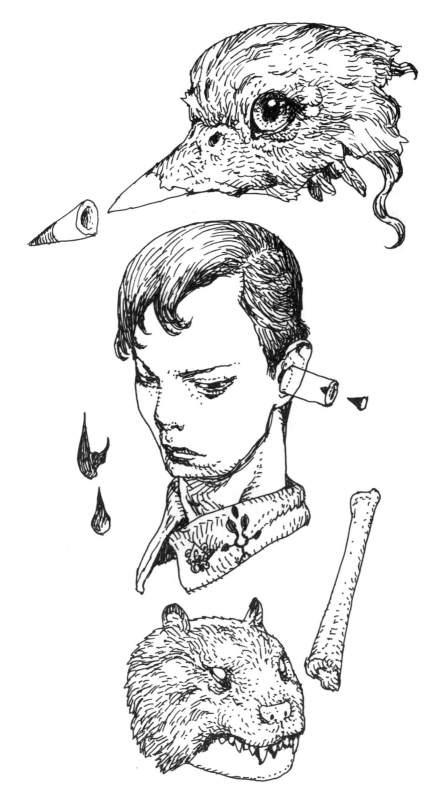

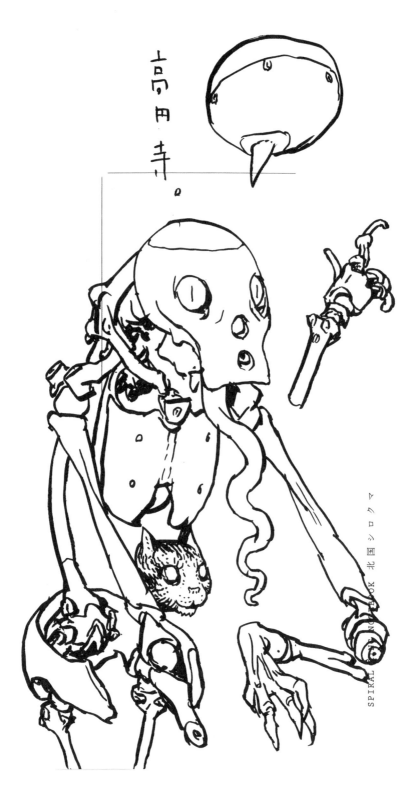

高円寺。

SPIRAL OF NOTEBOOK 北国シロクマ

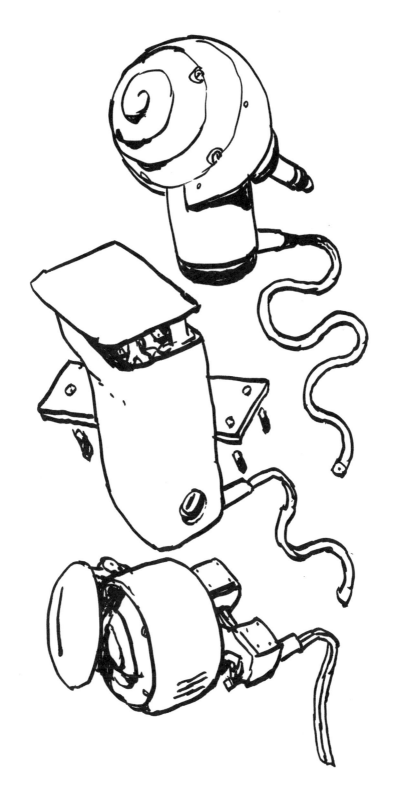

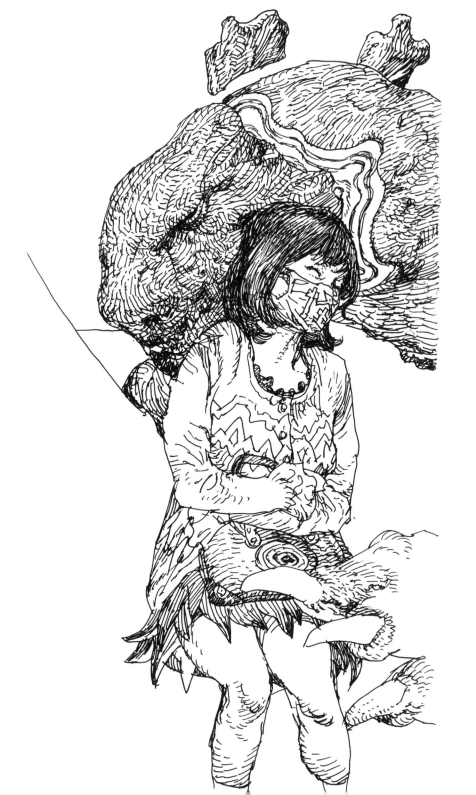

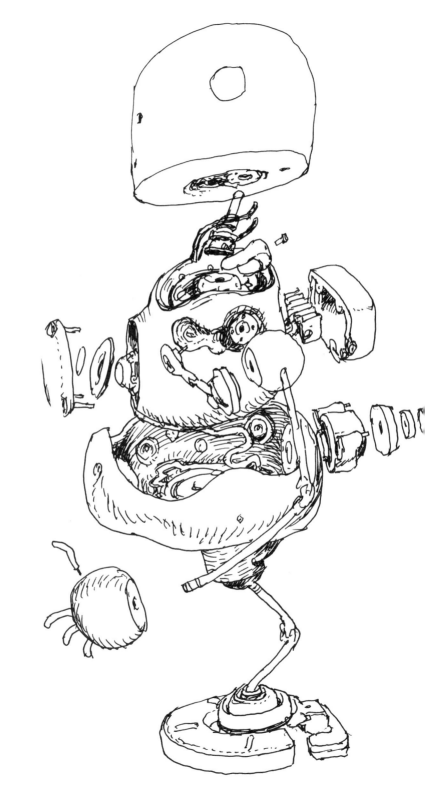

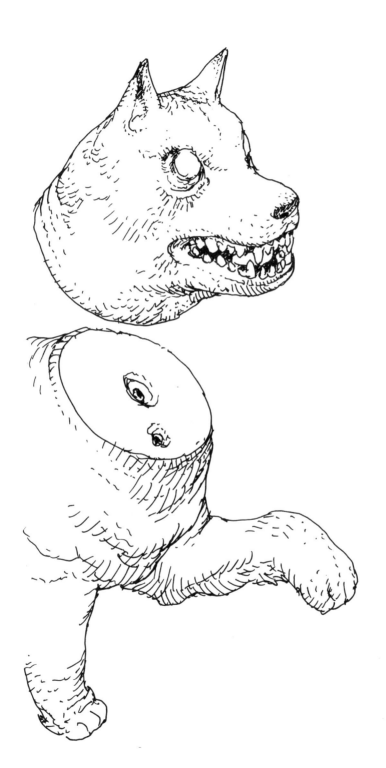

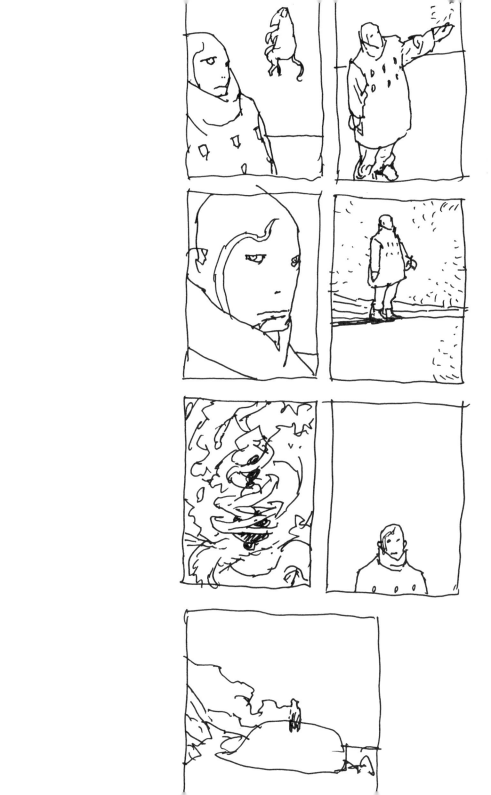

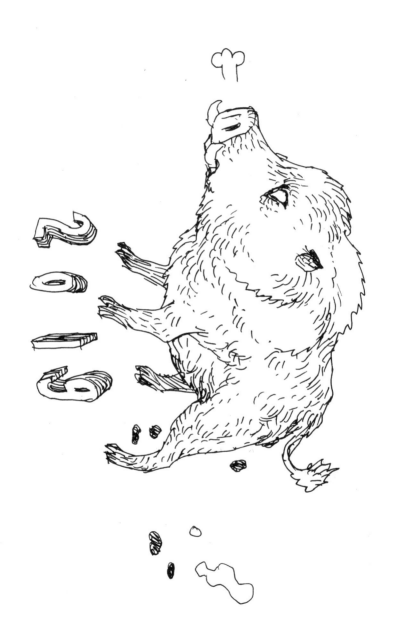

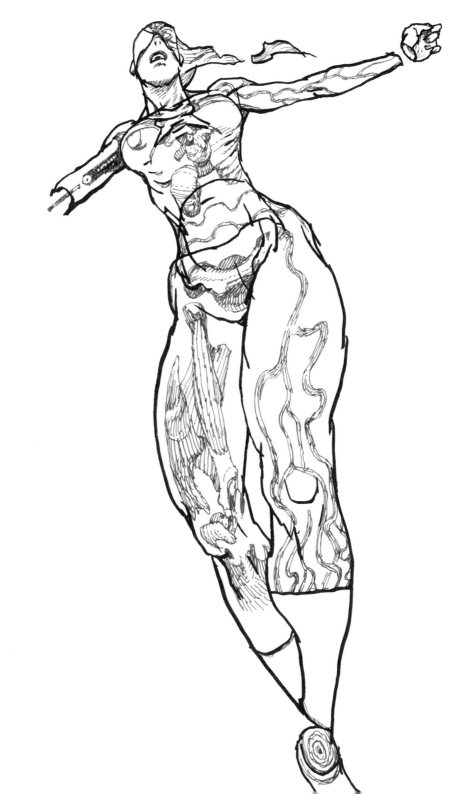

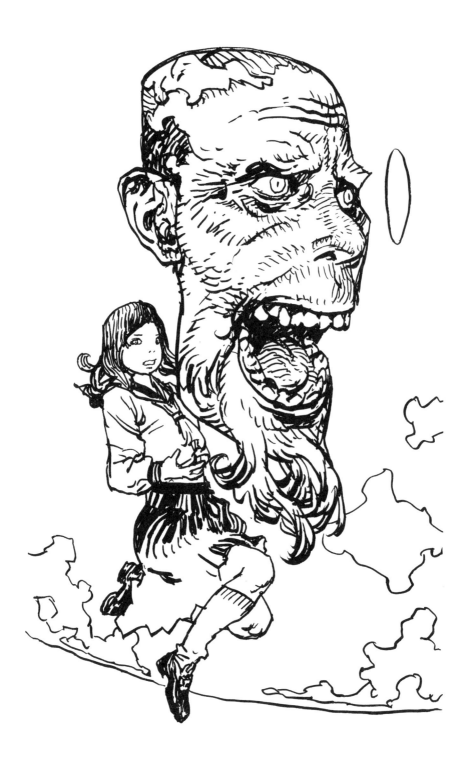

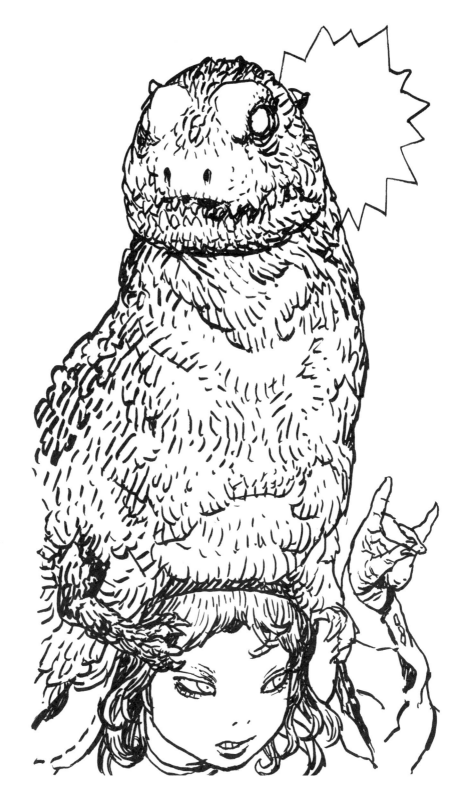

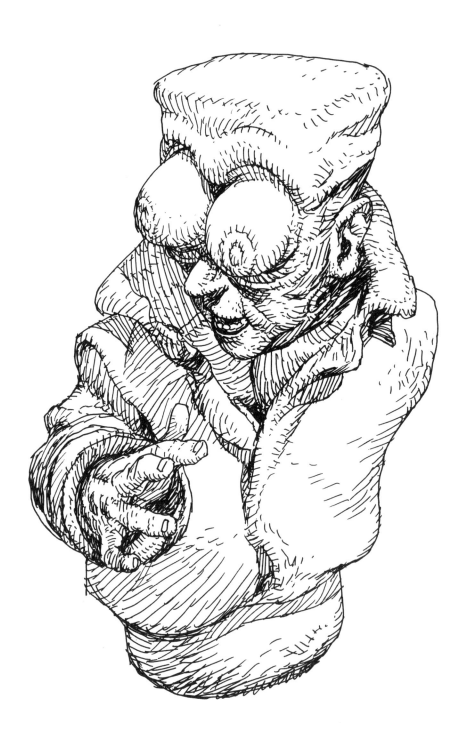

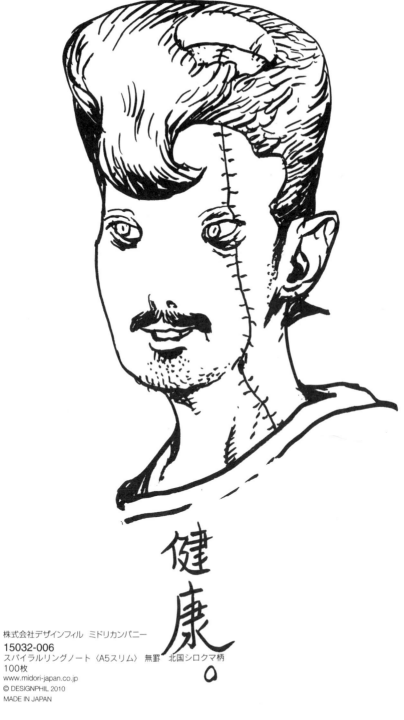

健
康
。

株式会社デザインフィル　ミドリカンパニー
15032-006
スパイラルリングノート〈A5スリム〉　無罫　北国シロクマ柄
100枚
www.midori-japan.co.jp
© DESIGNPHIL 2010
MADE IN JAPAN

寺田器は 28日で 終了です。

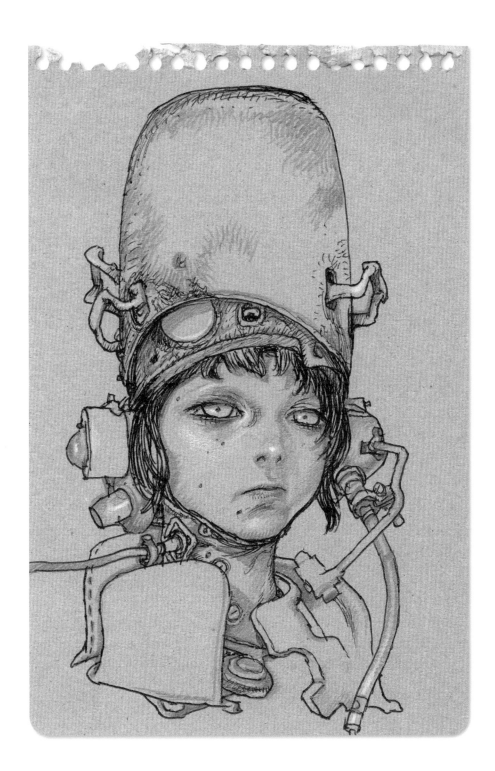

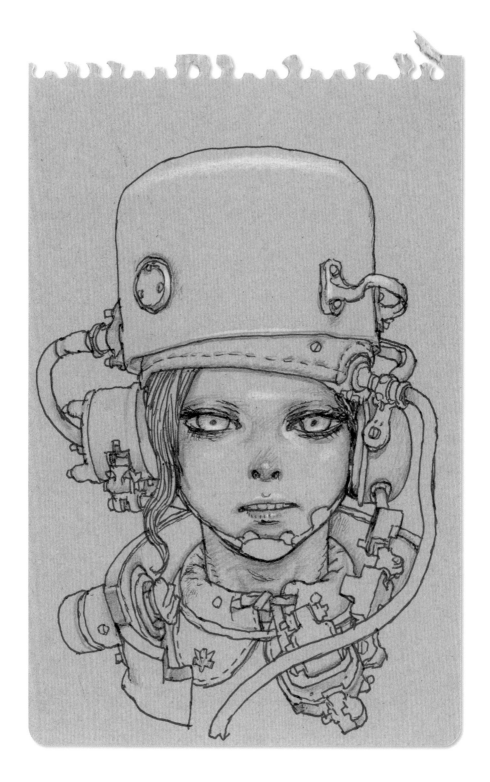

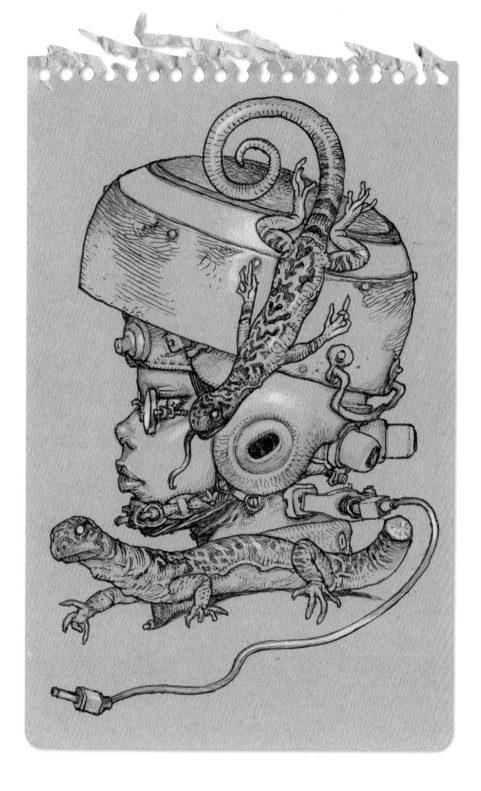

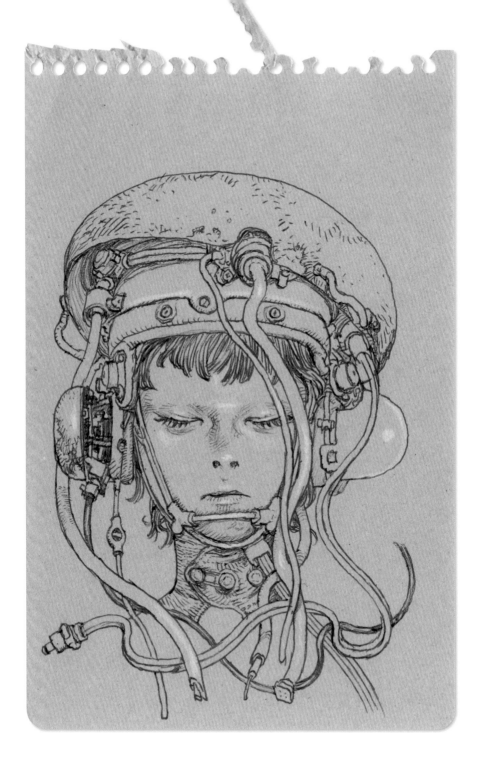

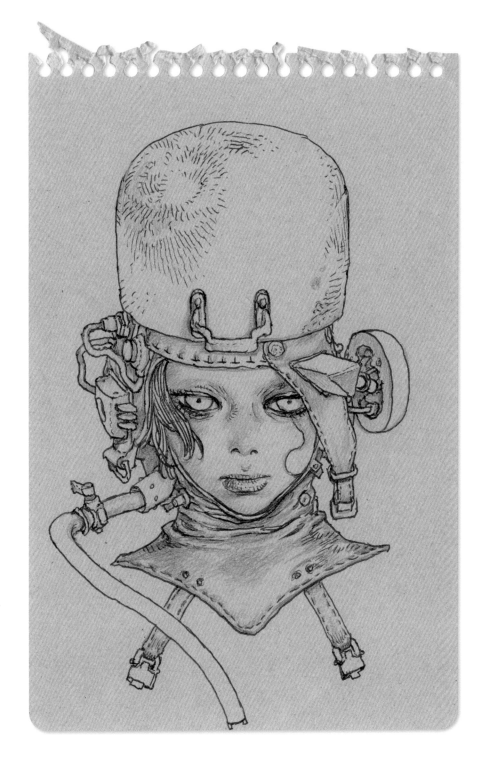

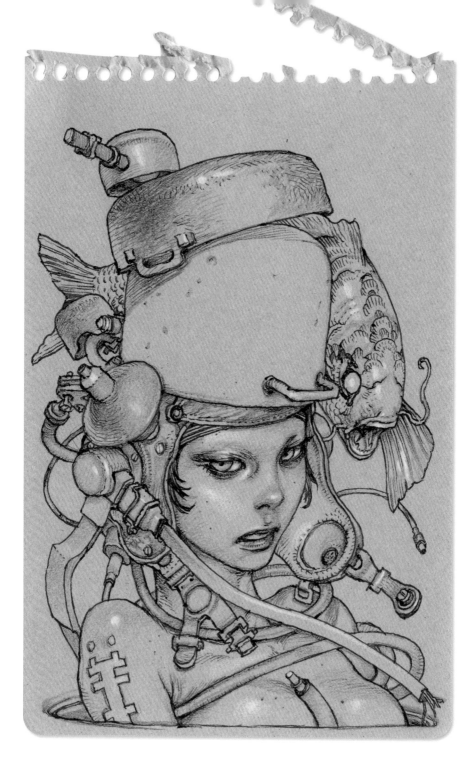

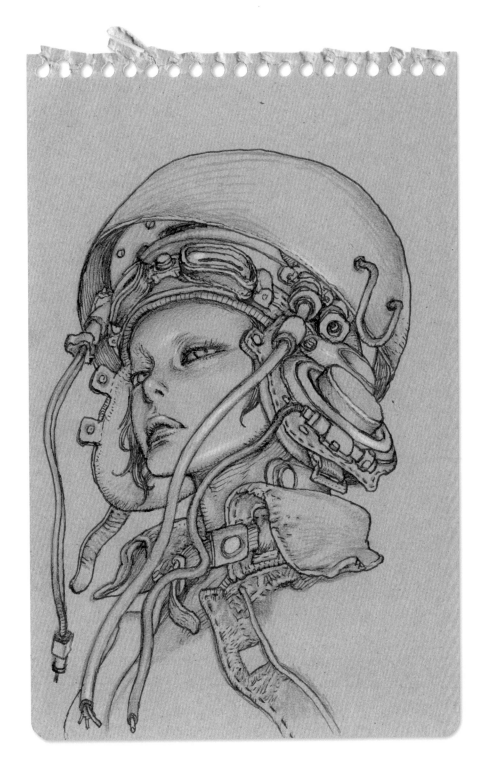

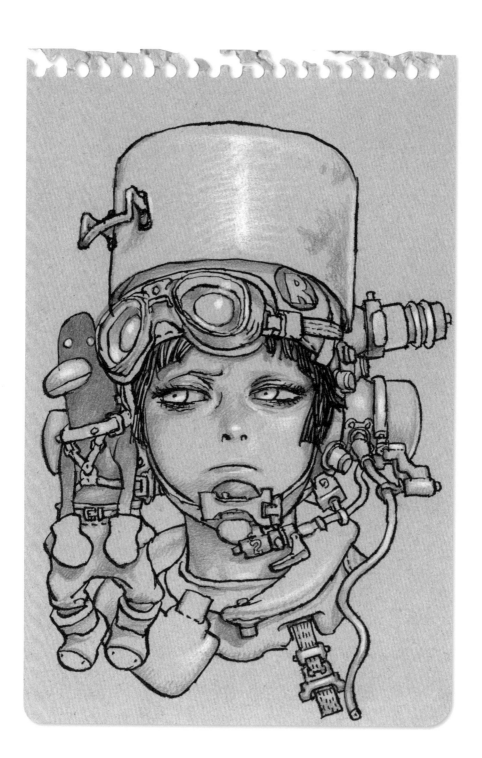

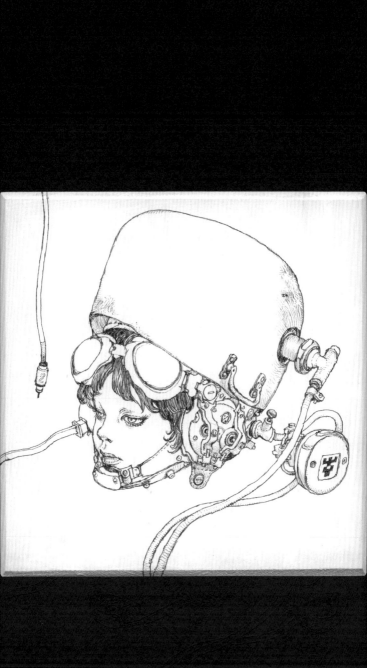

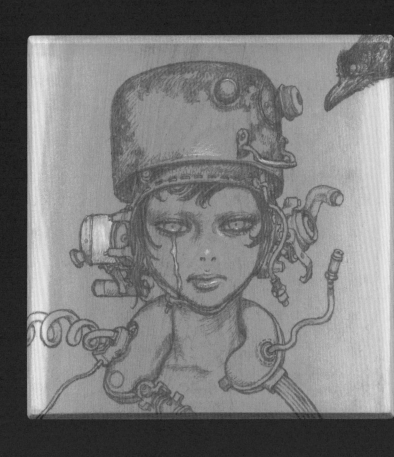

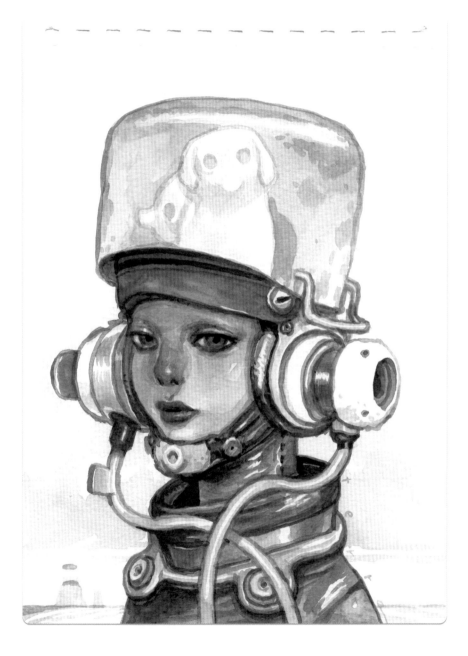

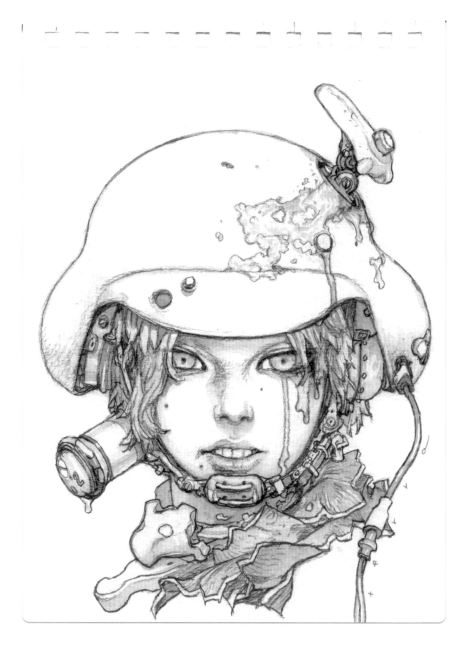

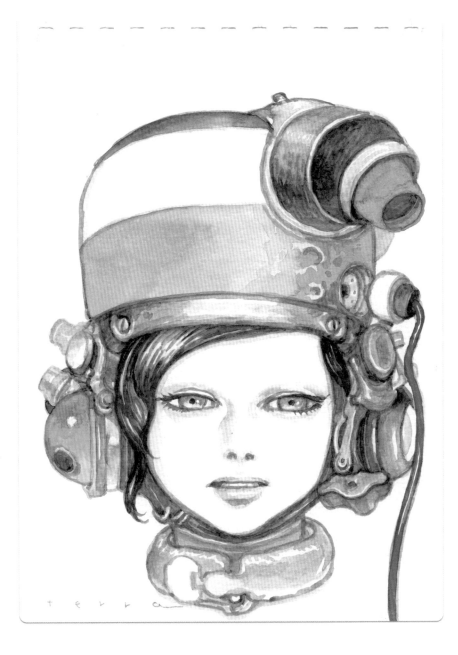

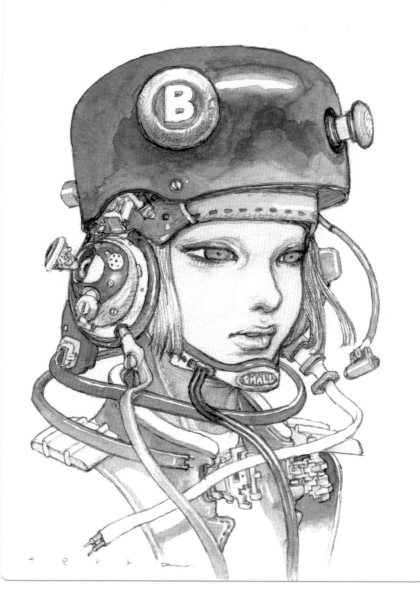

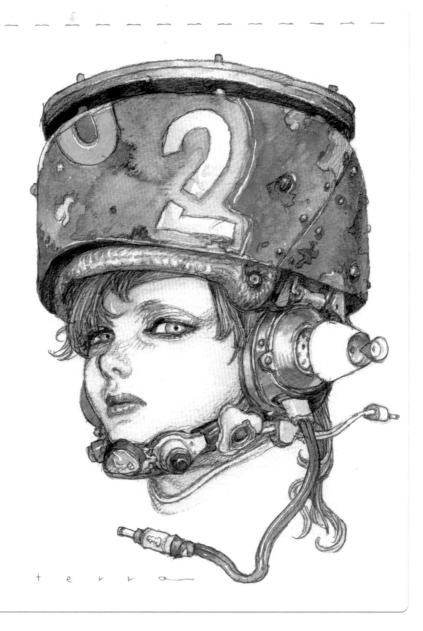

terra

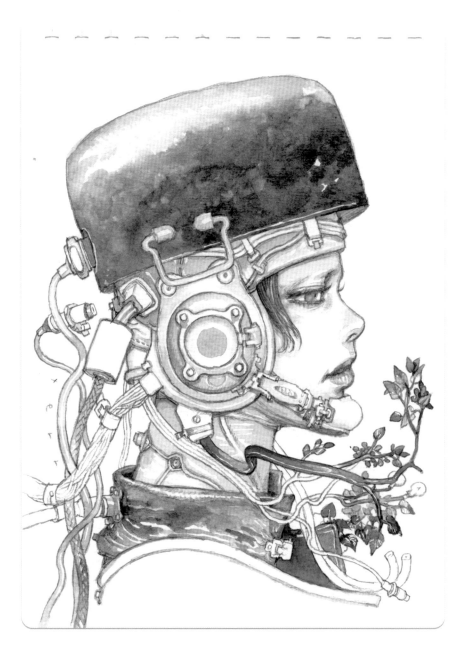

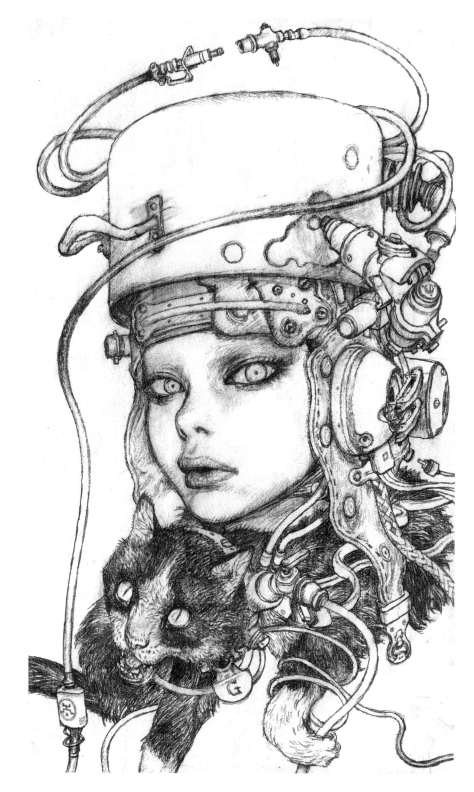

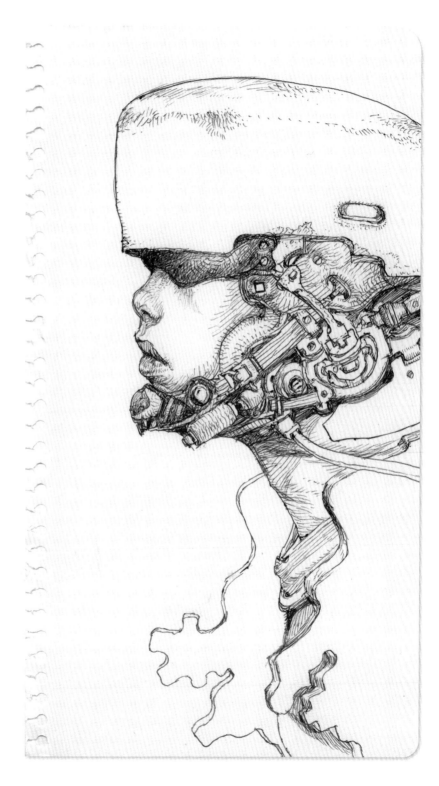

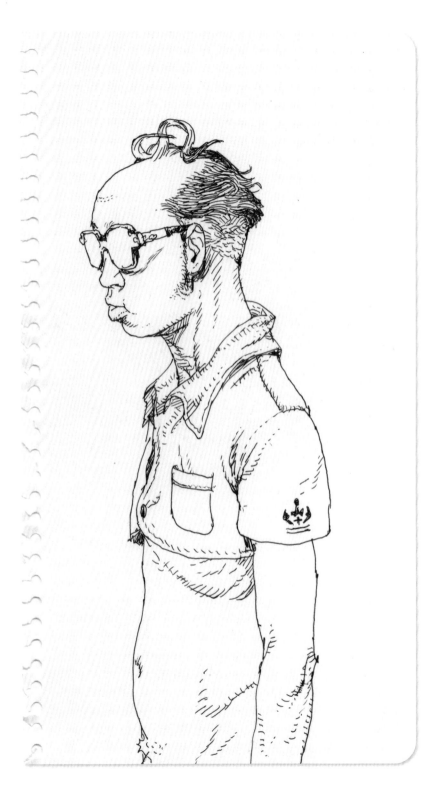

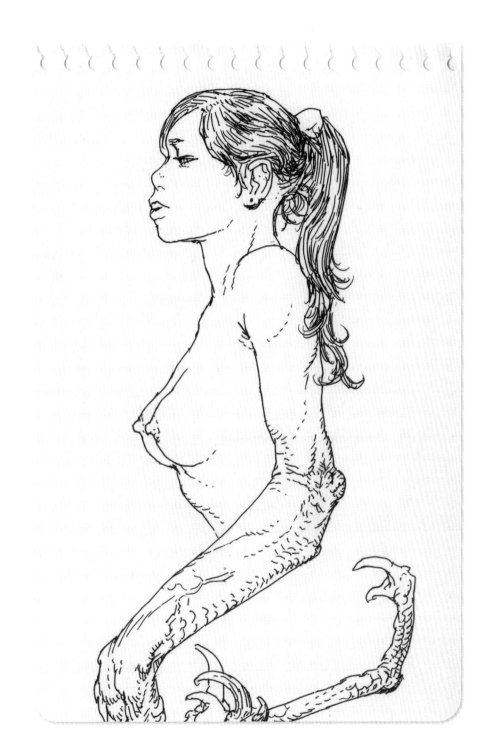

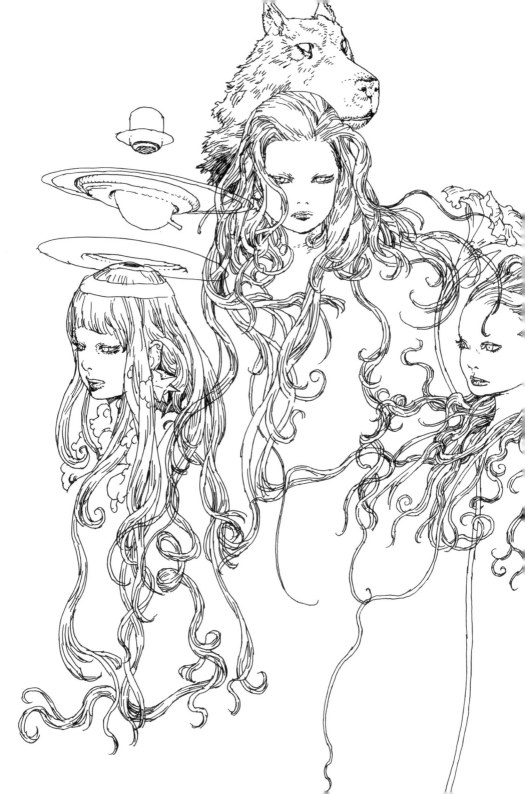

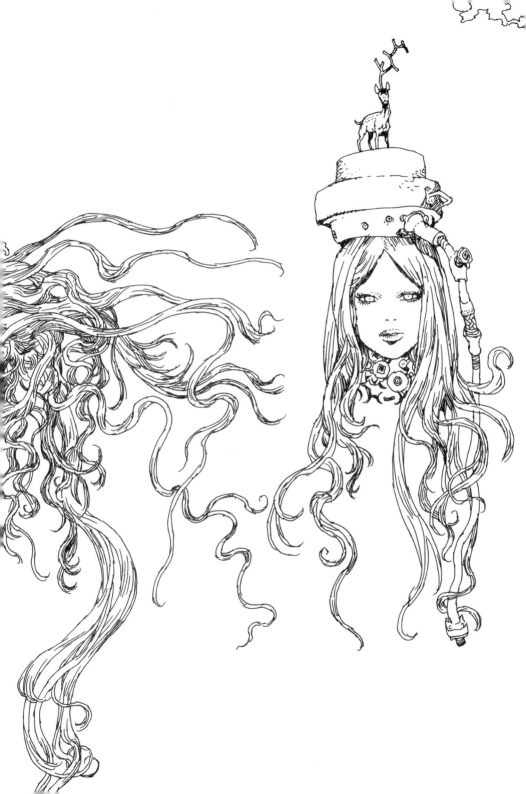

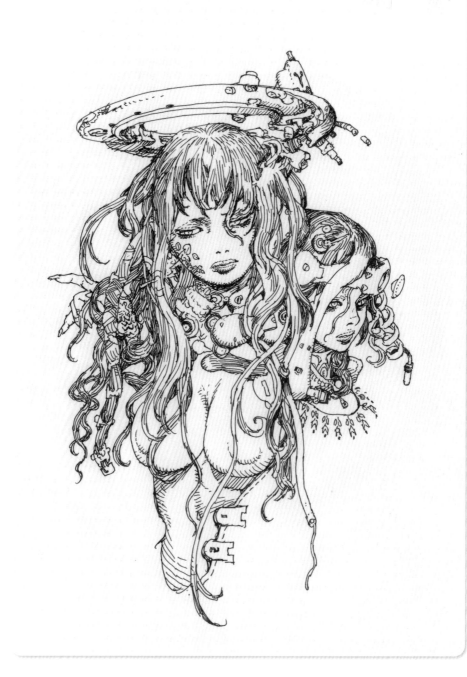

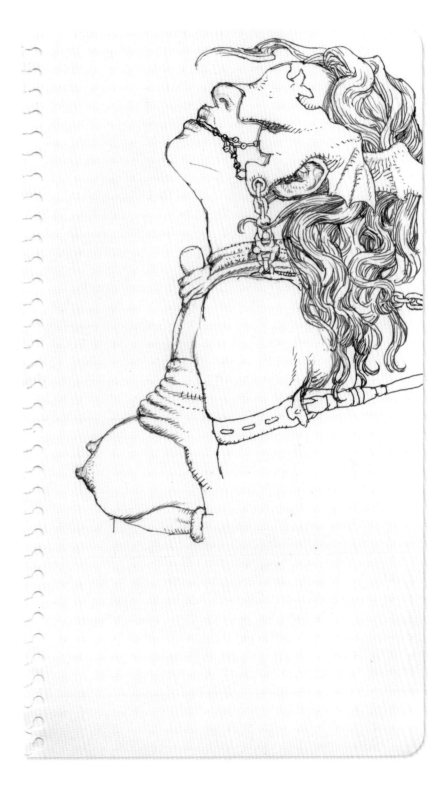

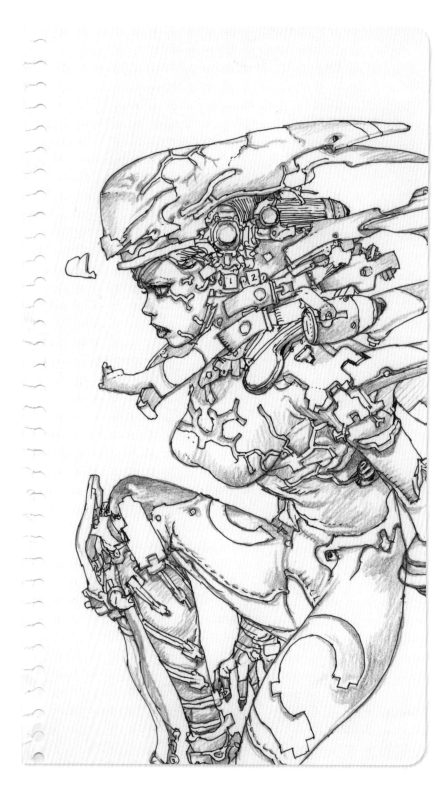

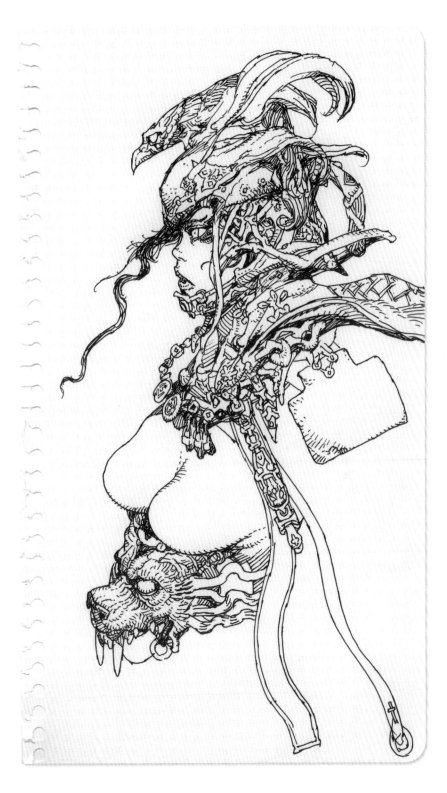

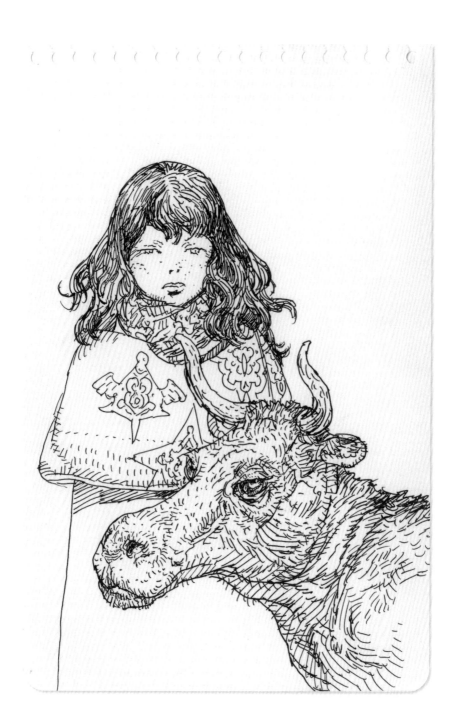

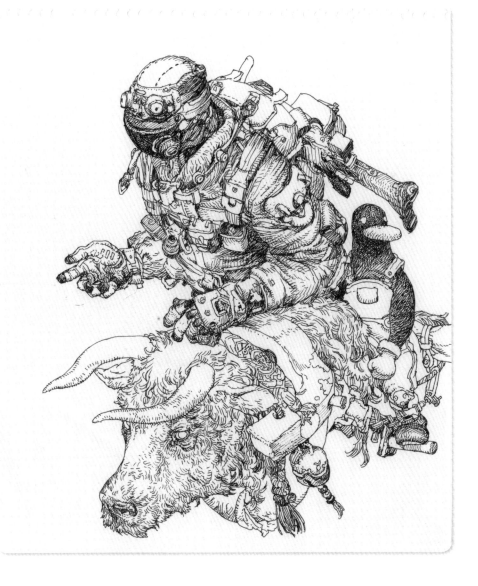

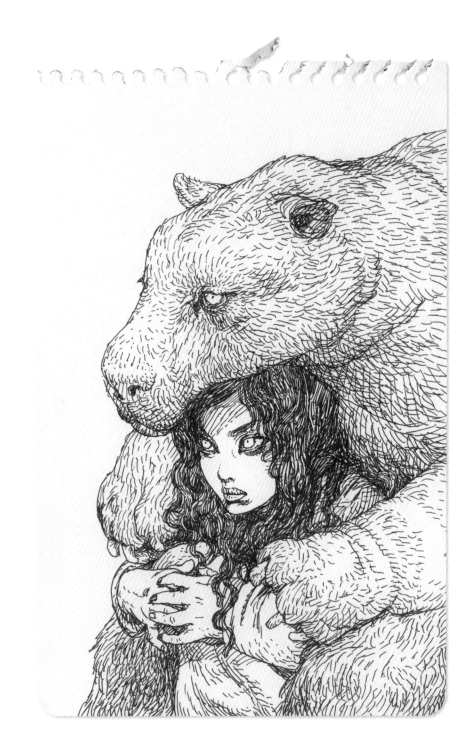

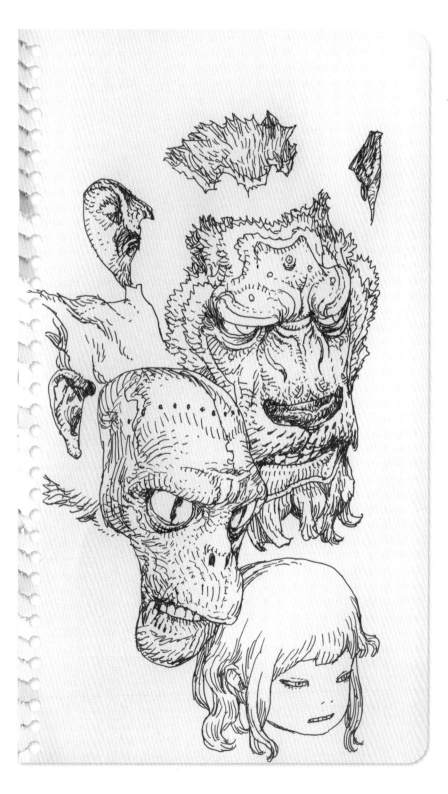

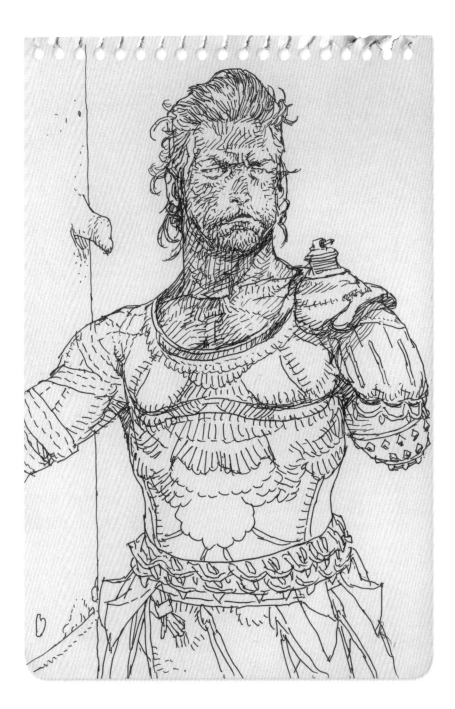

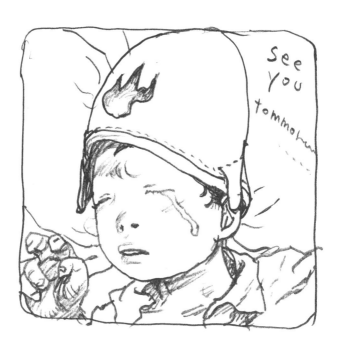

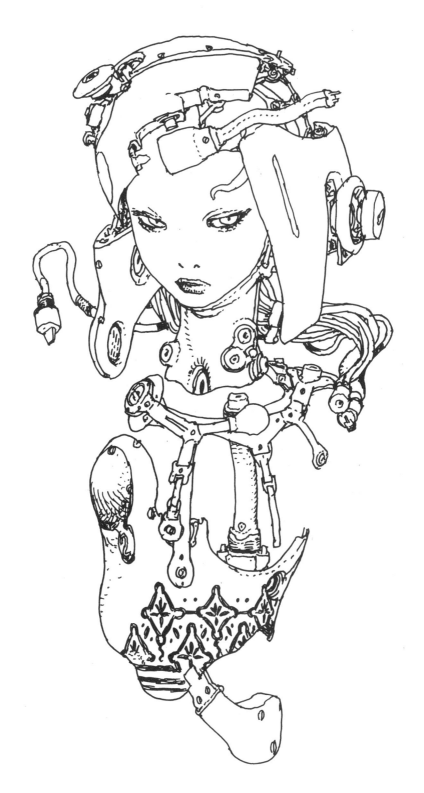

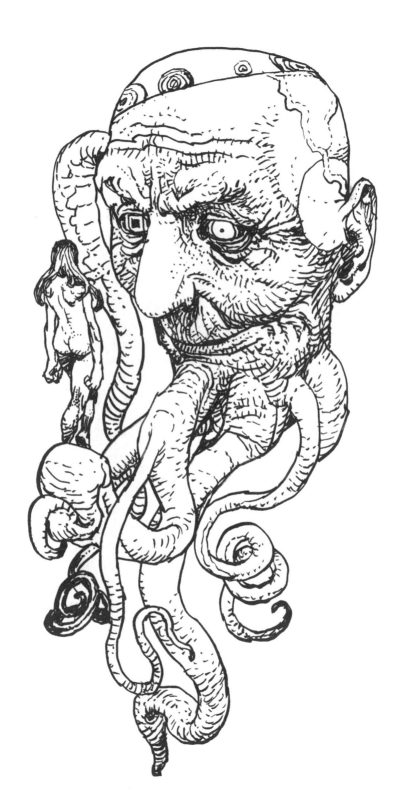

ちがうってさ——っ

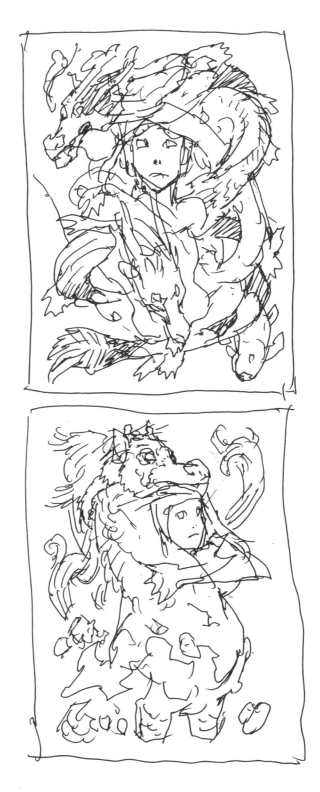

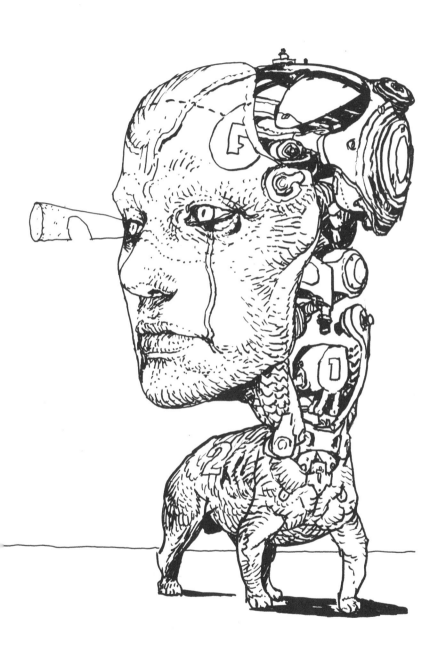

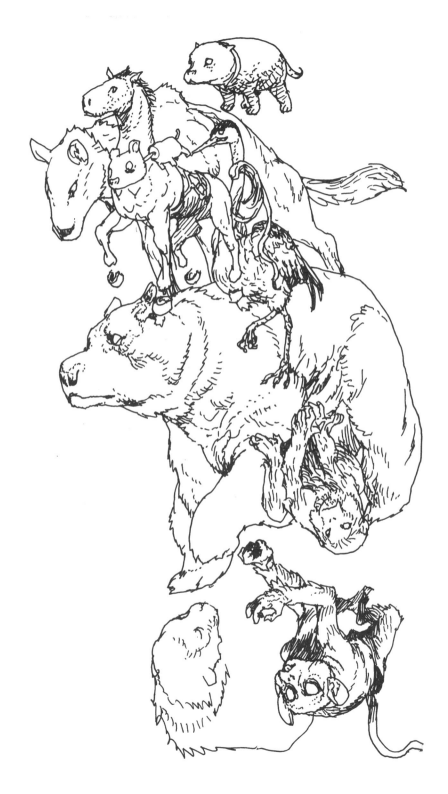

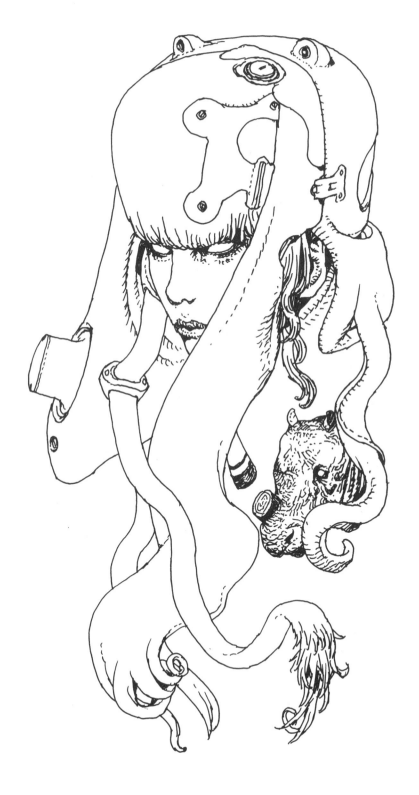

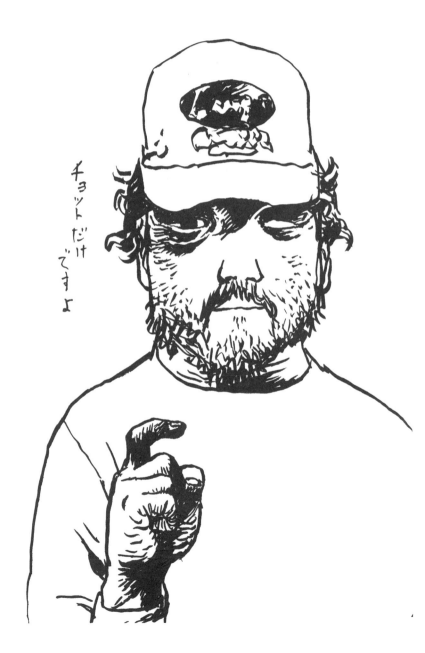

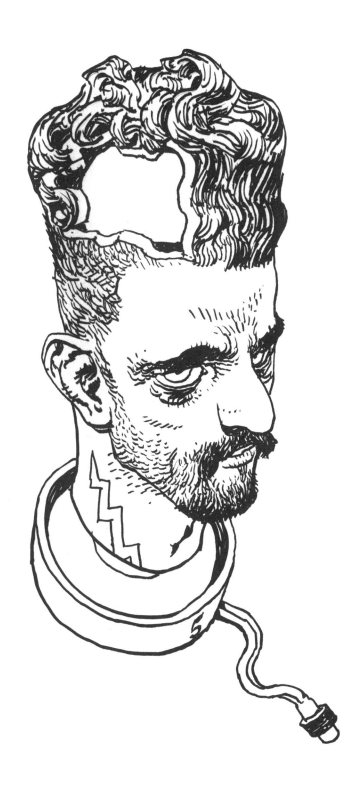

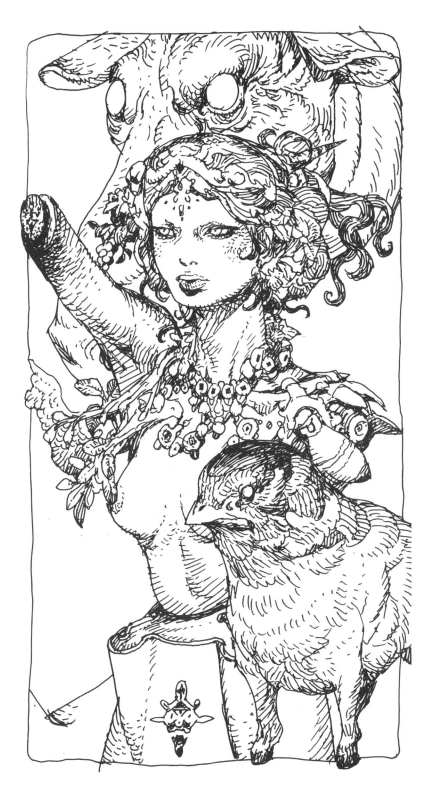

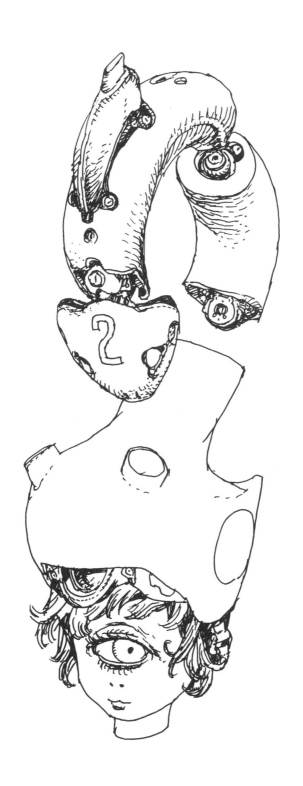

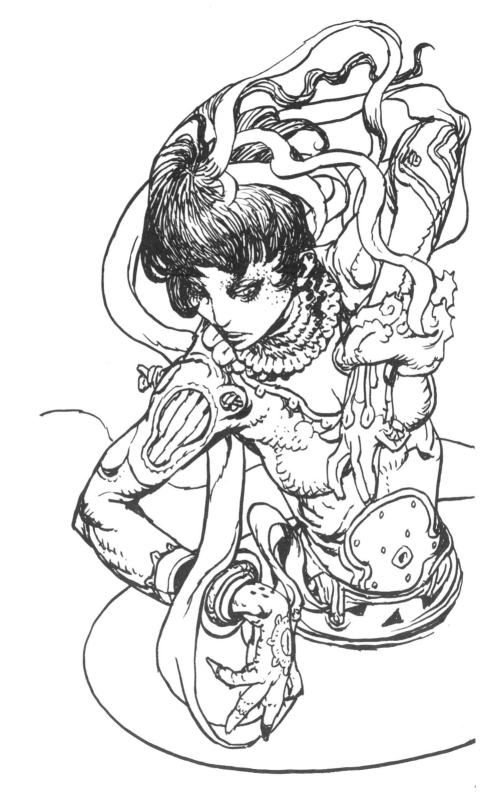

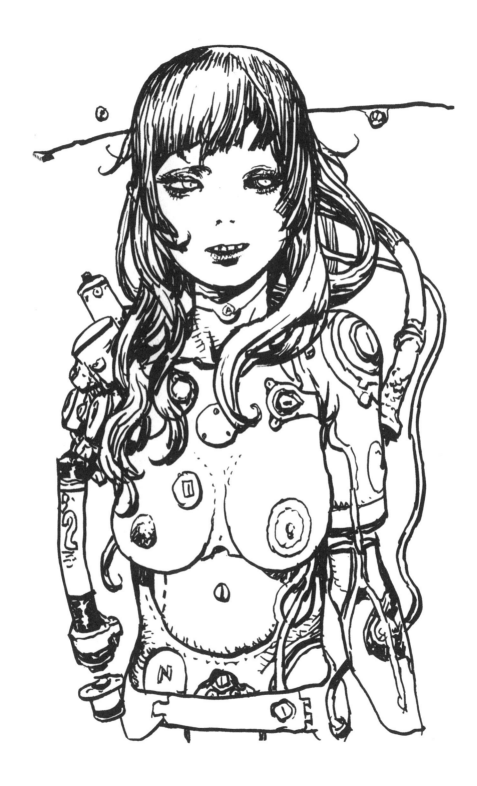

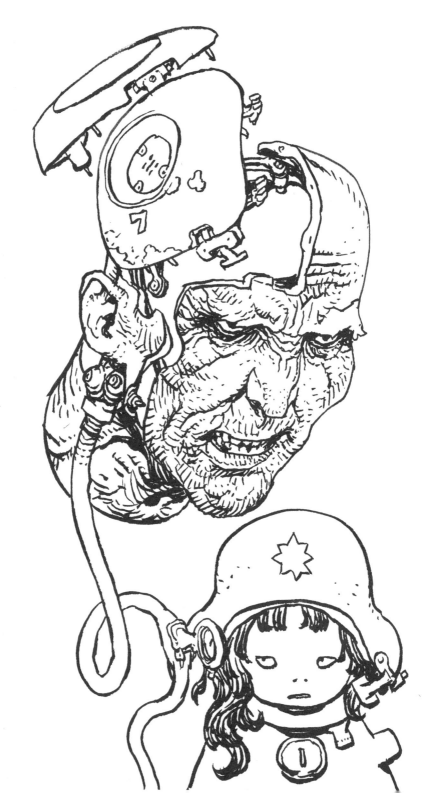

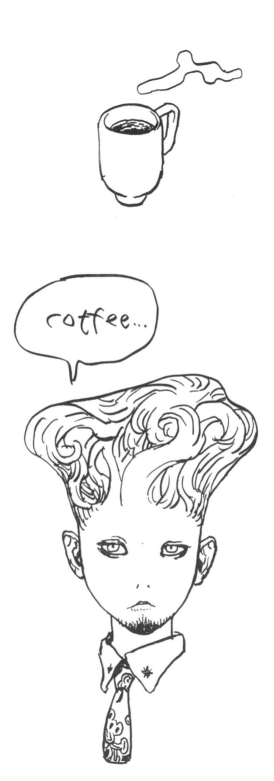

100年に1度

年賀

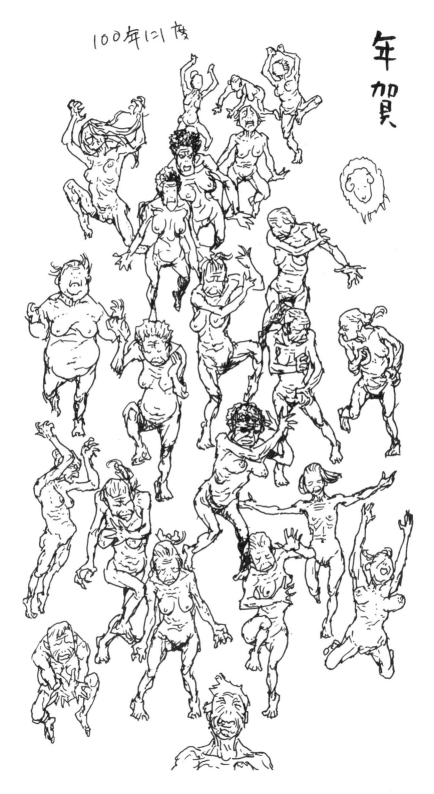

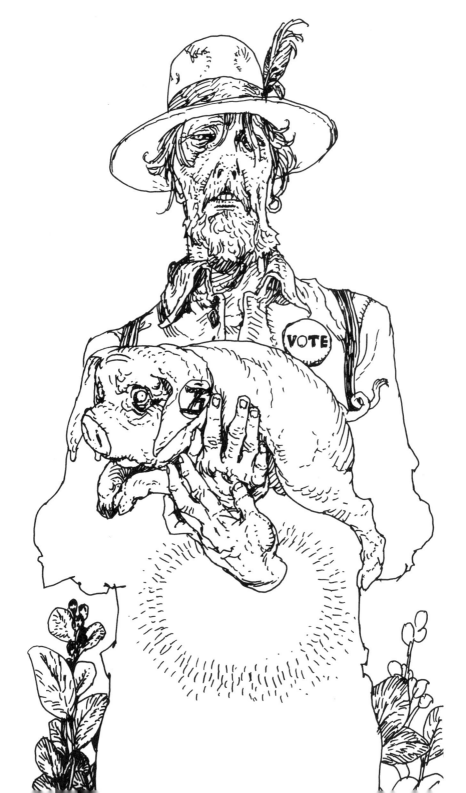

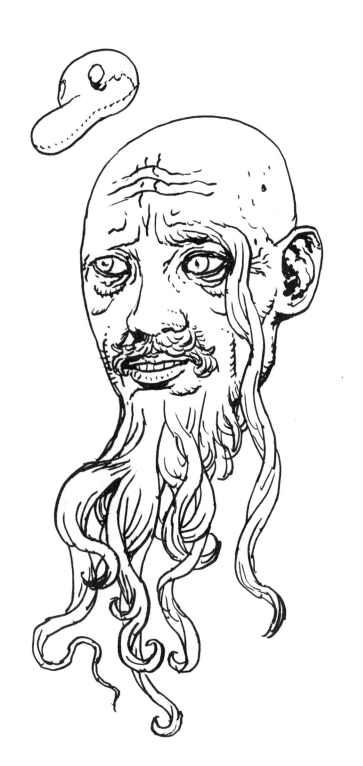

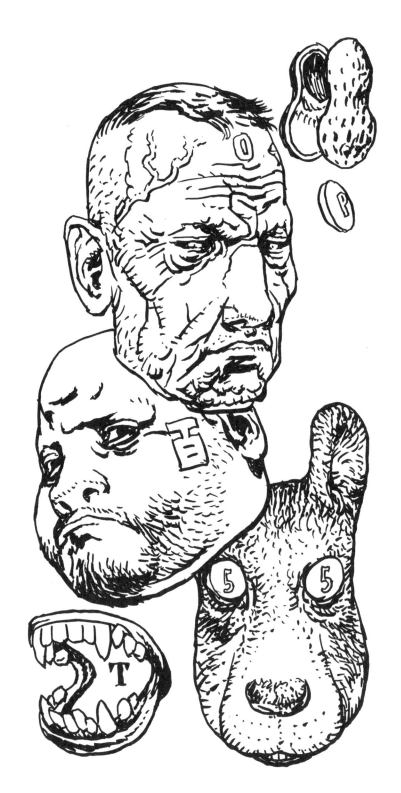

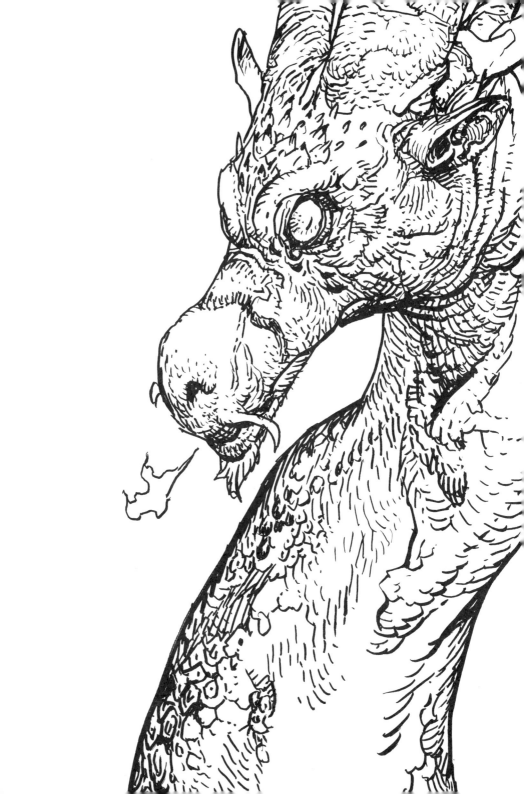

松山文創園區4號
倉庫

110台灣

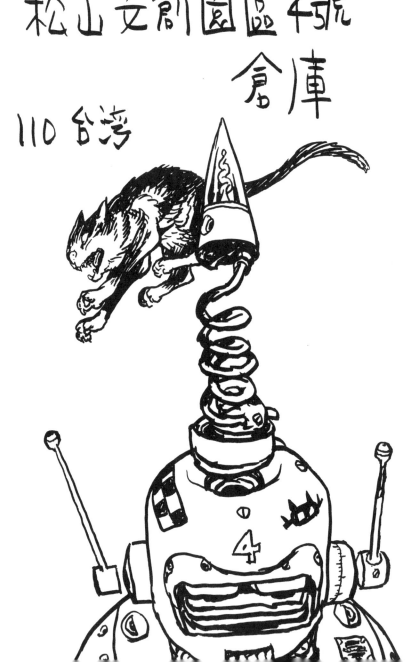

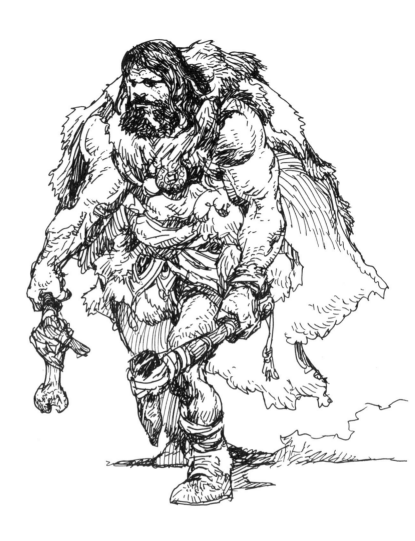

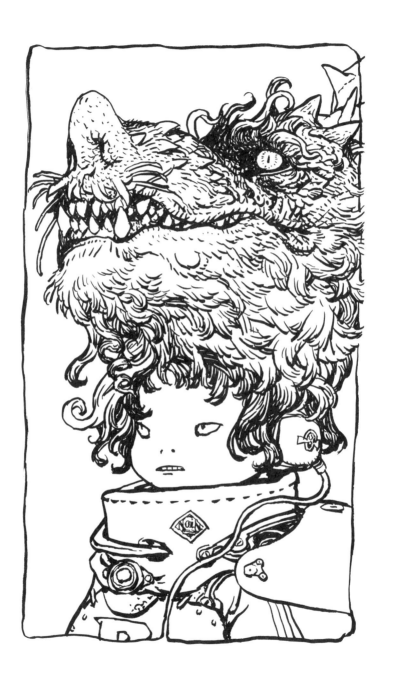

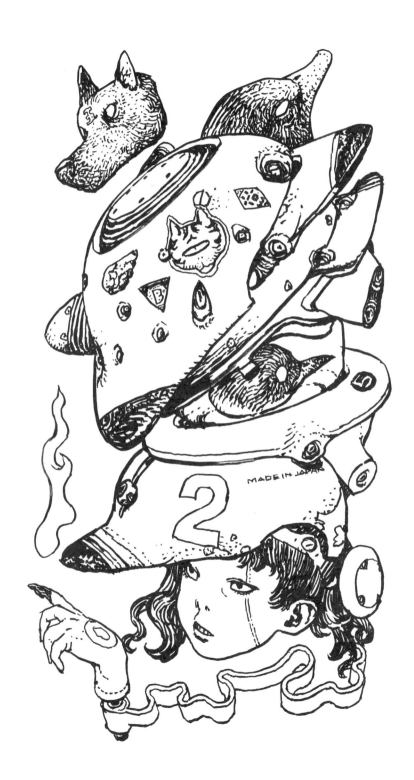

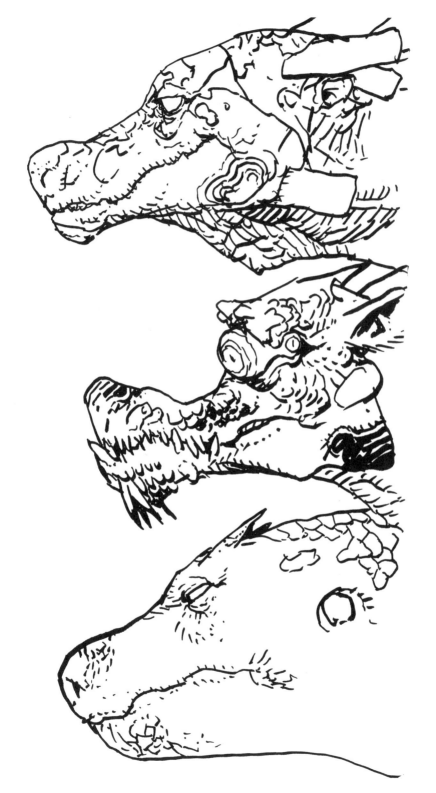

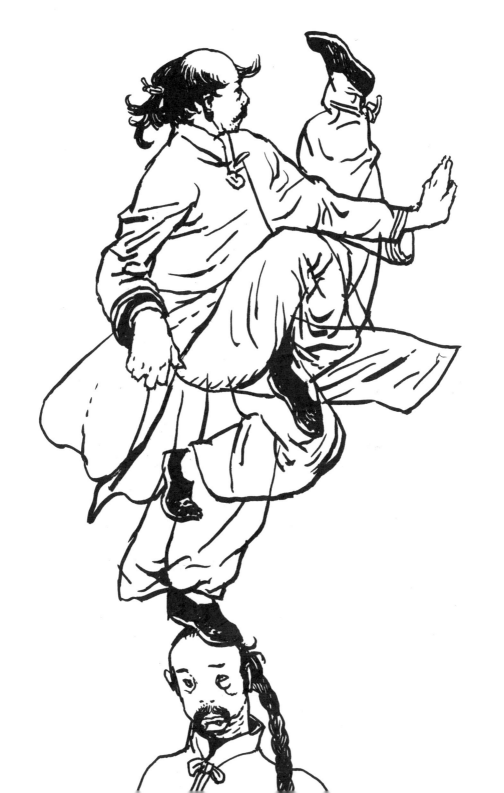

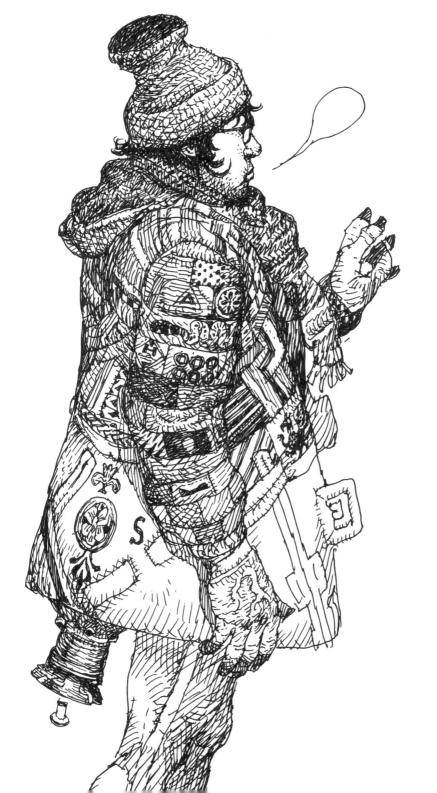

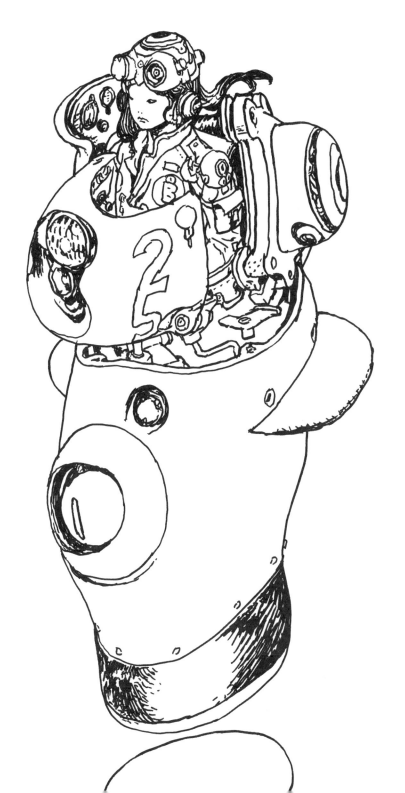

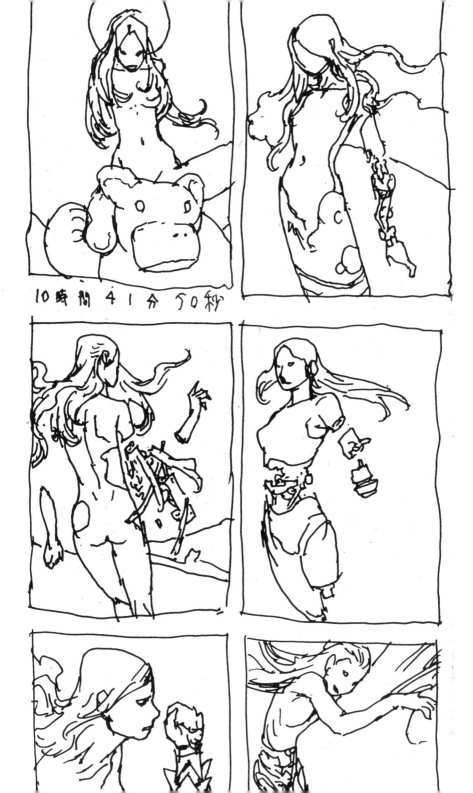

10時間 41分 50秒

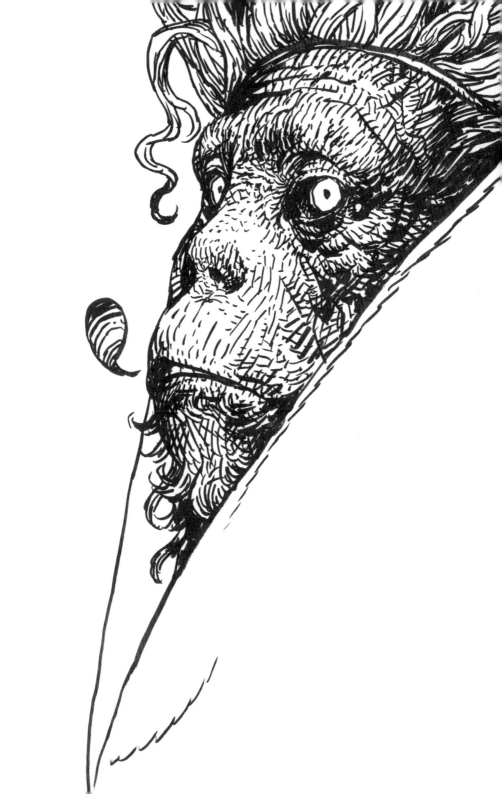

Information

SPIRAL RING NOTEBOOK

□ のんびり砂漠を歩くラクダ色のクラフト表紙

☑ 雪原を歩くシロクマのように真っ白なMD用紙

□ 軽快に飛び跳ねるカンガルーのような紙のポケット

中紙に使われているMD用紙は1960年代にミドリオリジナルのダイアリー
用紙として開発され、現在まで品質改良を重ね続けている筆記用紙です。
にじみや裏抜けがしにくく、書き味が良い筆記適正を追求した紙です。

TITLE

TITLE

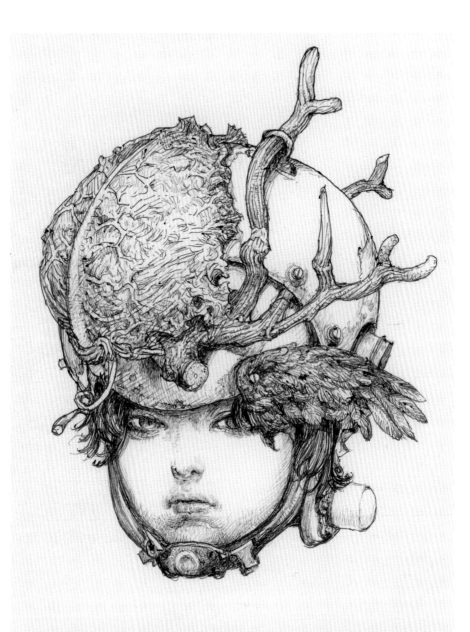

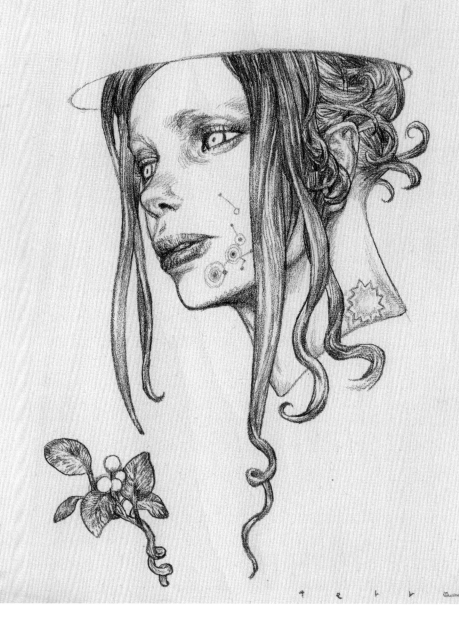

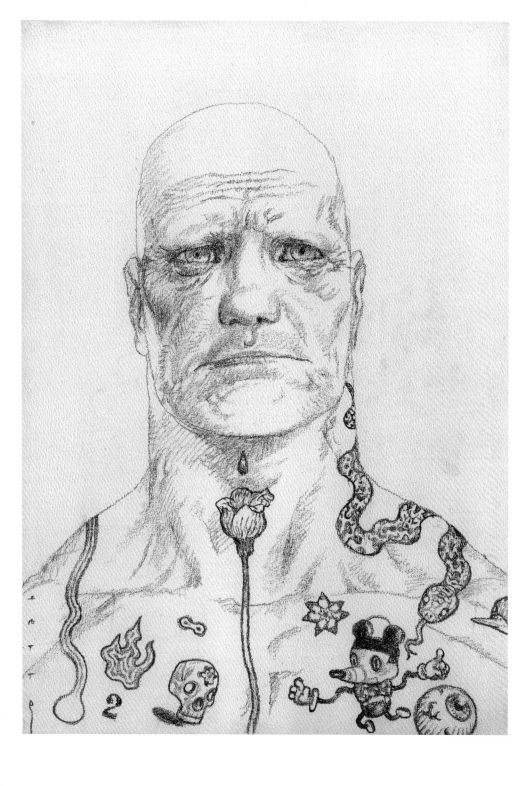

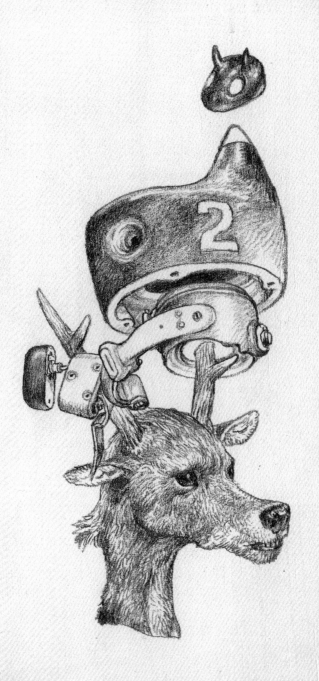

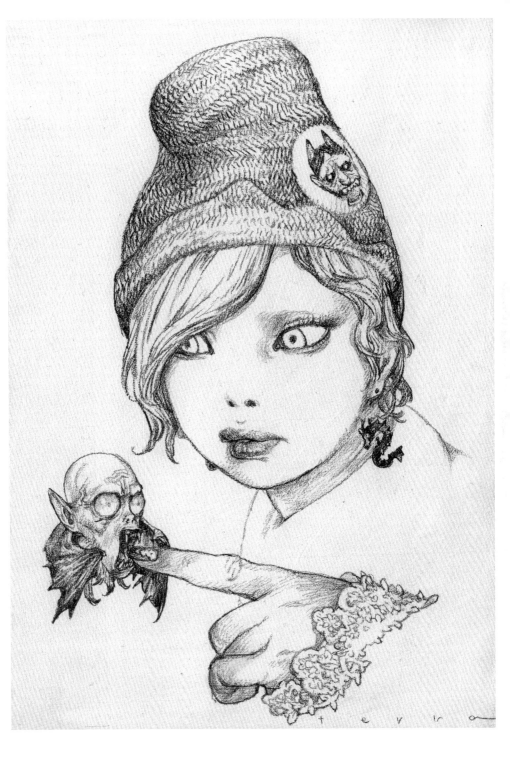

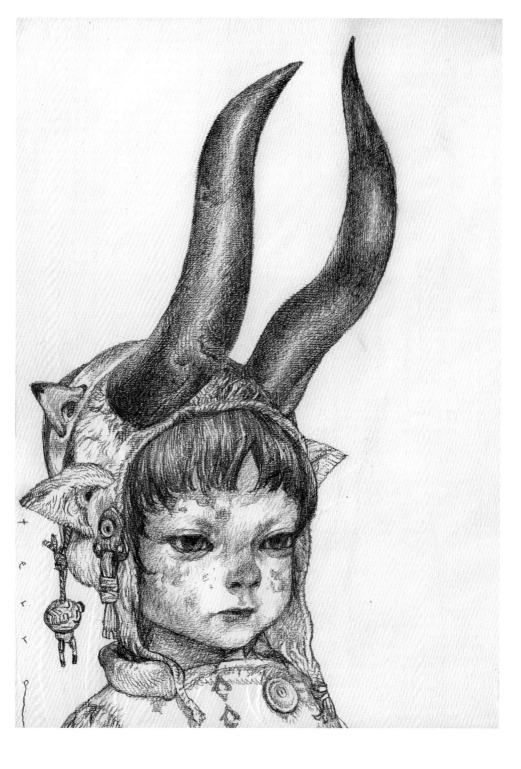

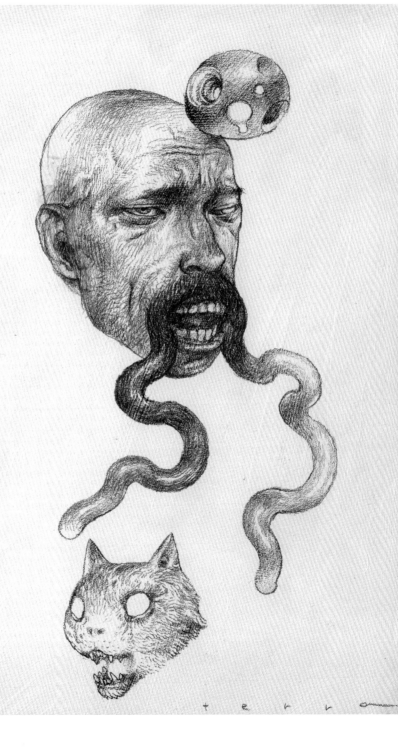

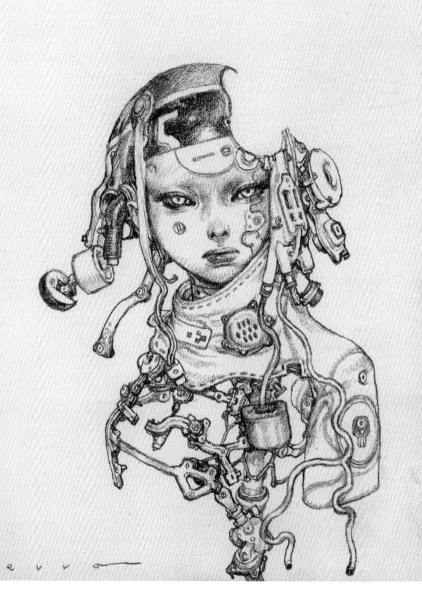

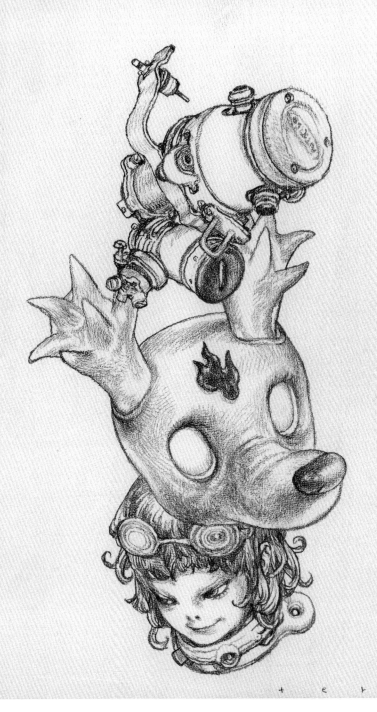

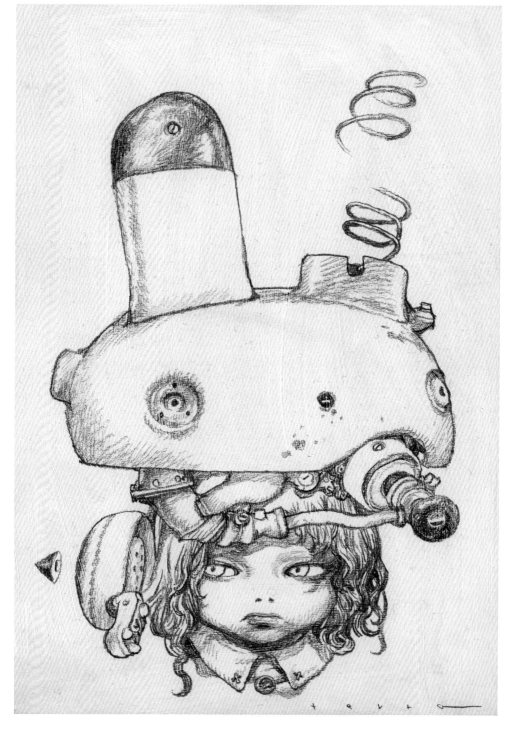

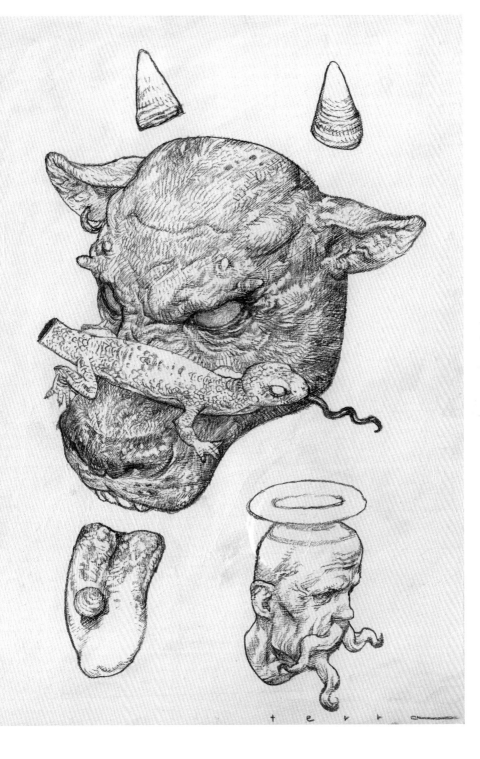

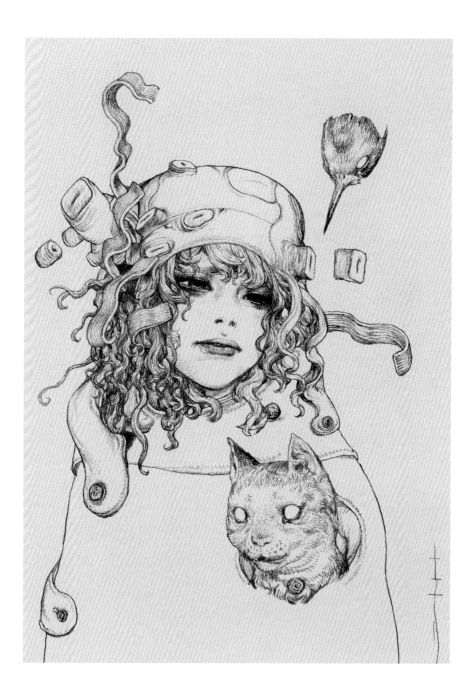

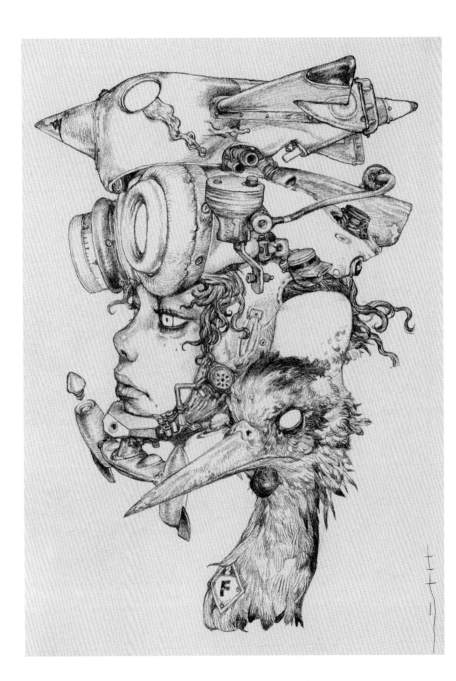

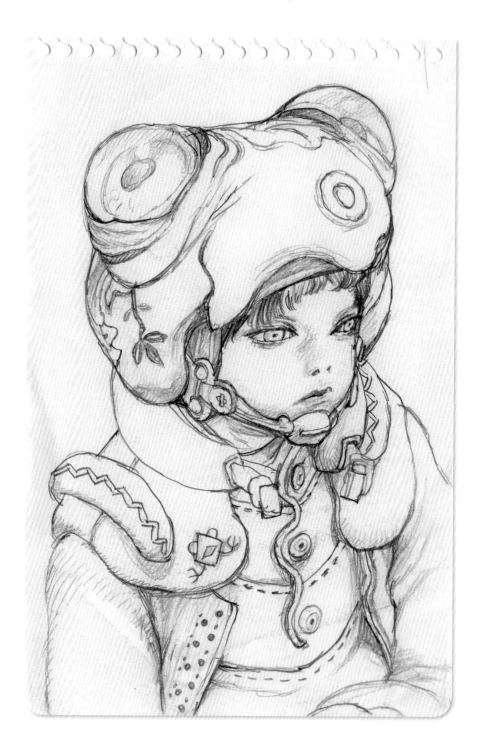

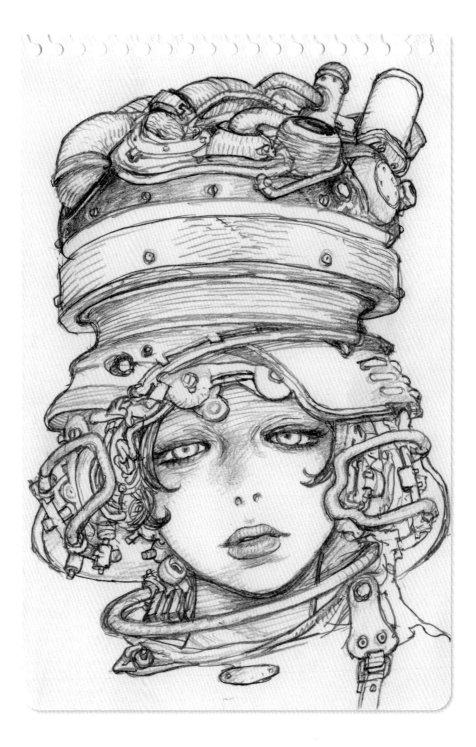

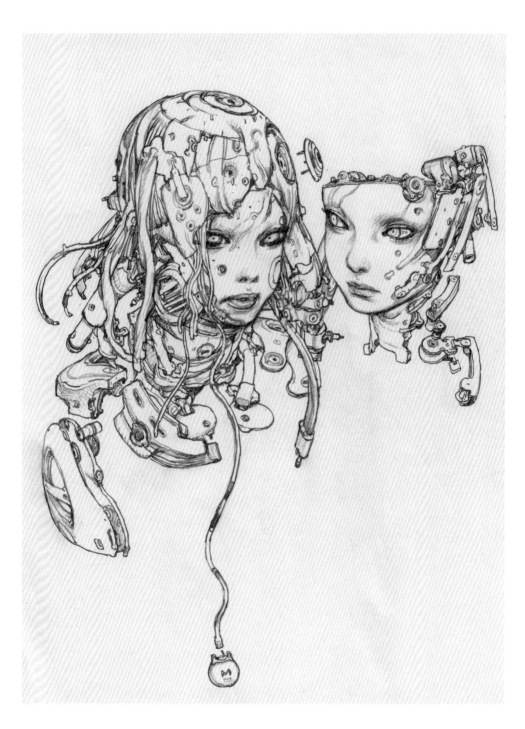

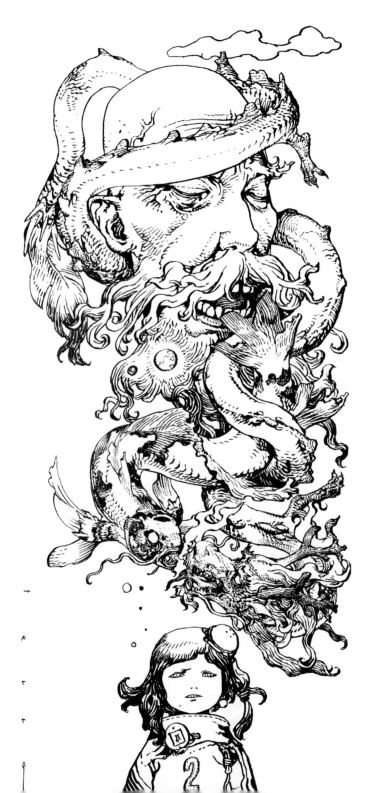

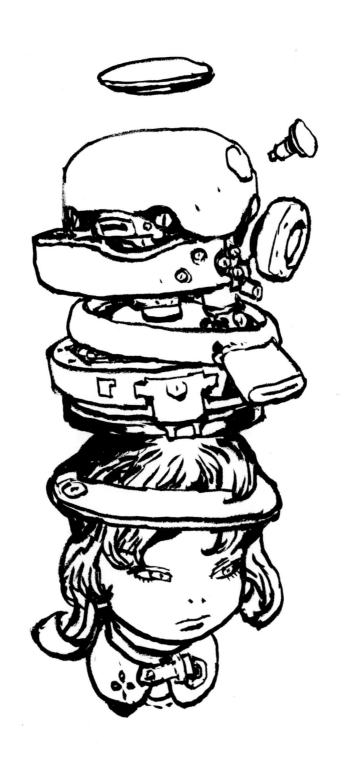

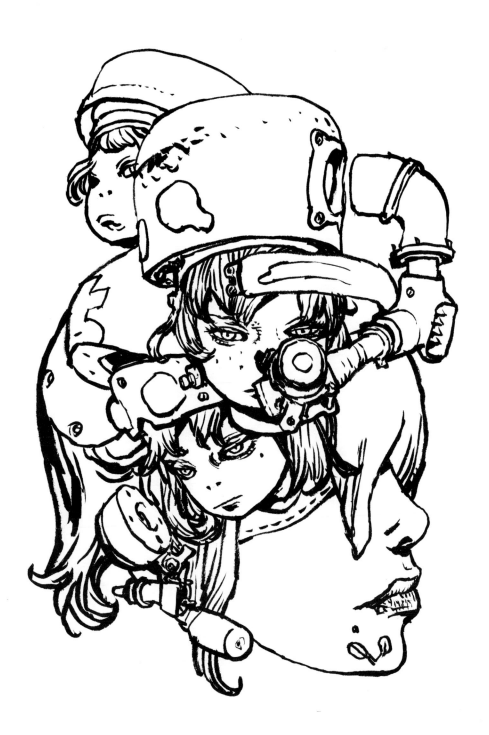

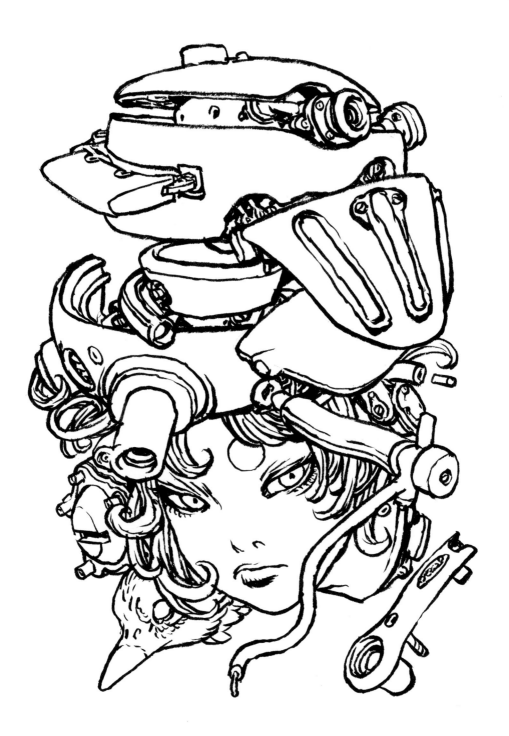

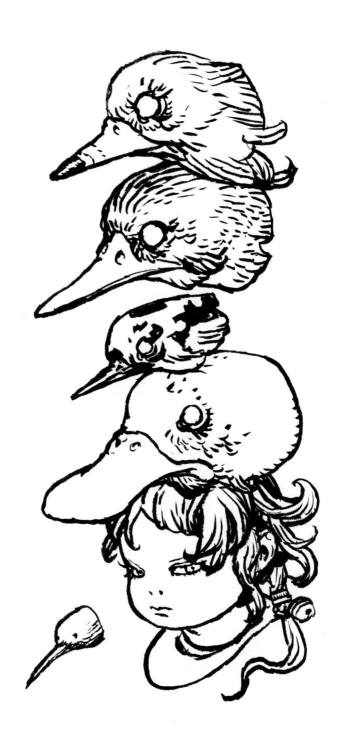

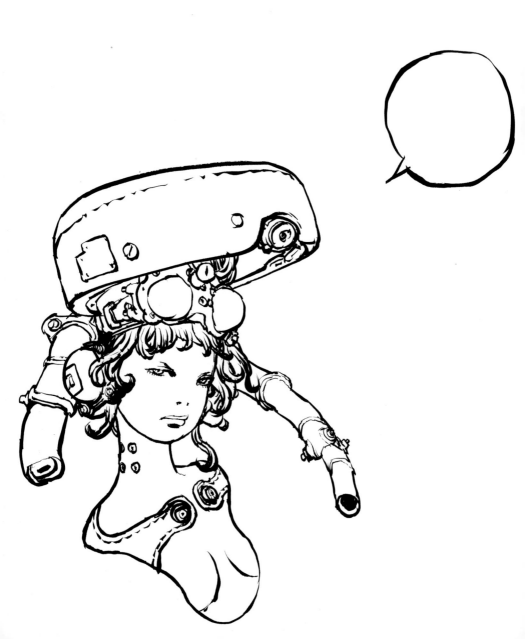

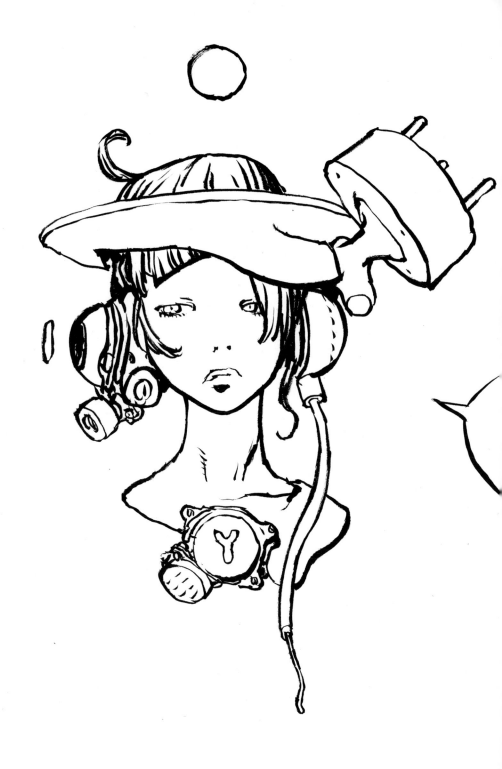

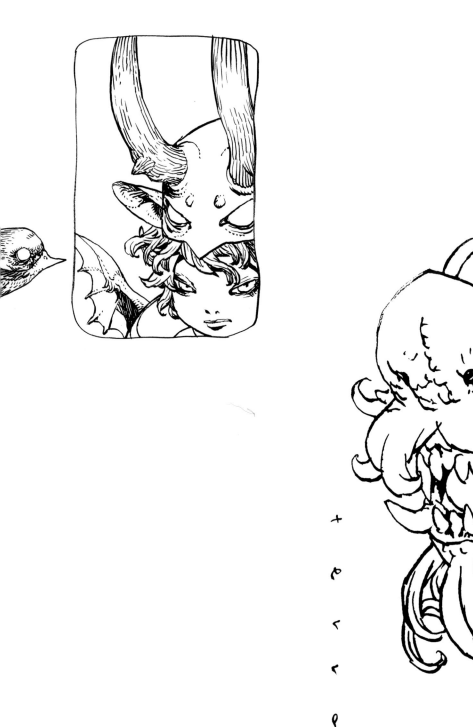

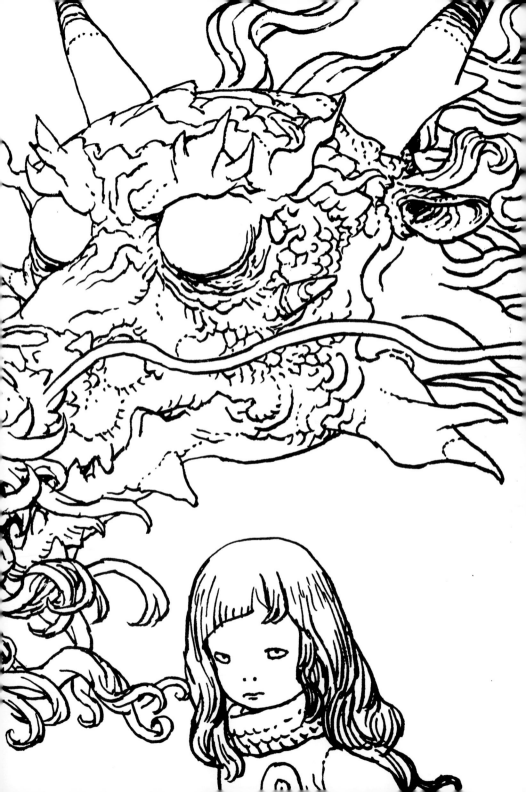

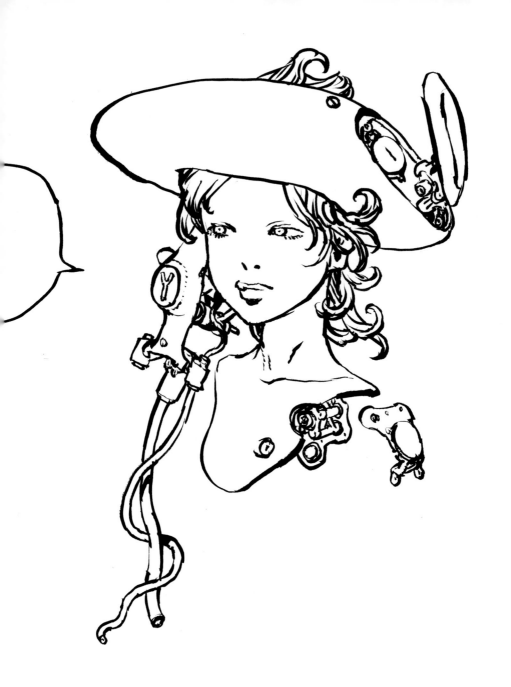

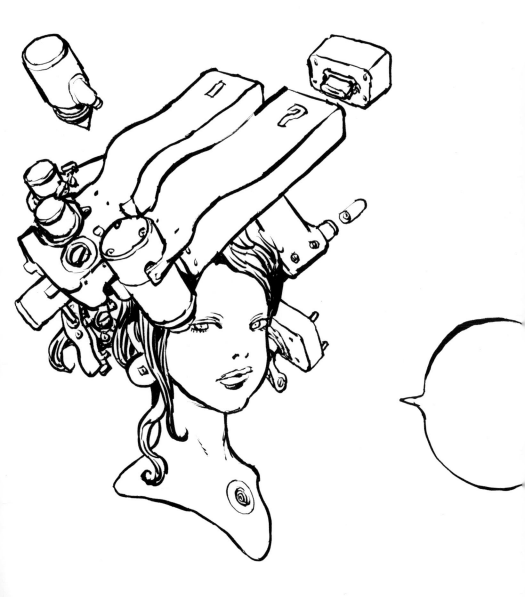

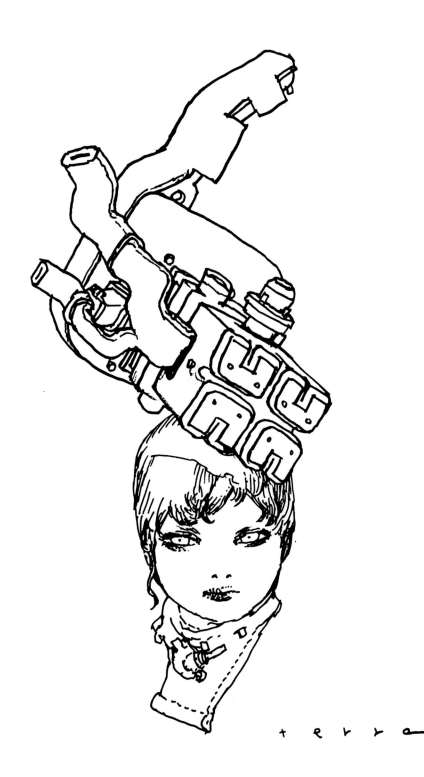

terra

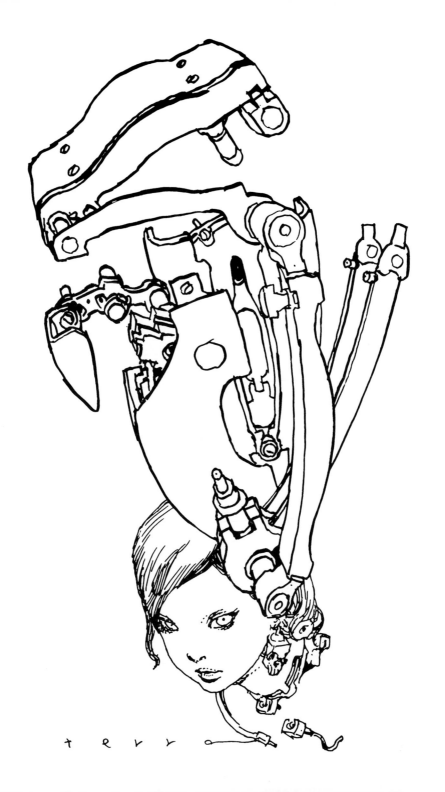

terry

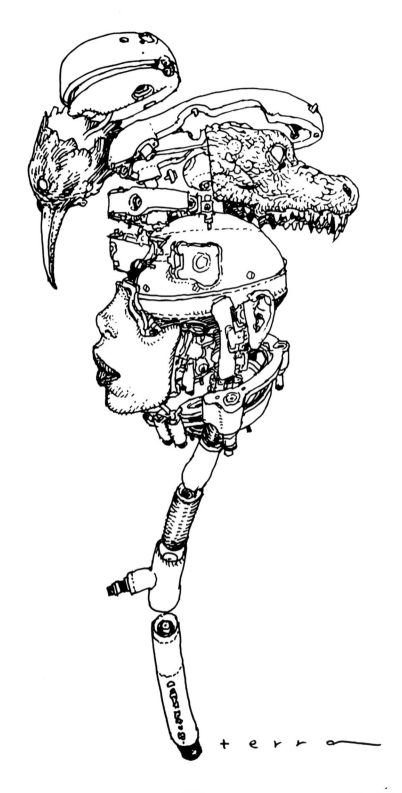

terra

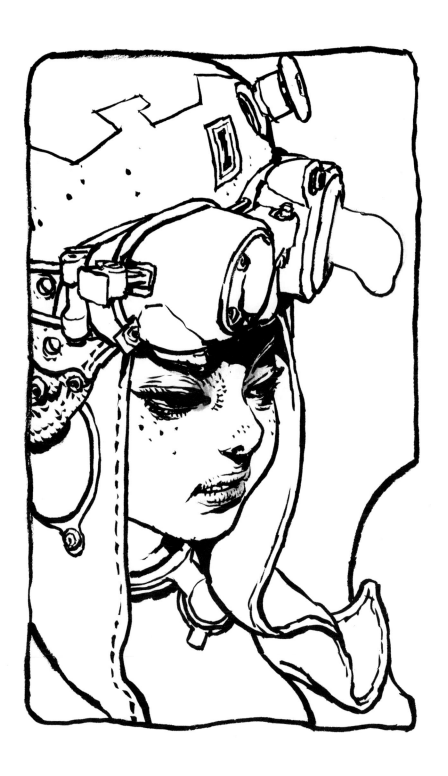

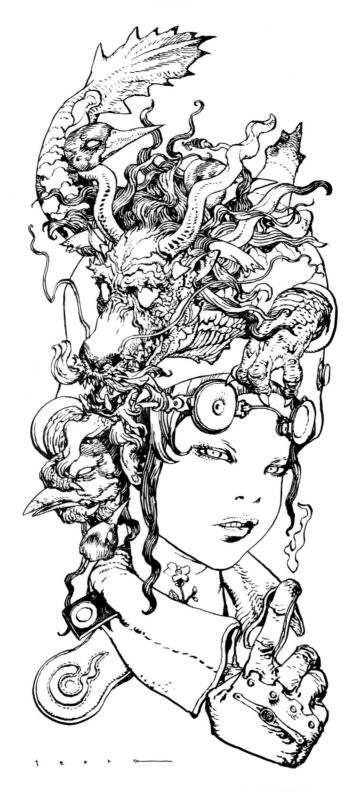

terra

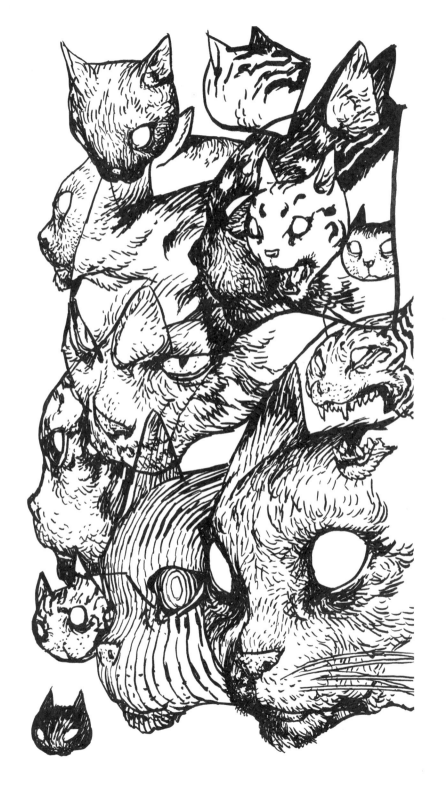

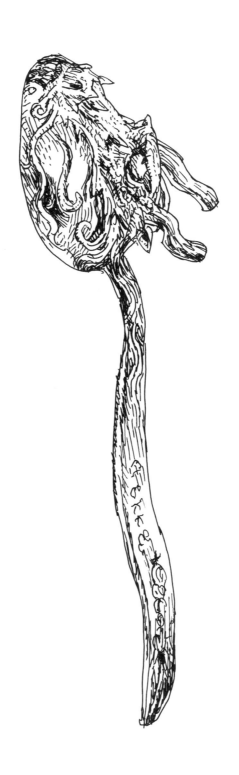

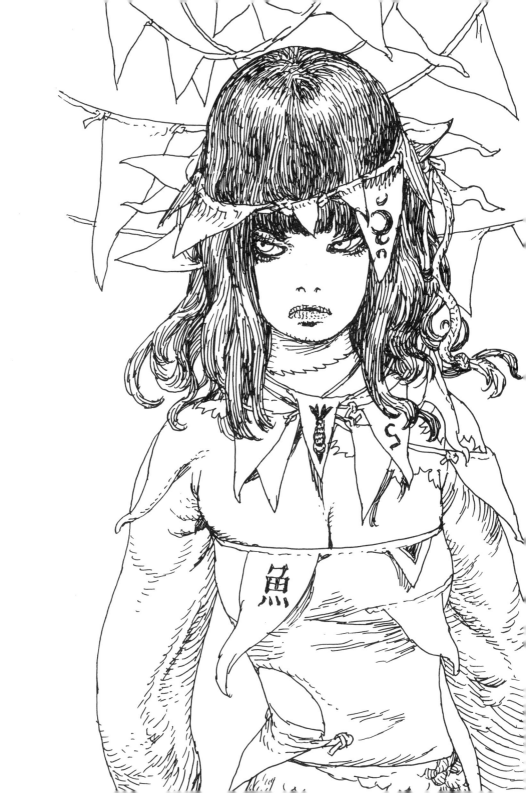

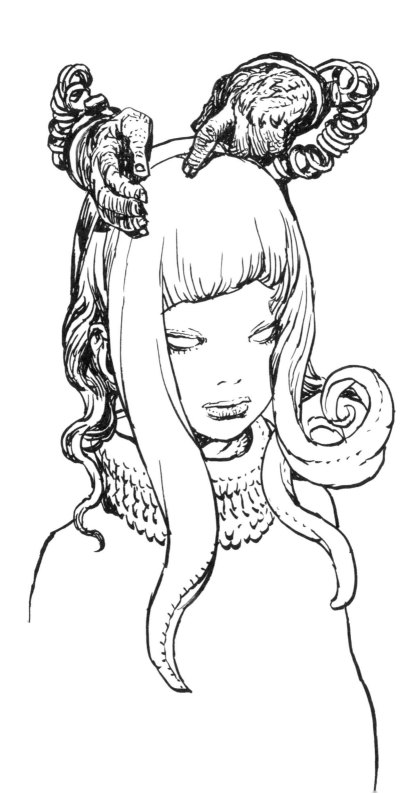

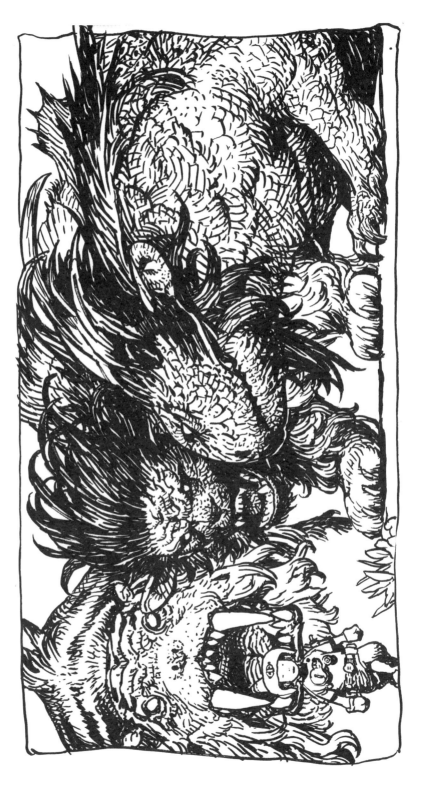

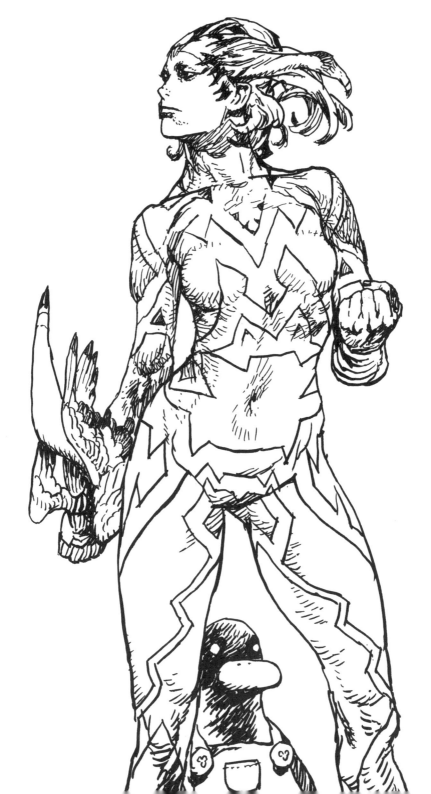

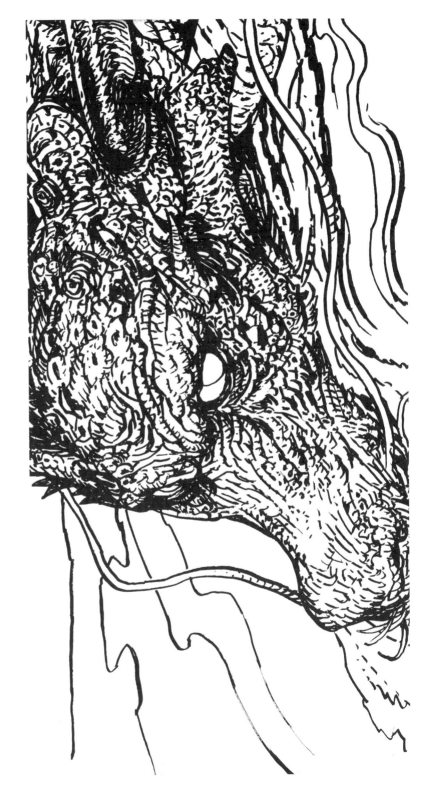

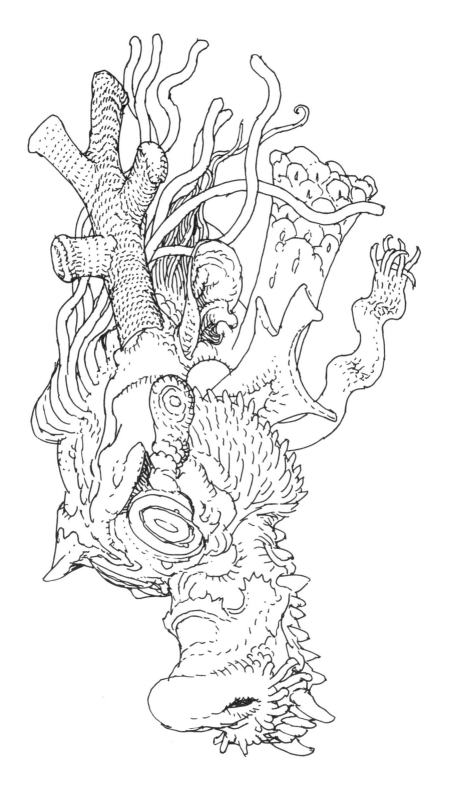

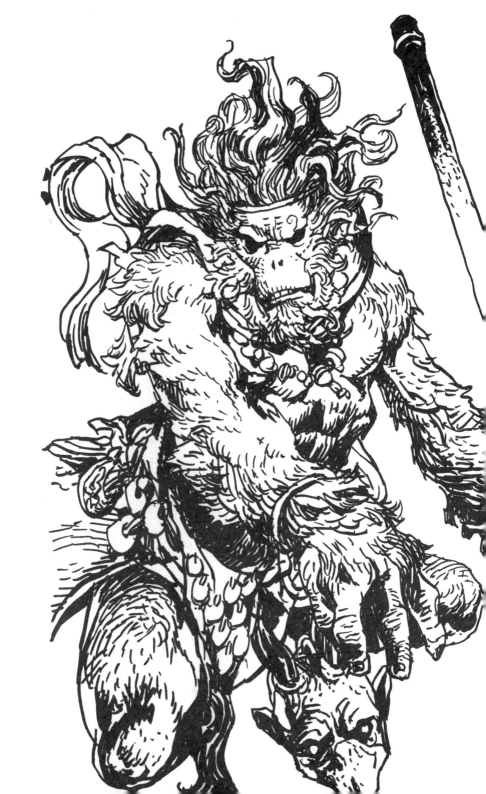

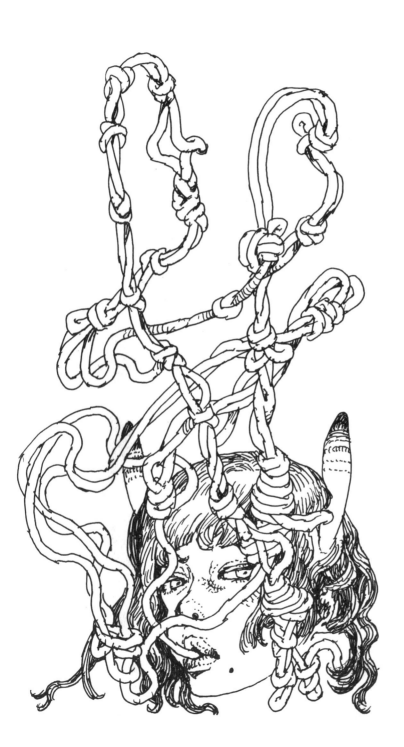

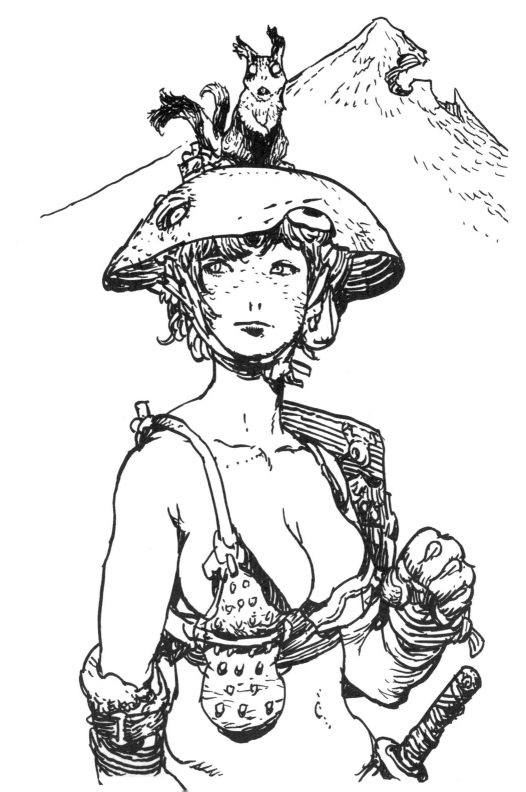

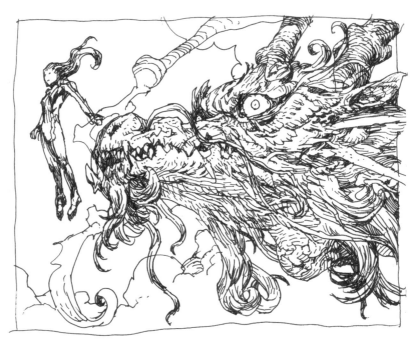

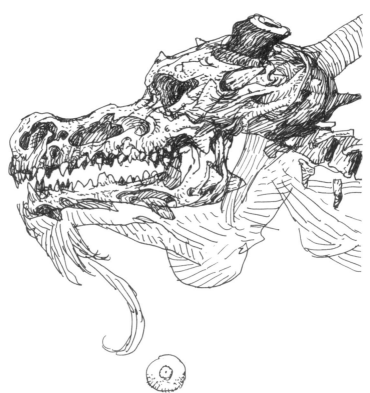

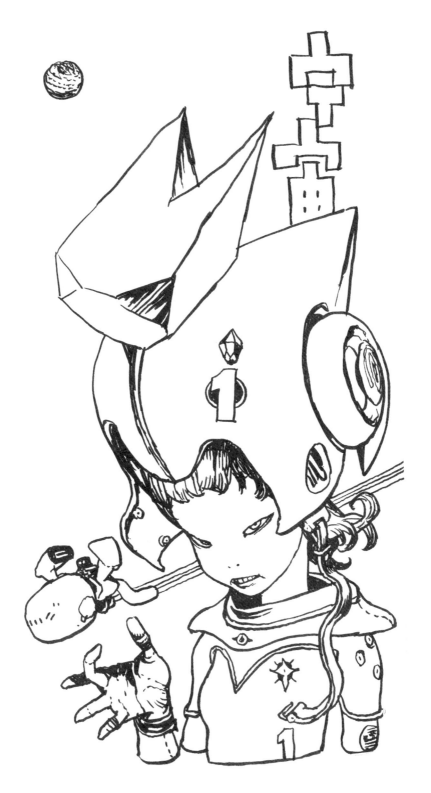

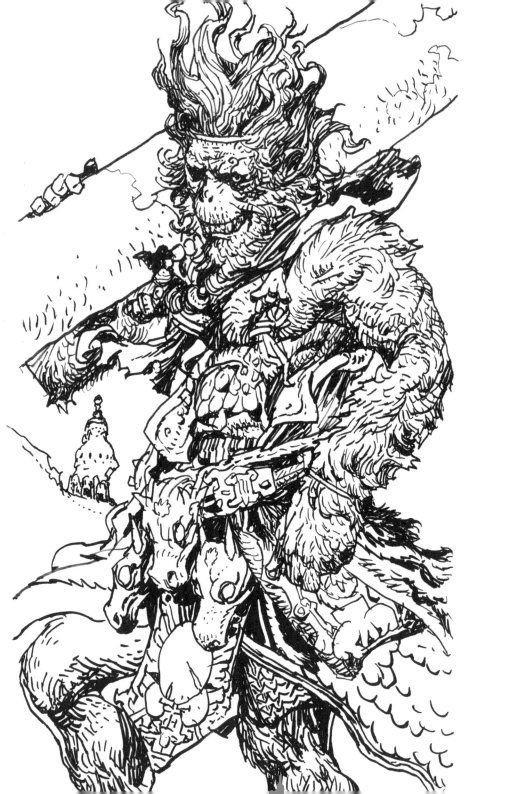

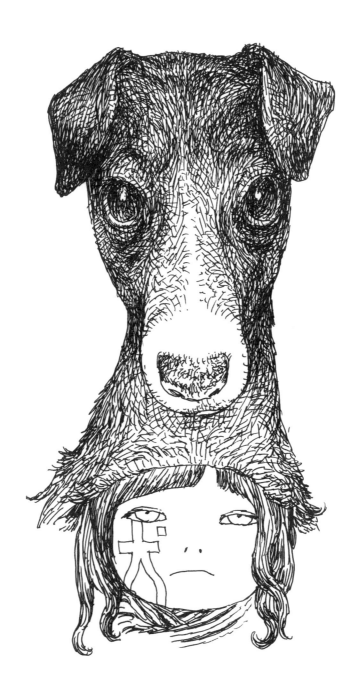

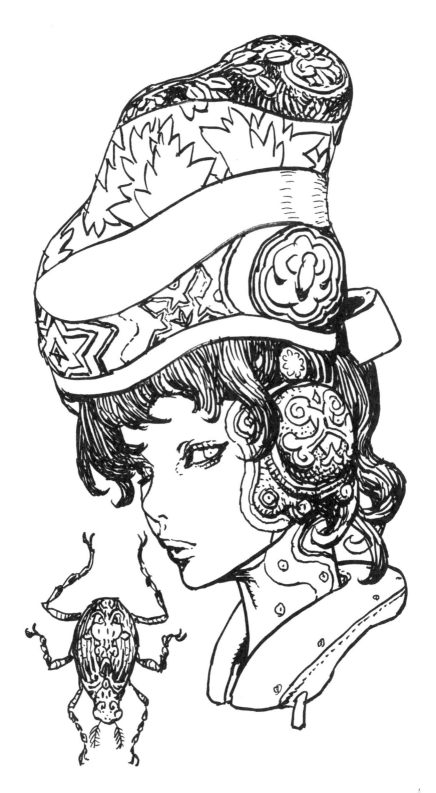

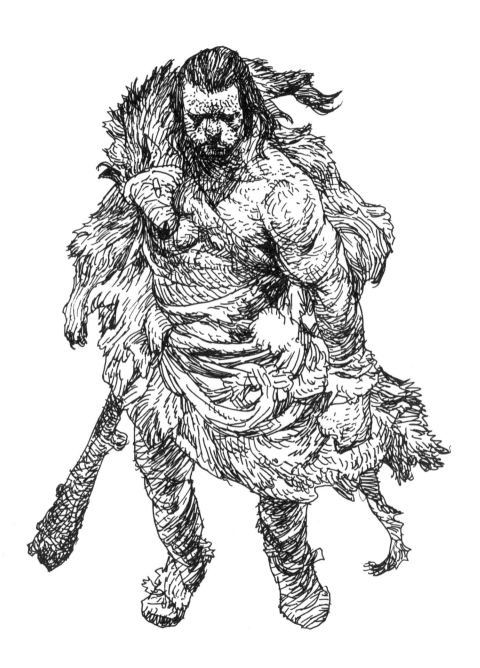

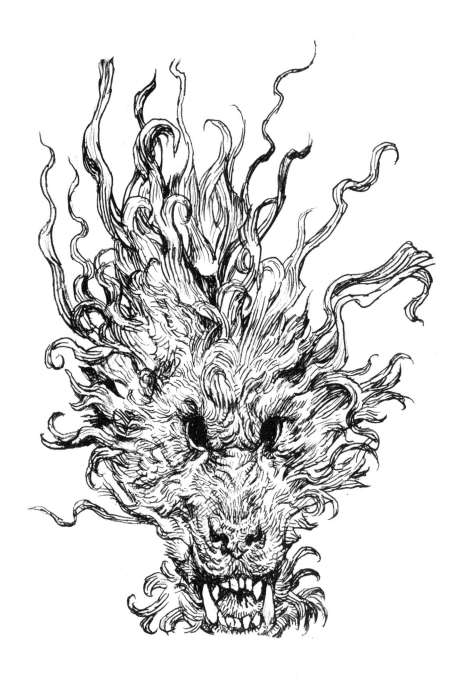

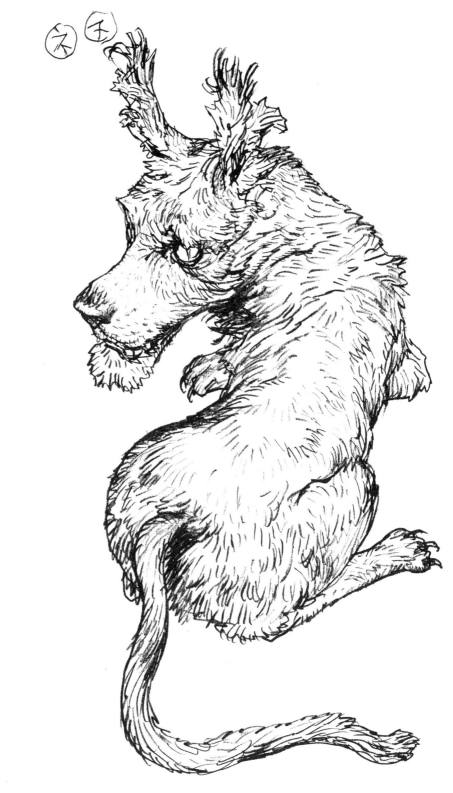

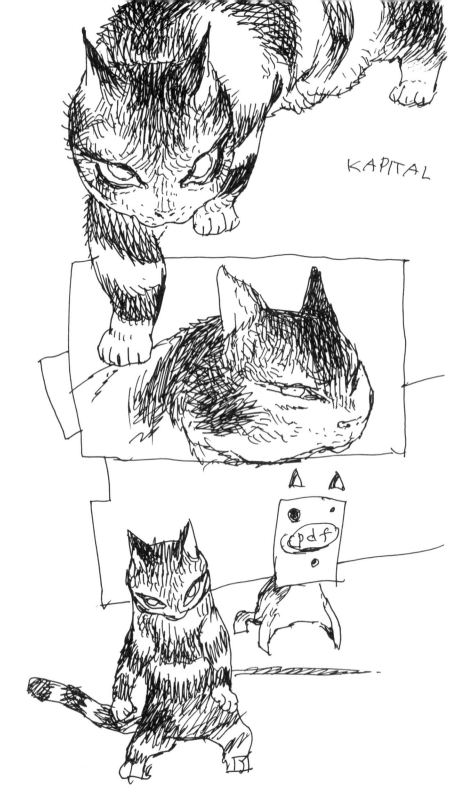

KAPITAL

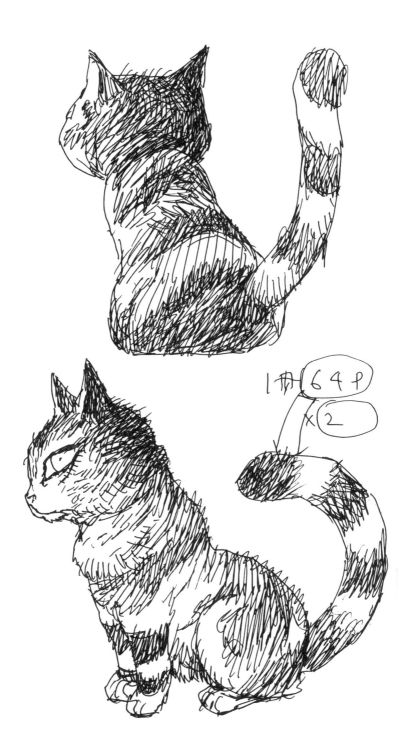

今夜は鮨だっ

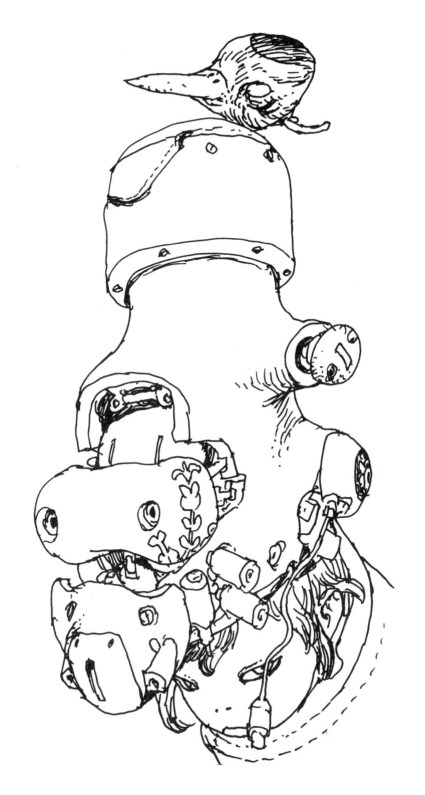

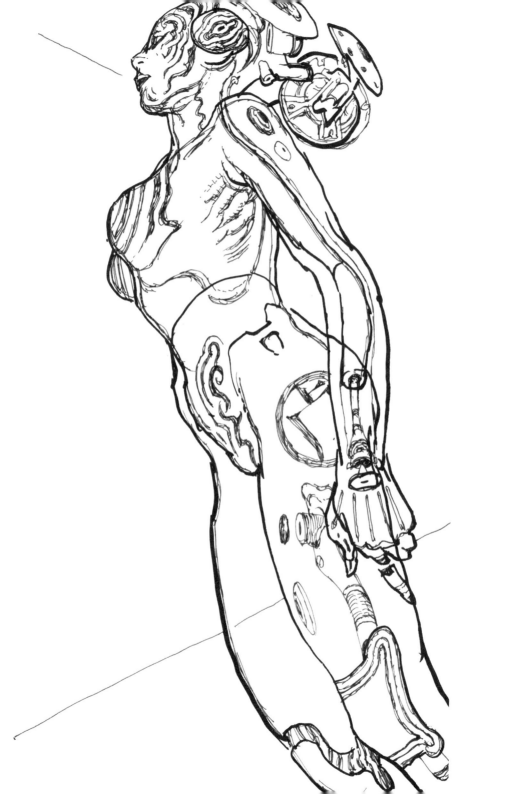

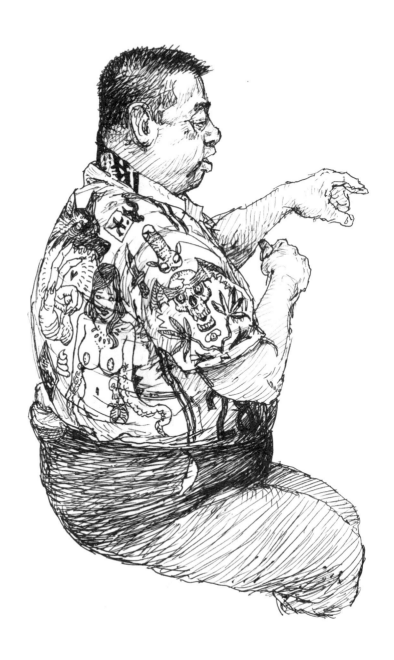

四谷。 2016-16-7

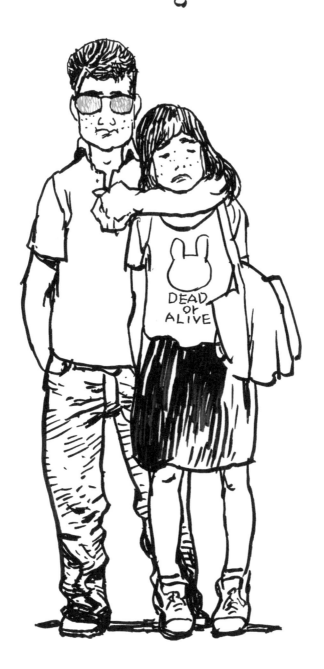

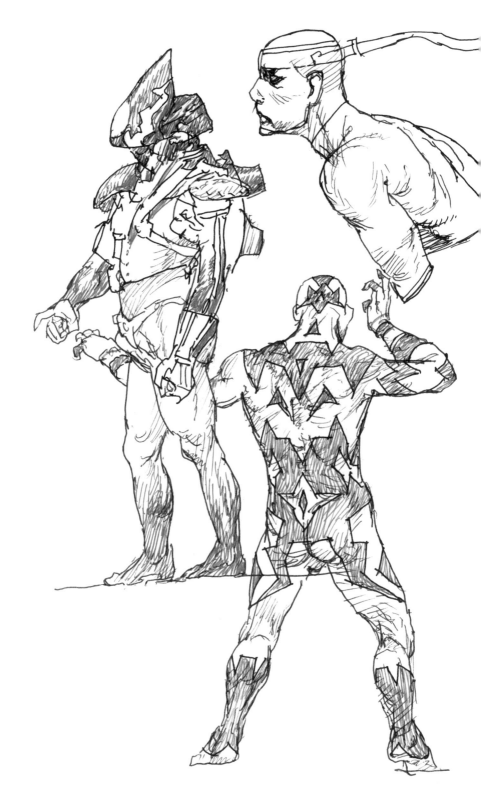

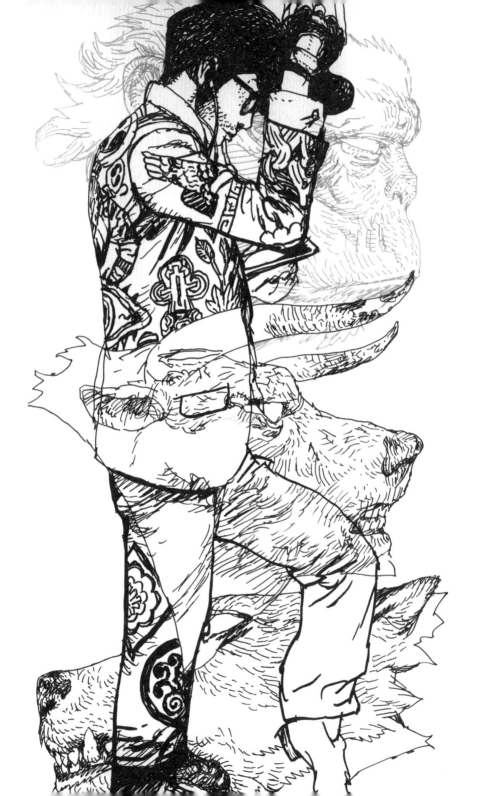

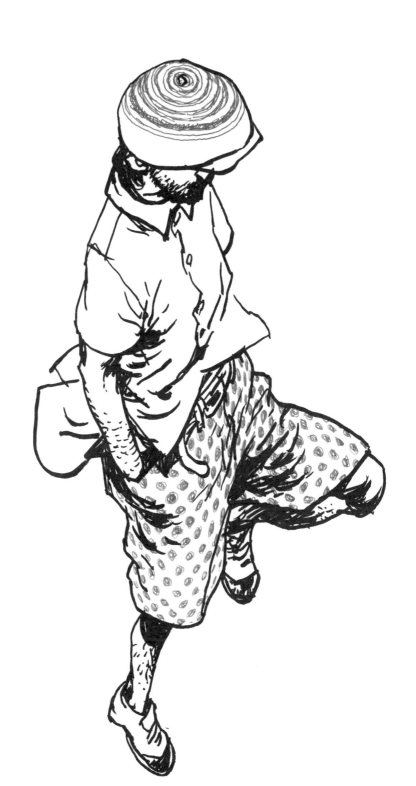

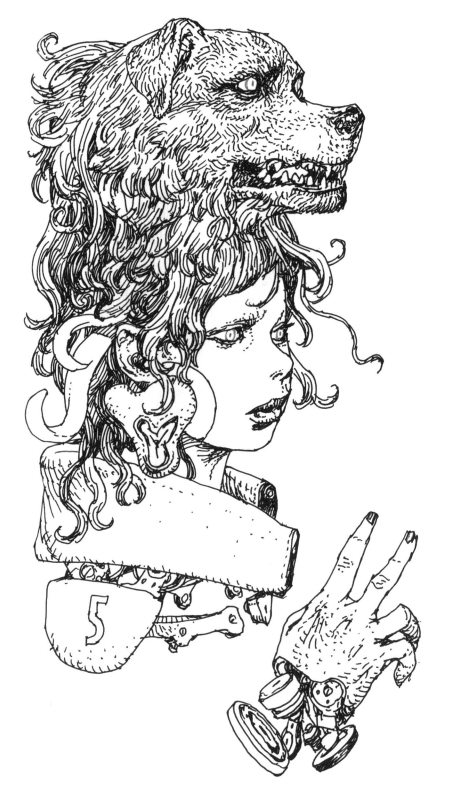

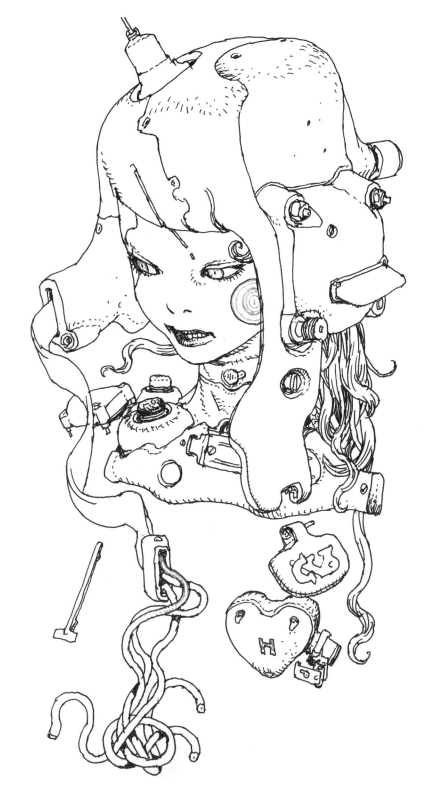

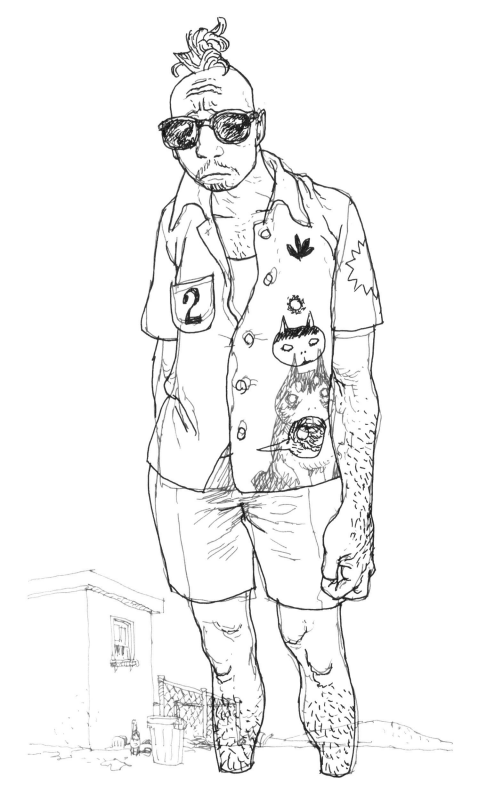

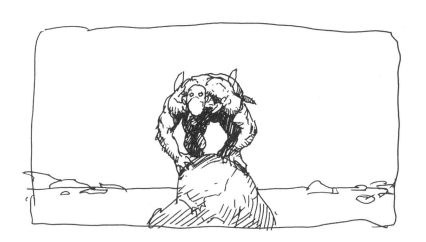

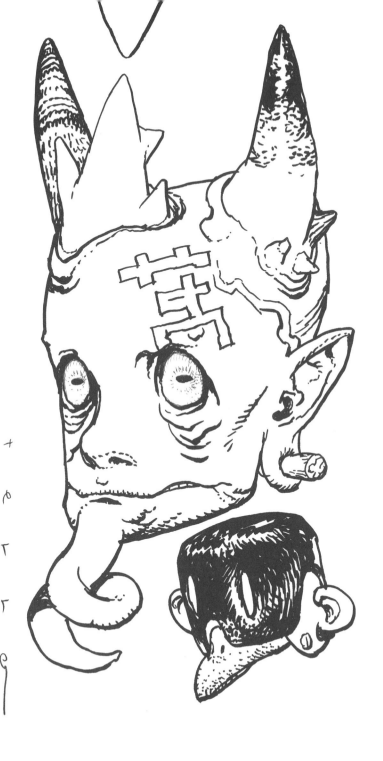

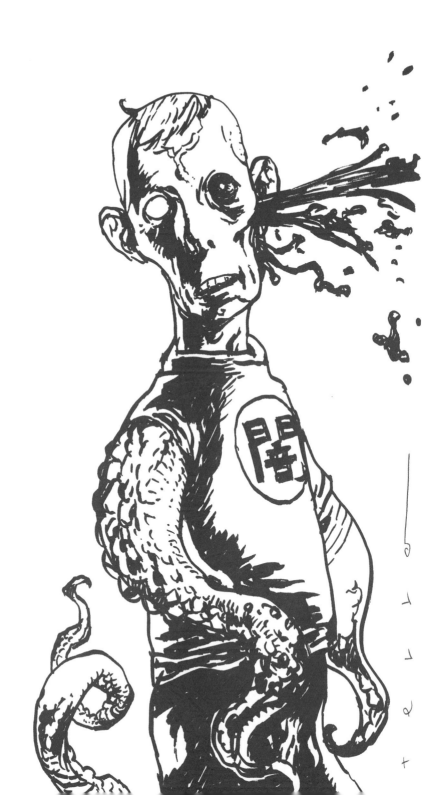

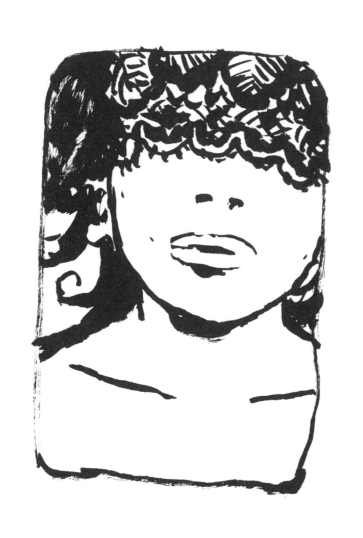

tello

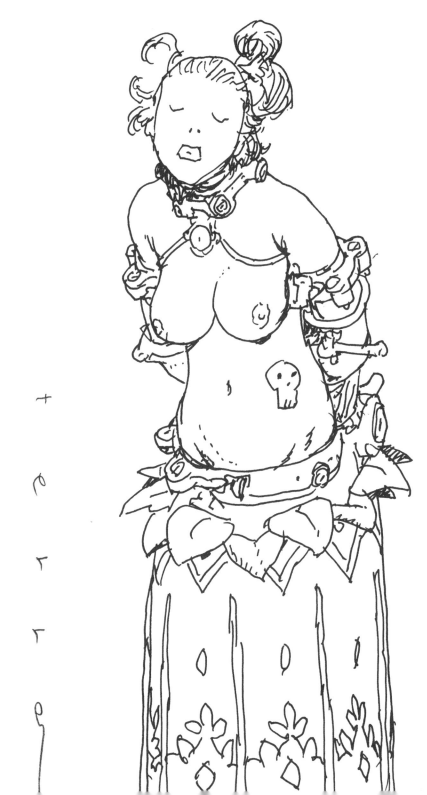

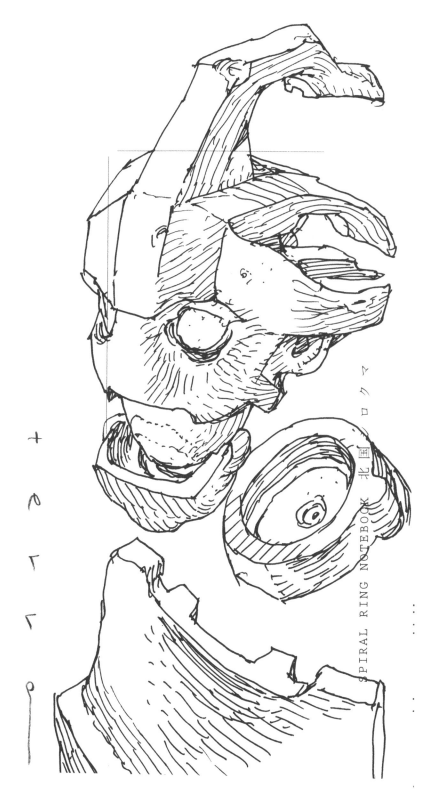

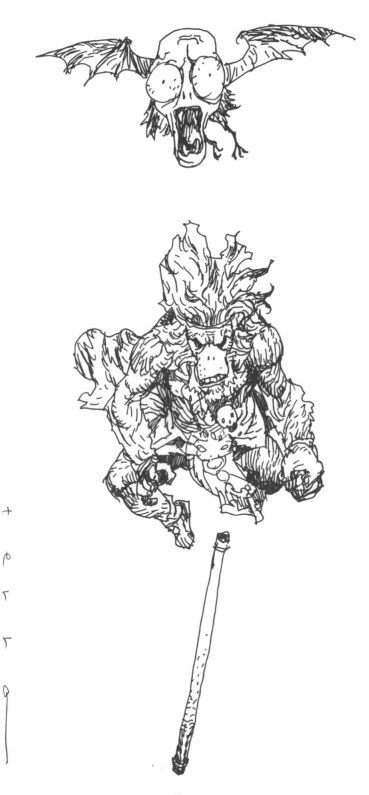

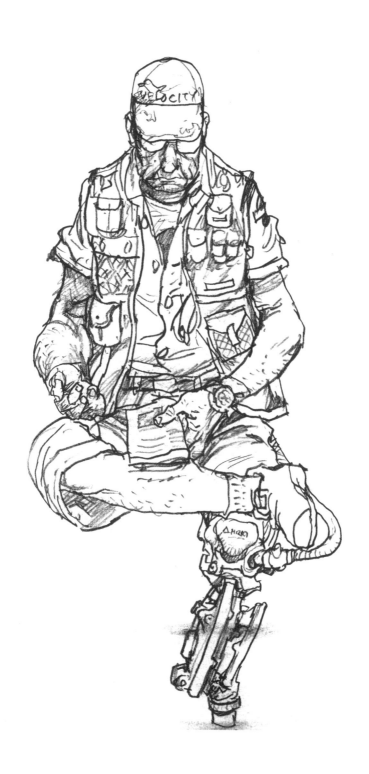

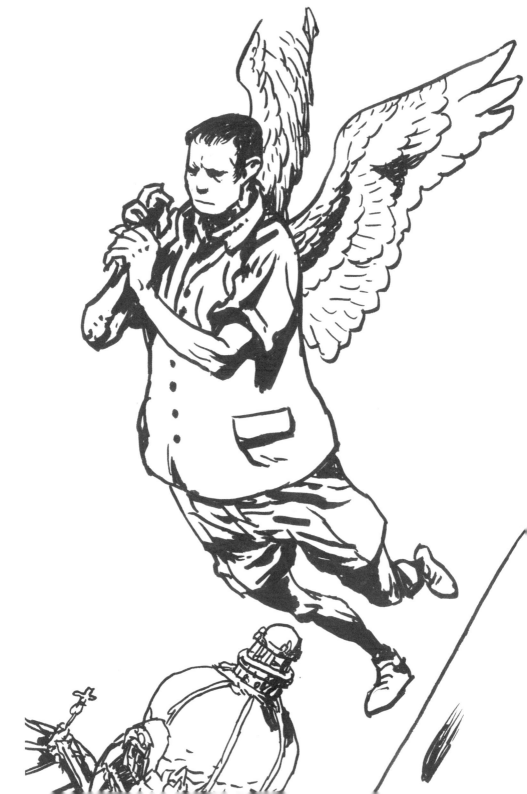

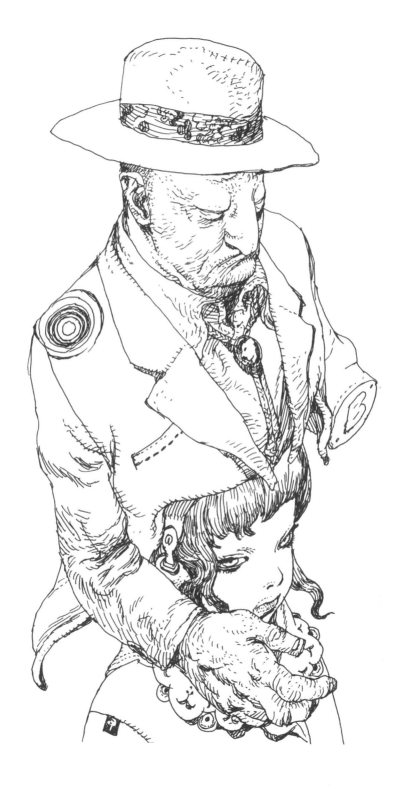

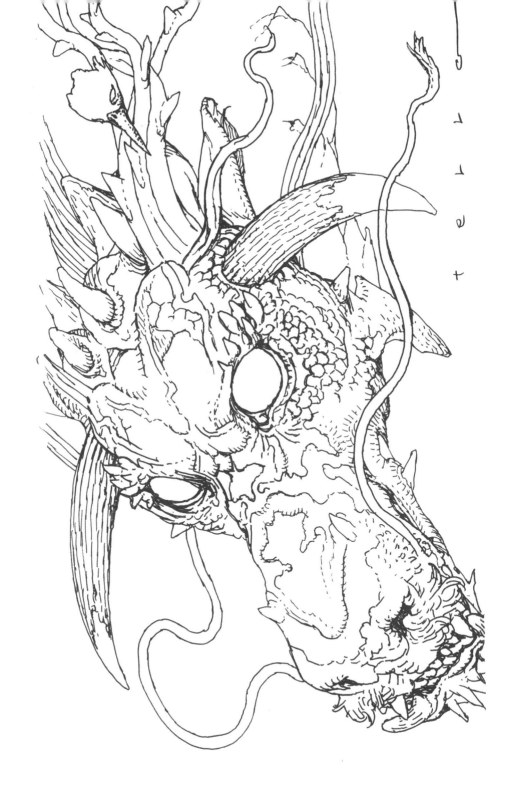

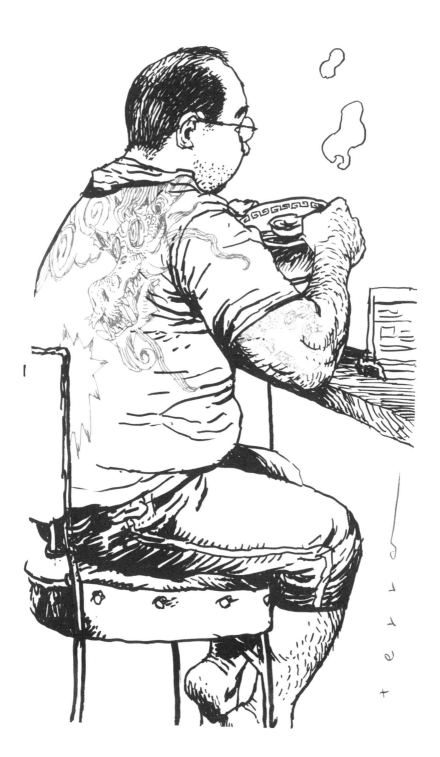

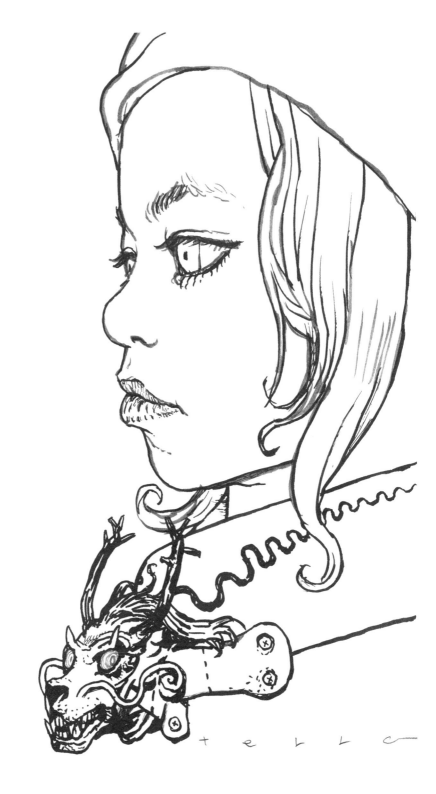

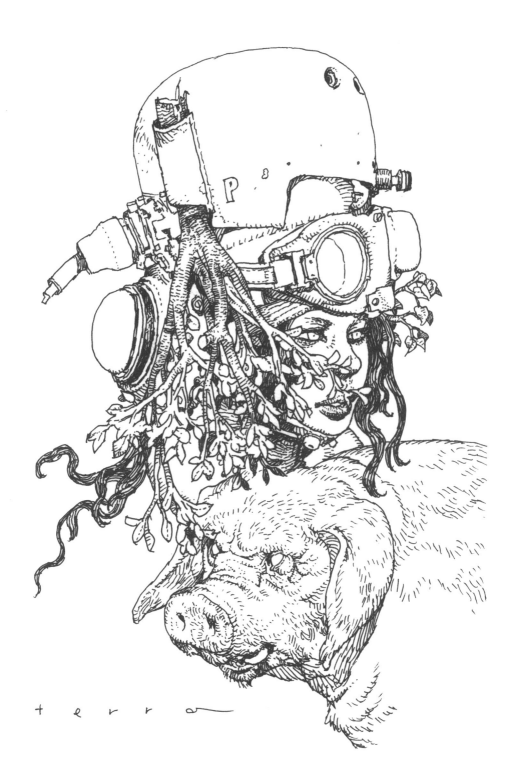

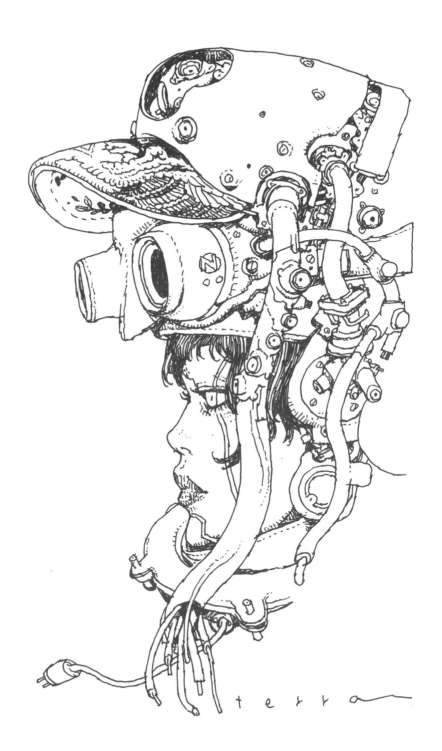

terra

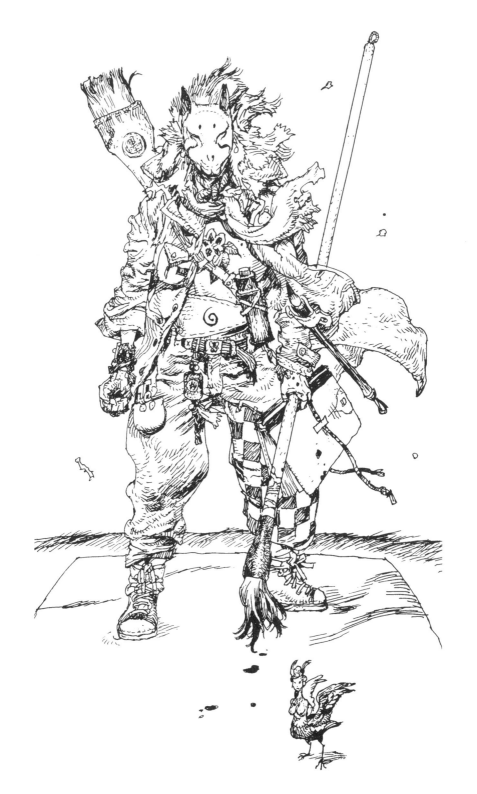

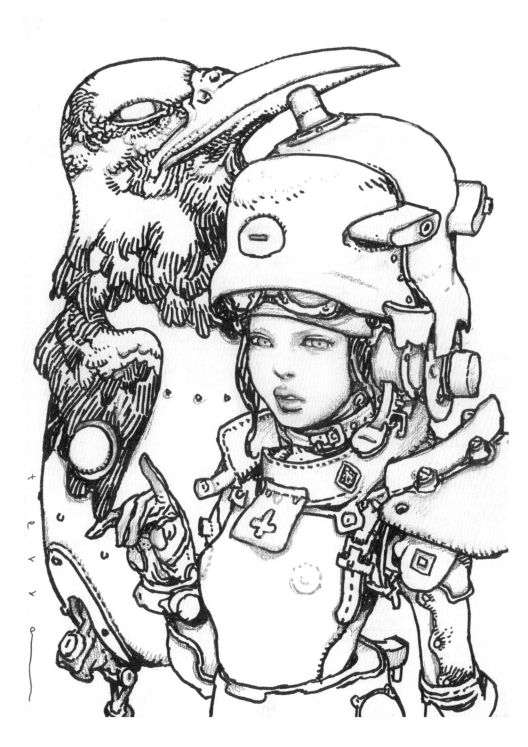

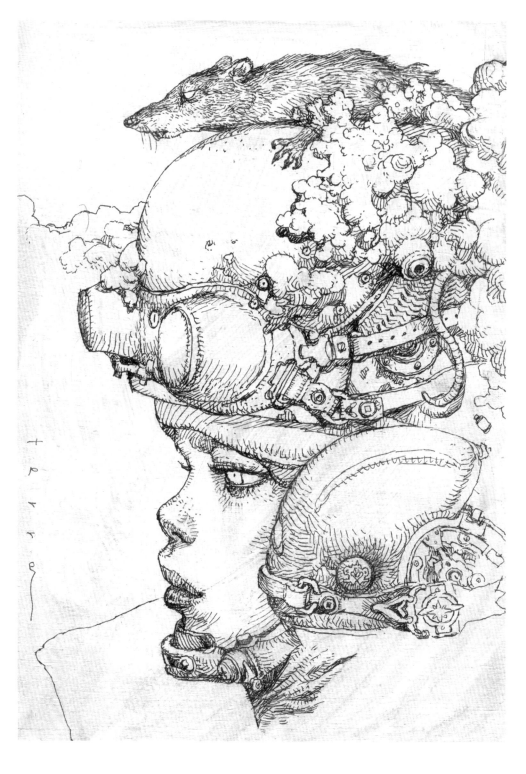

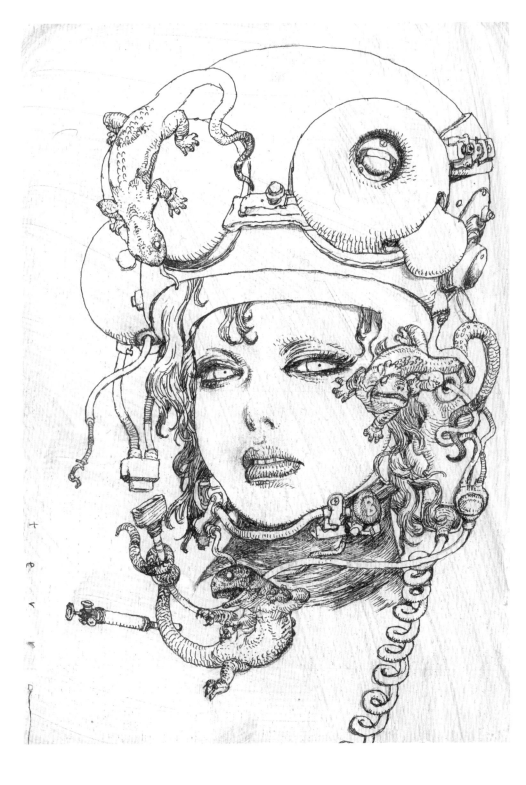

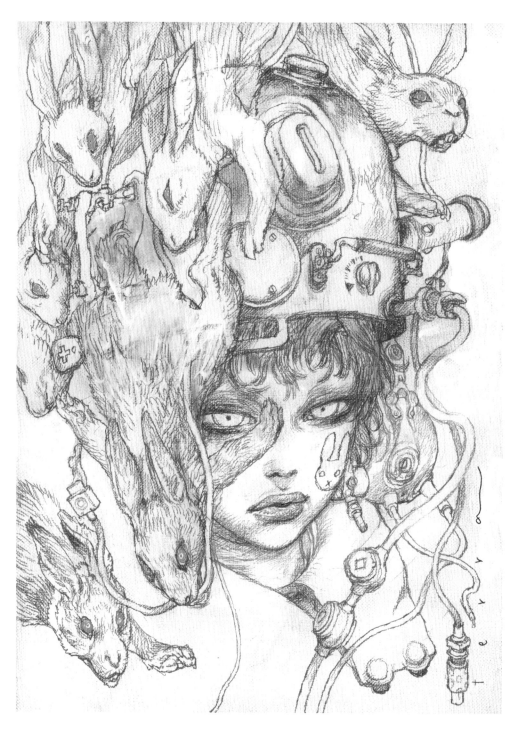

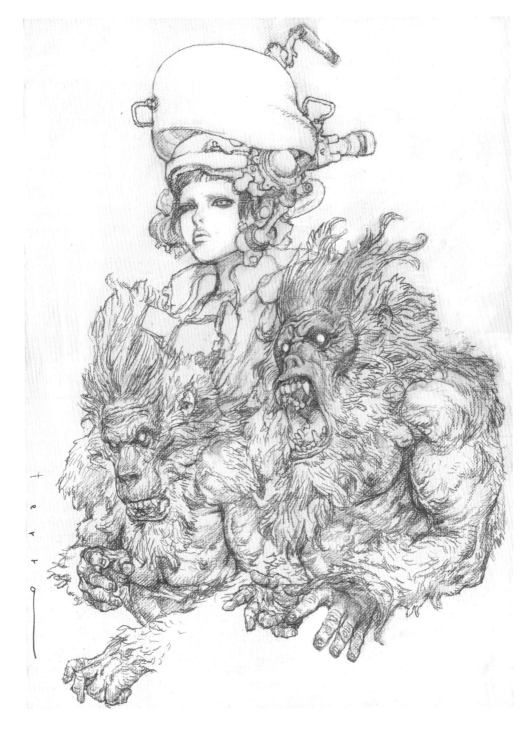

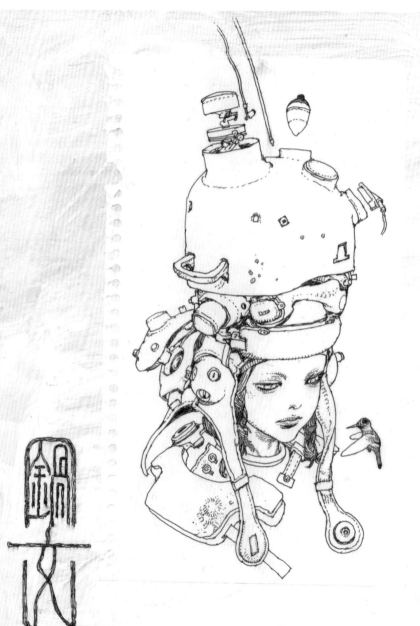

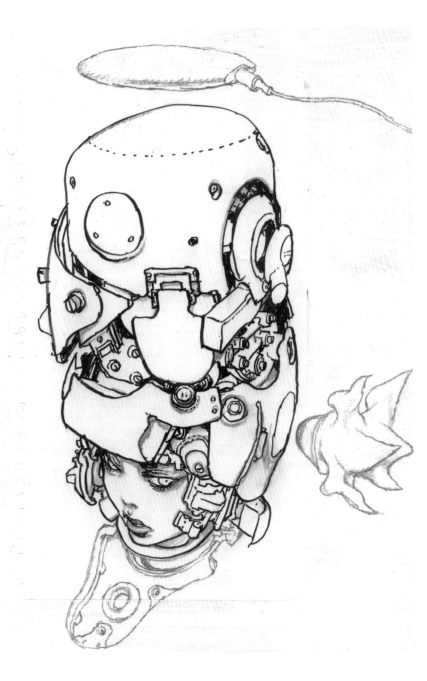

terror

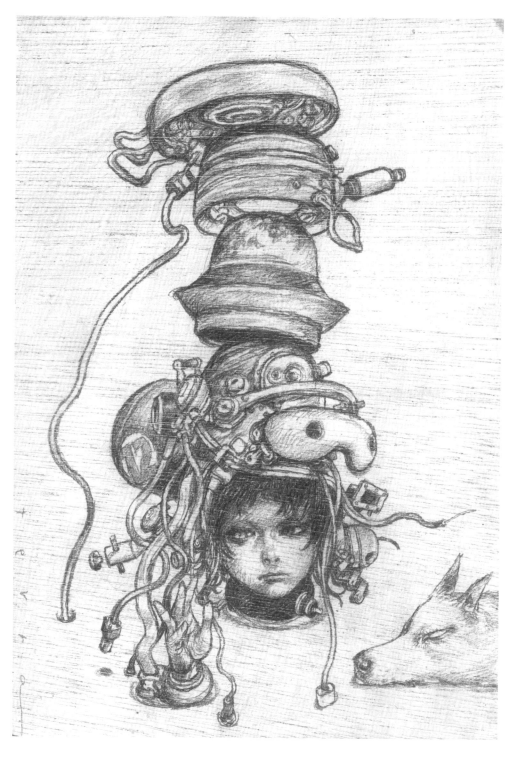

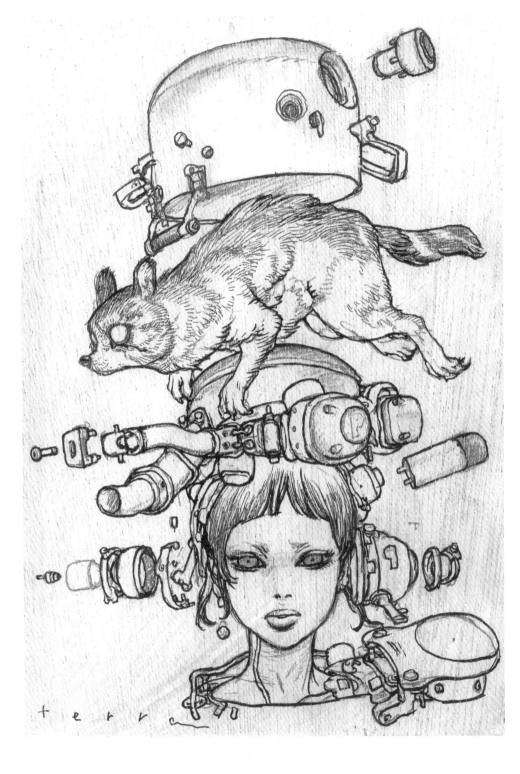

terra

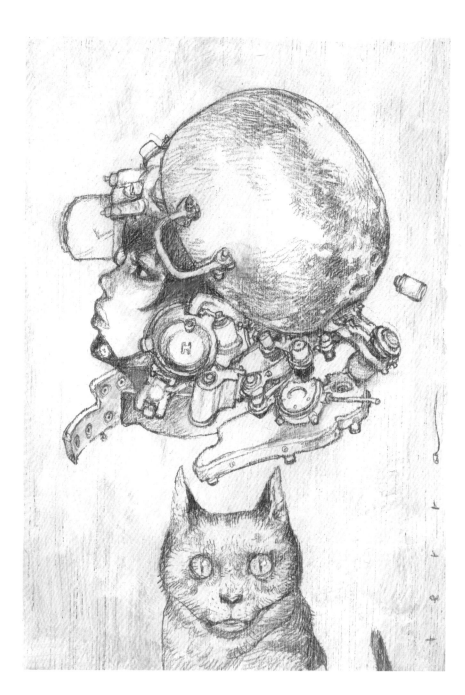

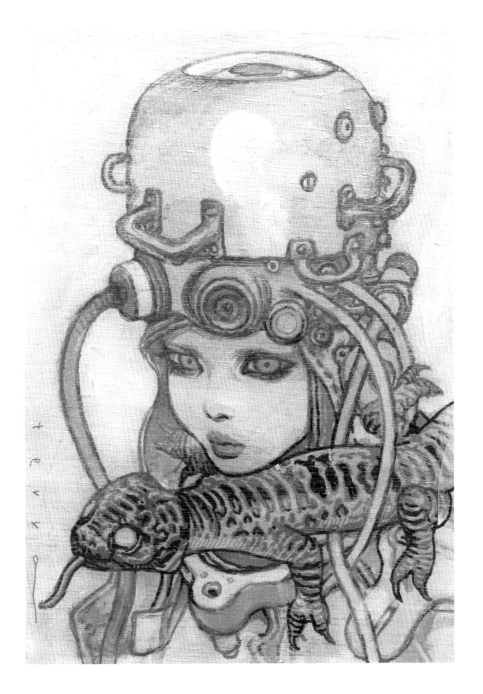

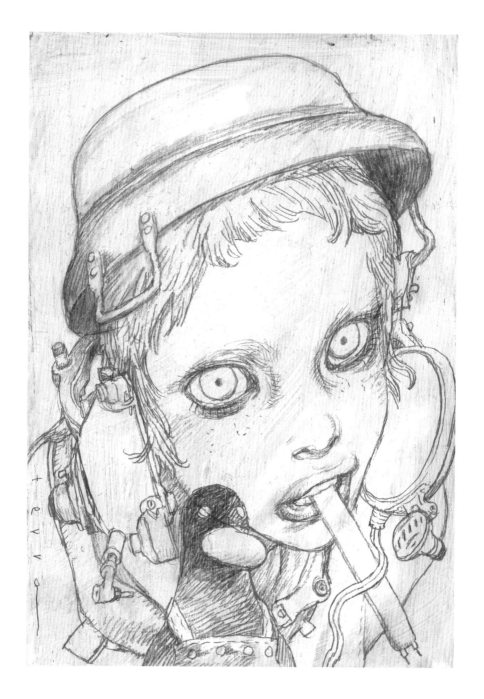

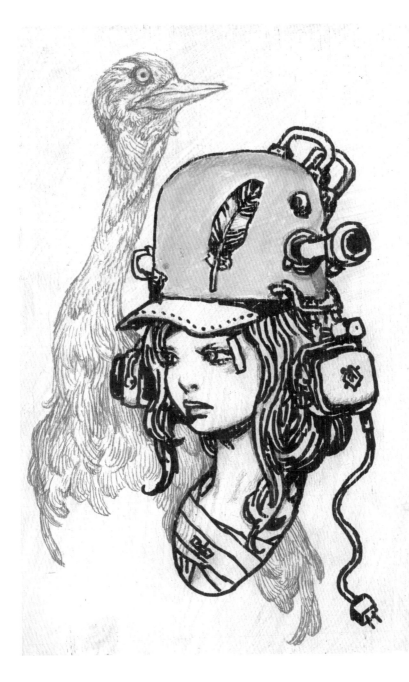

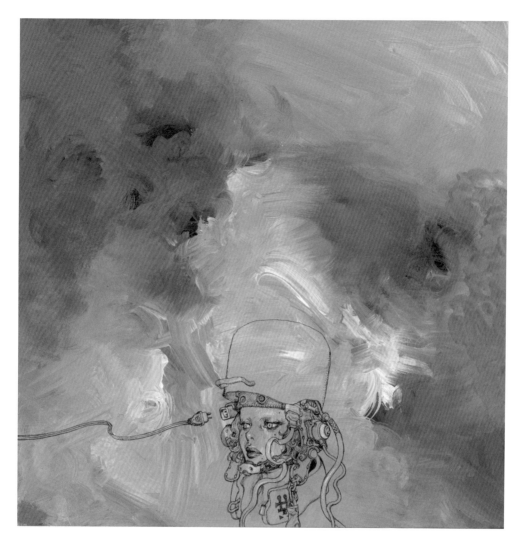

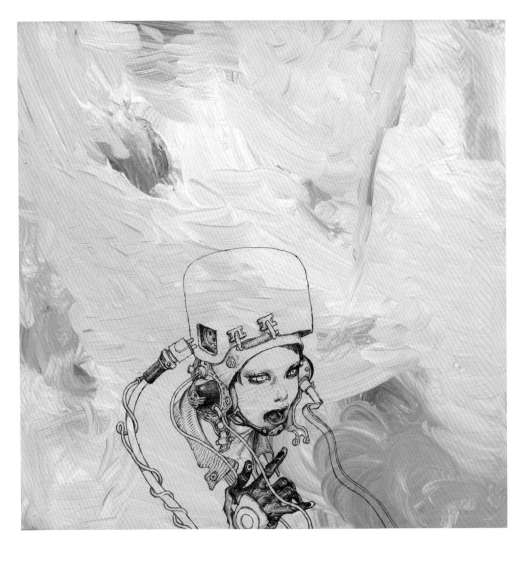

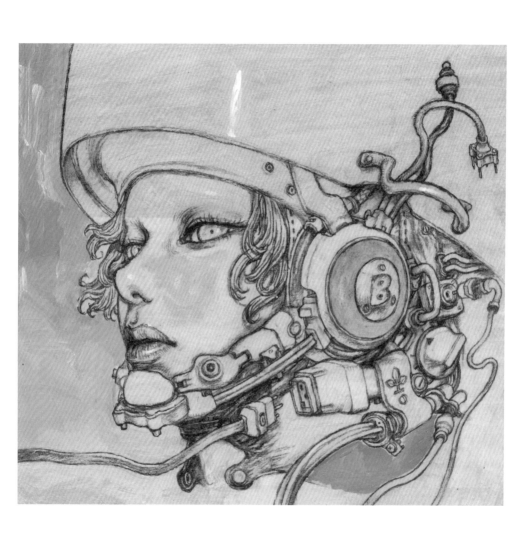

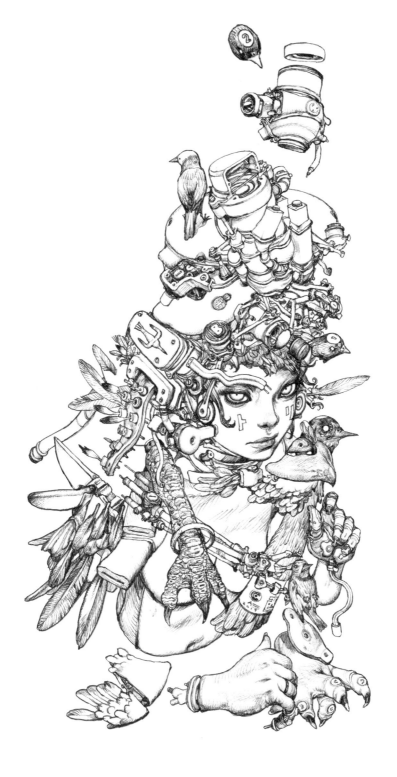

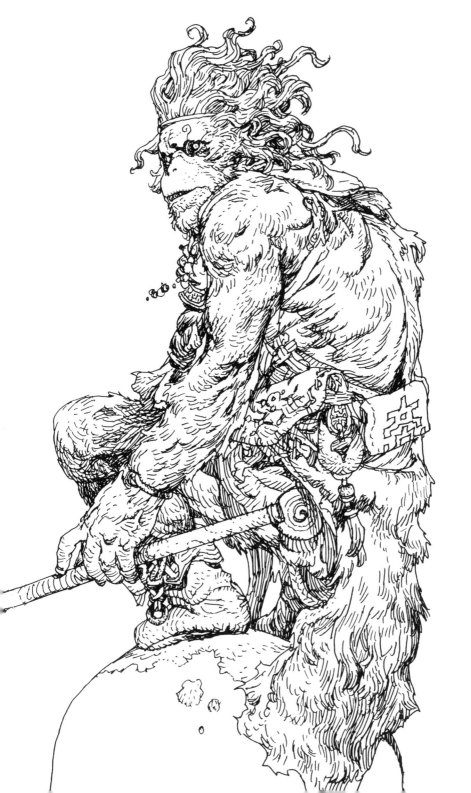

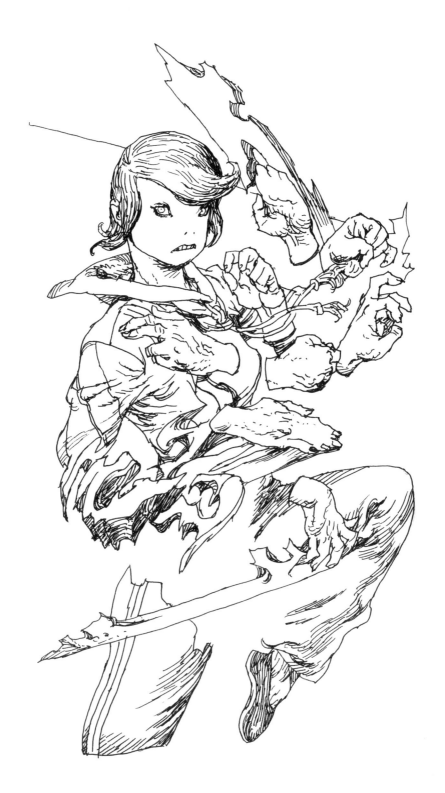

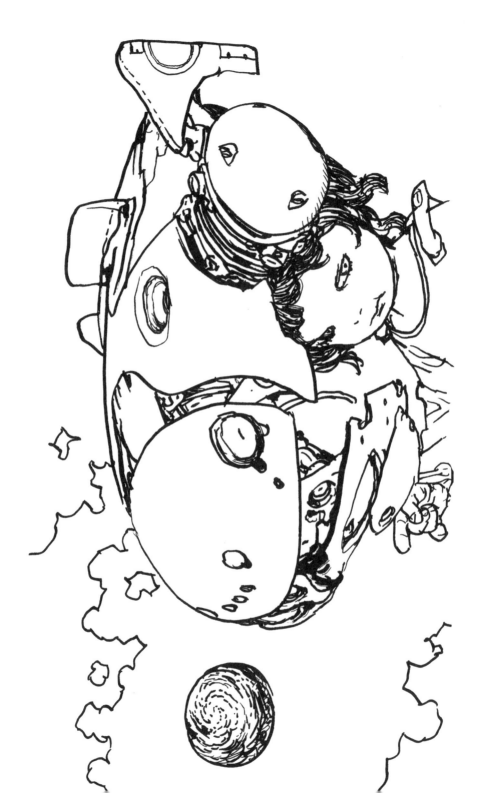

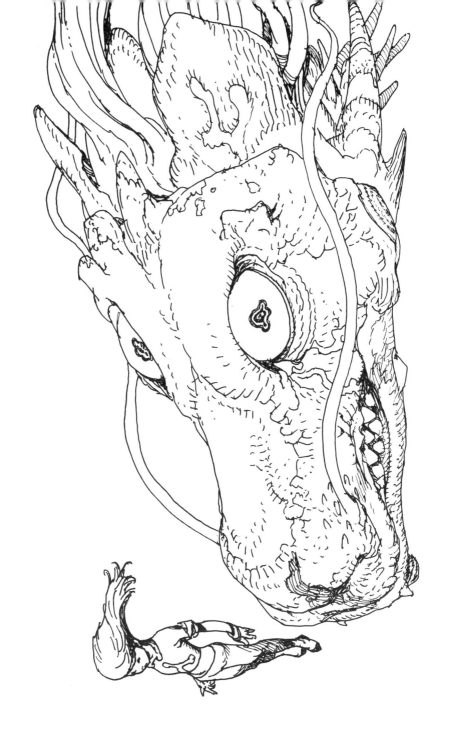

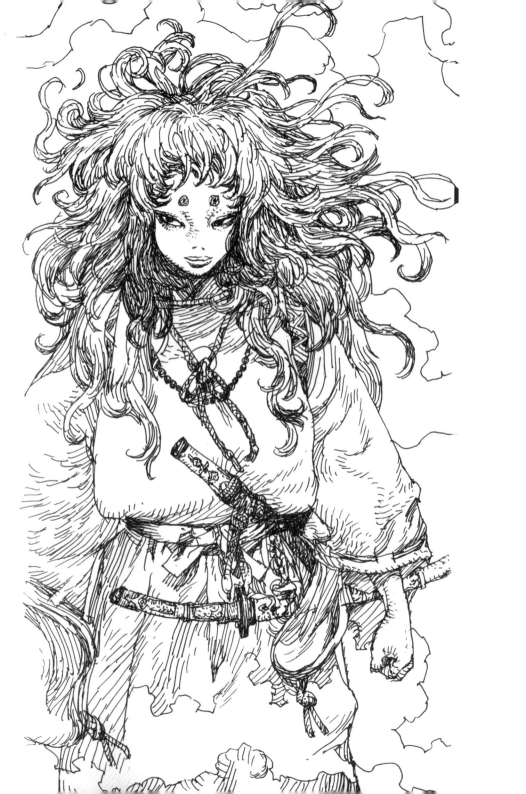

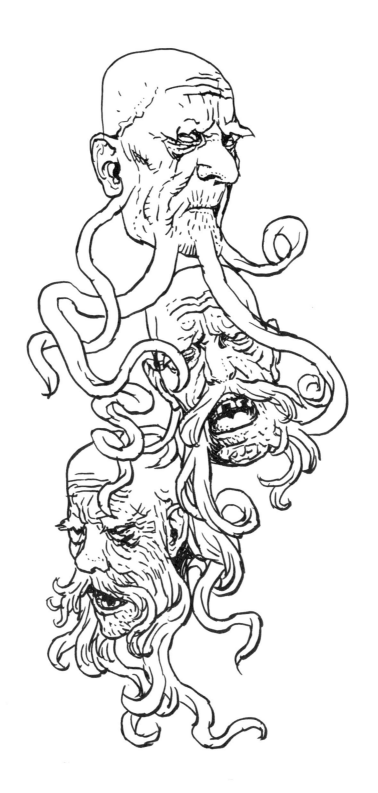

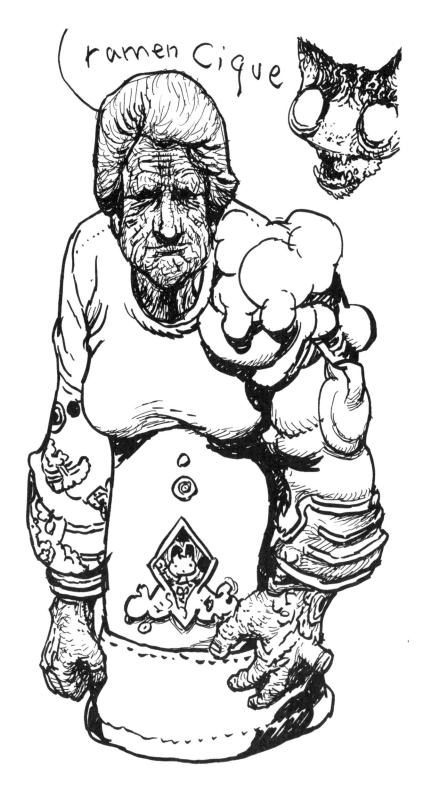

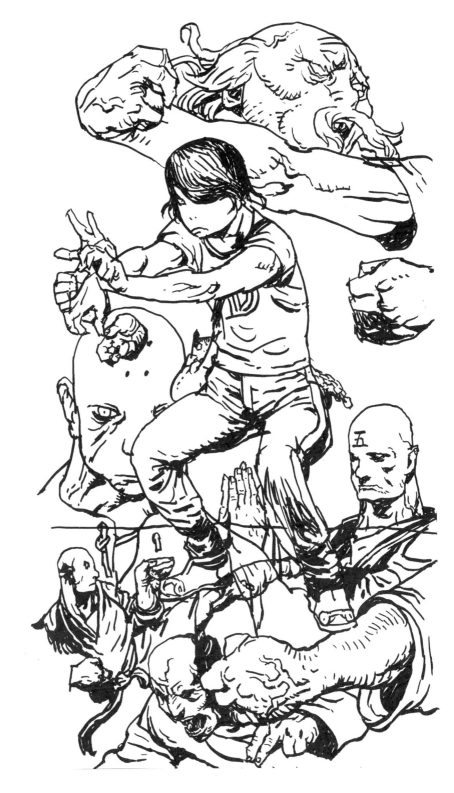

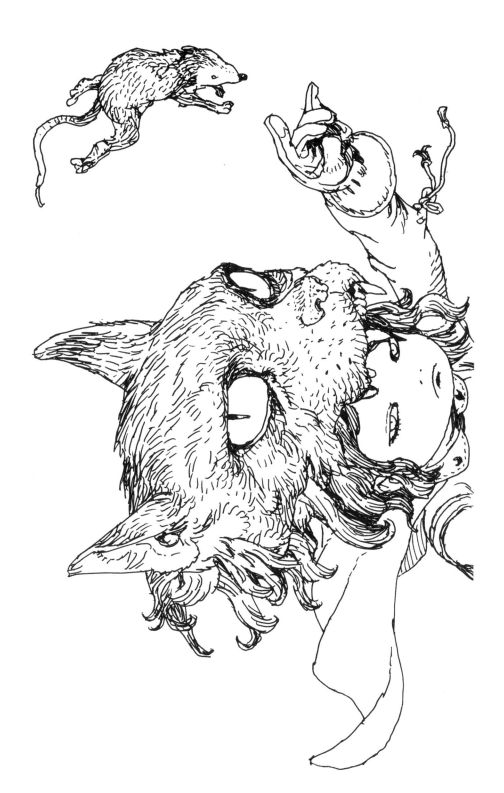

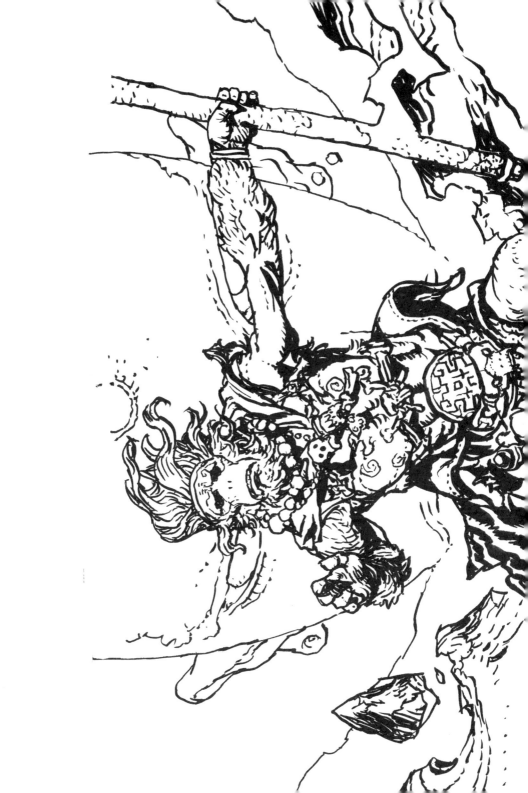

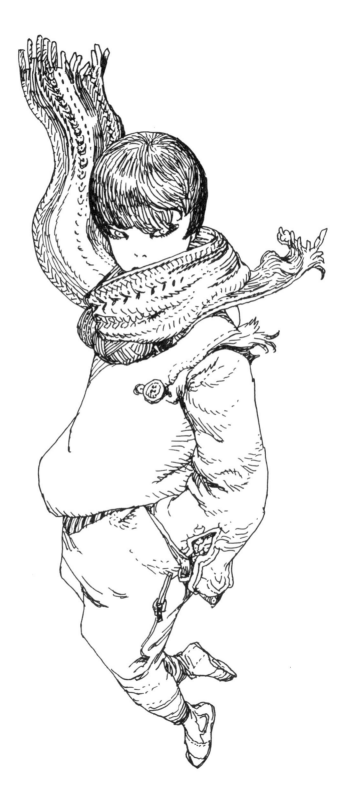

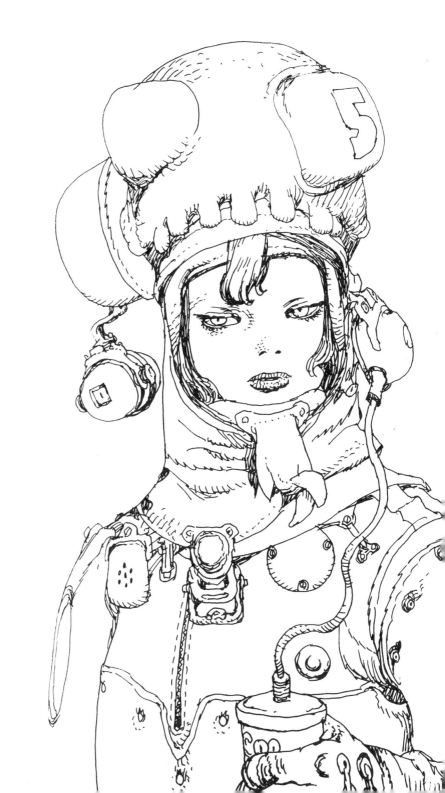

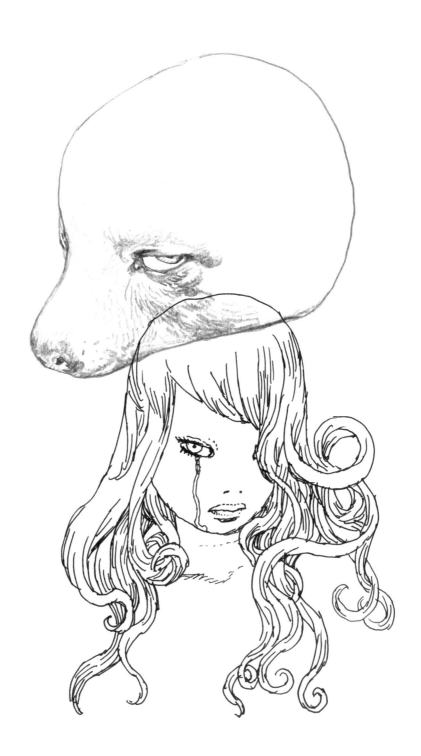

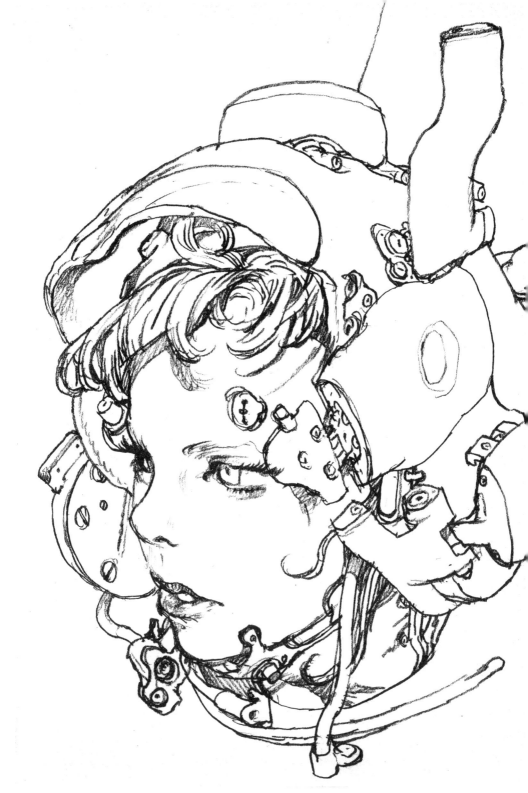

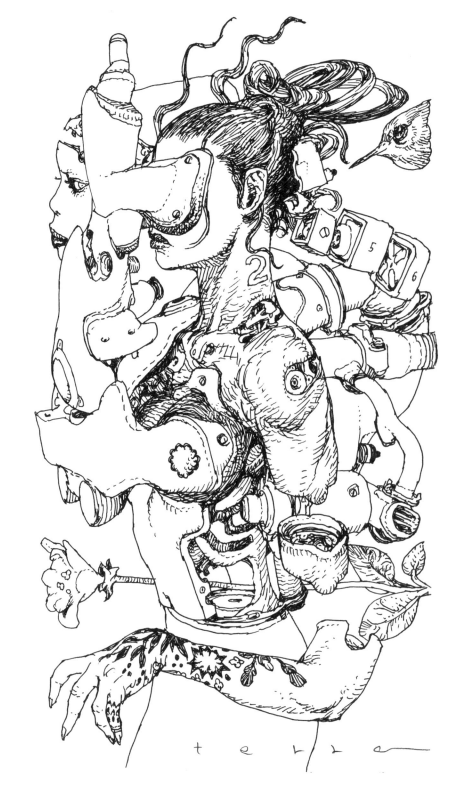

terra

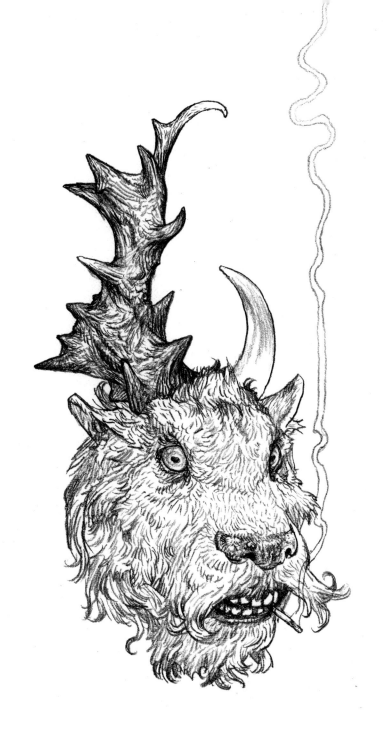

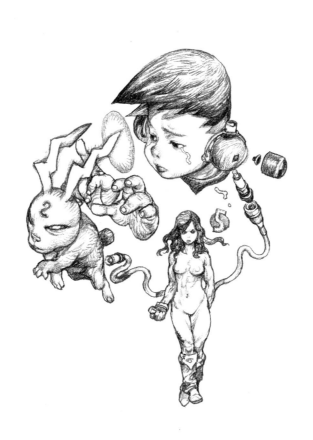

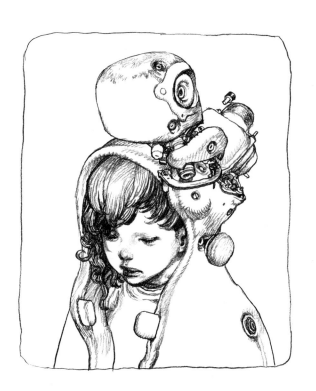

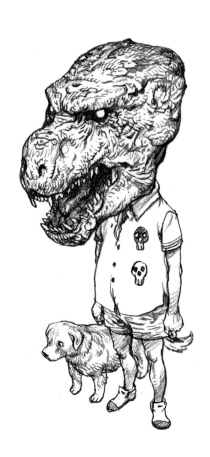

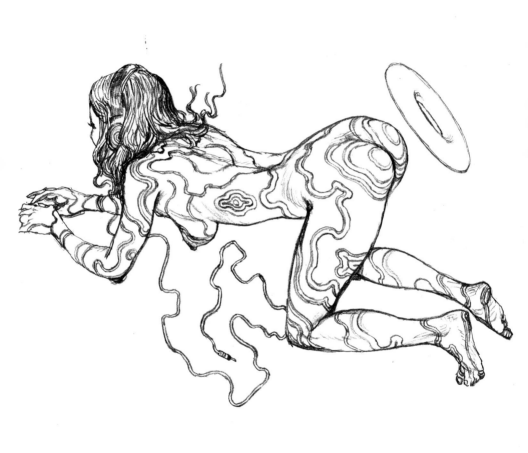

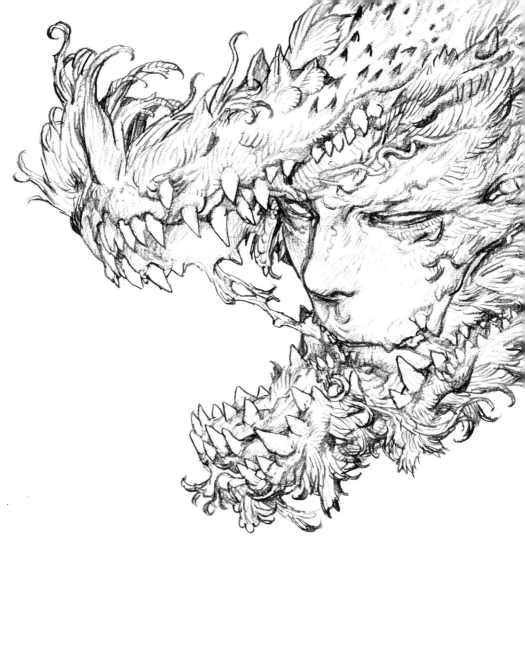

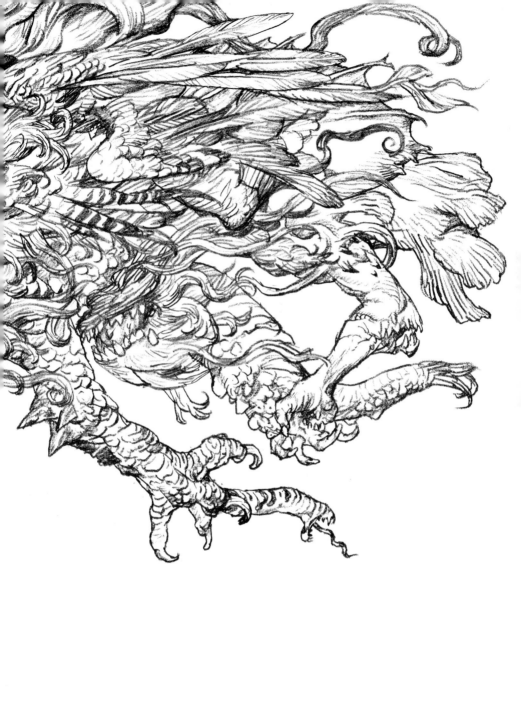

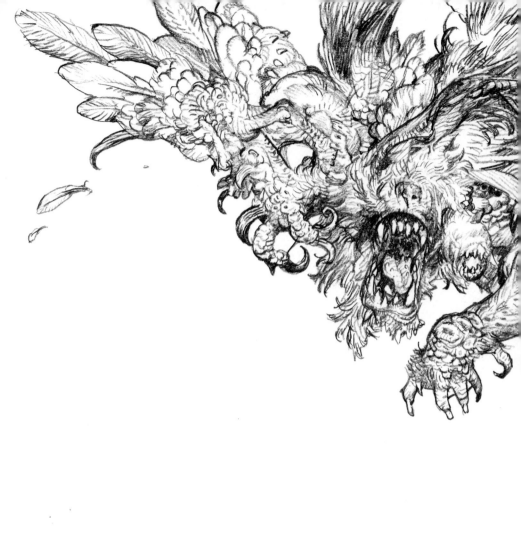

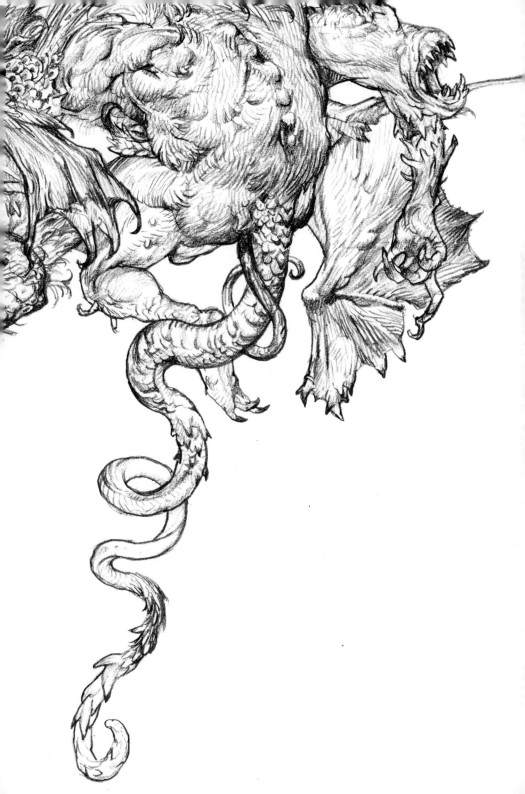

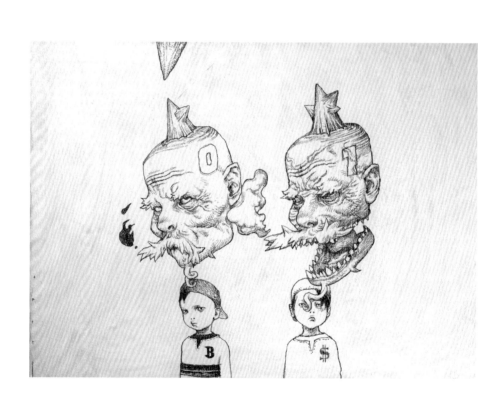

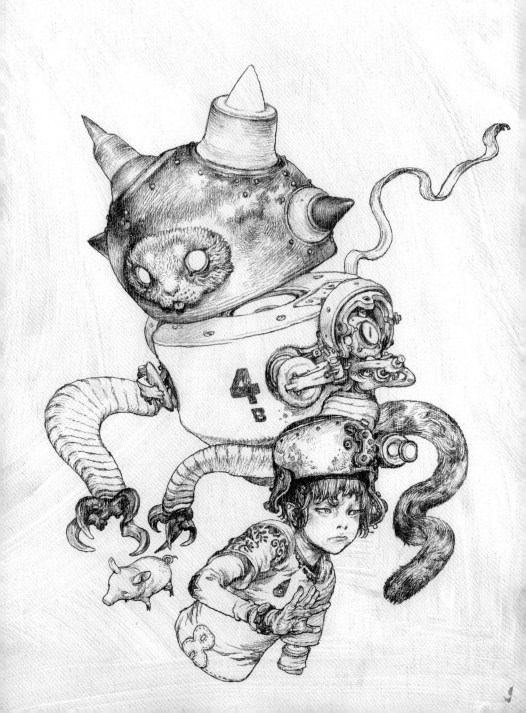

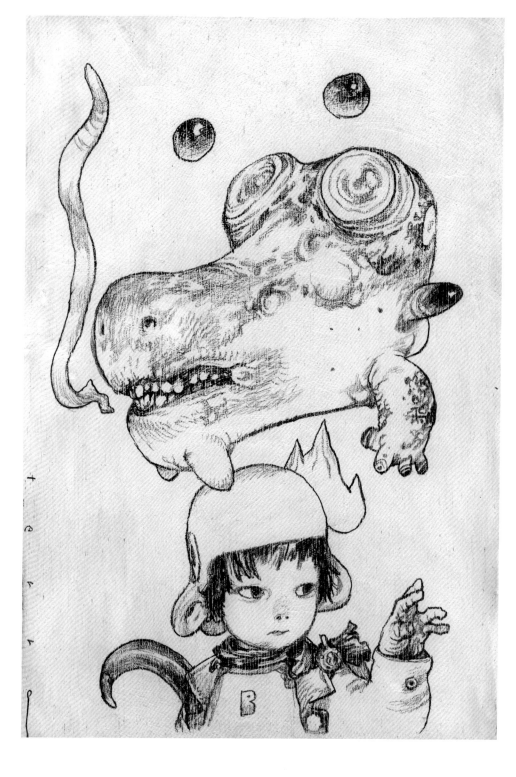

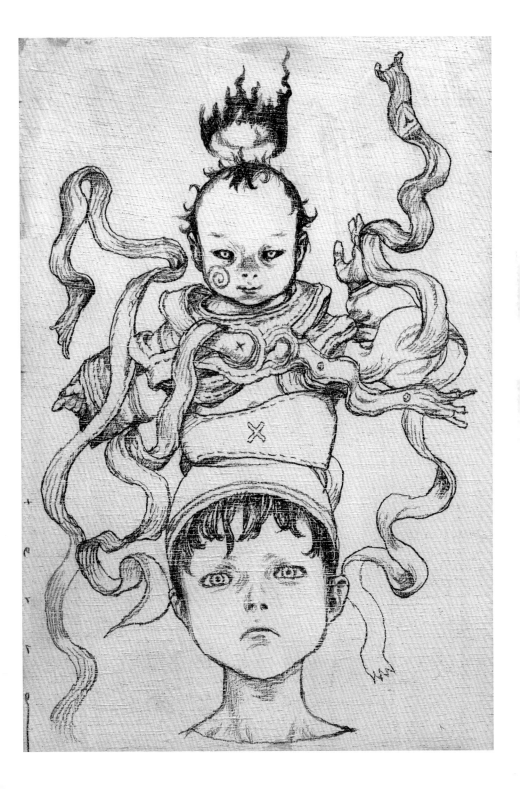

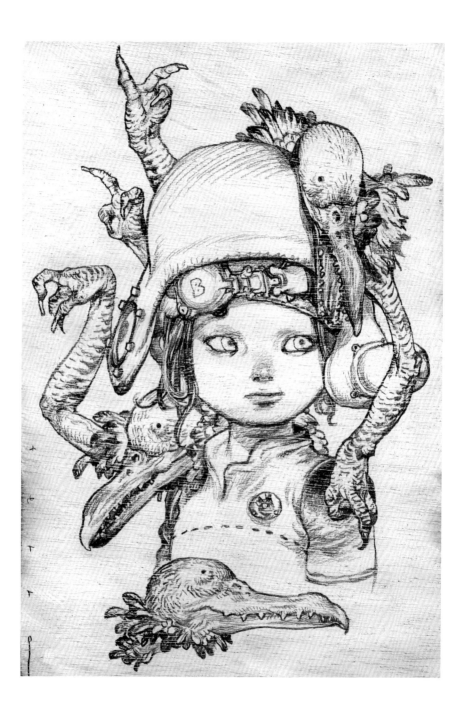

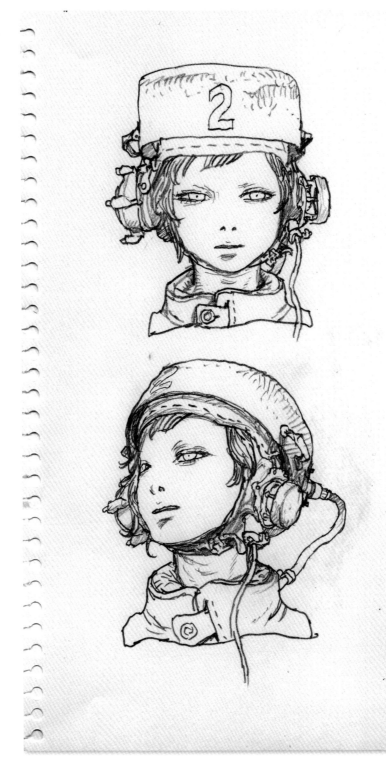

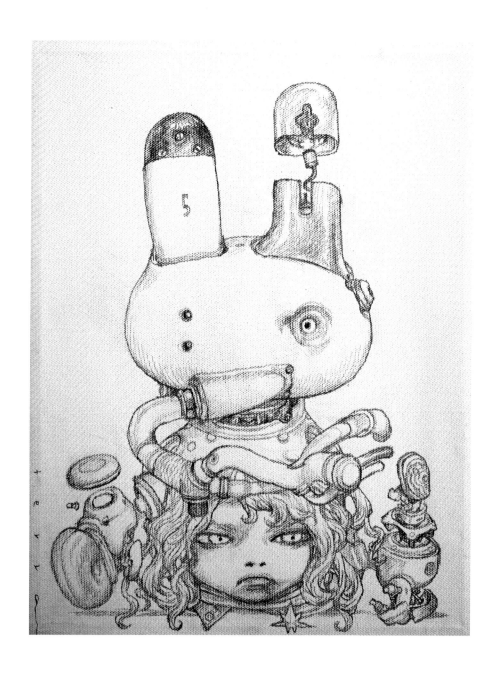

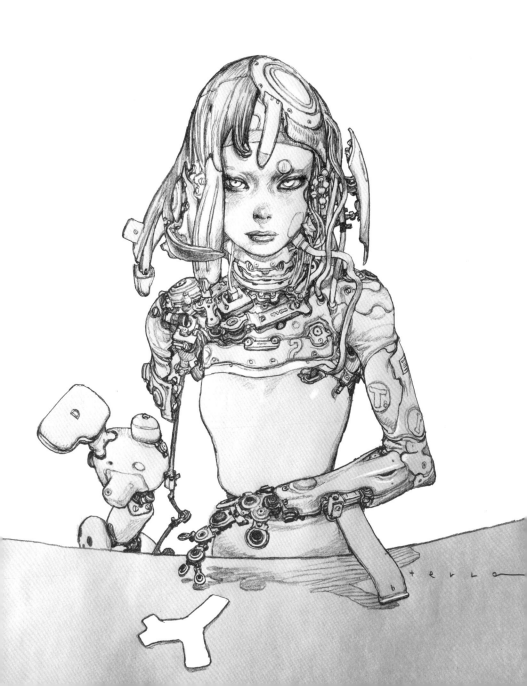

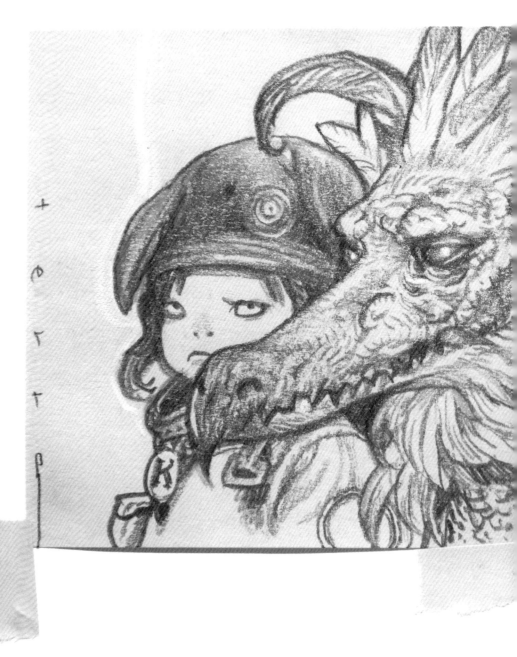

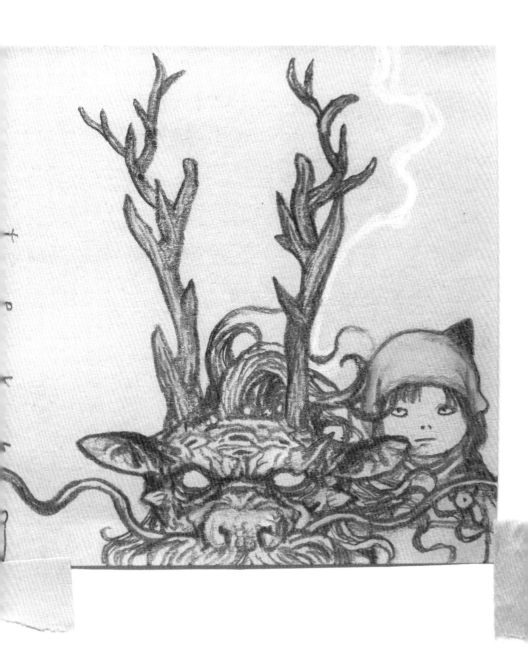

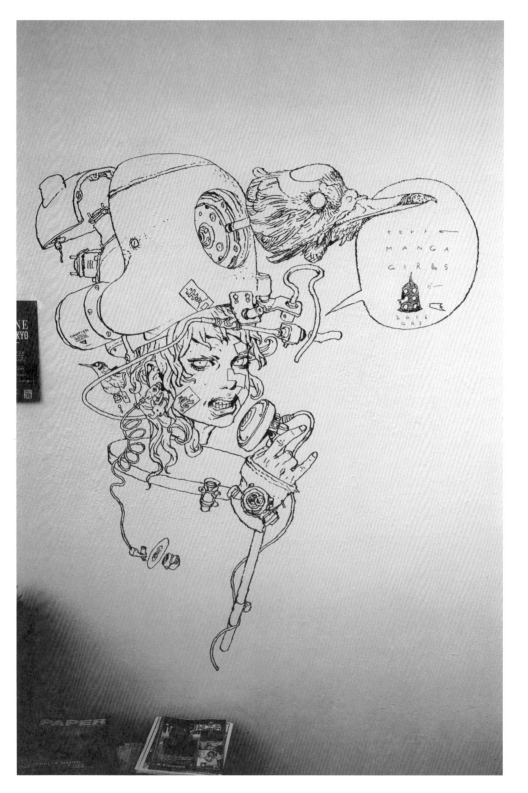

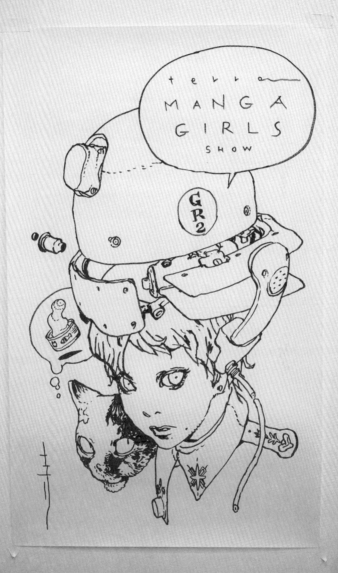

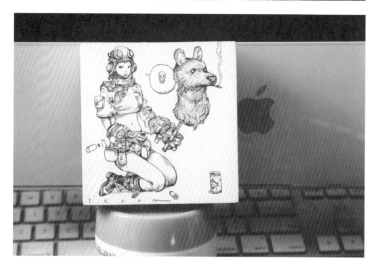

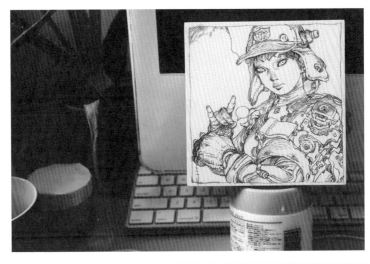

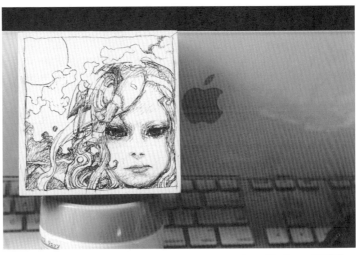

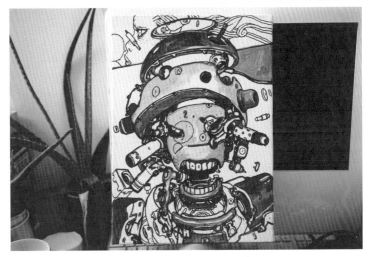

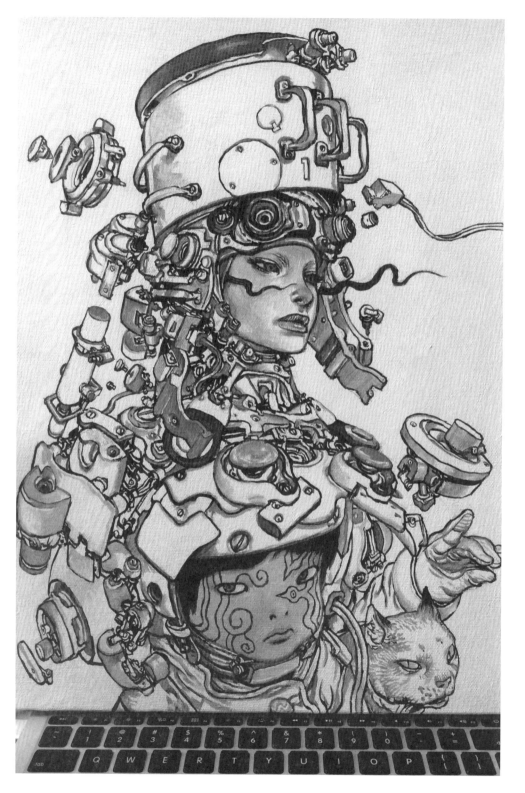

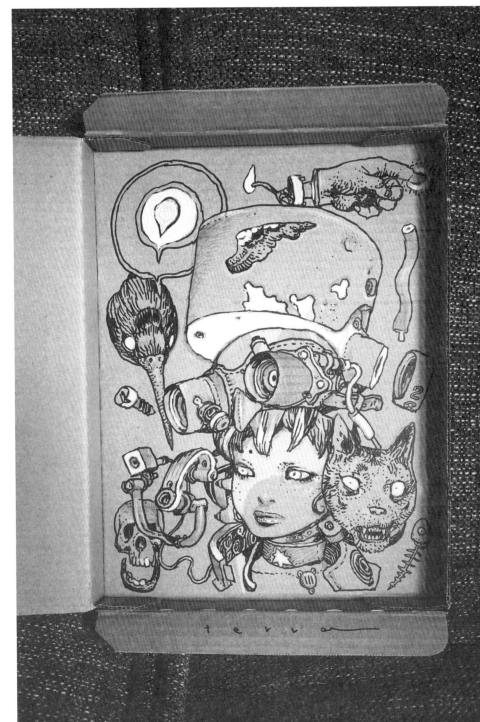

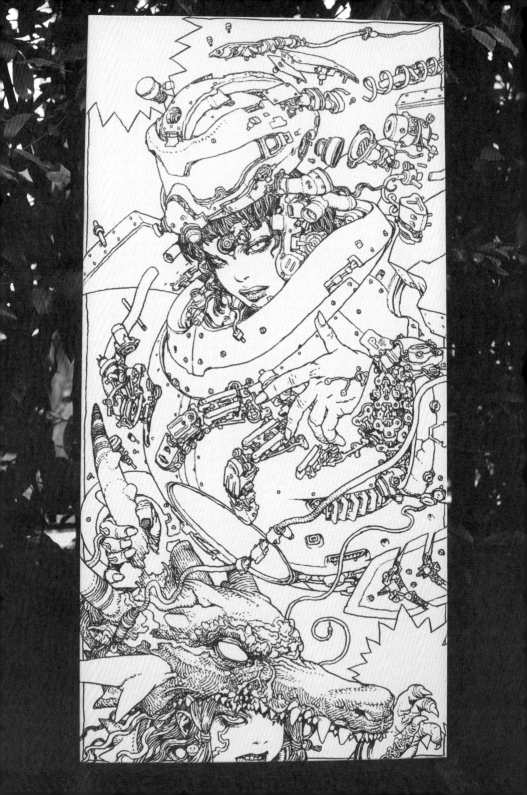

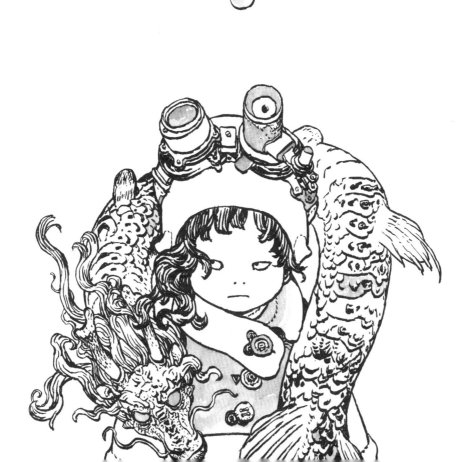

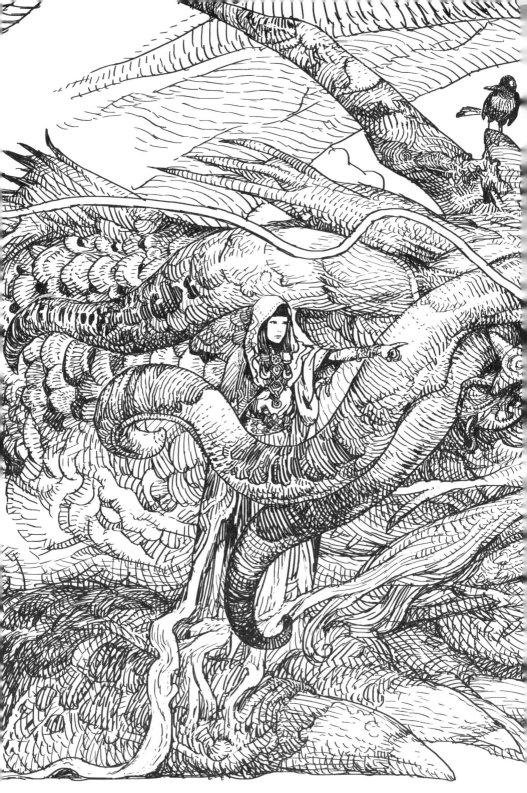

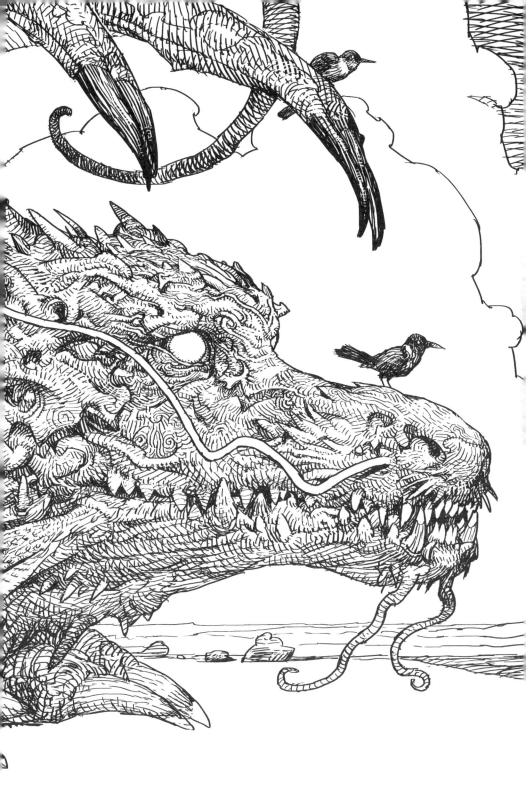

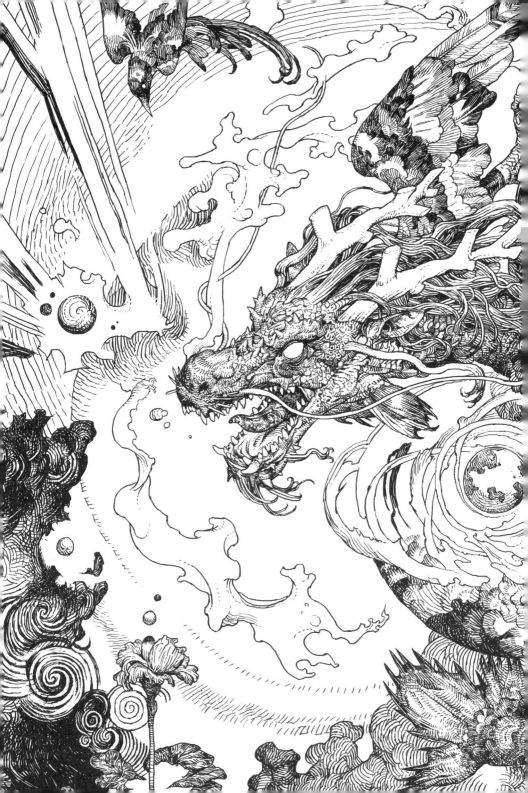

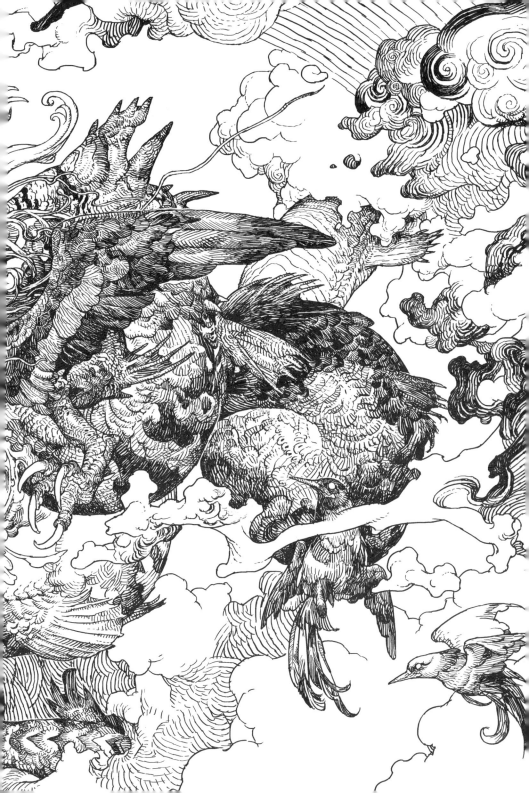

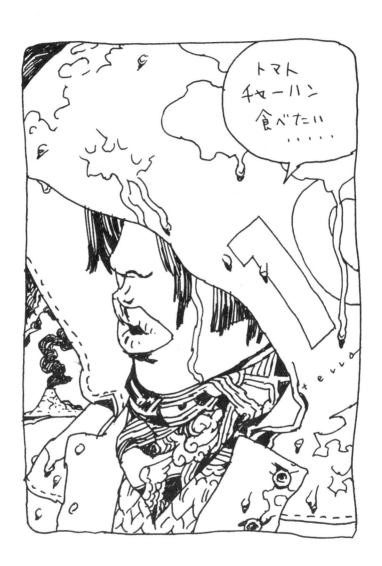

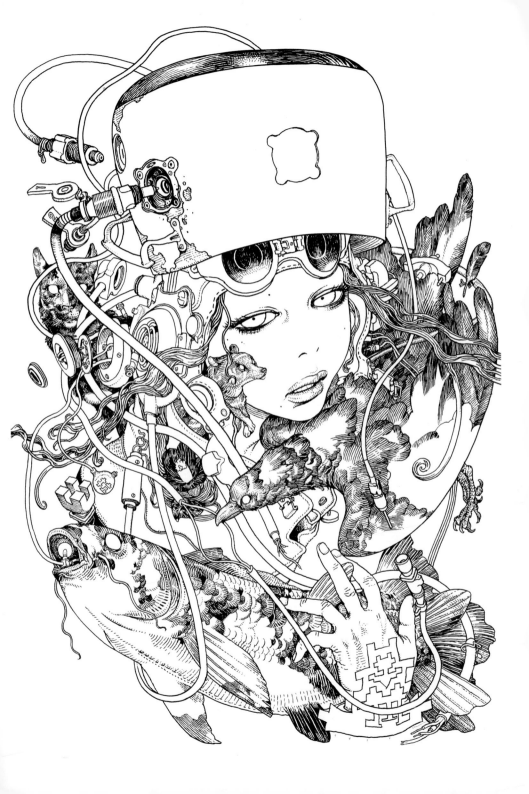

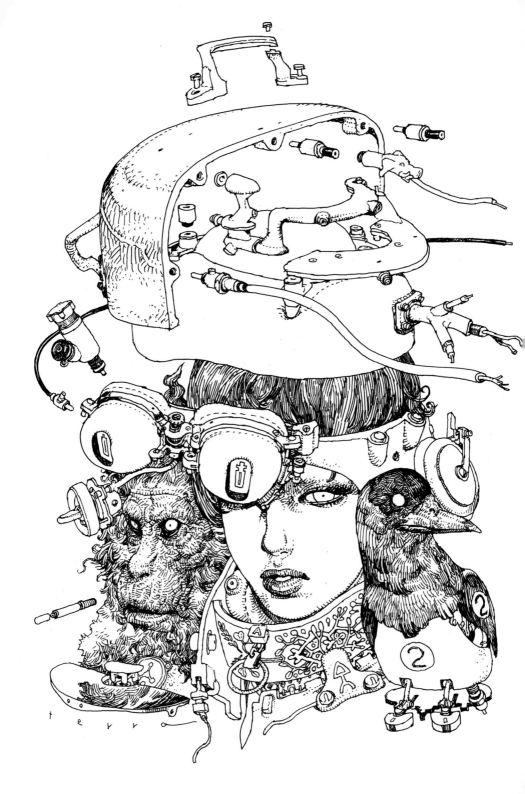

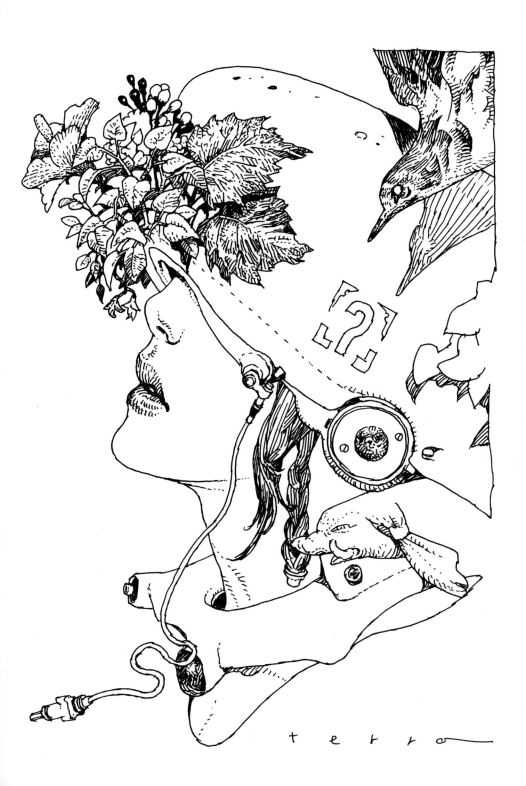

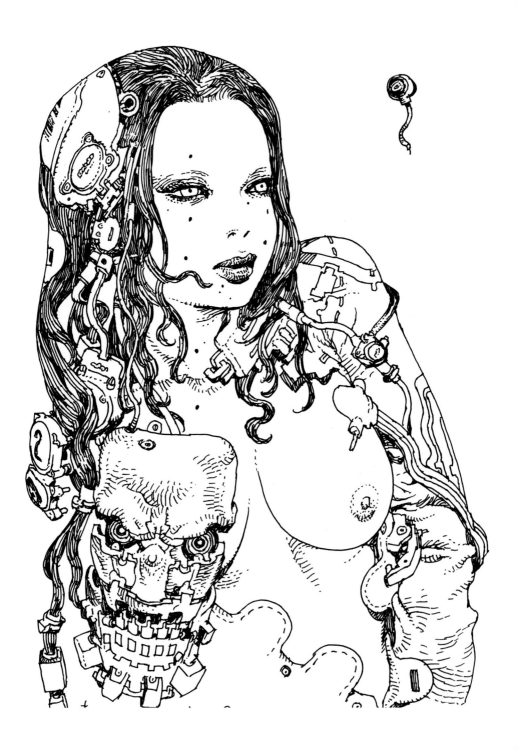

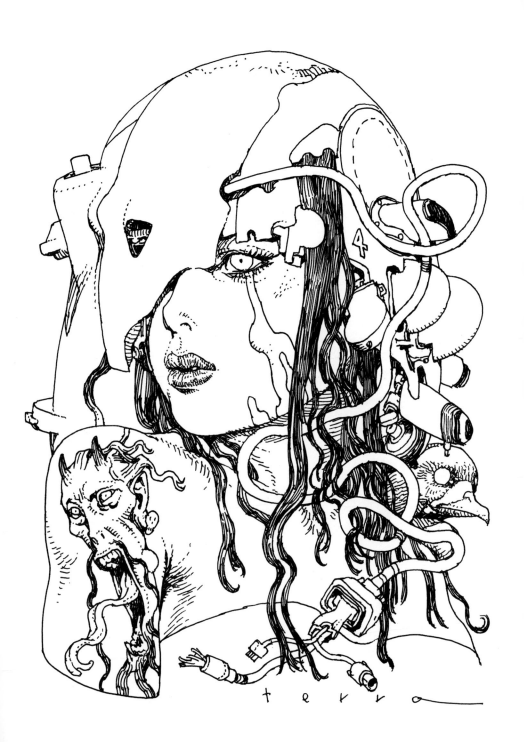

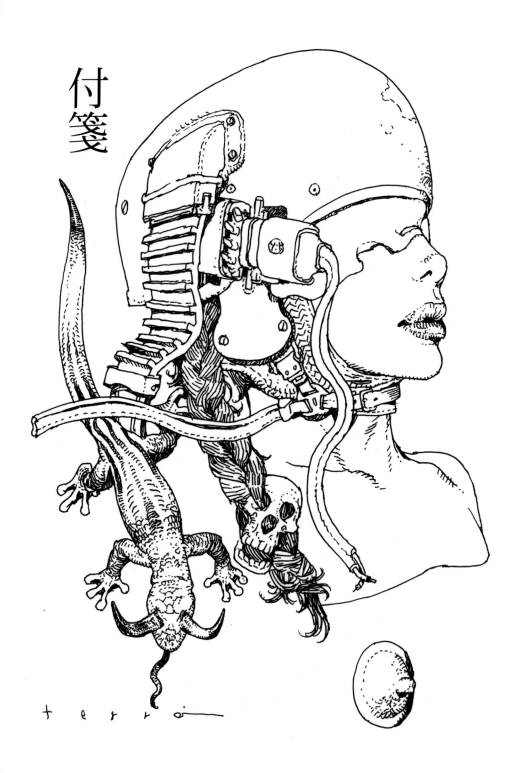

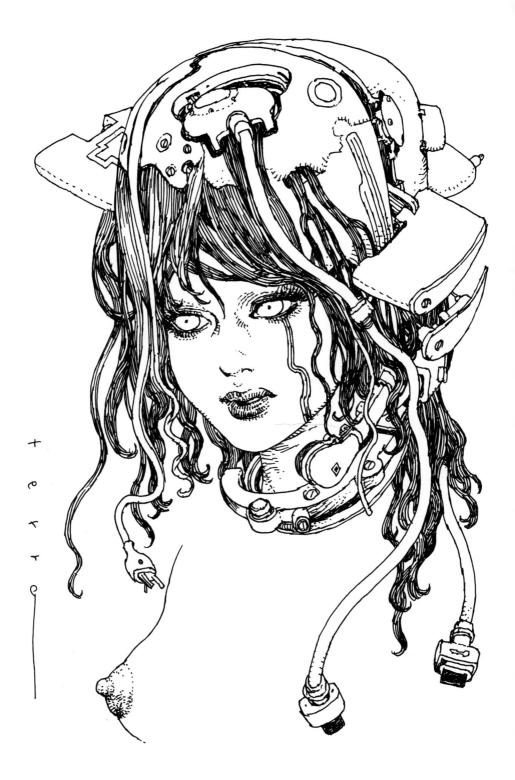

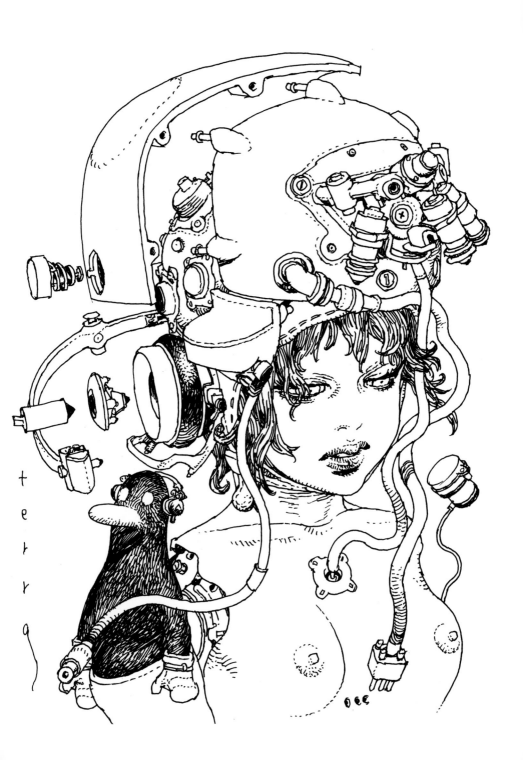

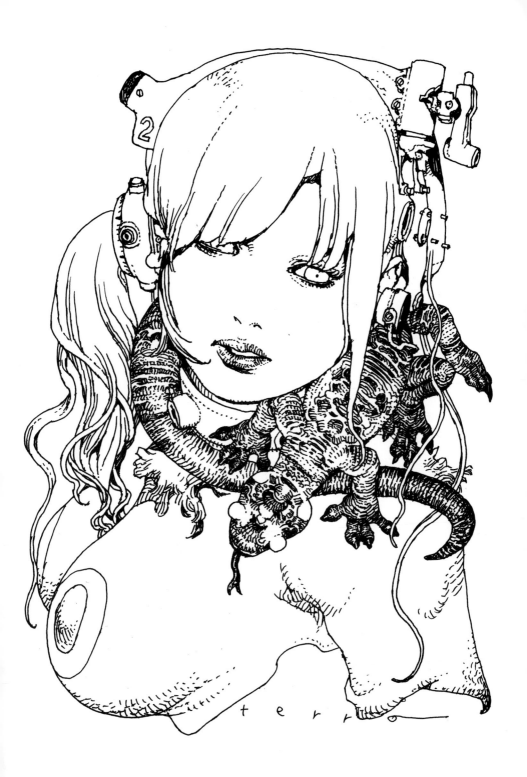

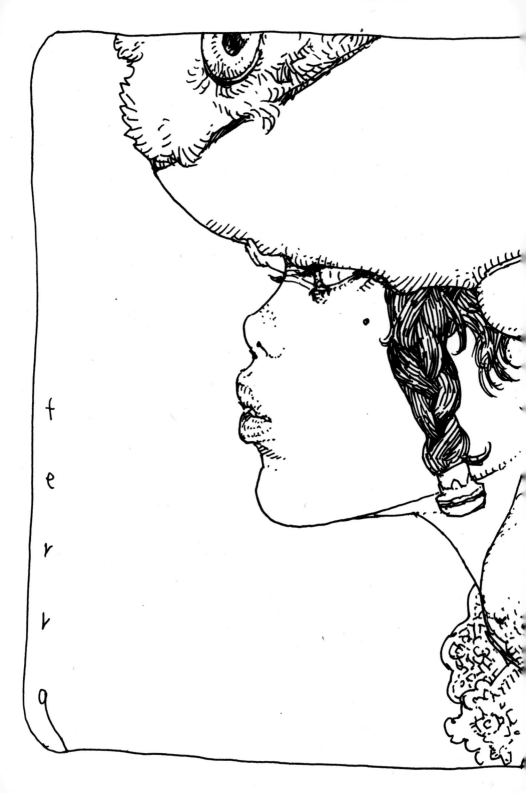

terra

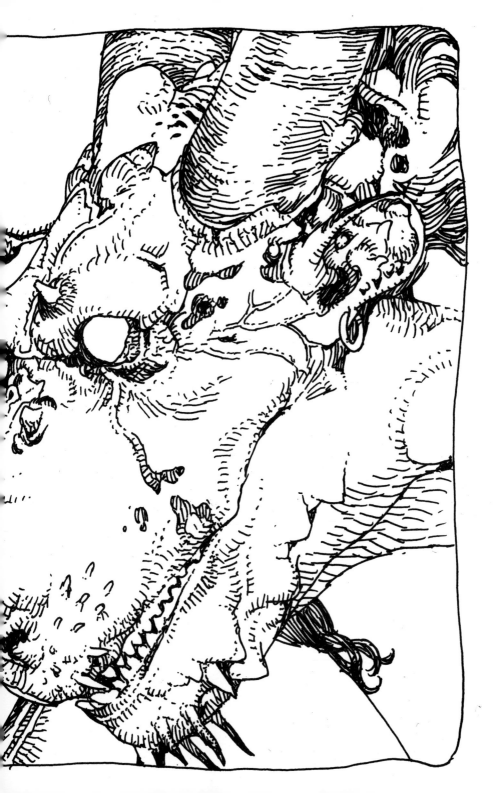

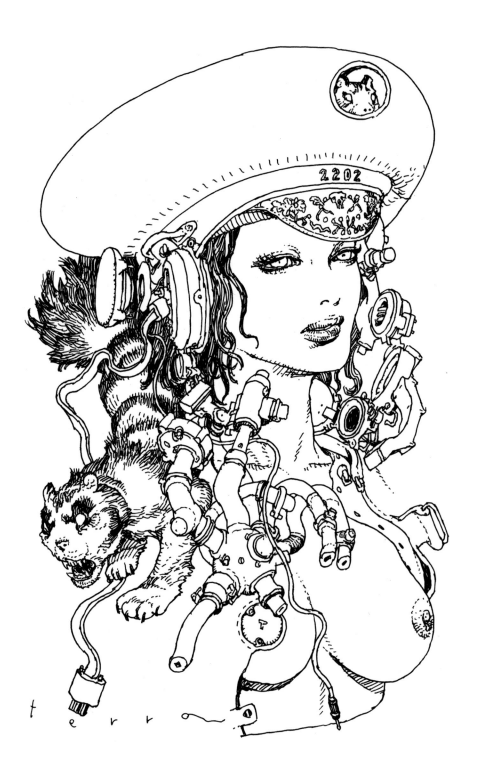

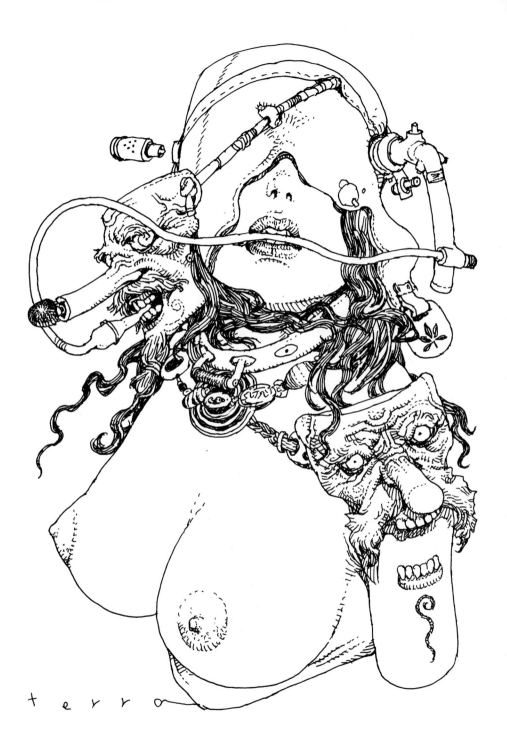

terra

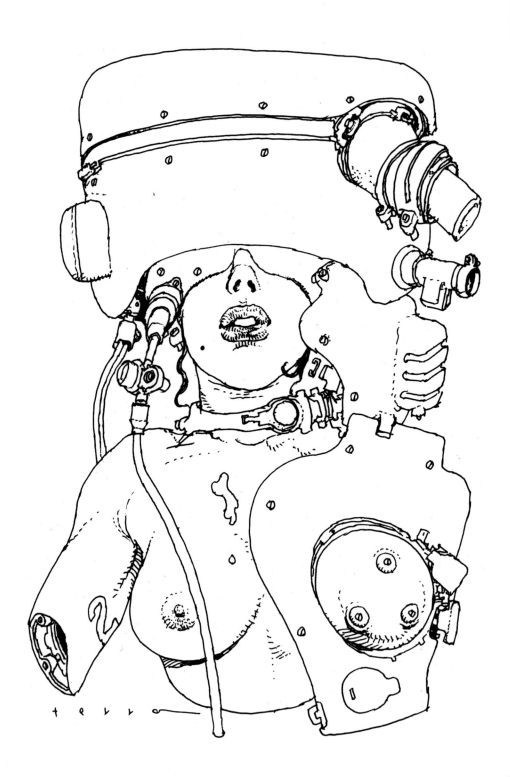

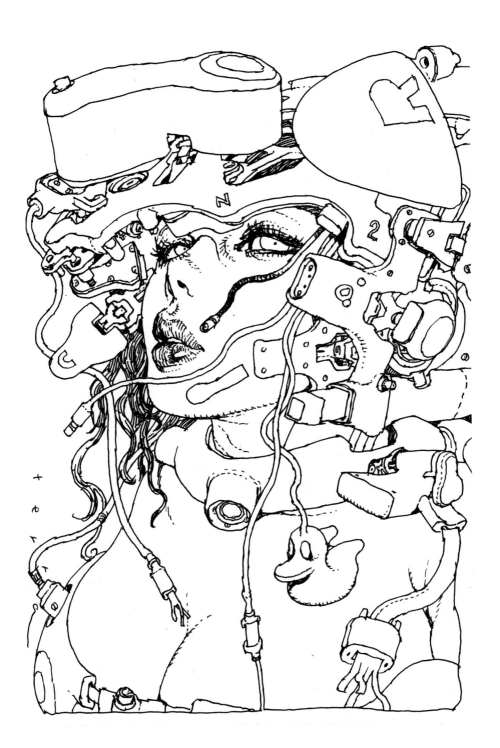

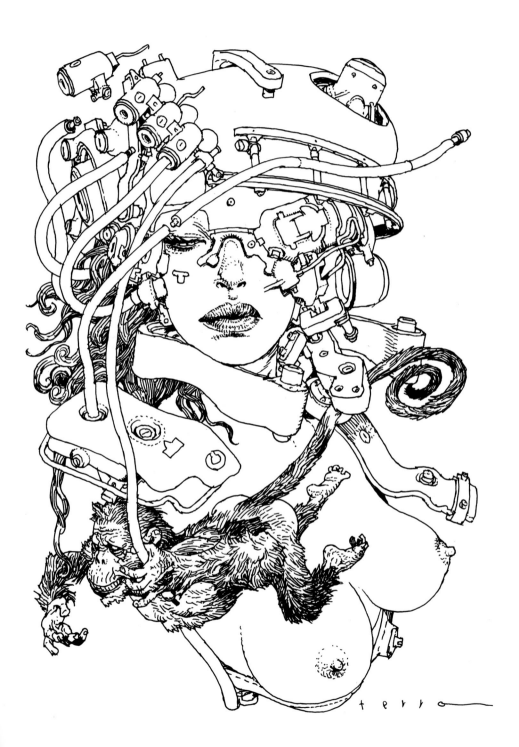

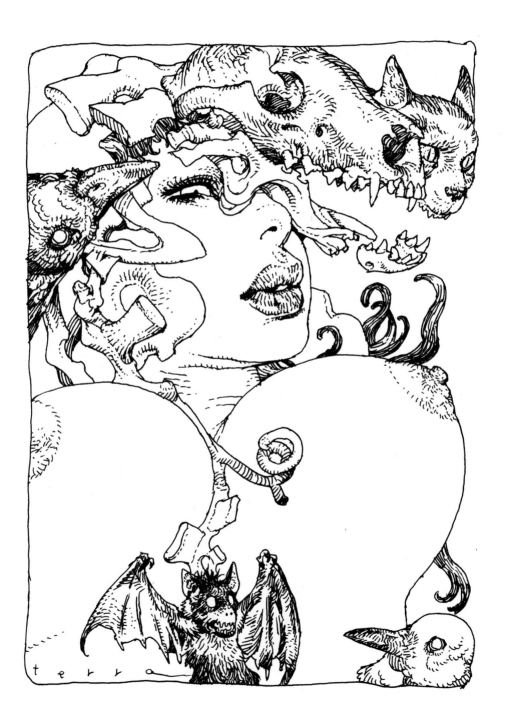

terra

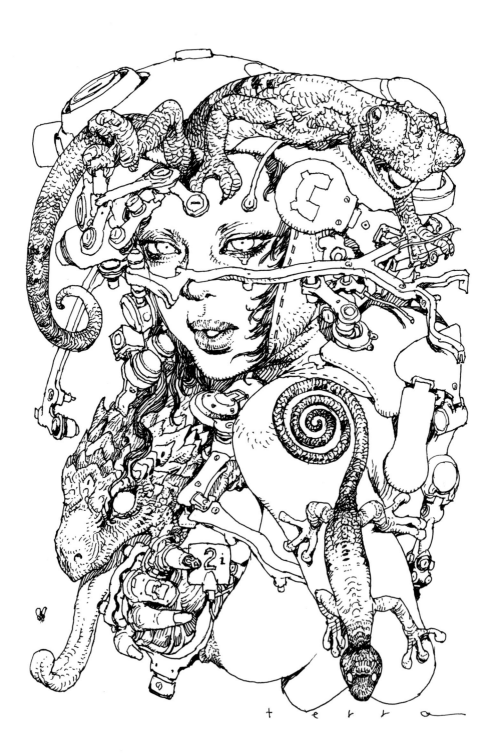

terra

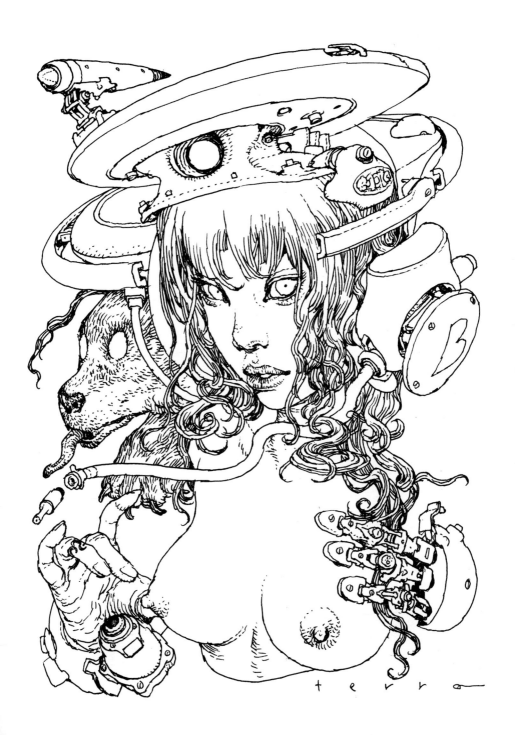

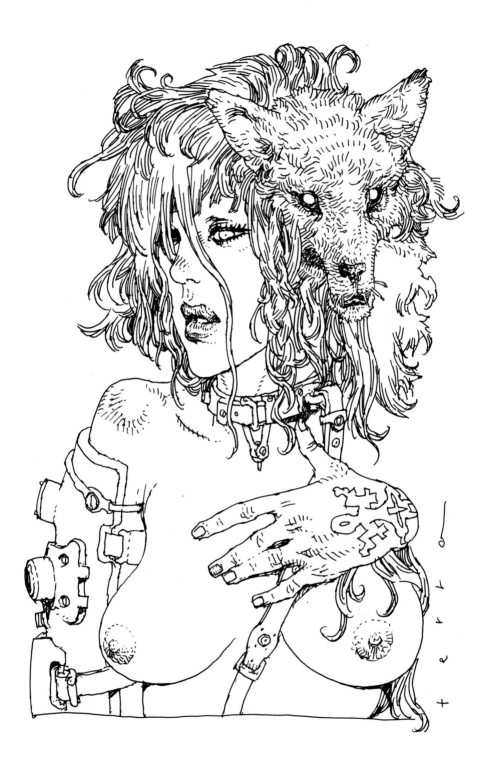

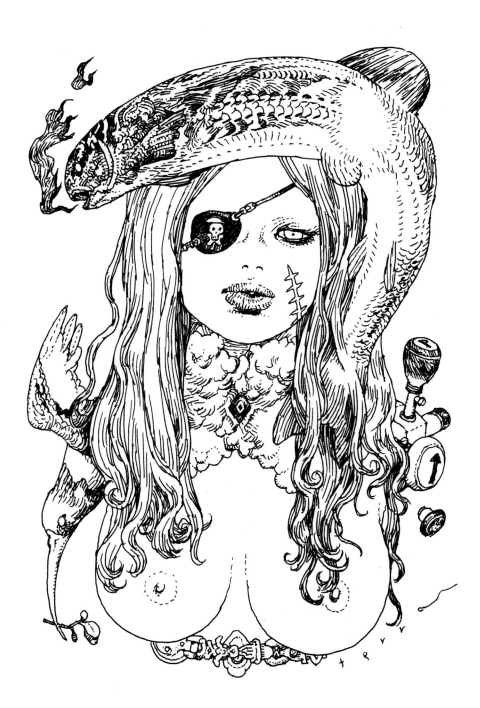

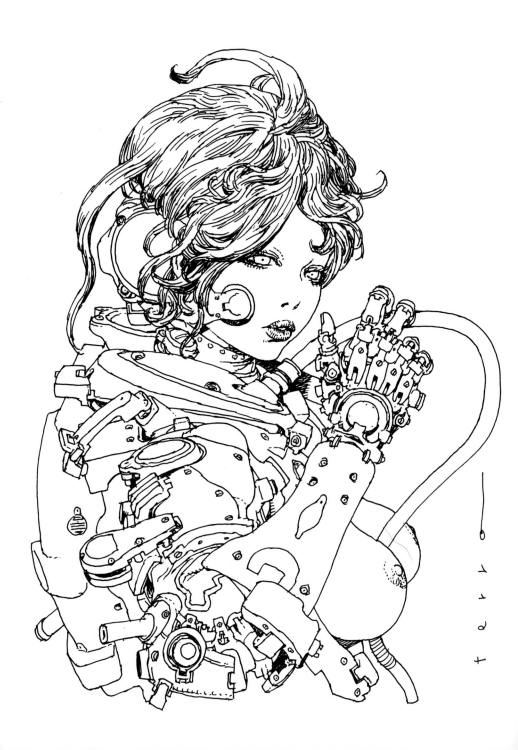

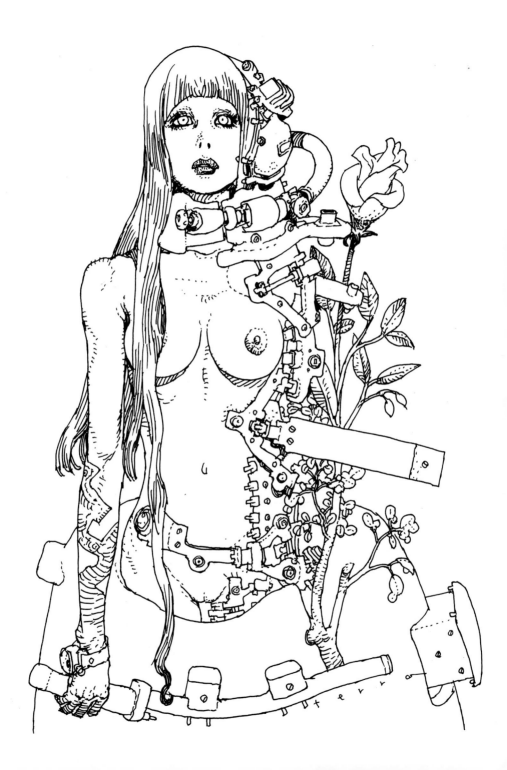

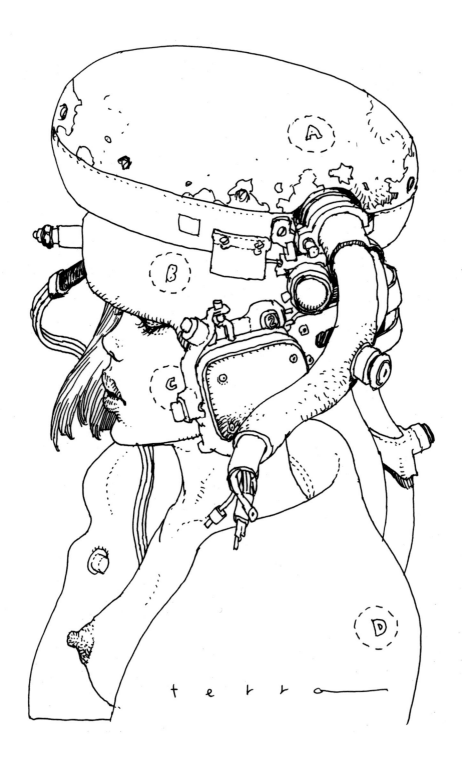

terra

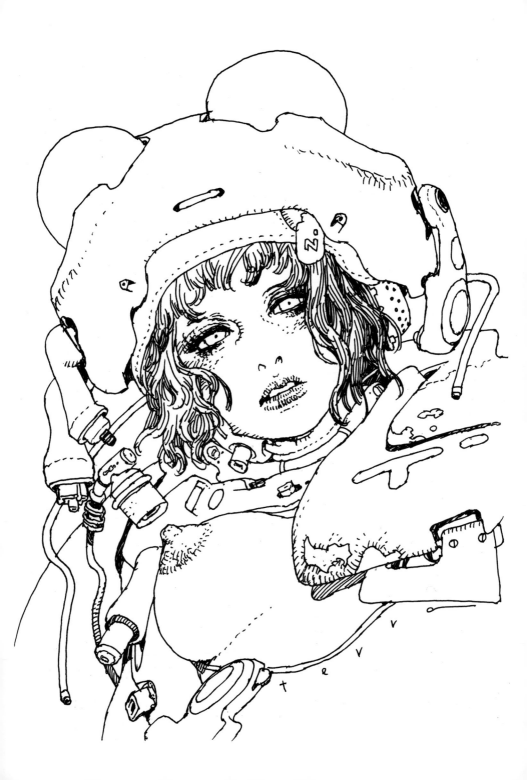

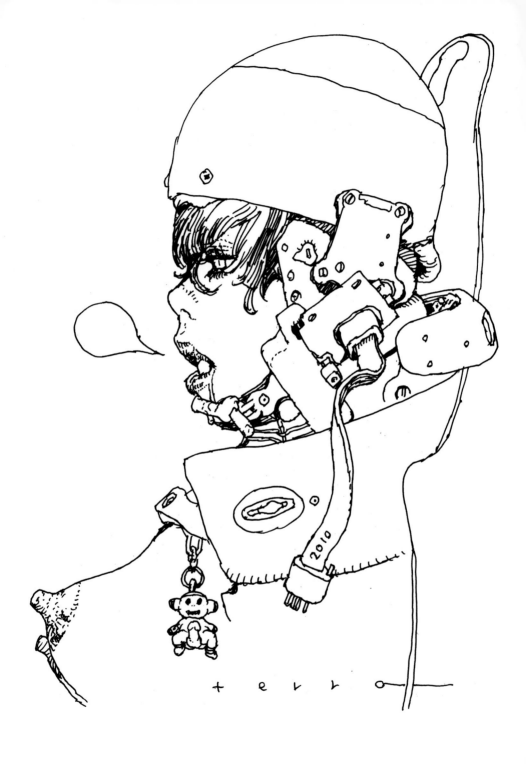

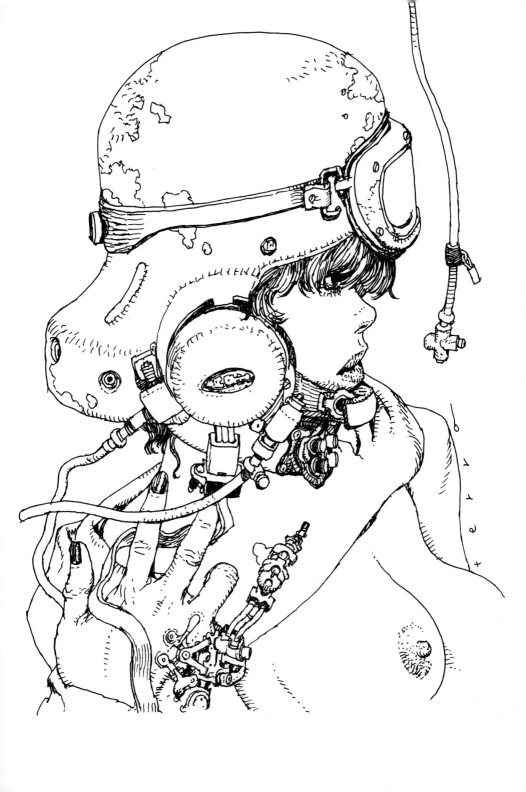

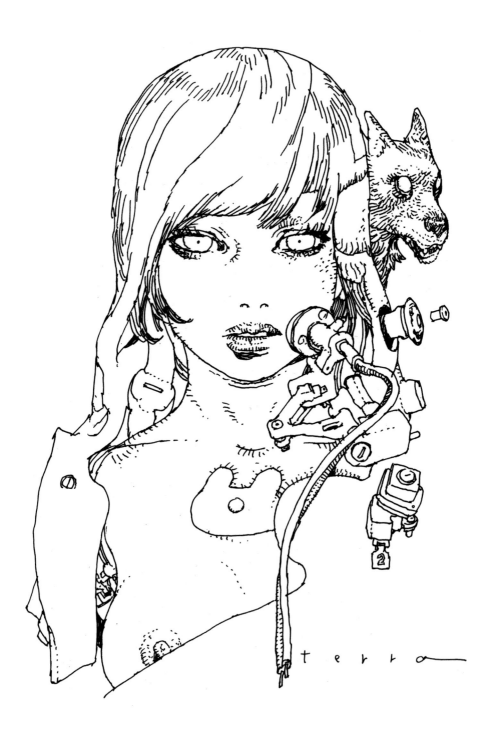

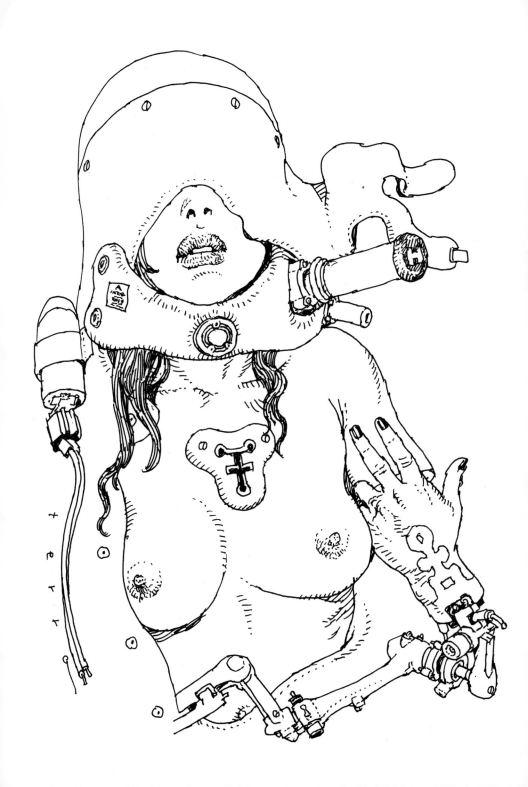

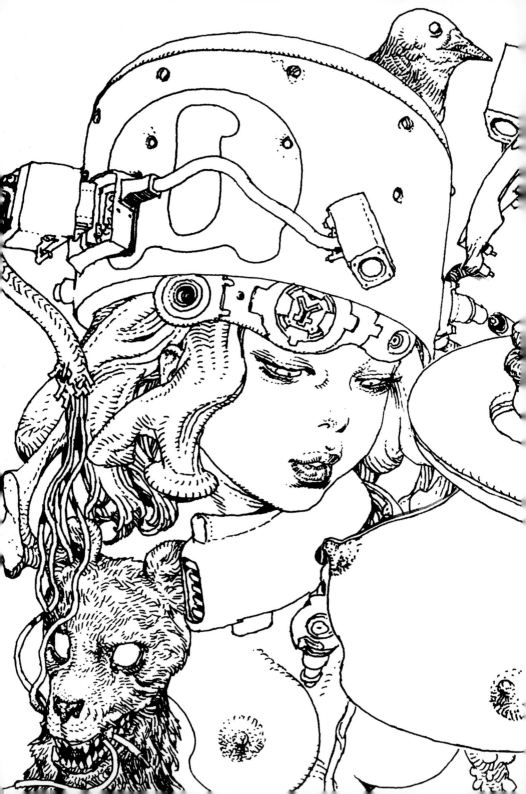

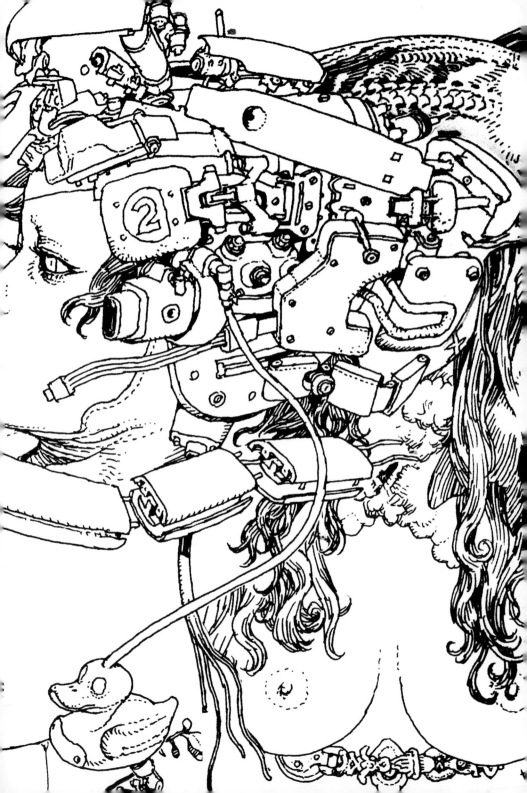

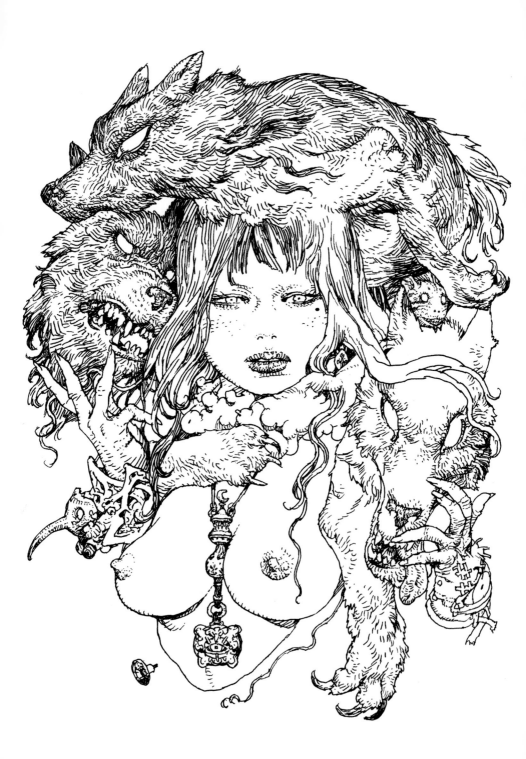

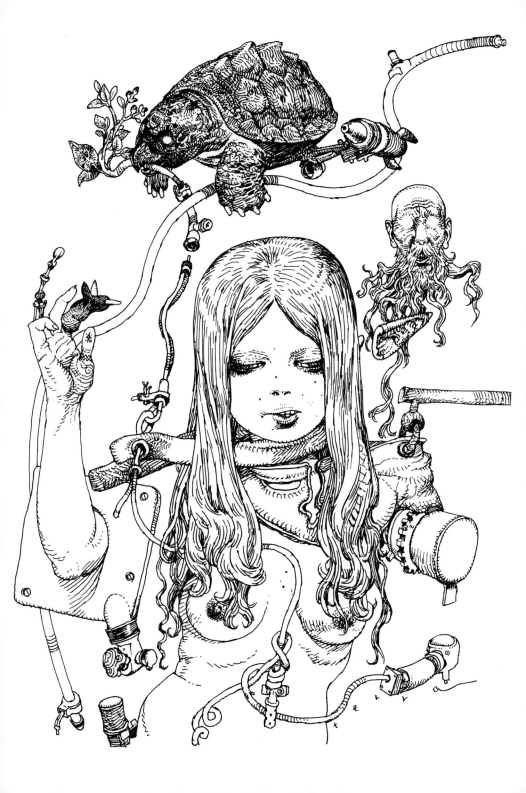

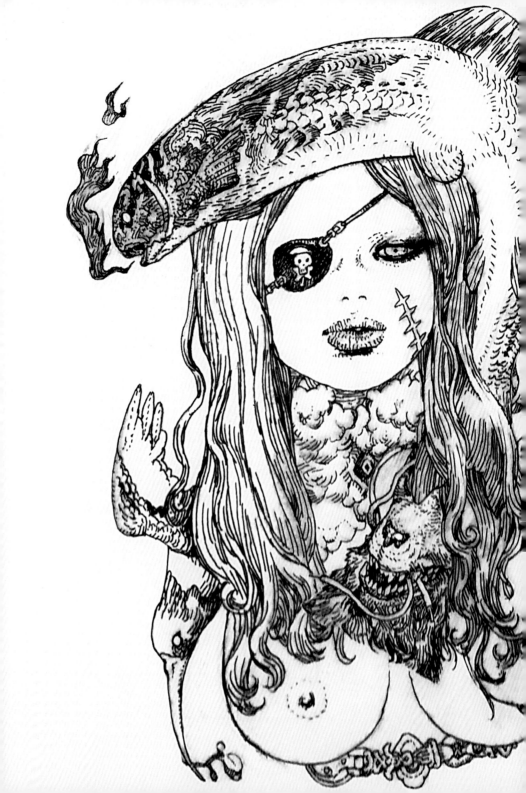

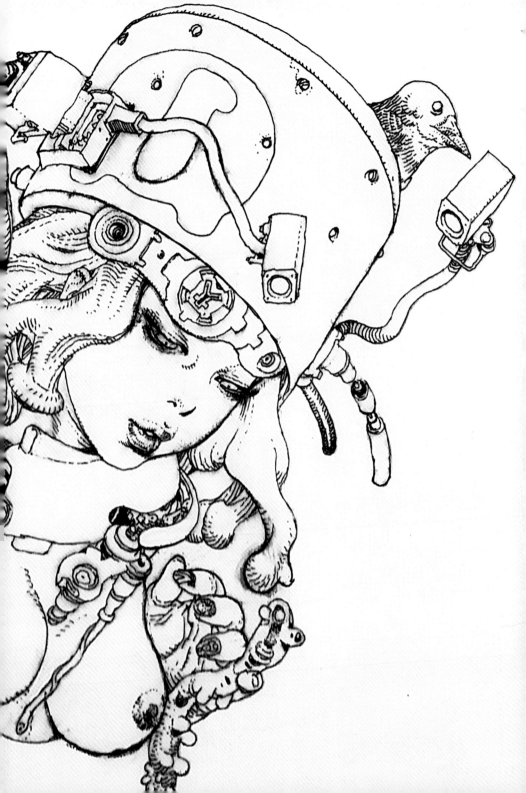

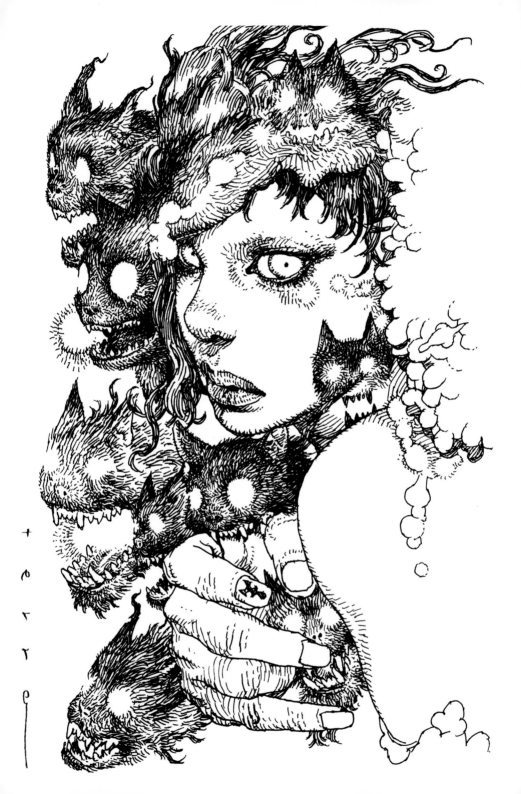

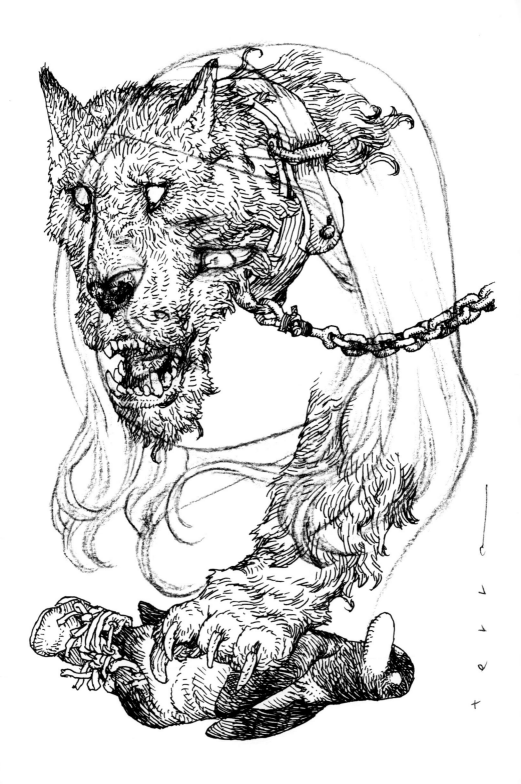

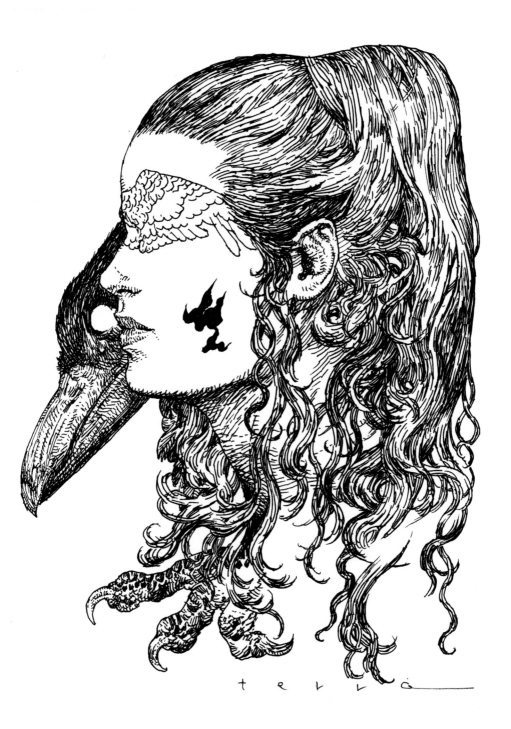

terra

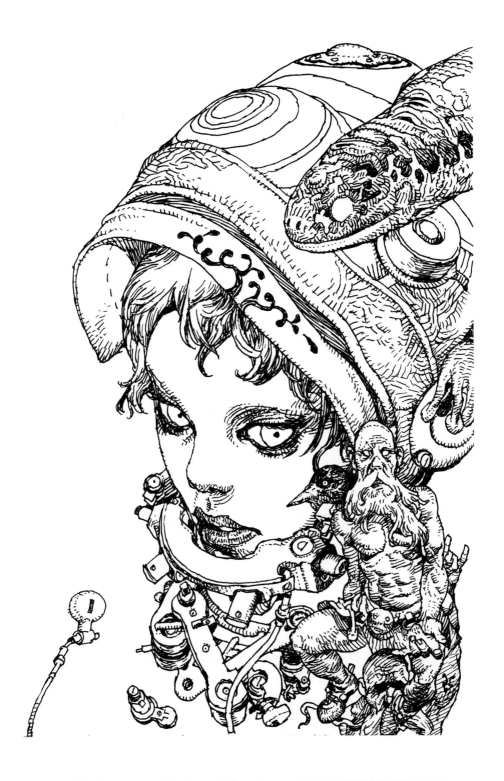

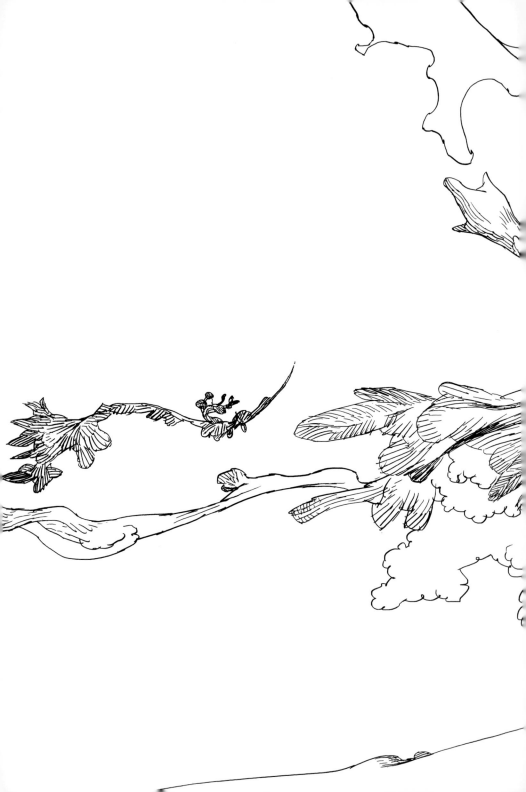

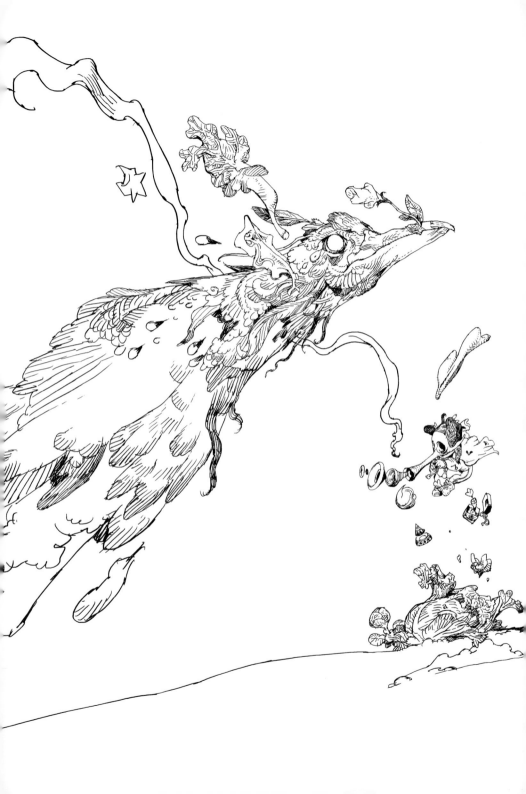

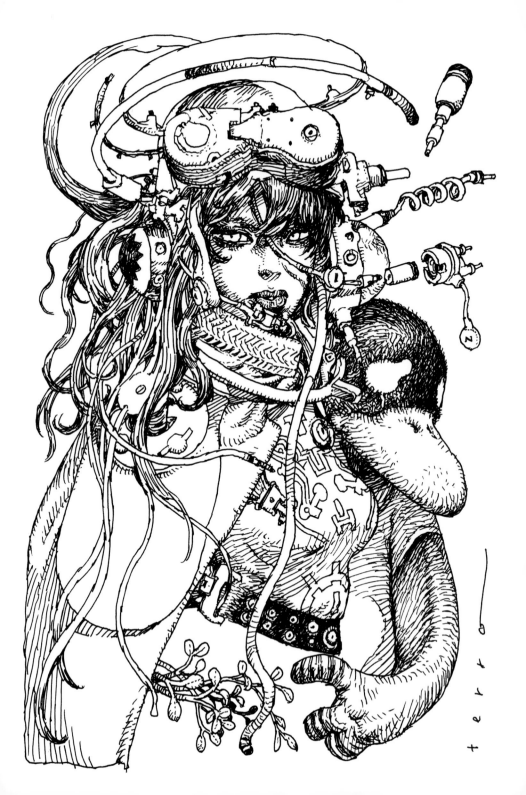

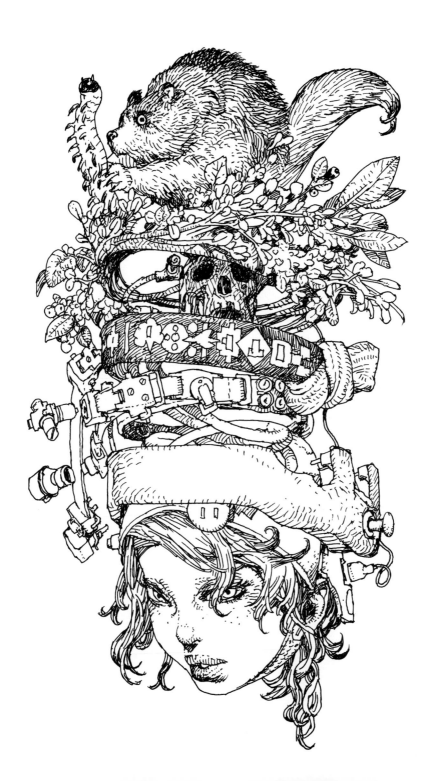

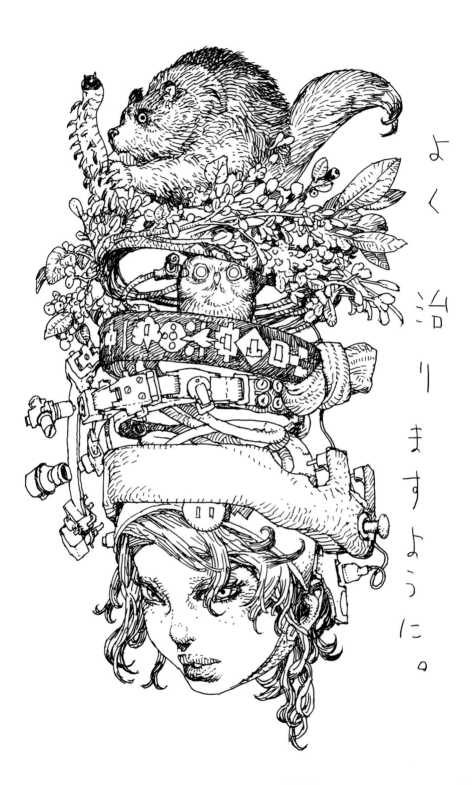

よく治りますように。

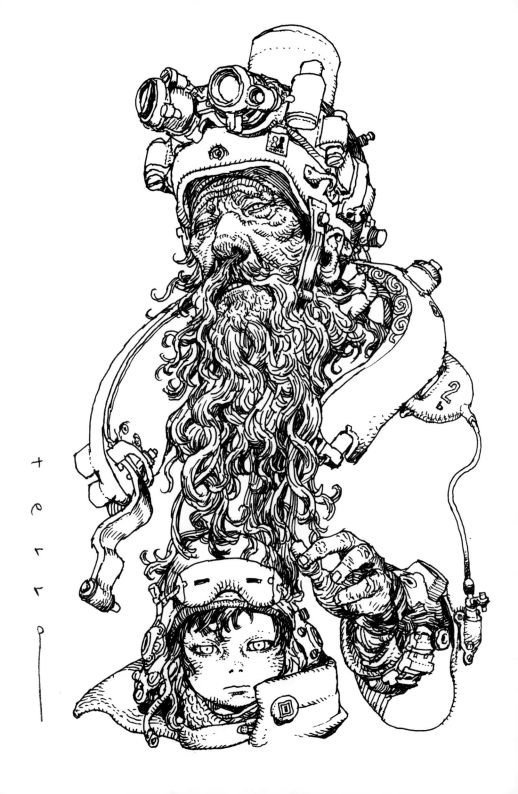

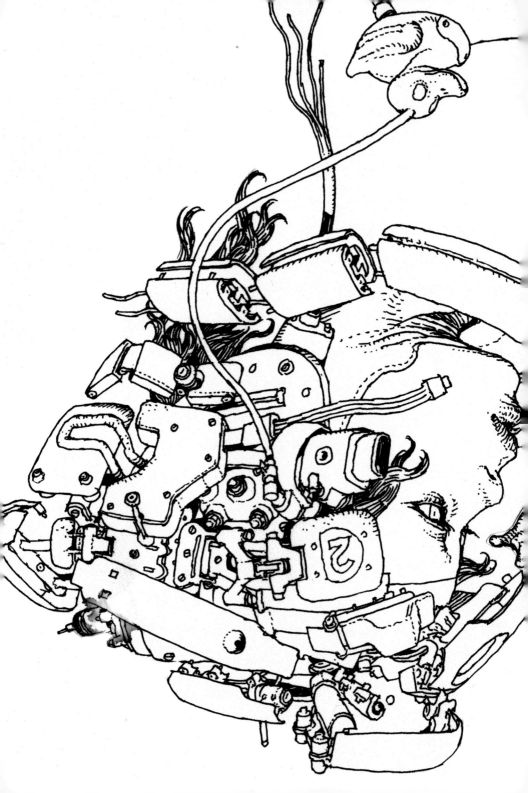

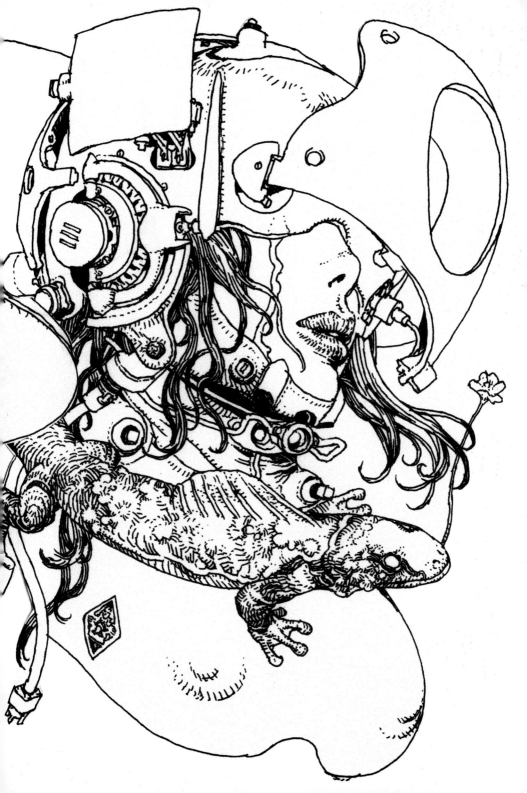

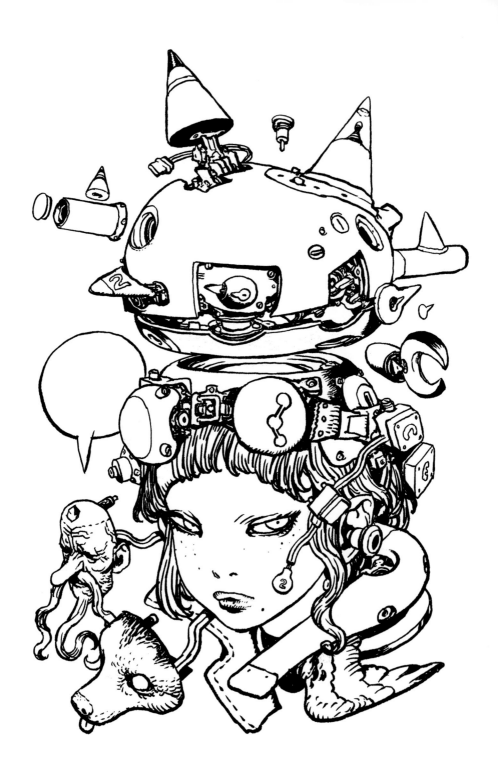

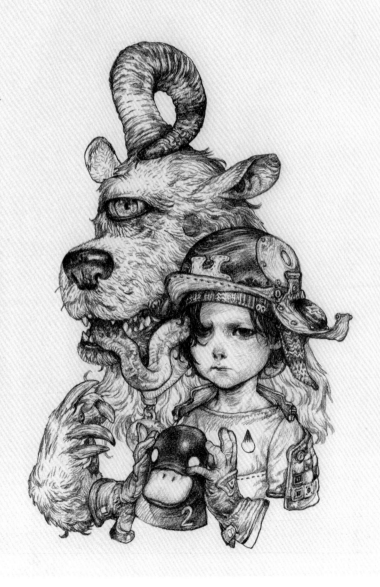

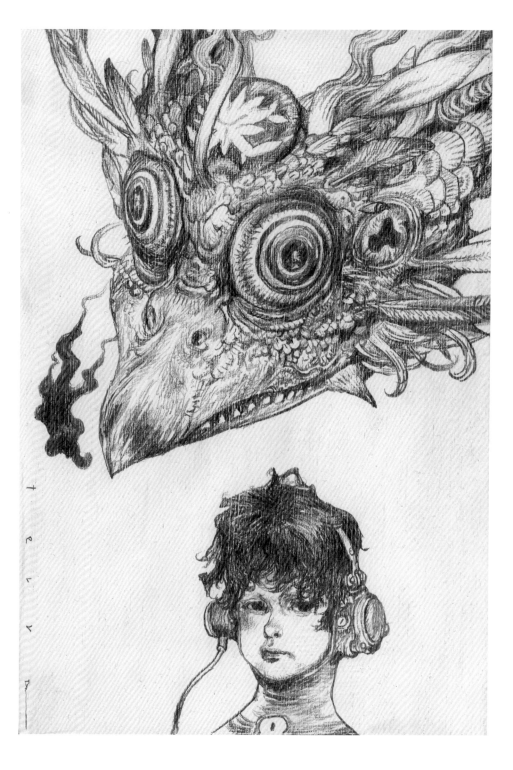

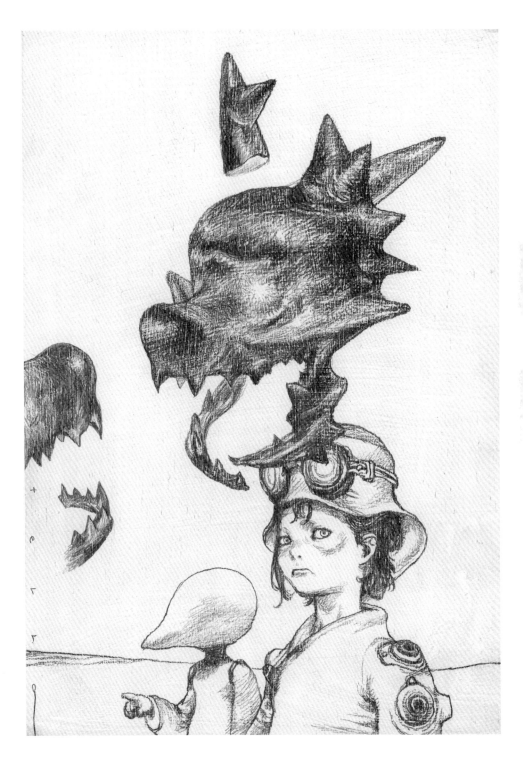

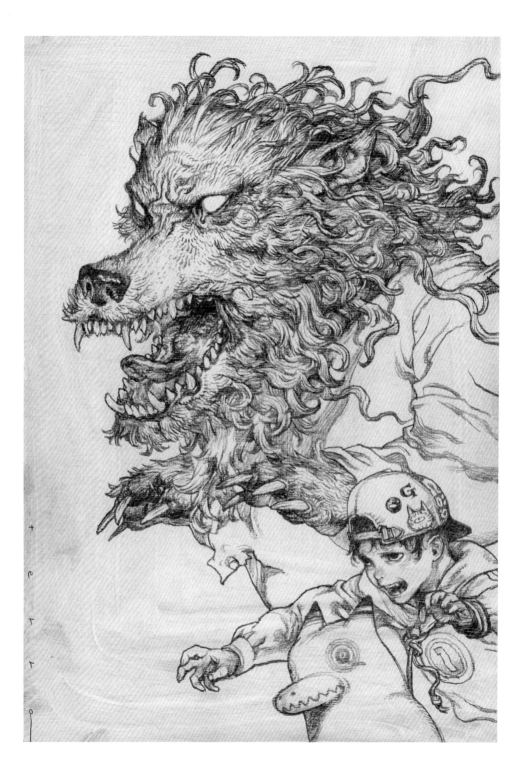

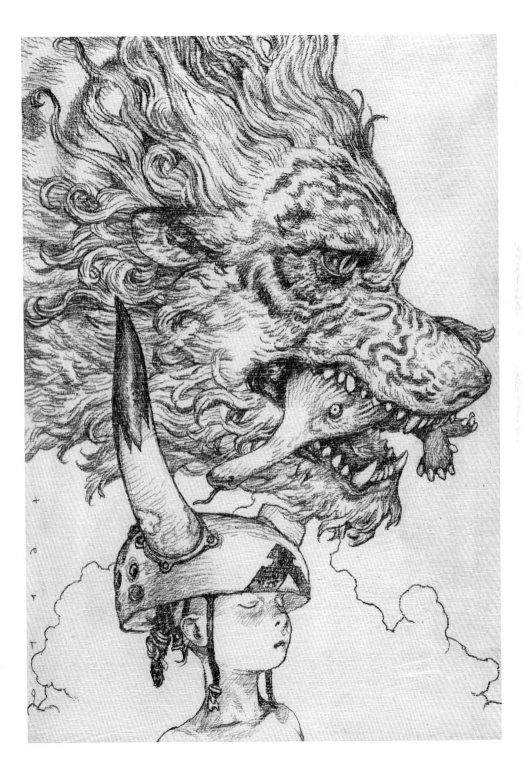

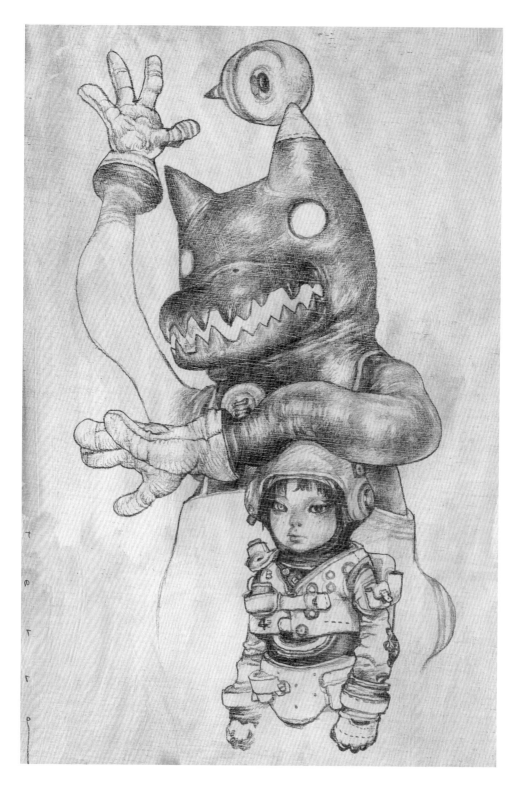

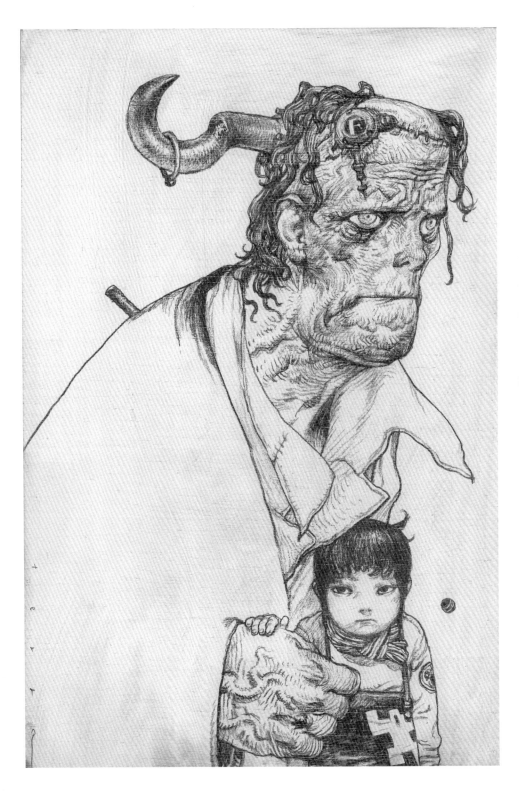

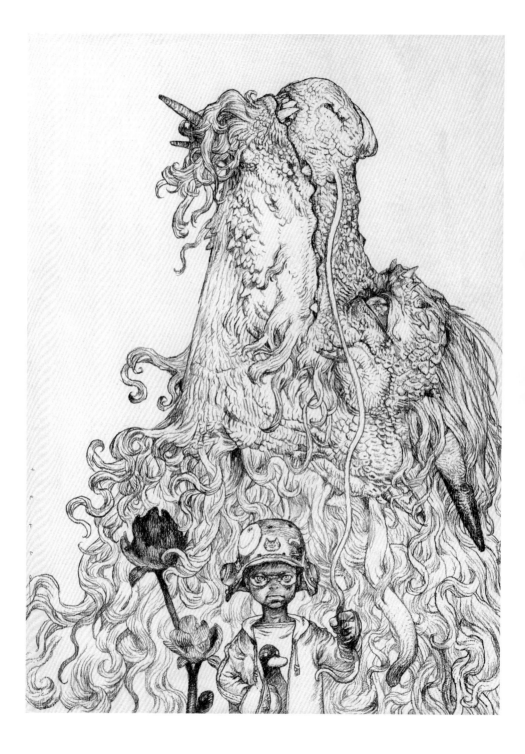

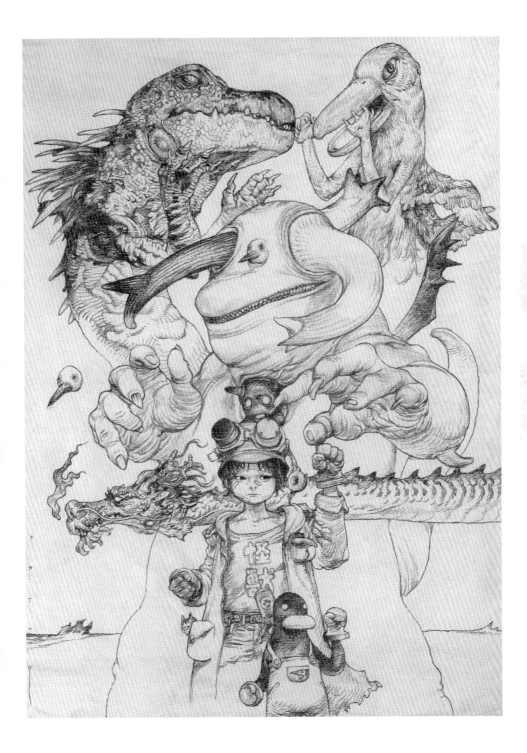

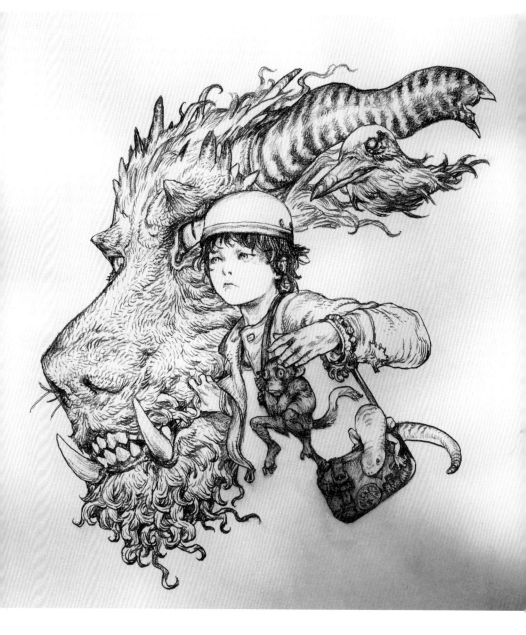

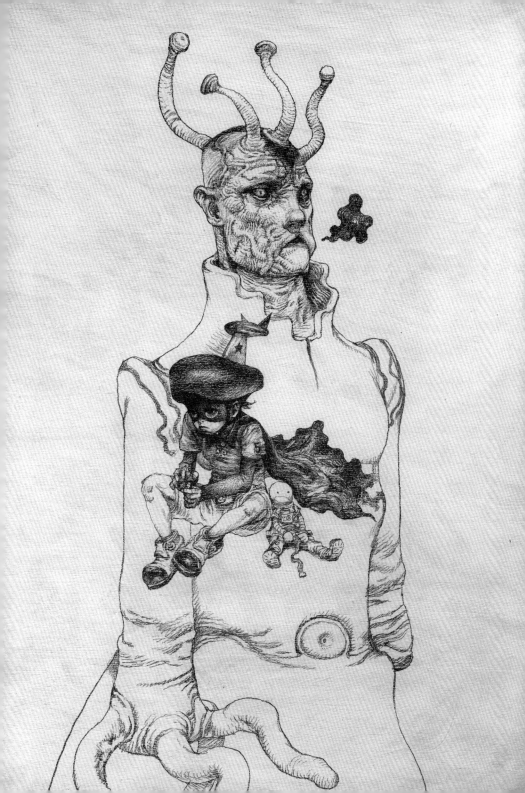

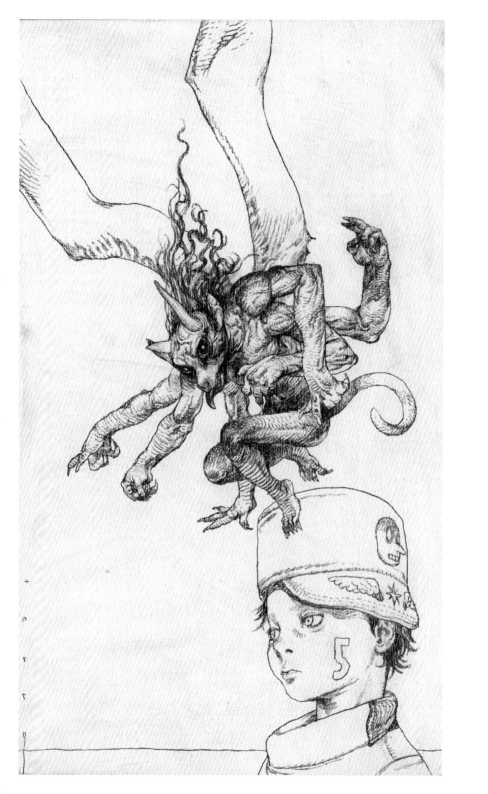

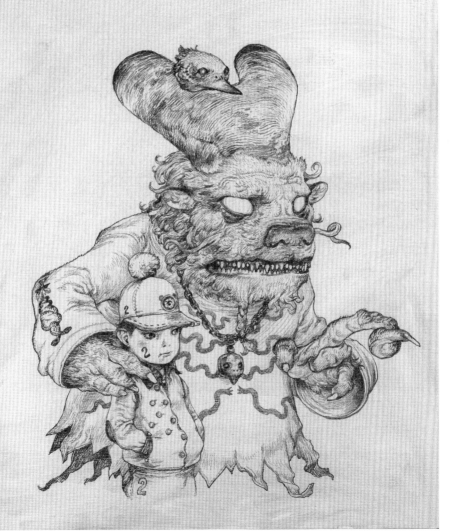

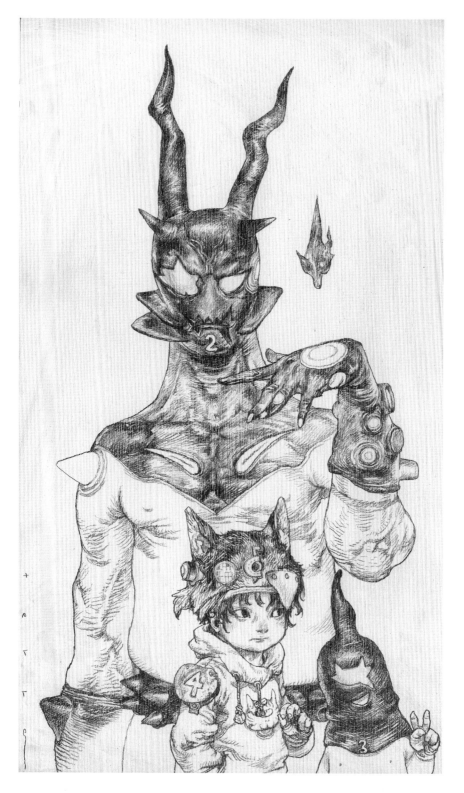

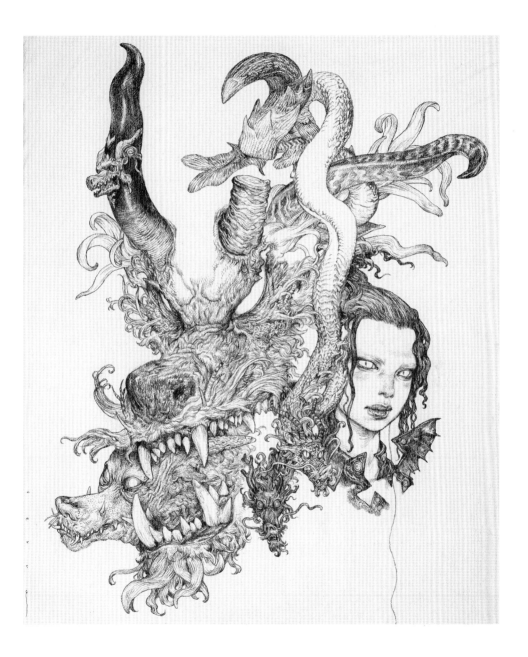

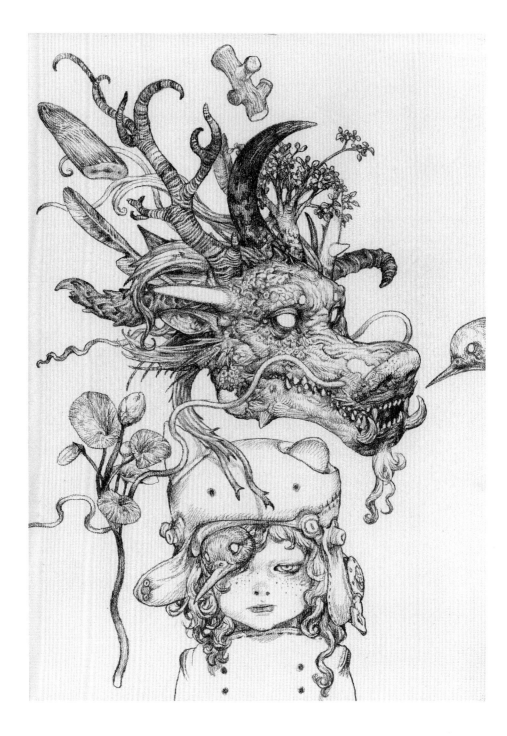

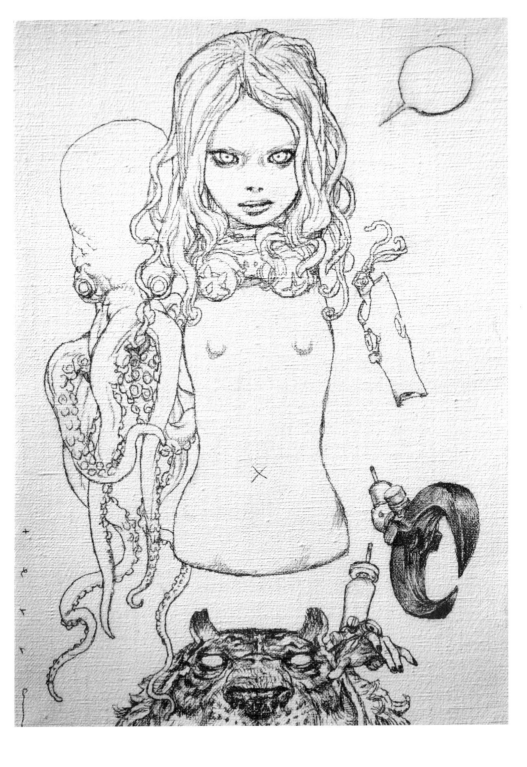

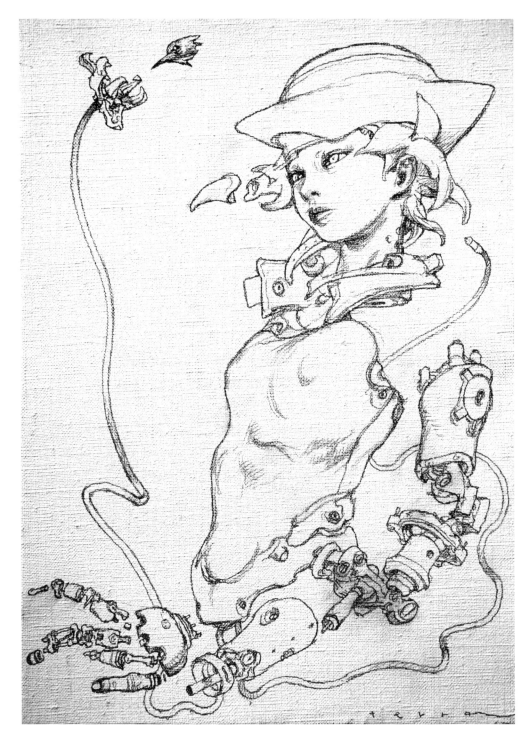

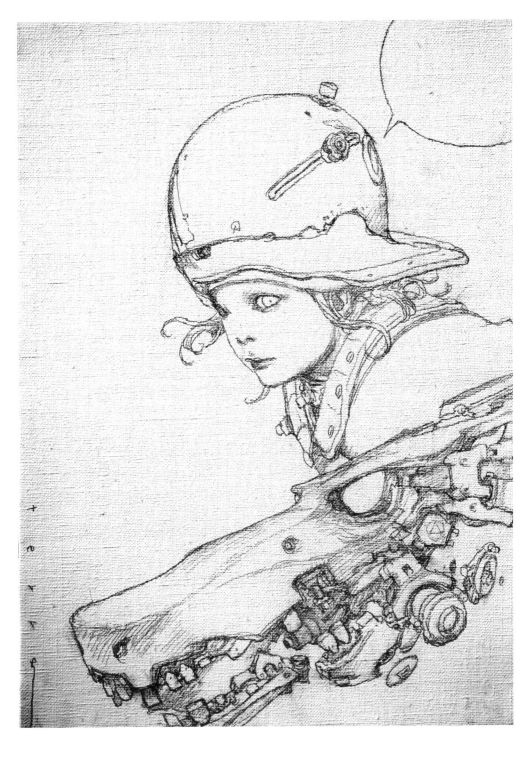

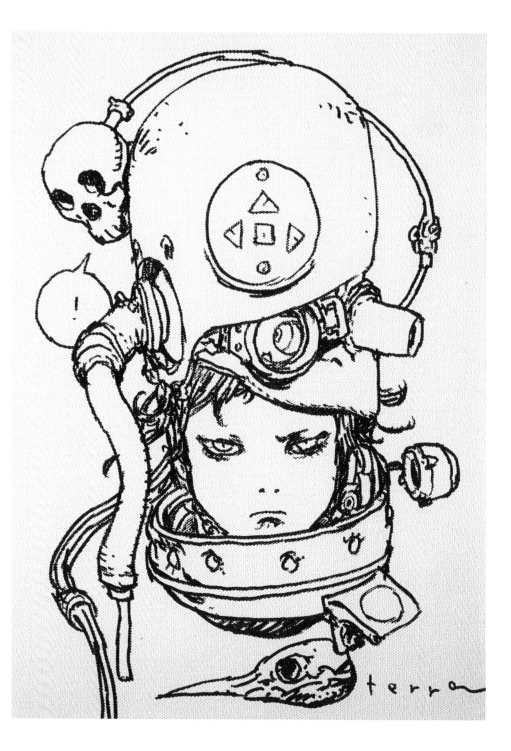

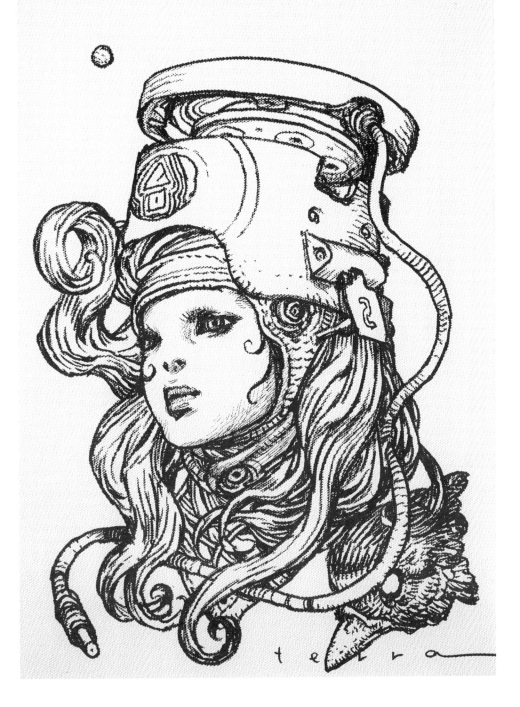

terra

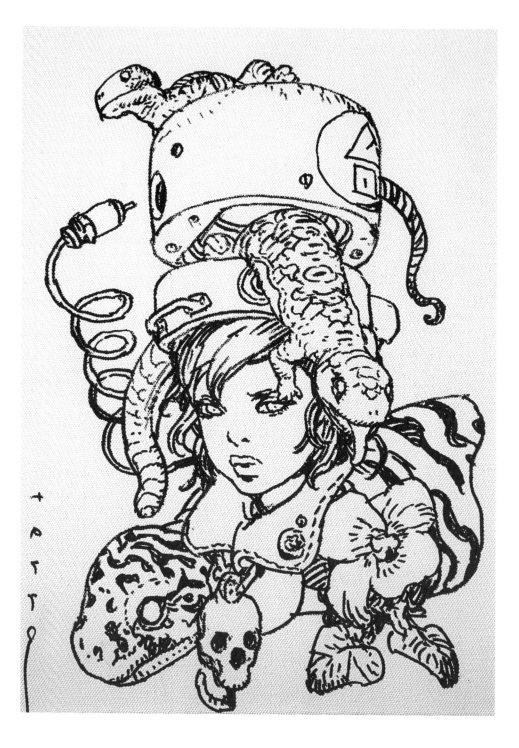

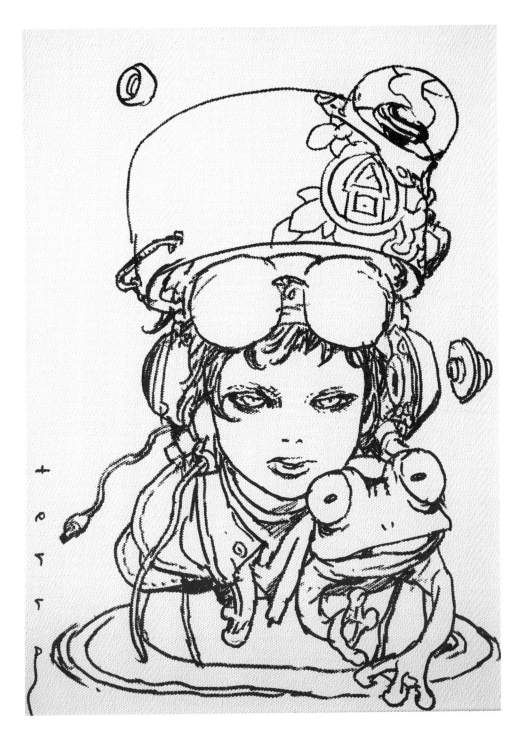

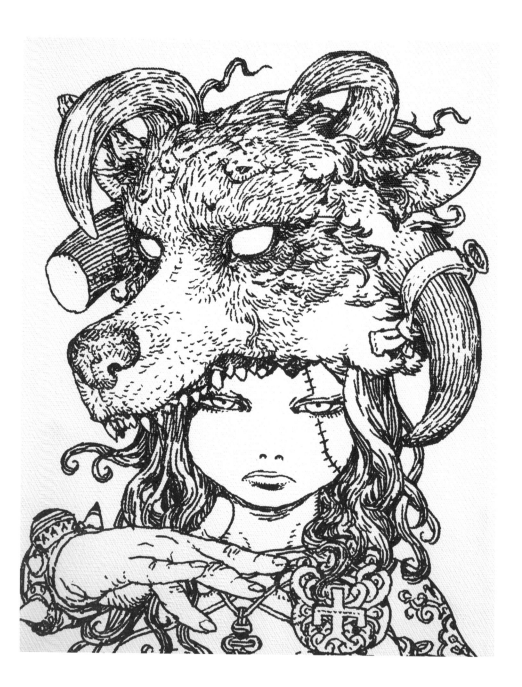

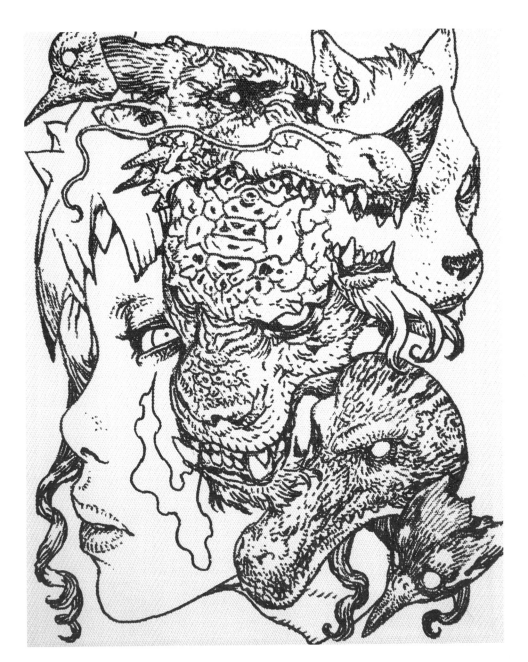

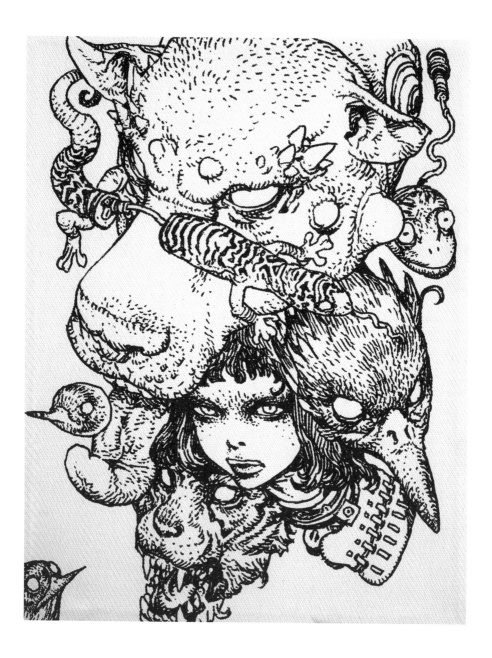

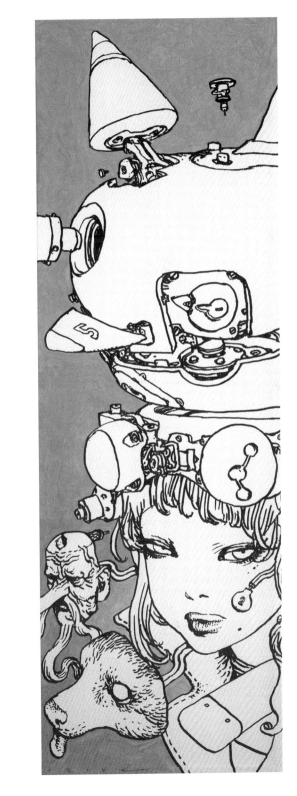

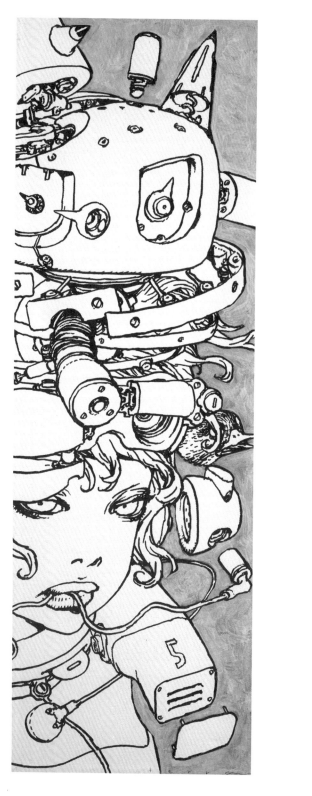

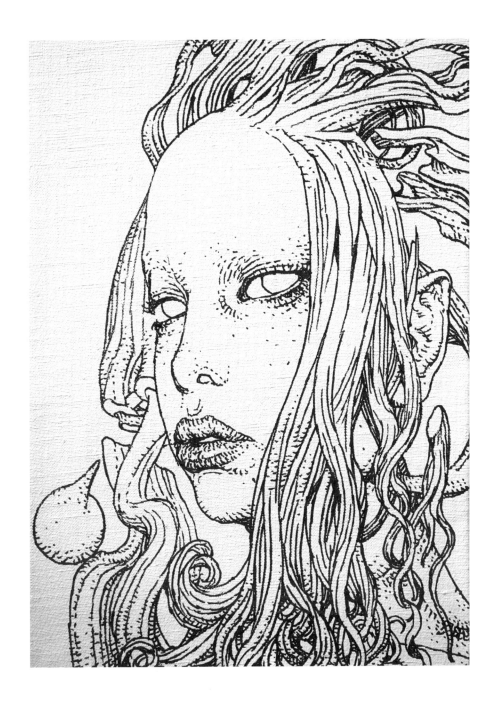

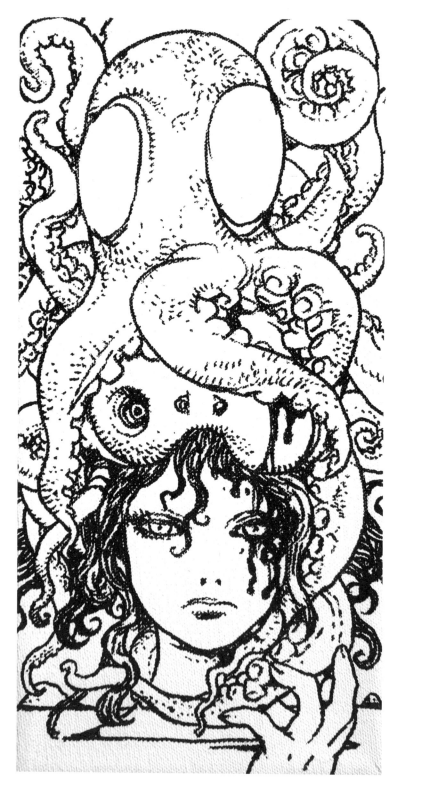

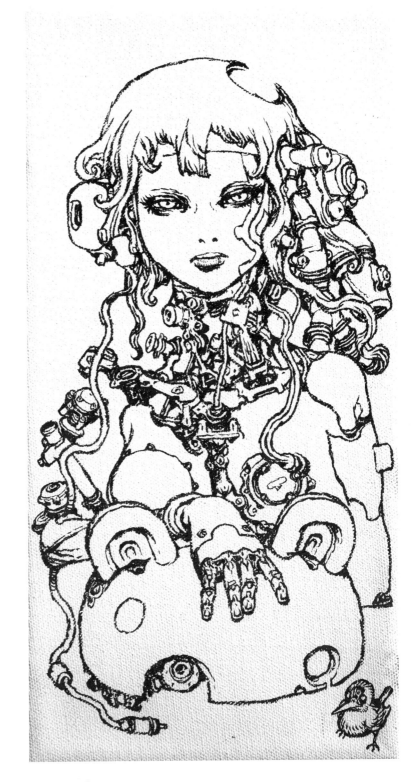

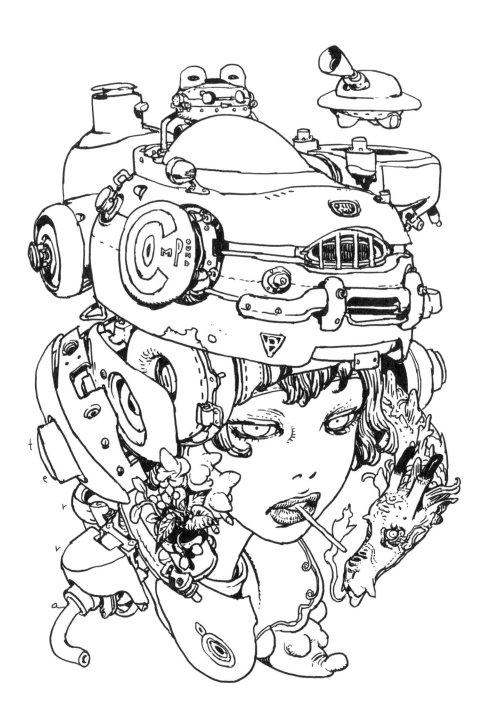

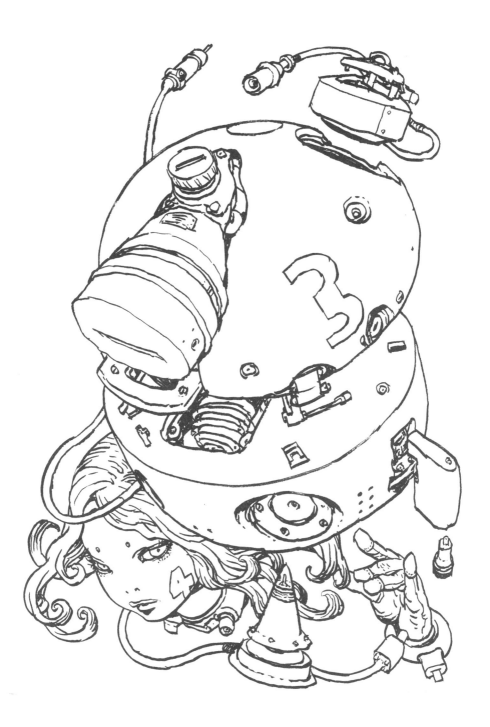

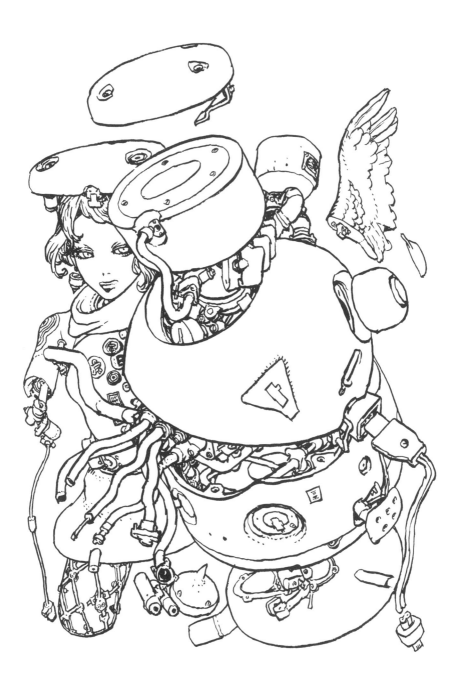

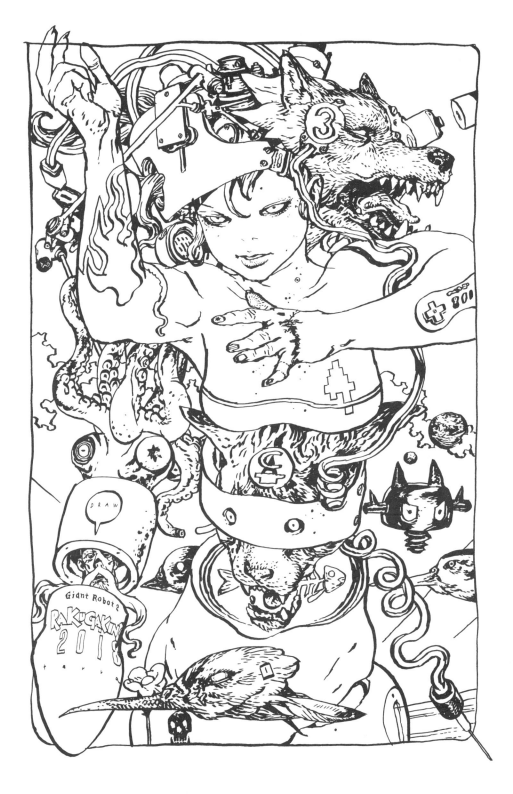

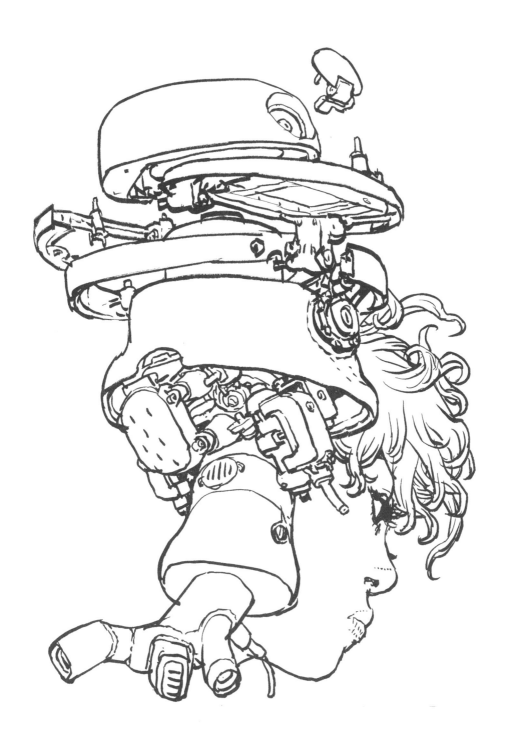

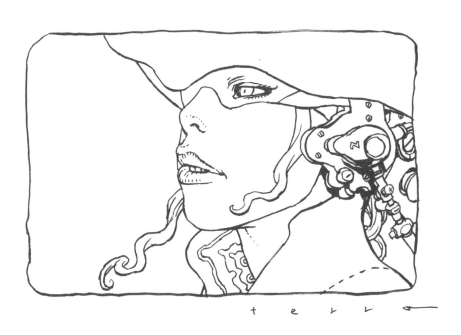

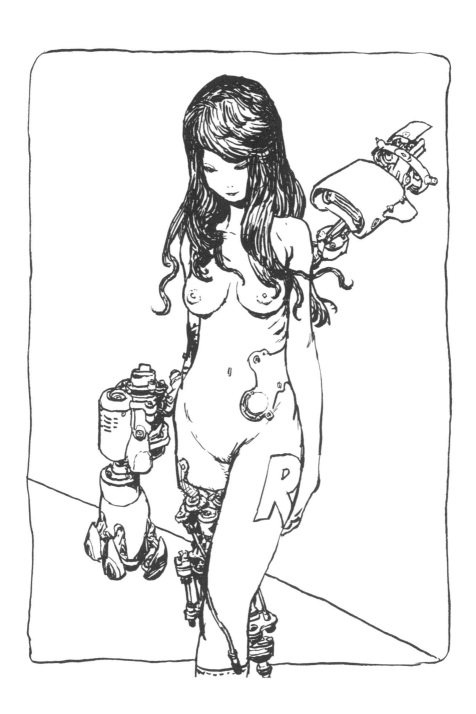

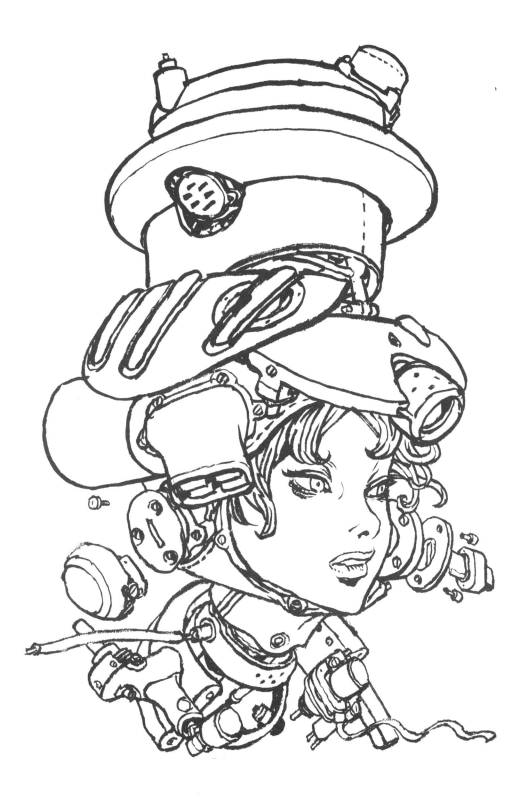

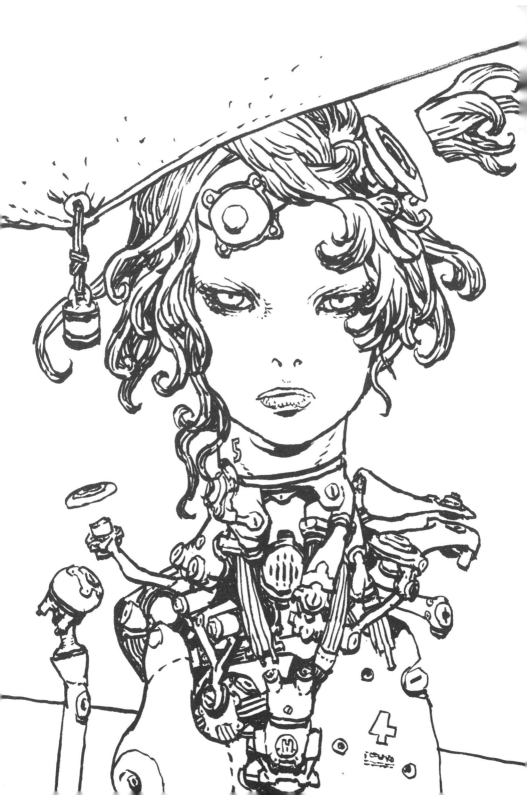

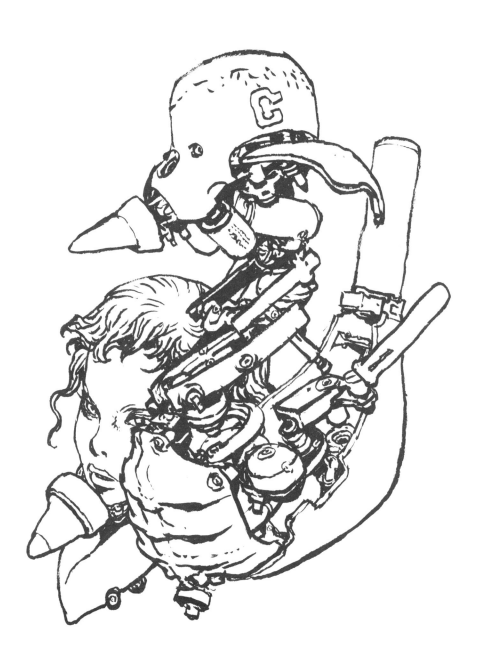

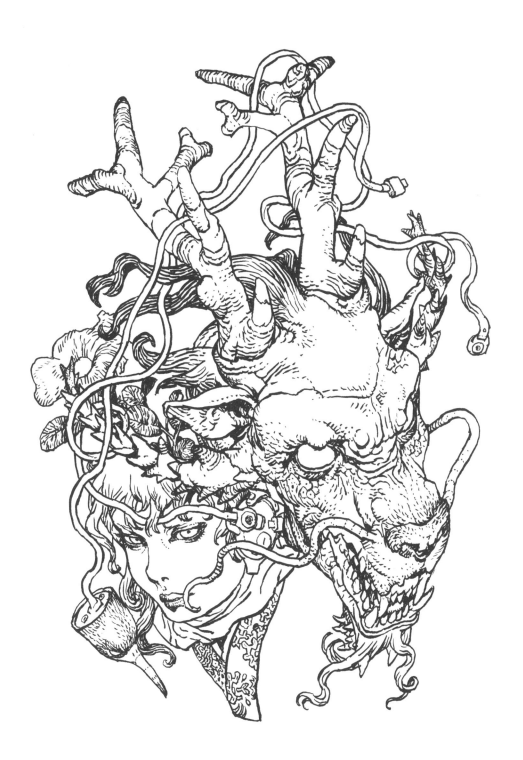

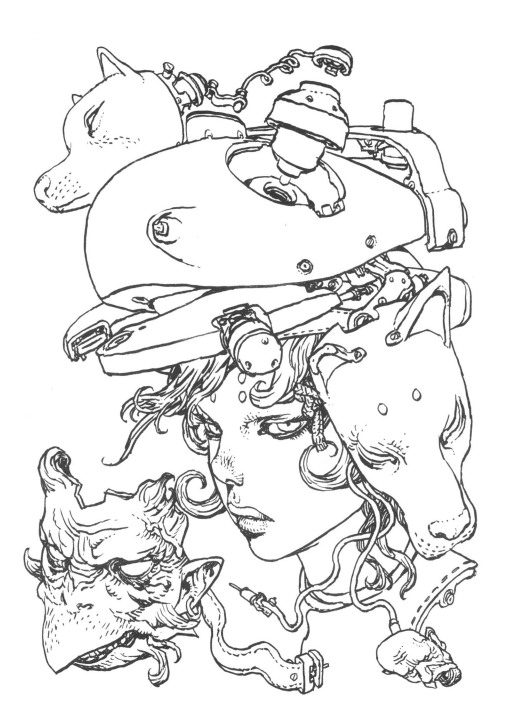

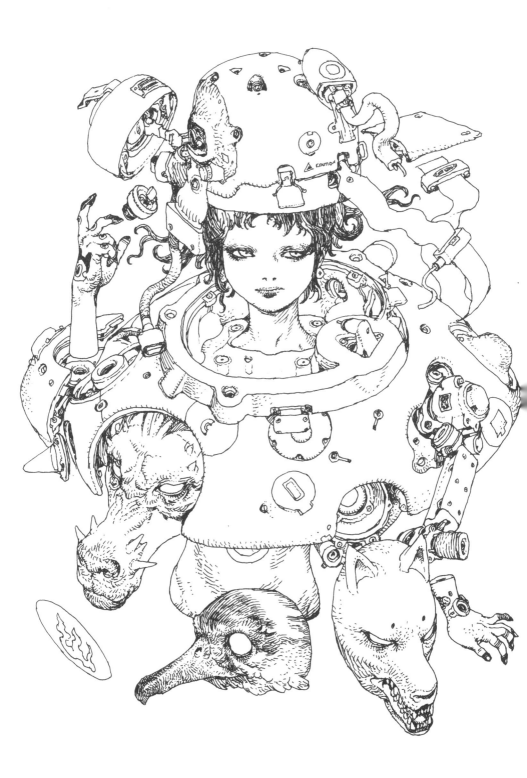

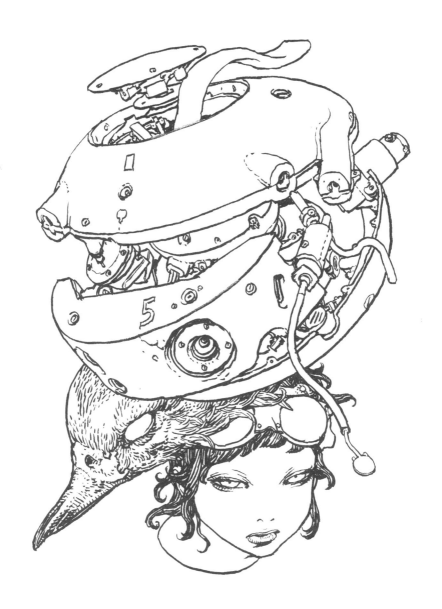

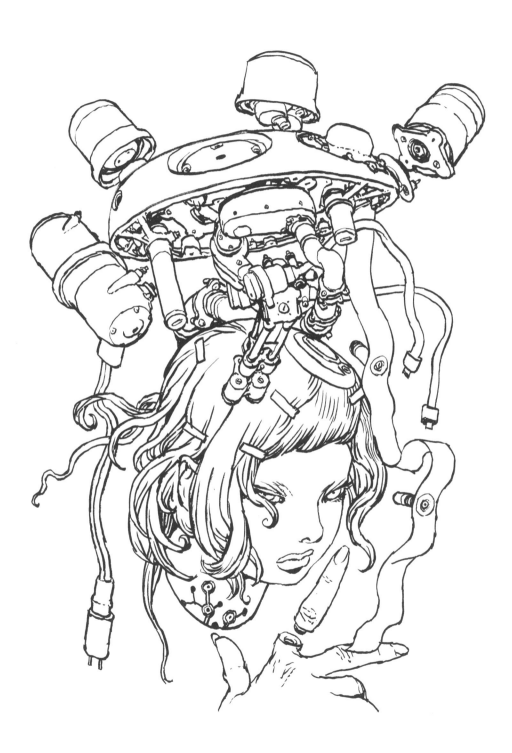

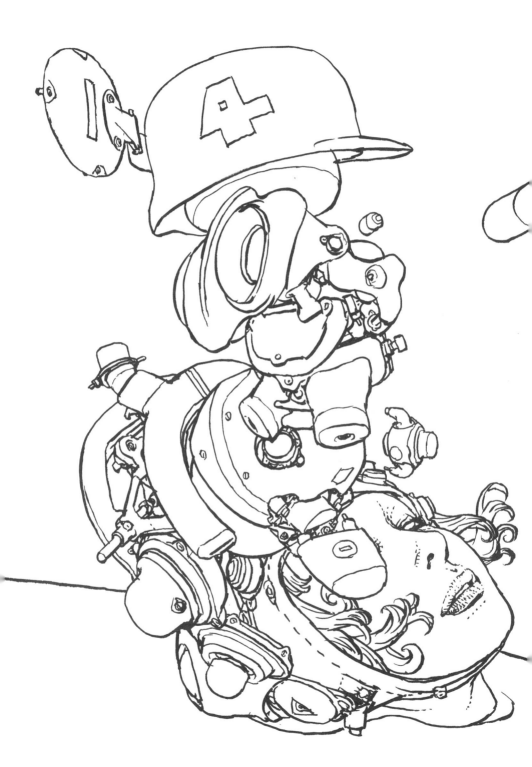

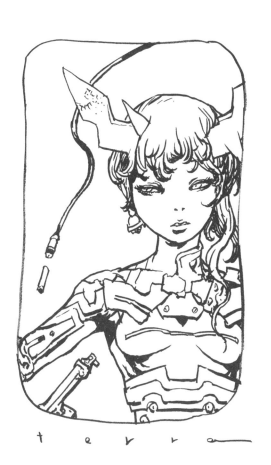

terra

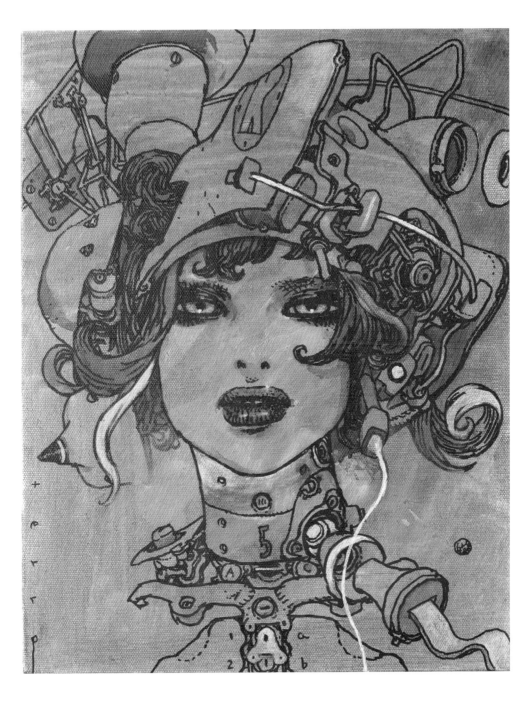

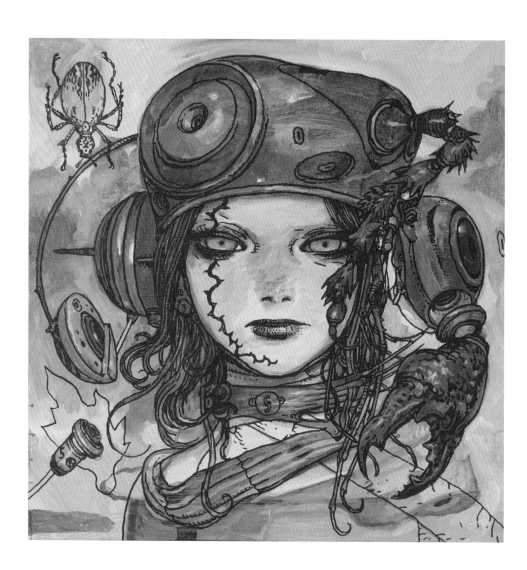

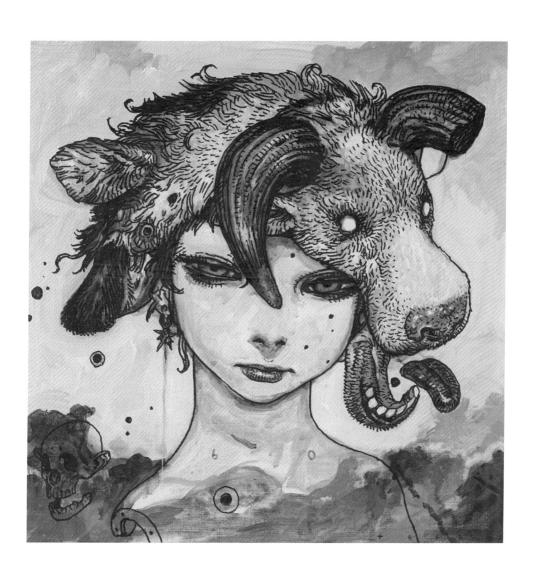

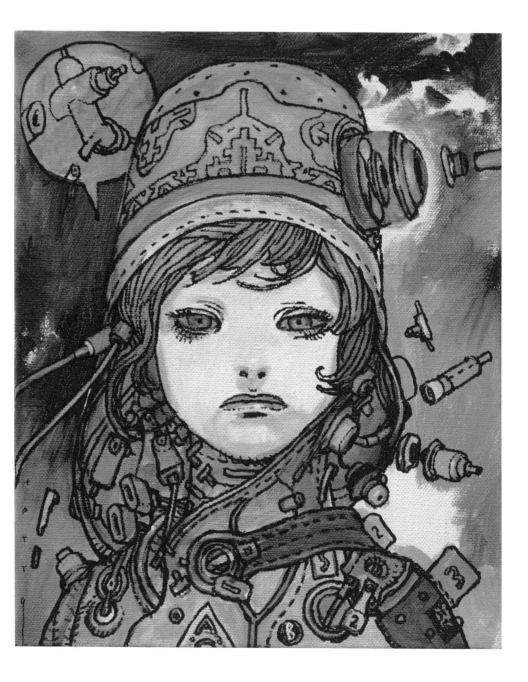

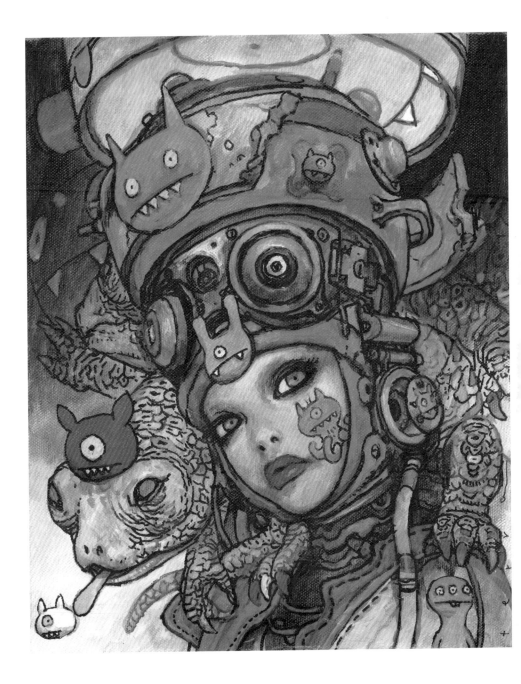

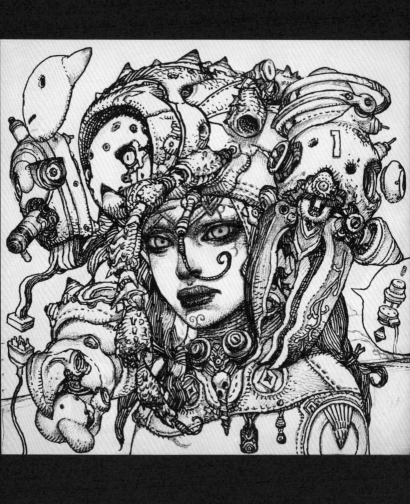

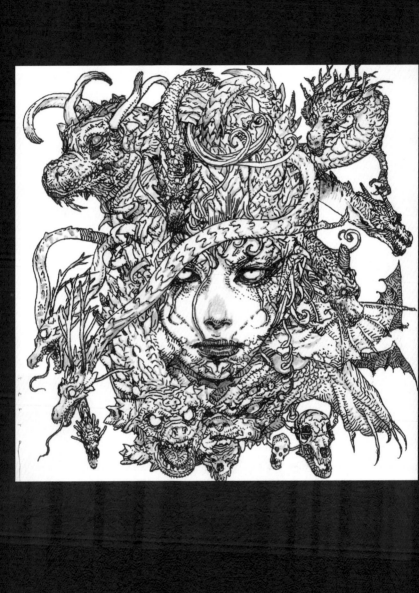

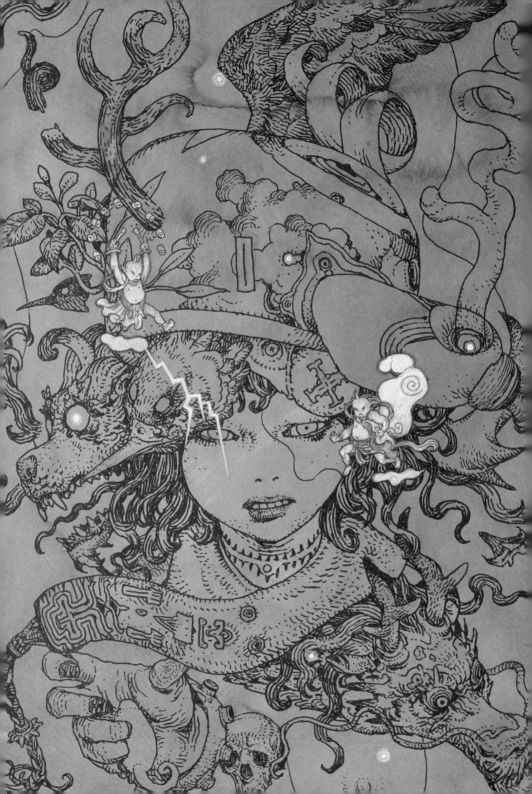

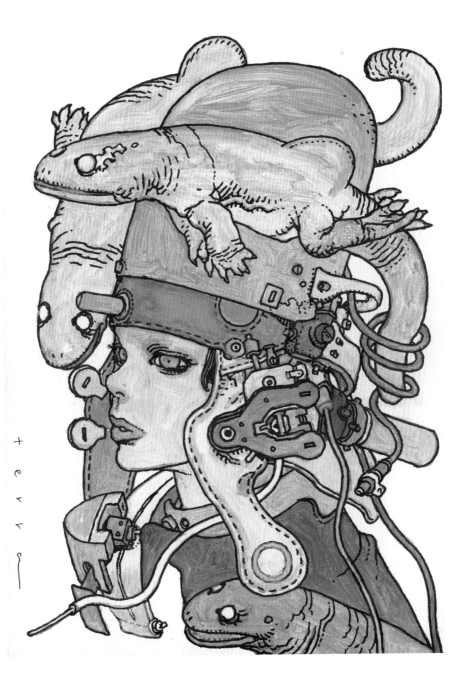

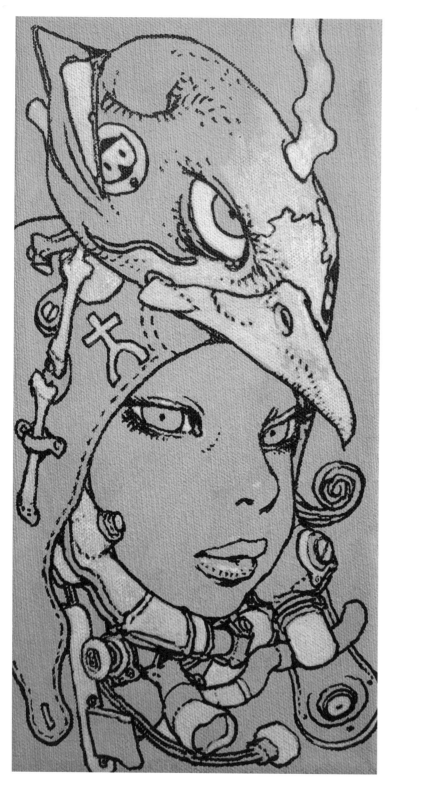

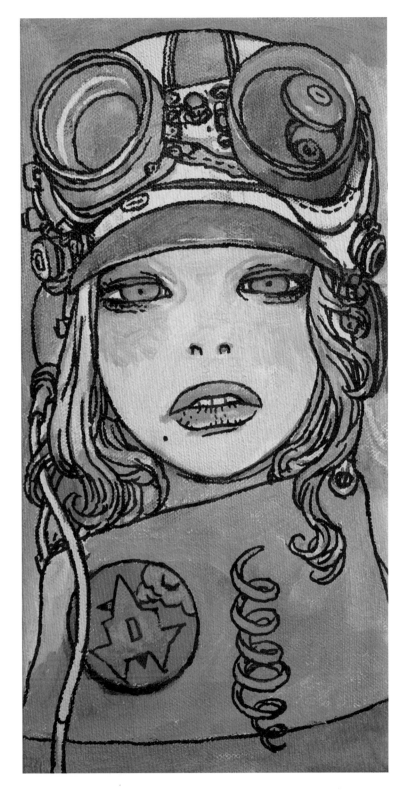

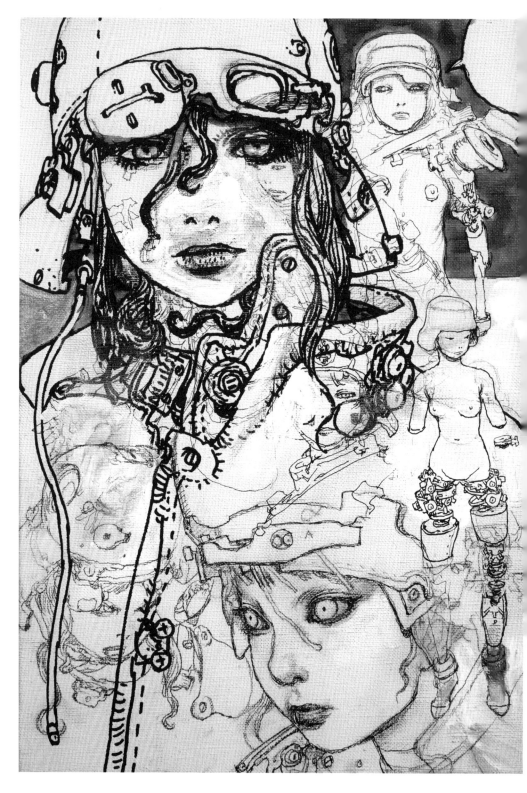

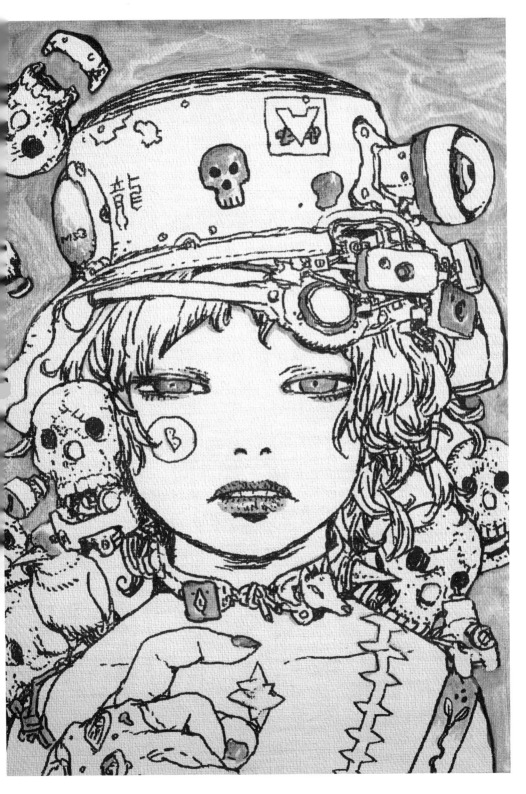

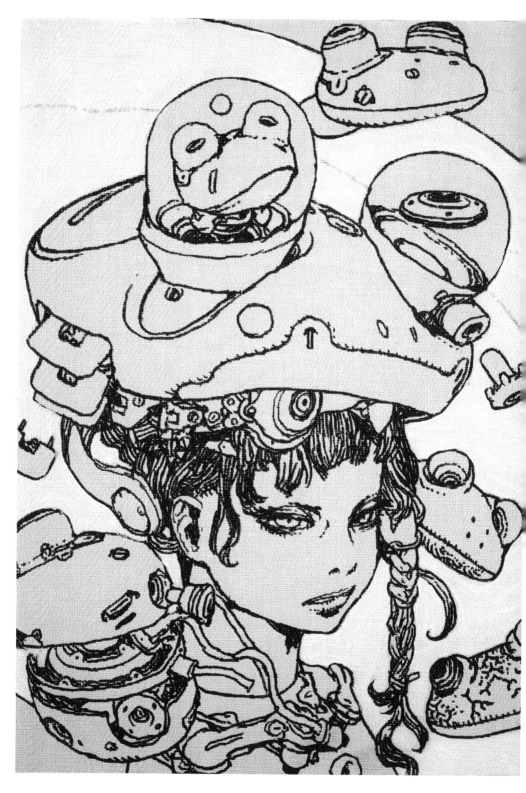

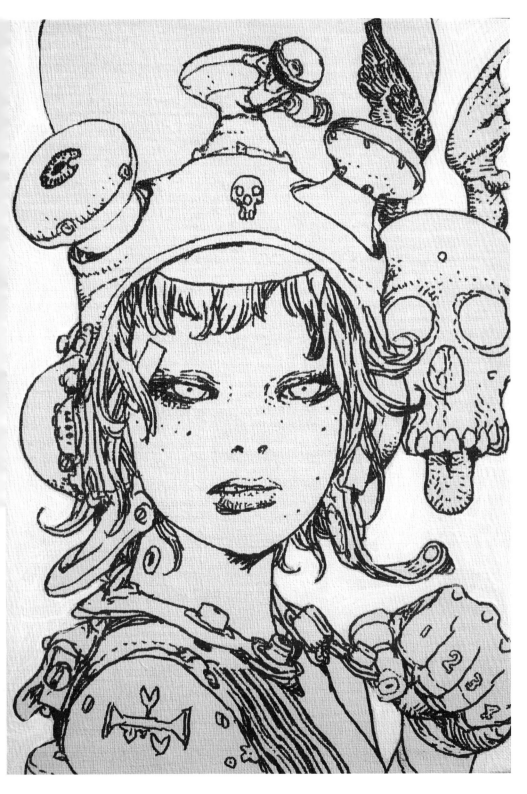

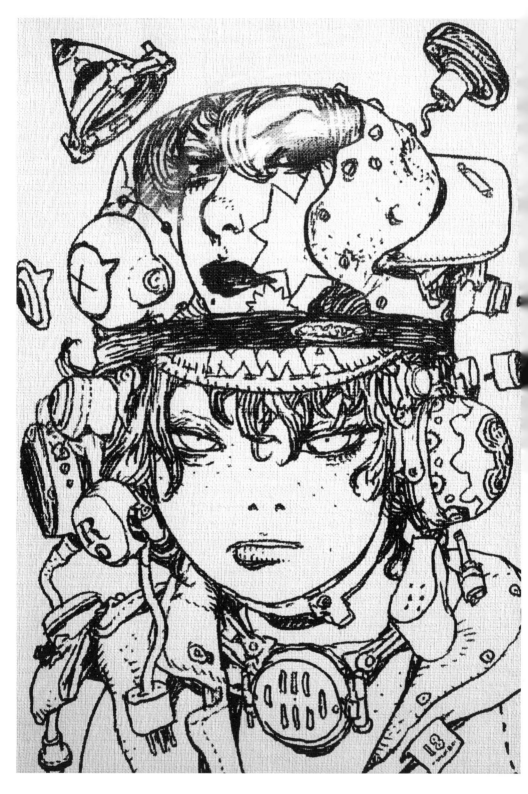

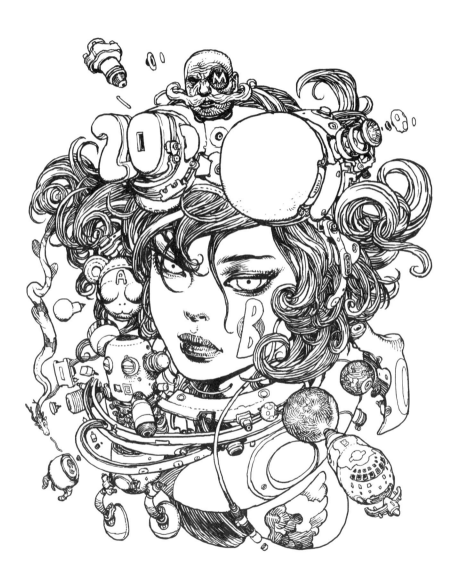

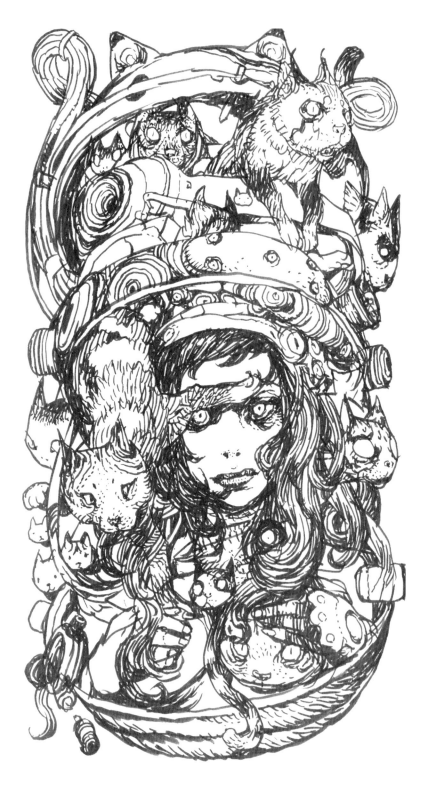

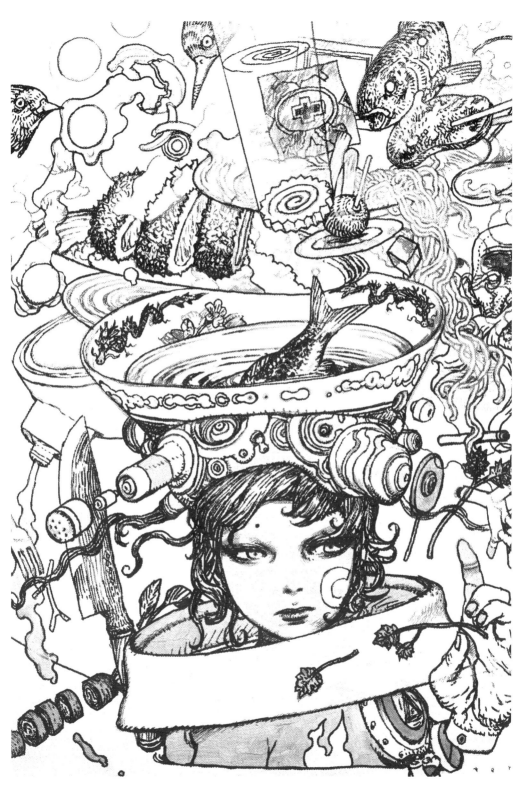

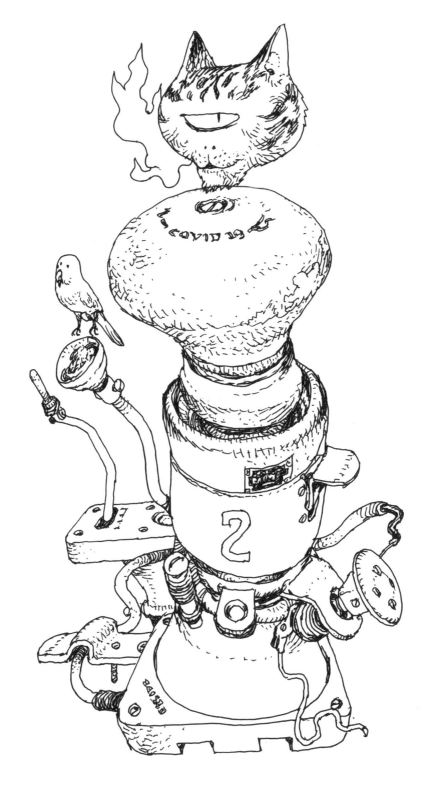

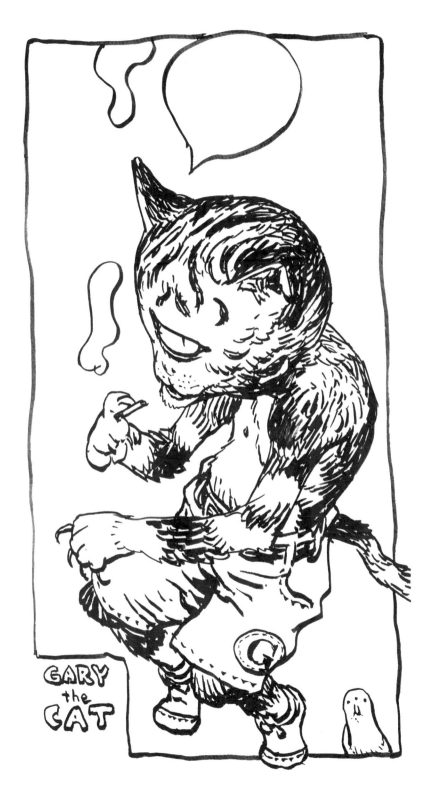

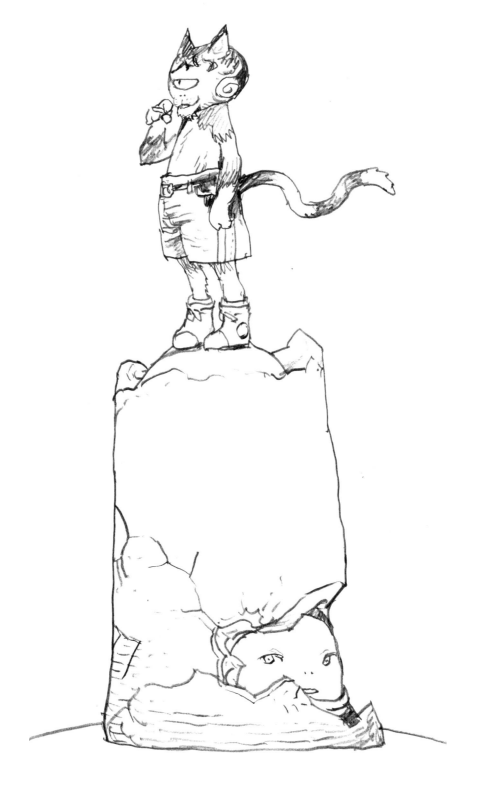

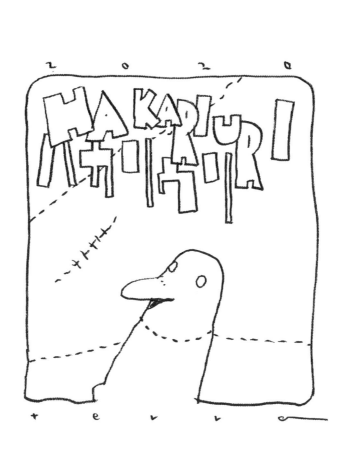

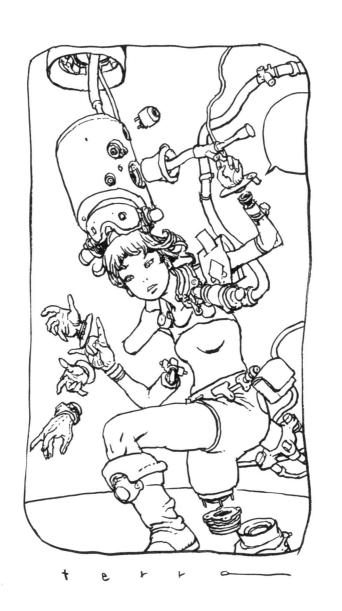

terra

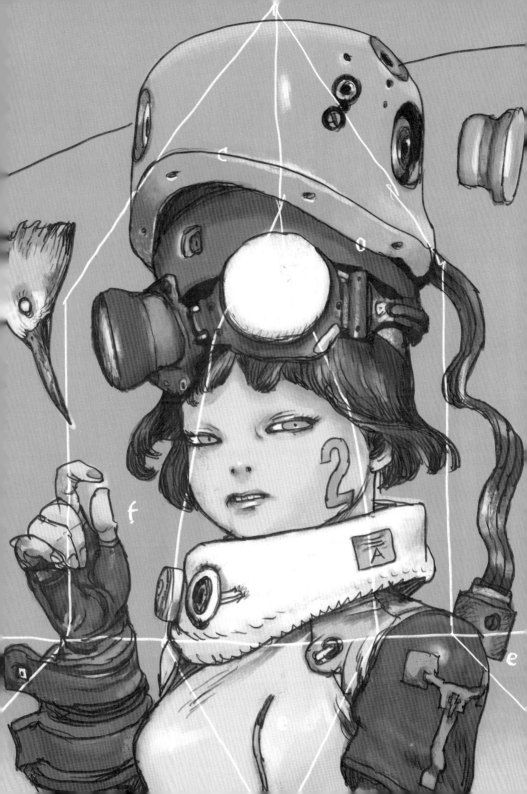

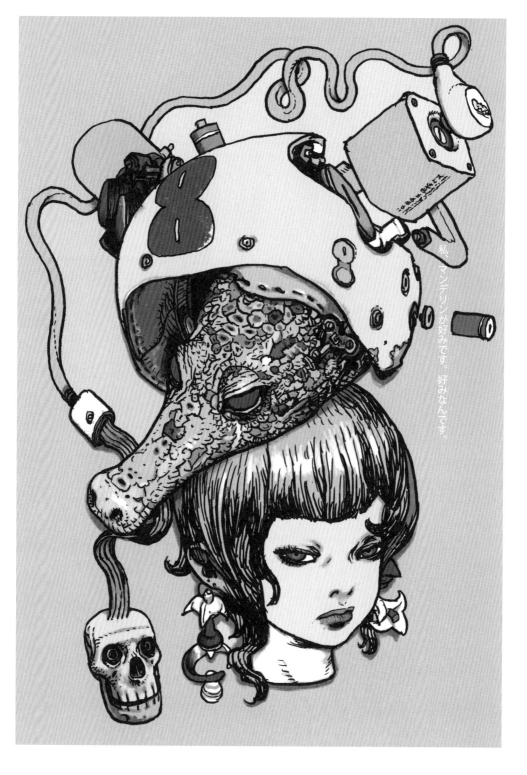

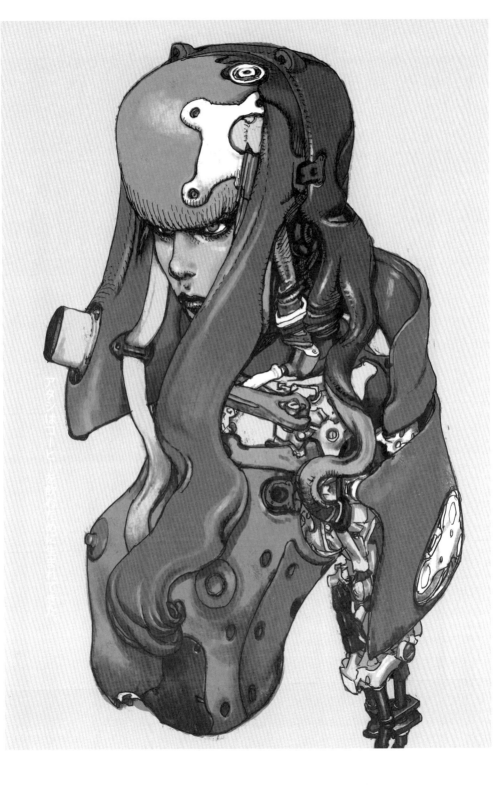

アタシはコーヒーを飲むためにうまれてきた。

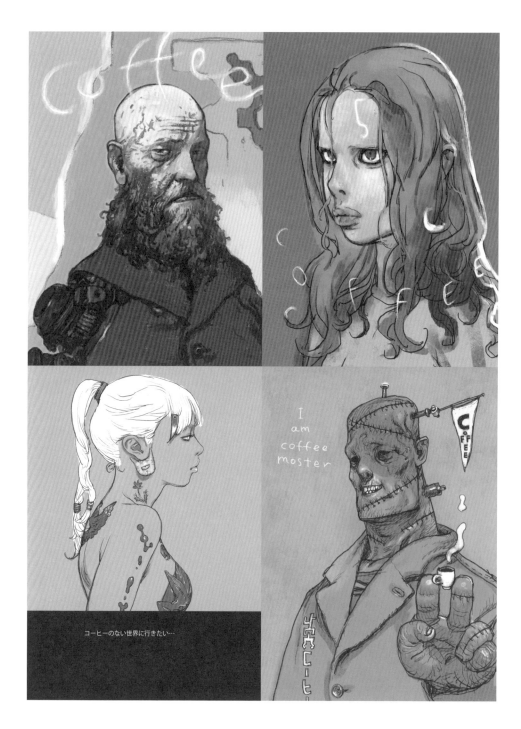

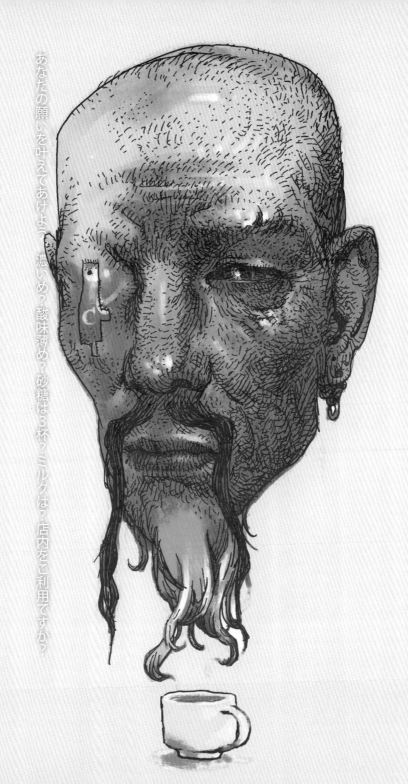

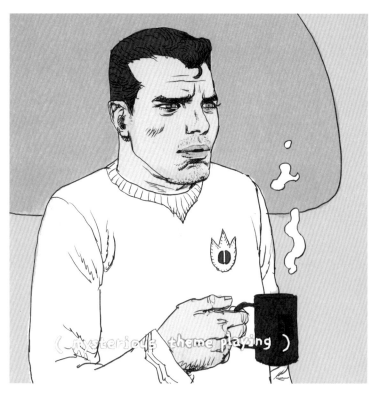

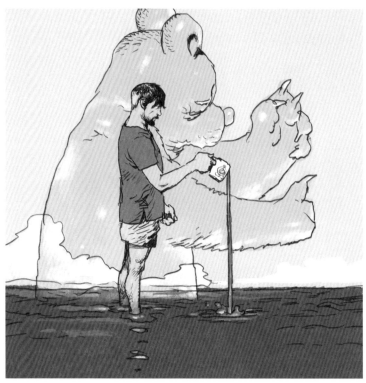

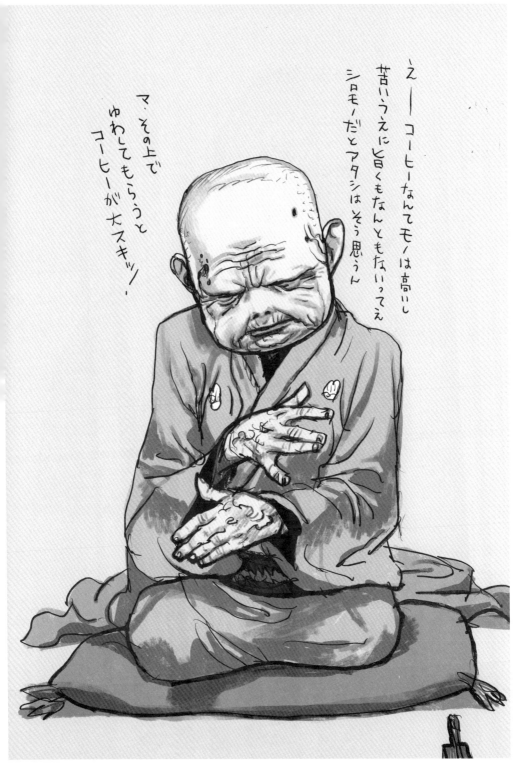

We
need

"sexy"
and
"fun"
right?

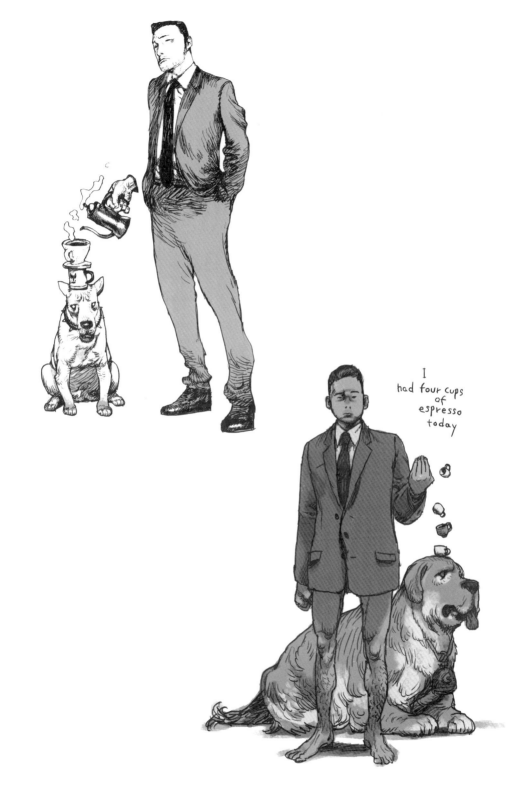

I had four cups of espresso today

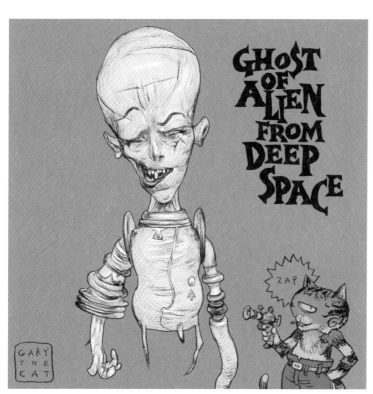

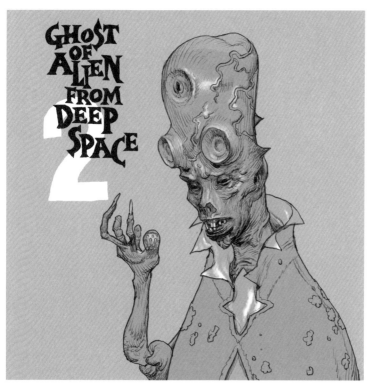

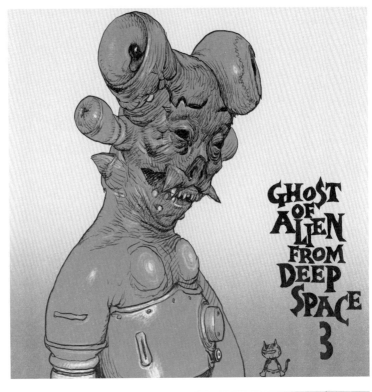

GHOST
OF
ALIEN
FROM
DEEP
SPACE
3

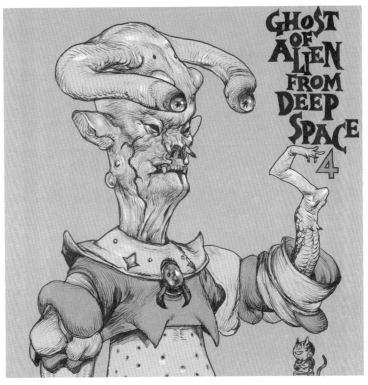

GHOST
OF
ALIEN
FROM
DEEP
SPACE
4

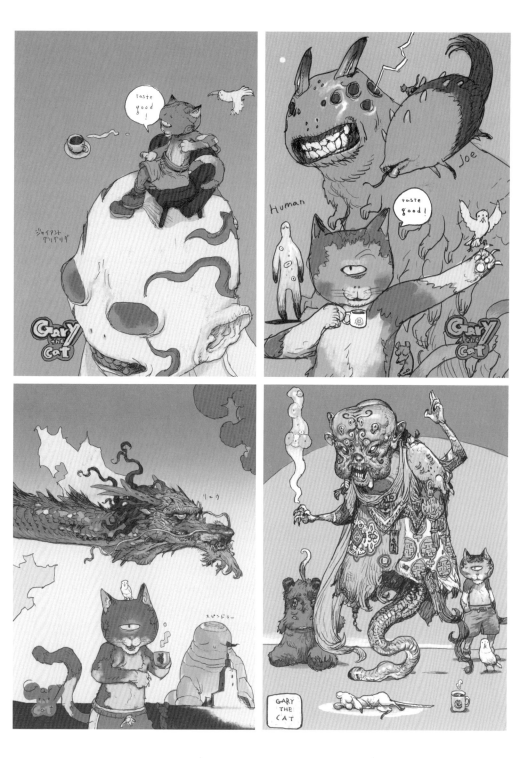

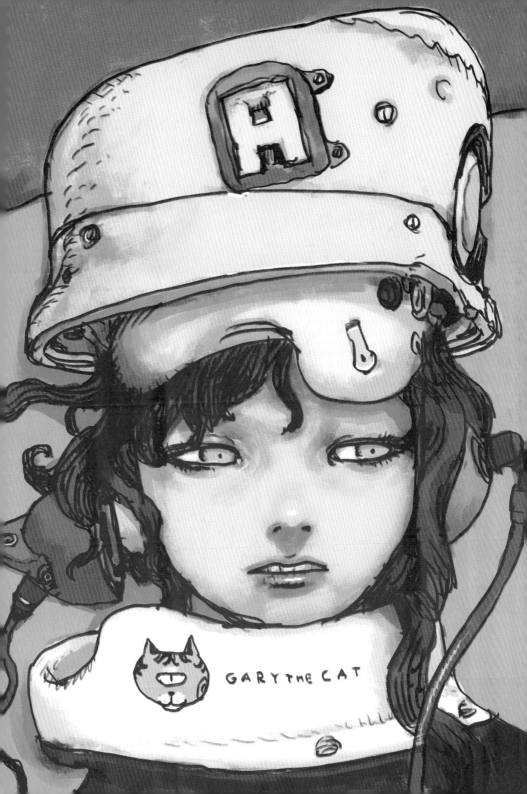

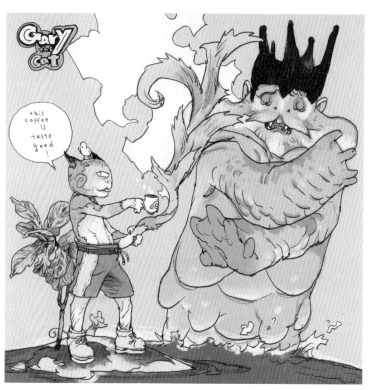

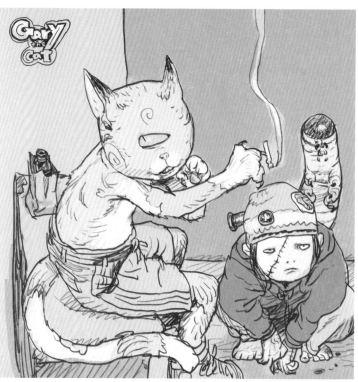

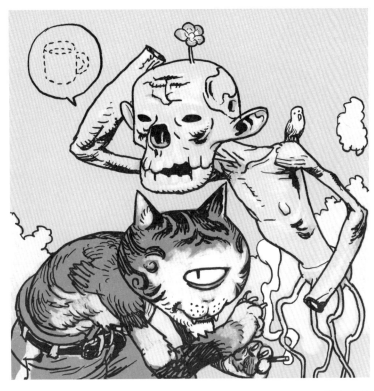

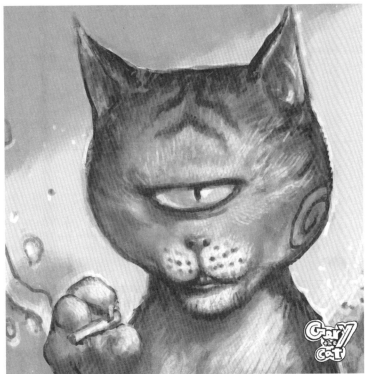

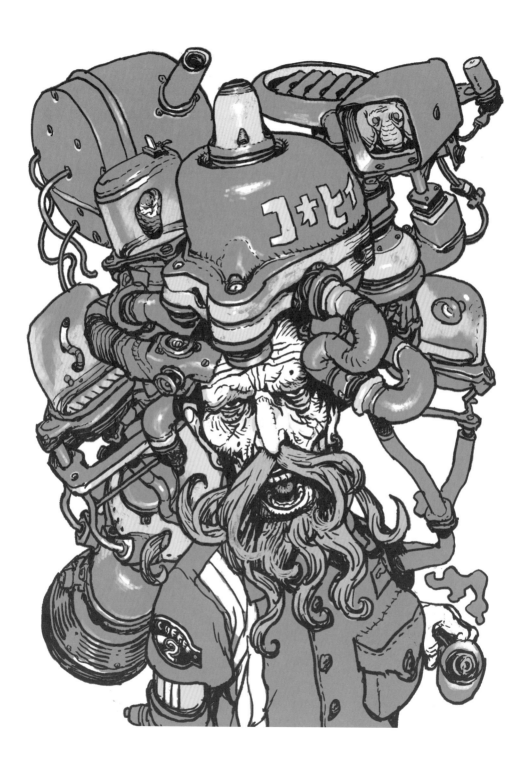

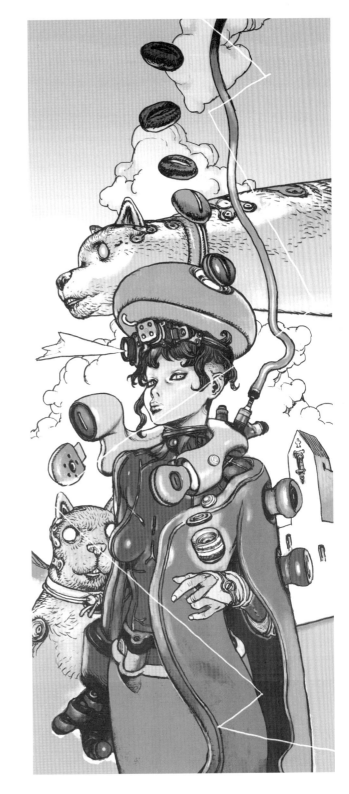

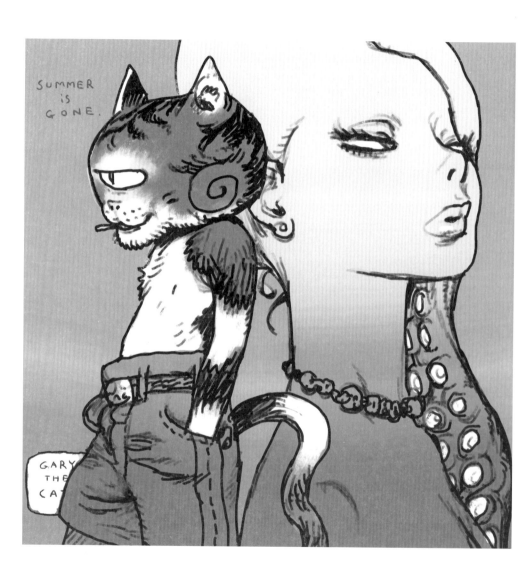

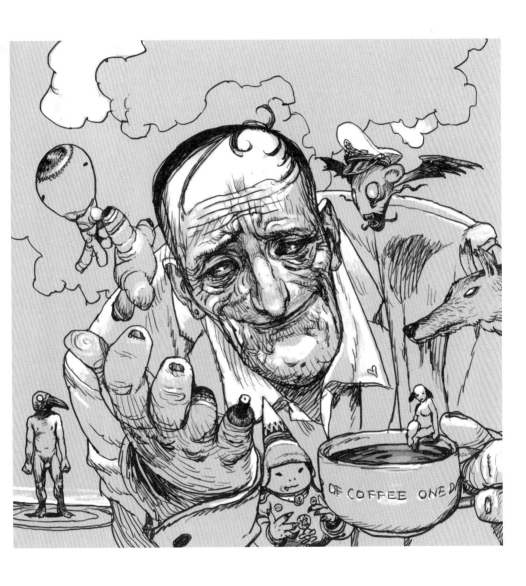

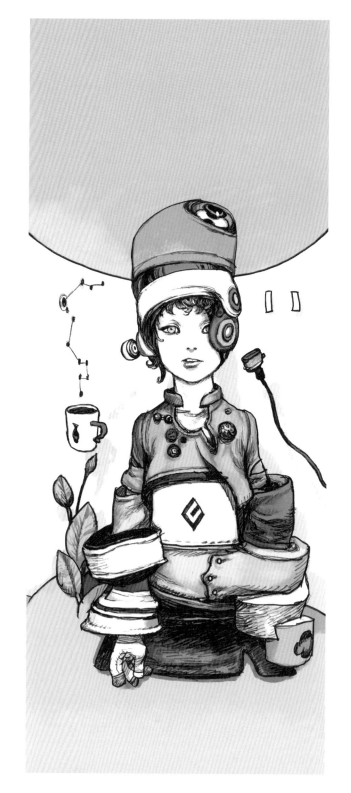

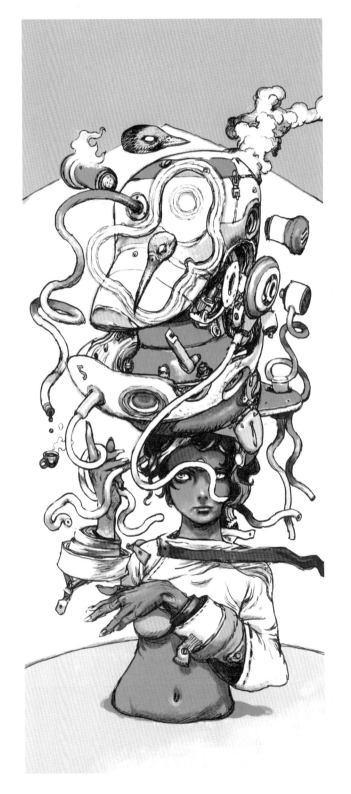

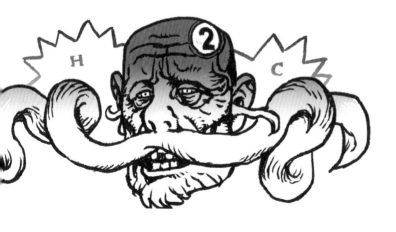

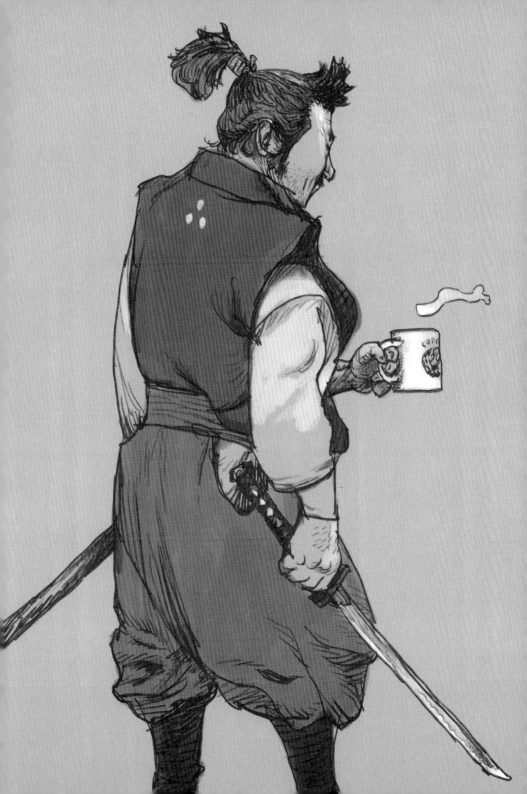

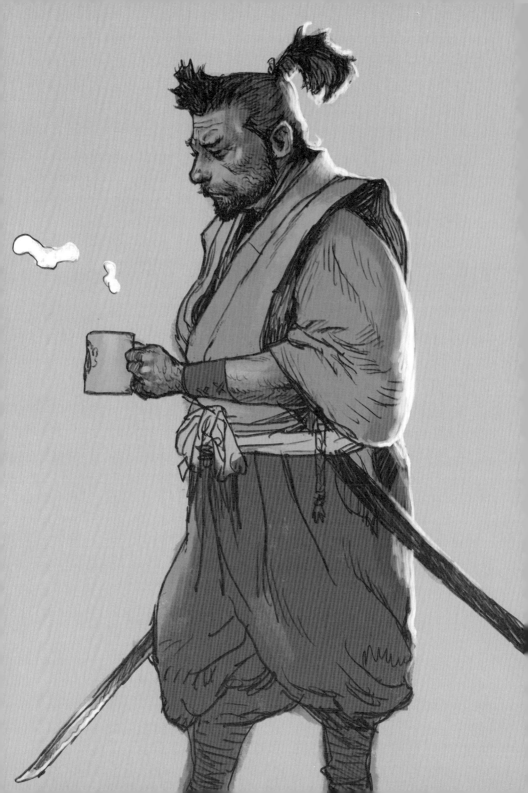

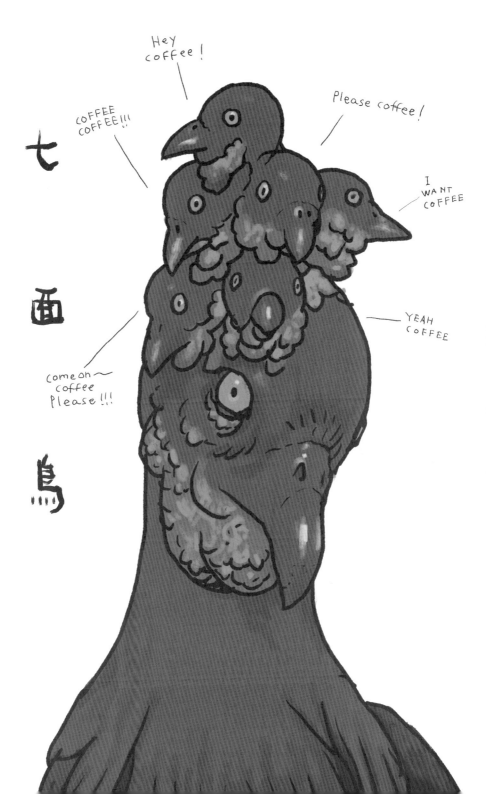

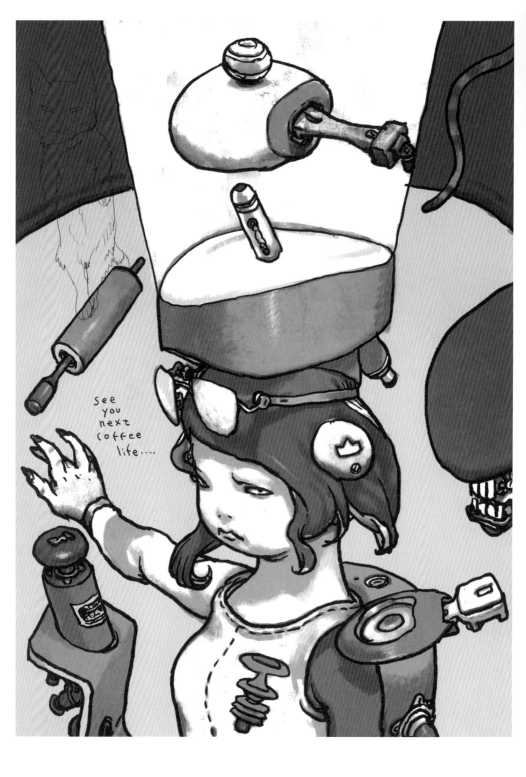

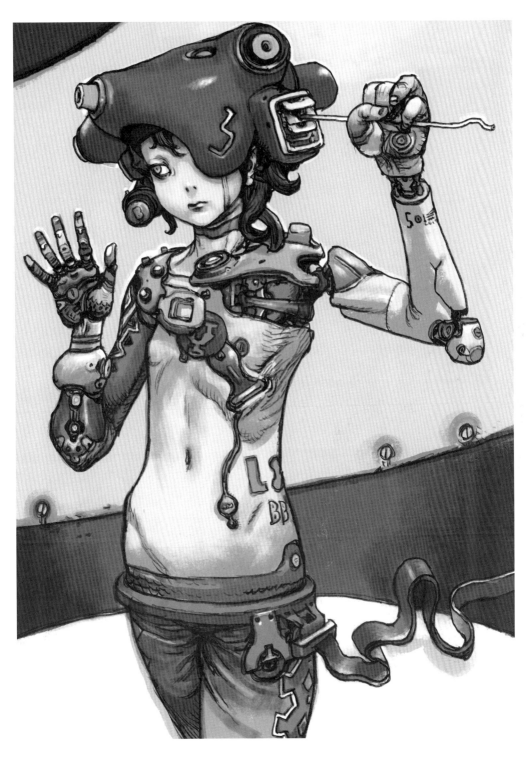

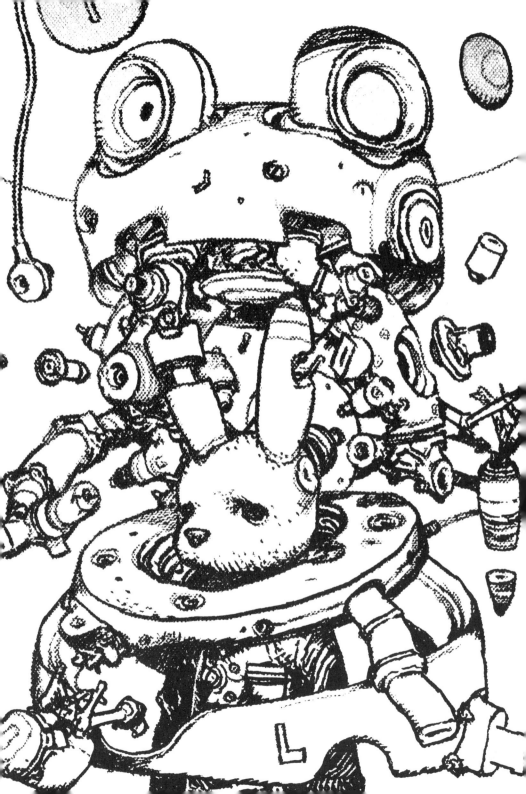

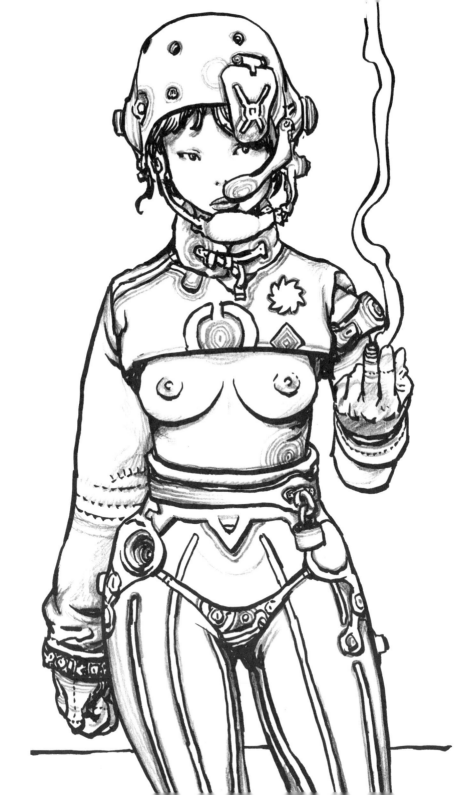

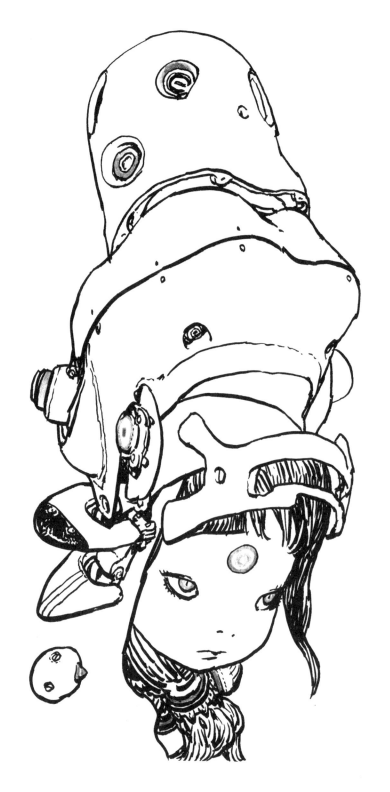

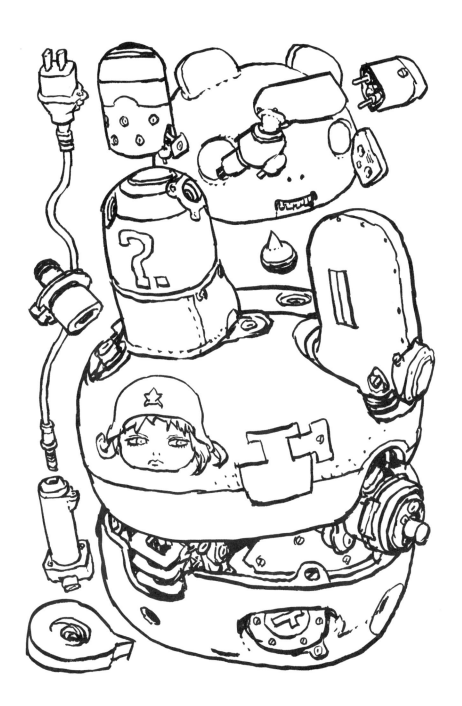

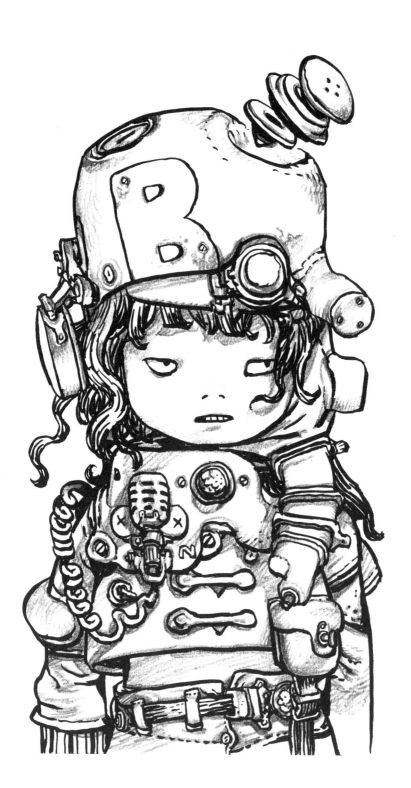

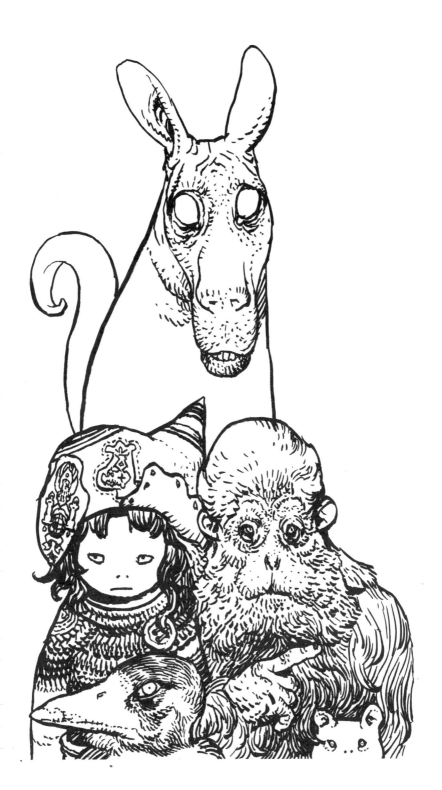

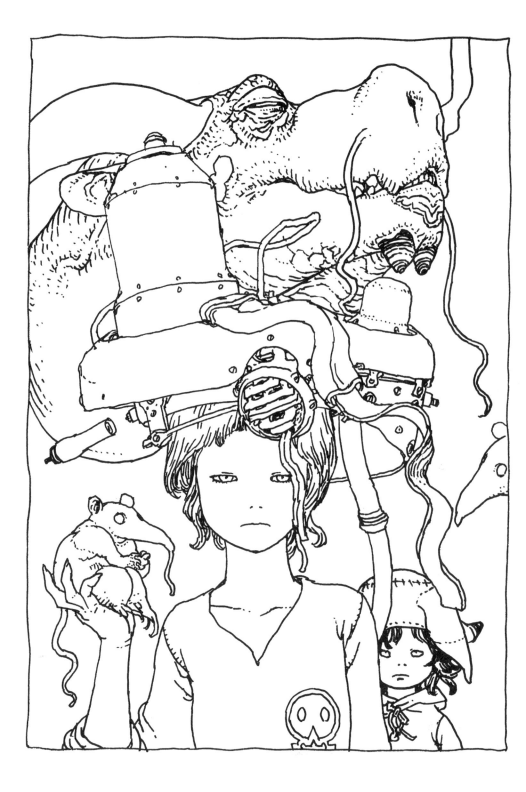

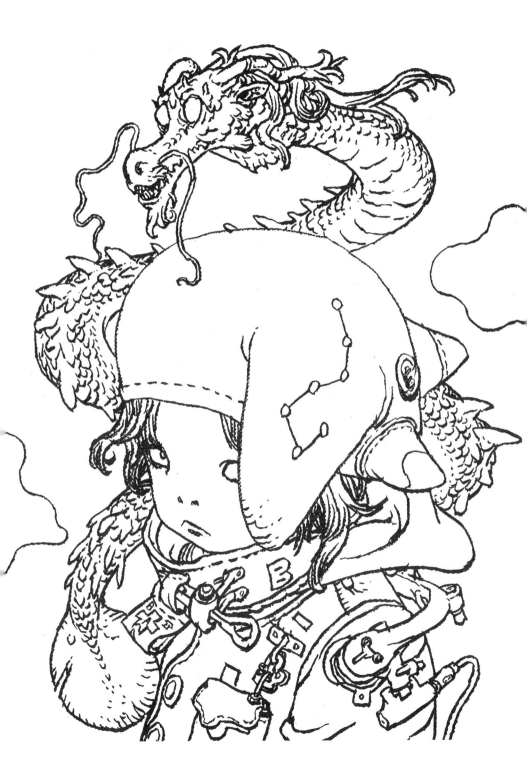

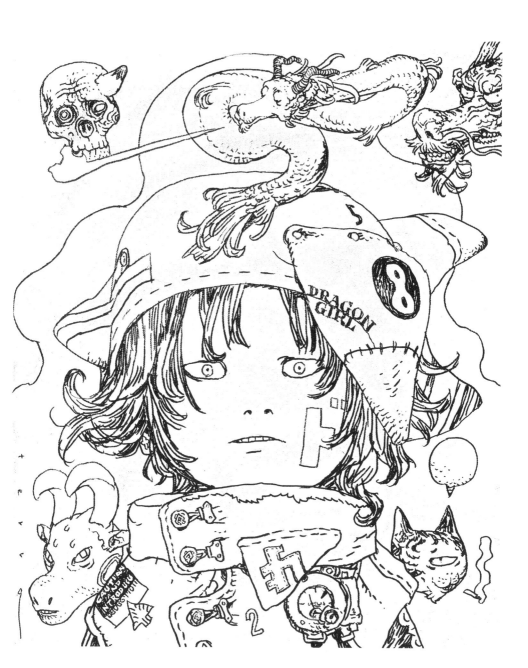

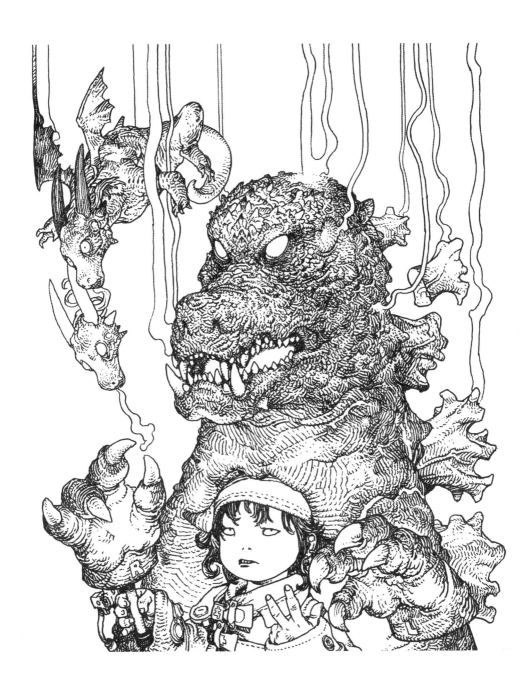

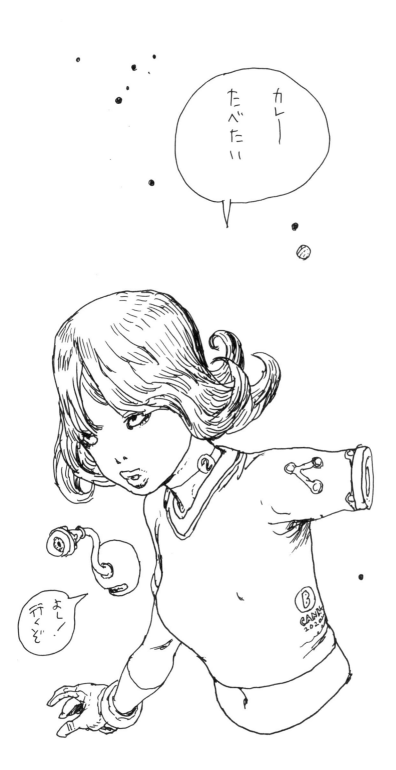

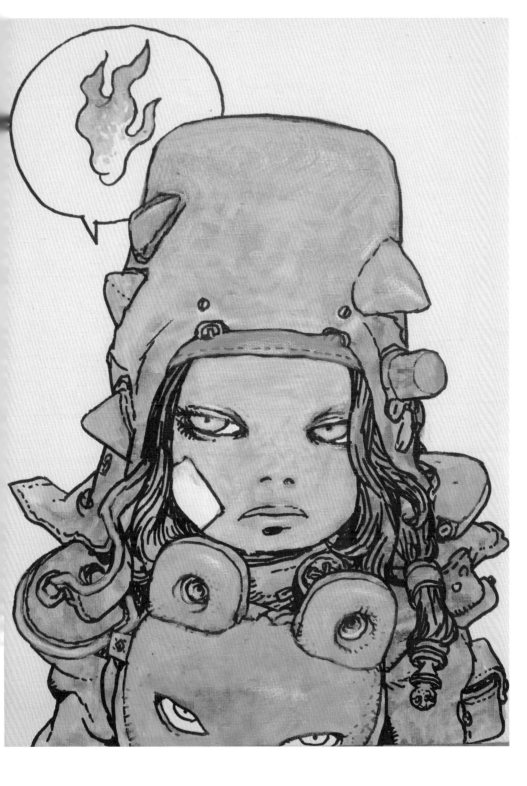

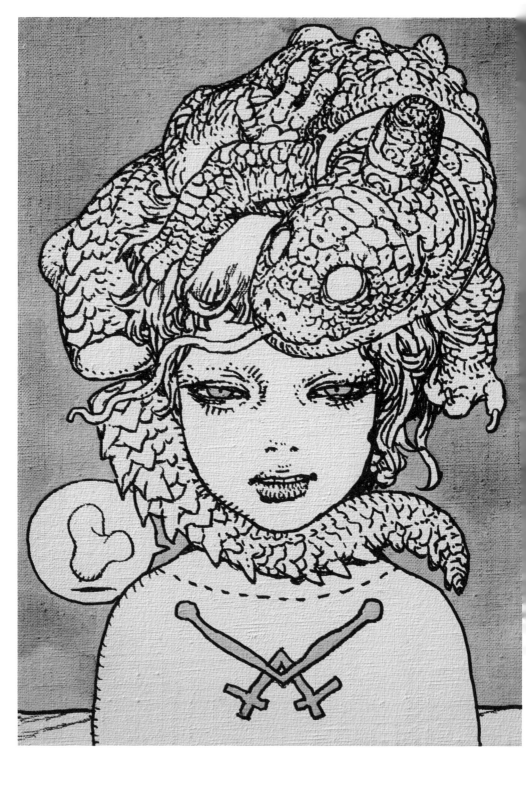

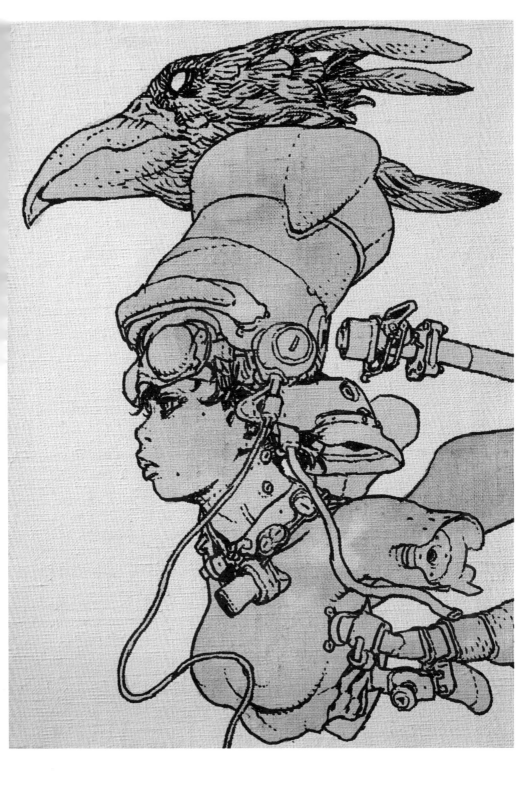

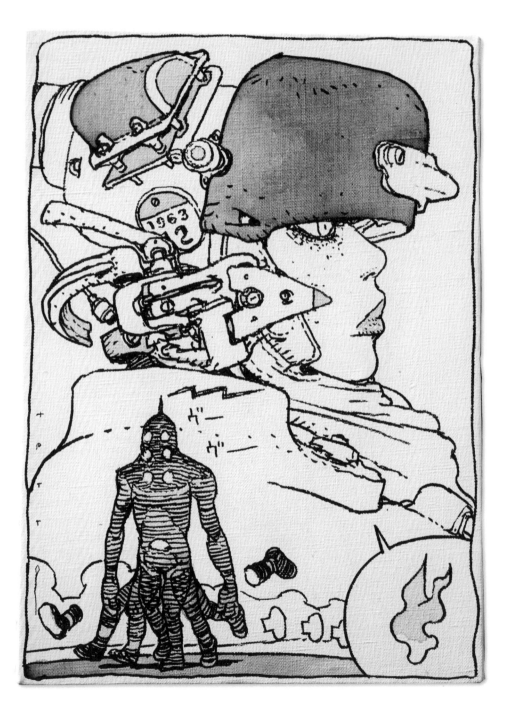

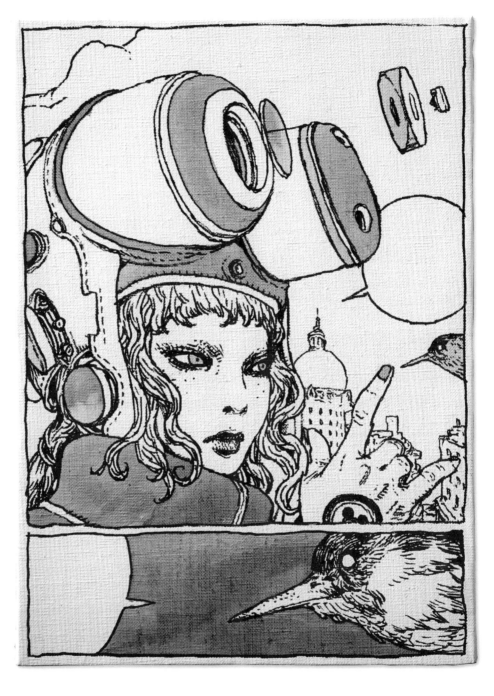

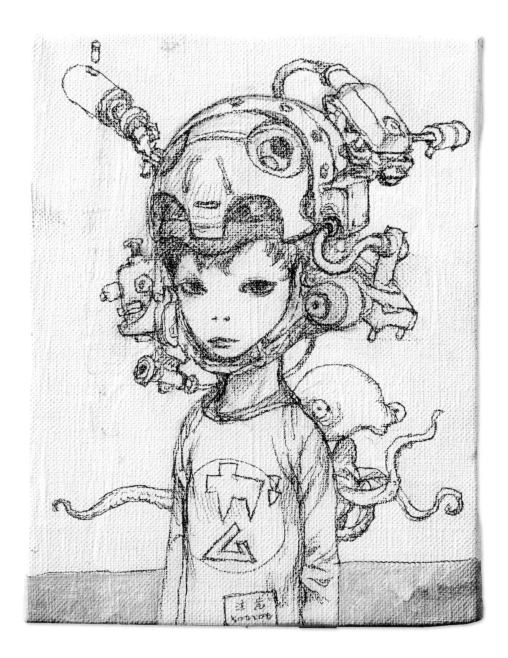

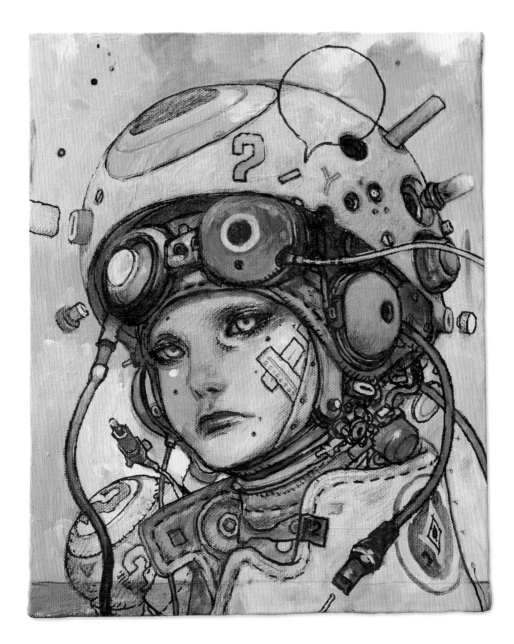

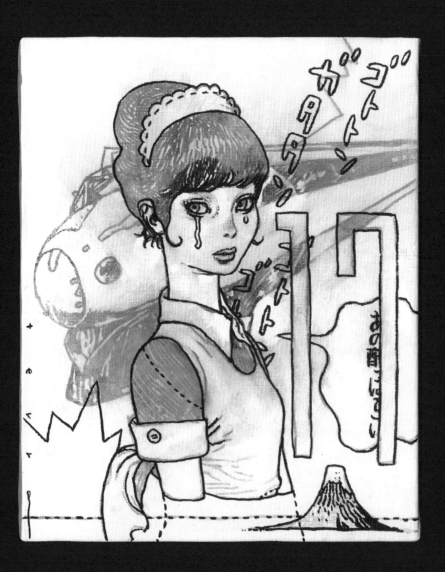

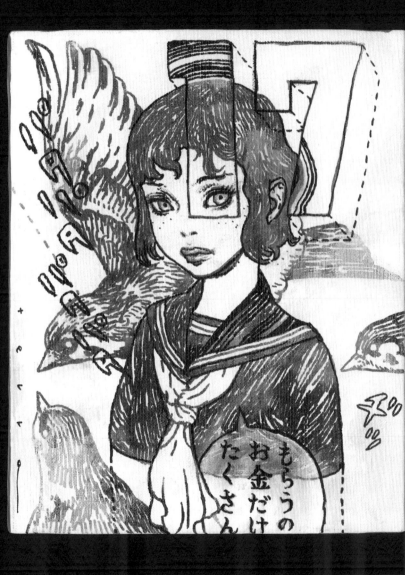

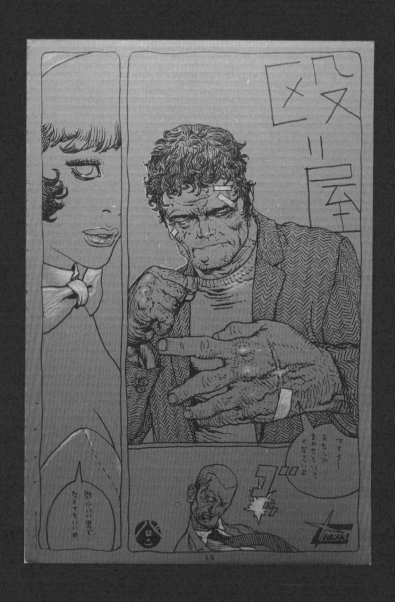

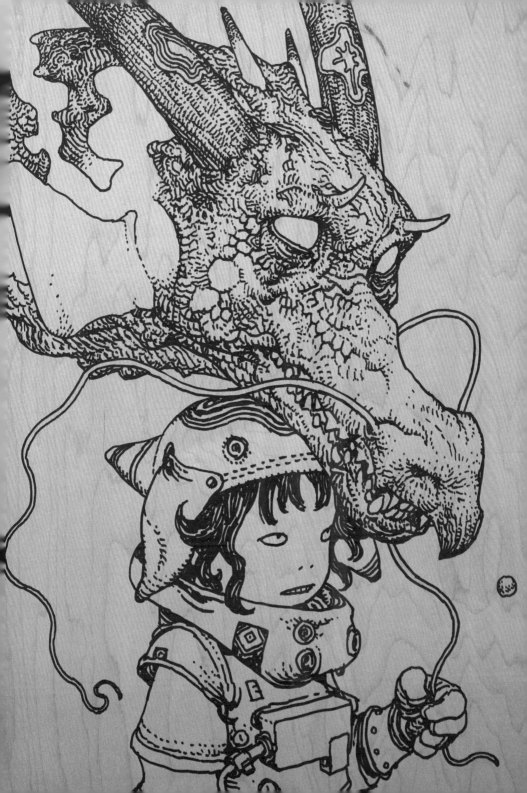

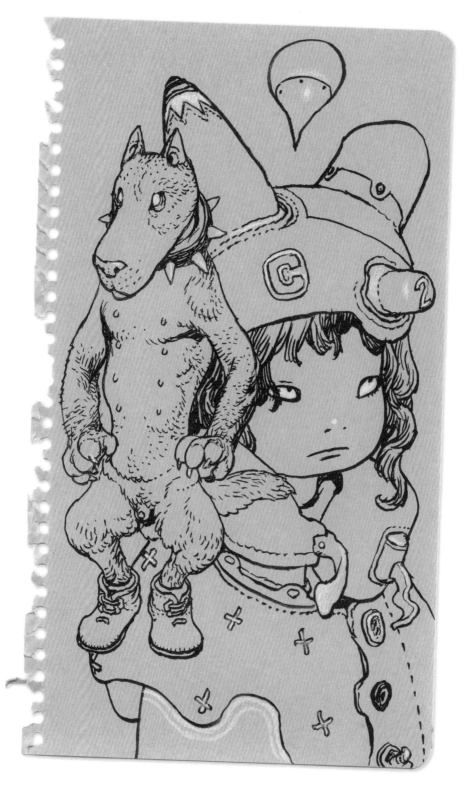

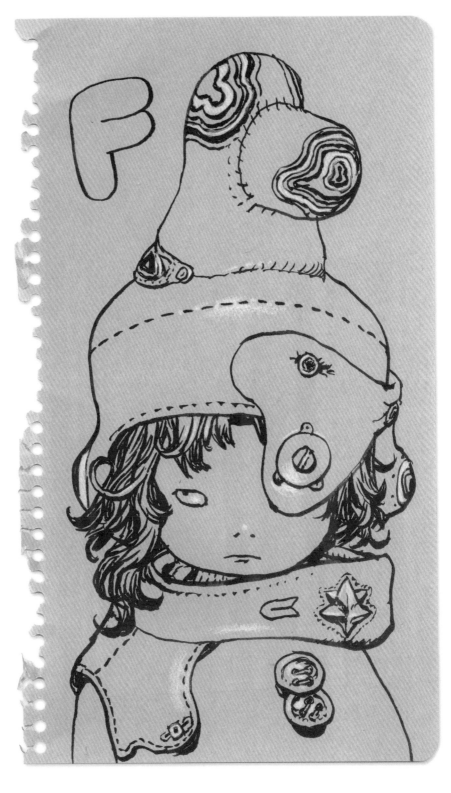

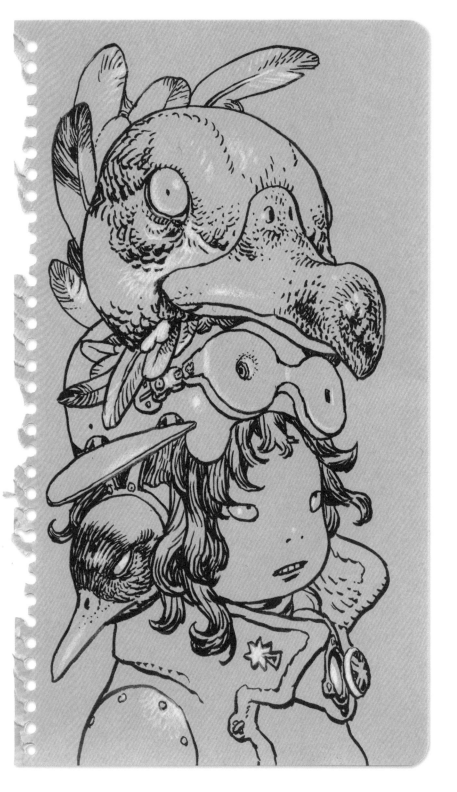

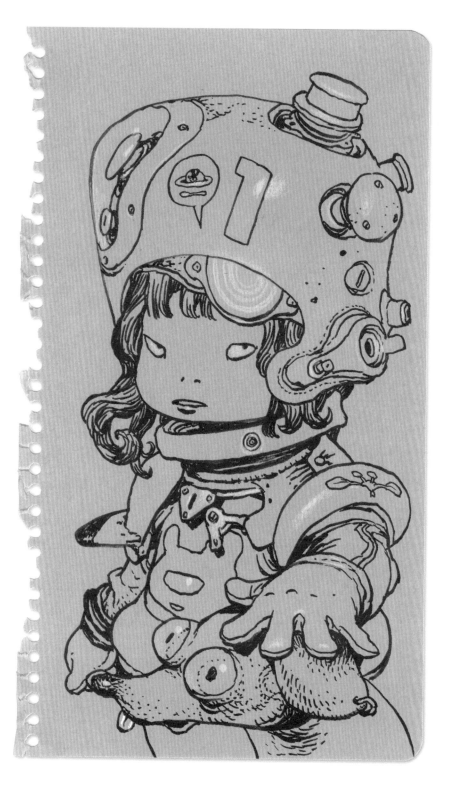

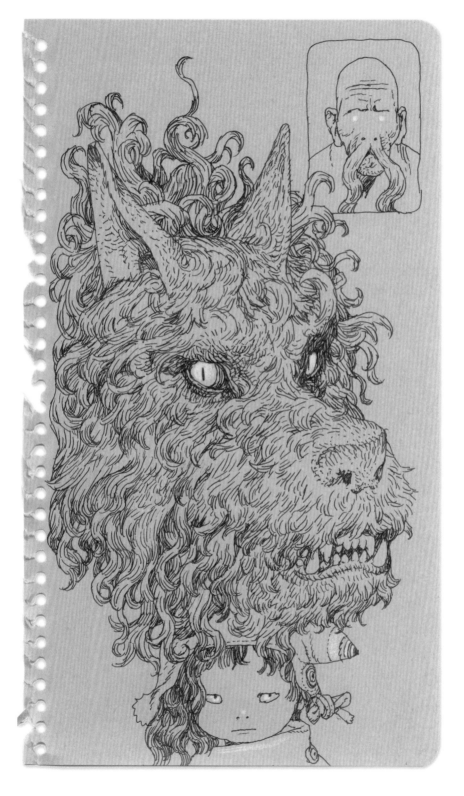

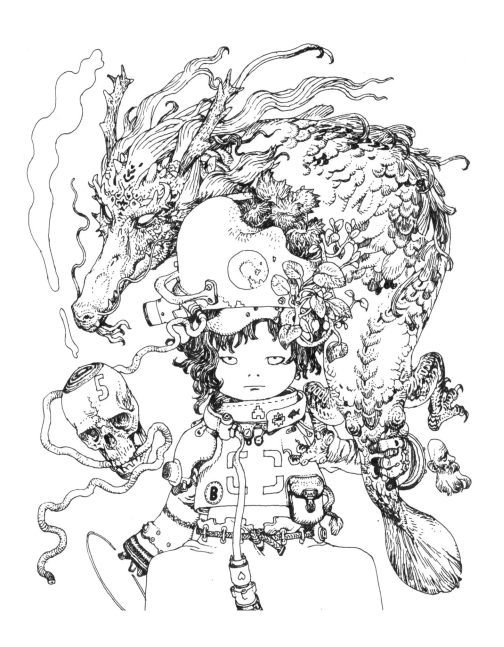

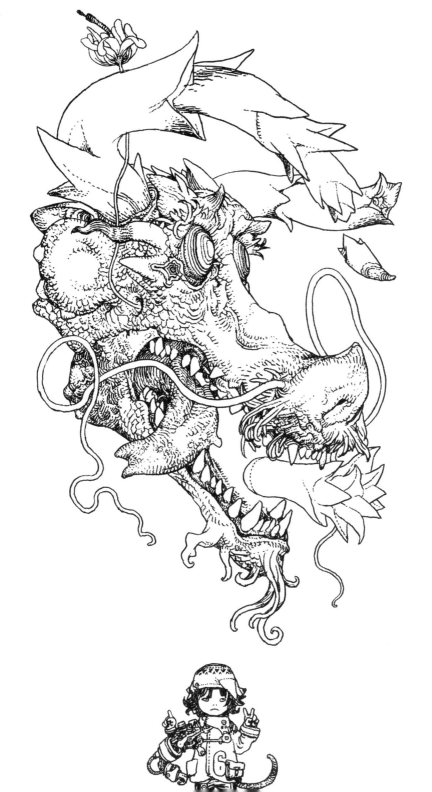

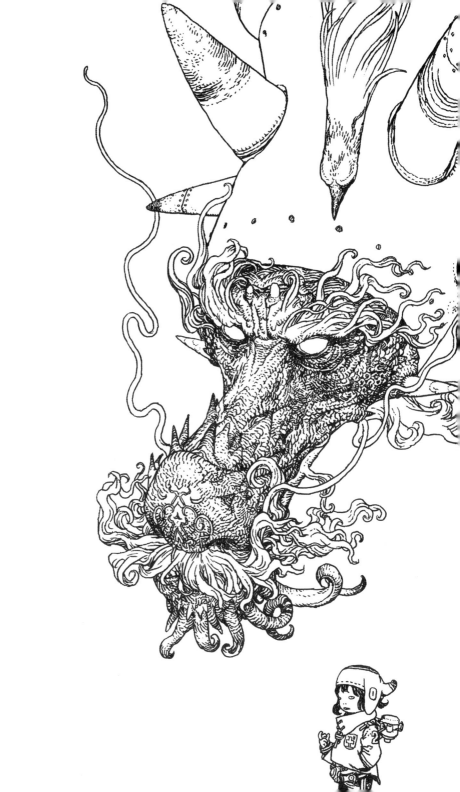

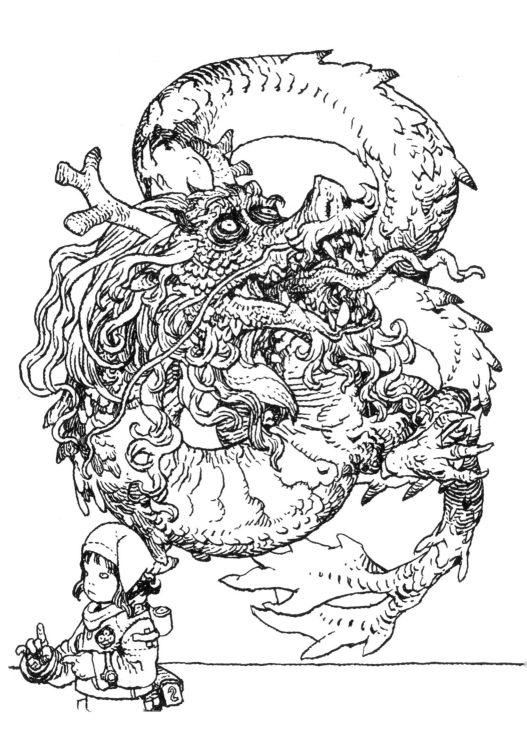

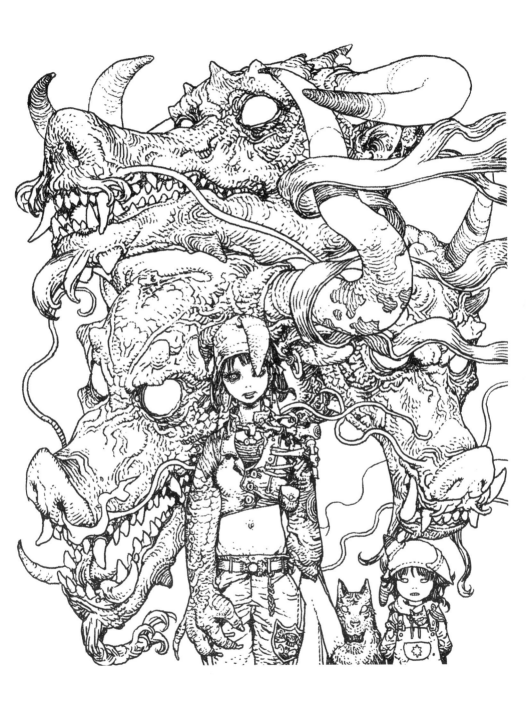

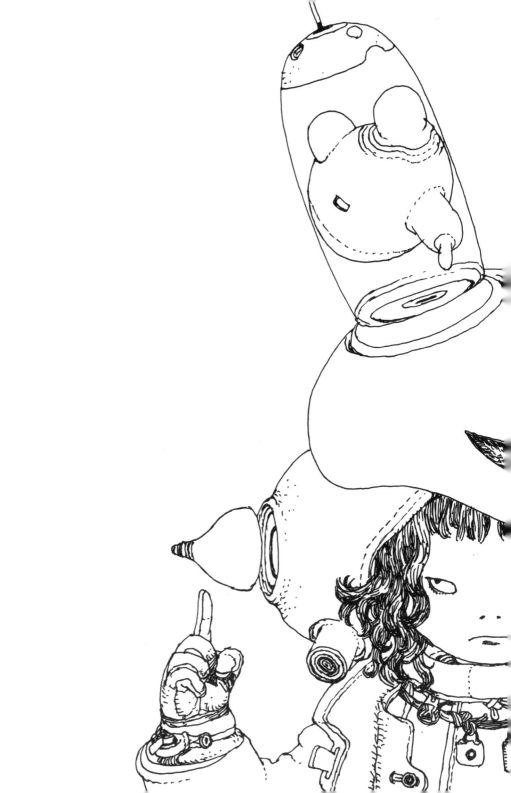

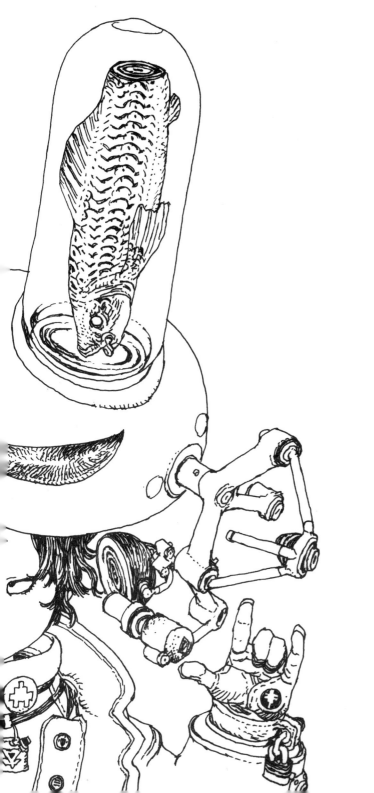

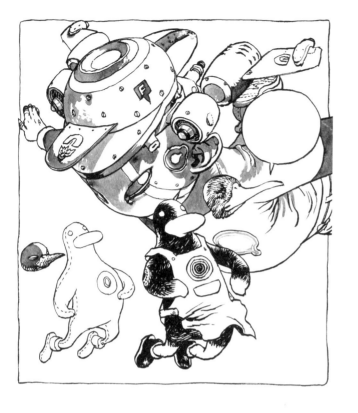

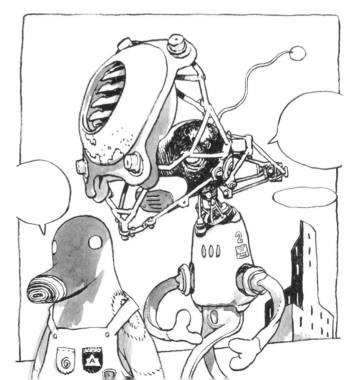

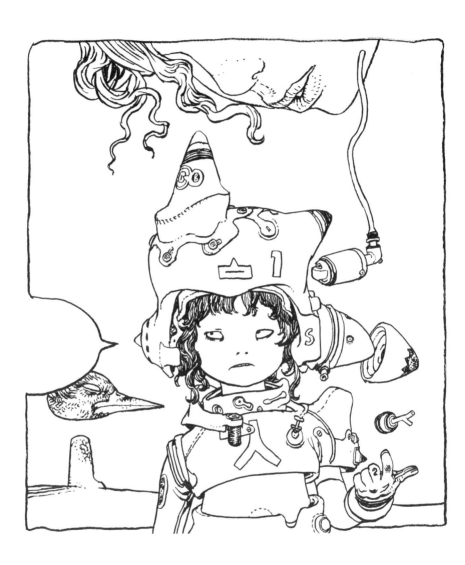

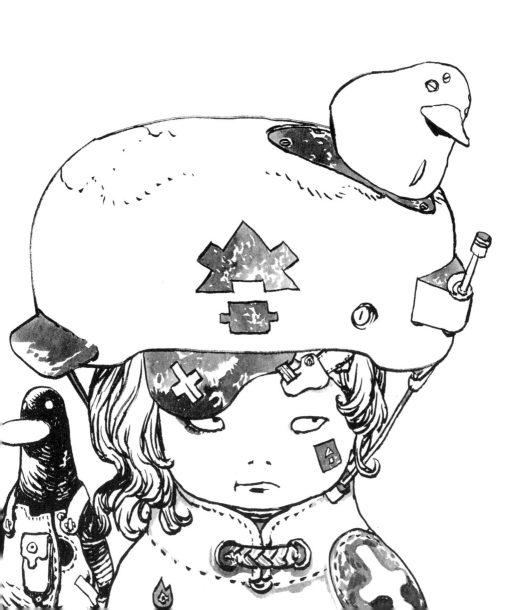

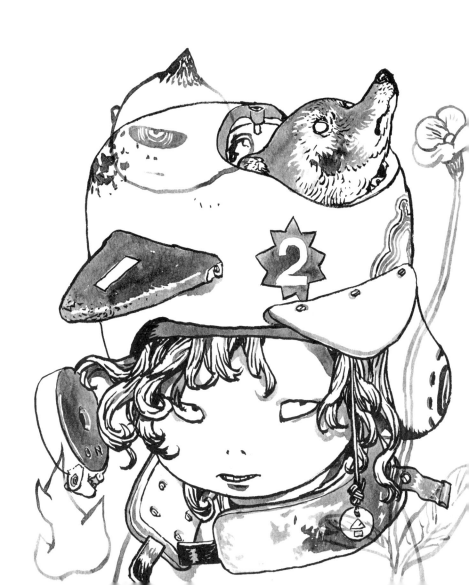

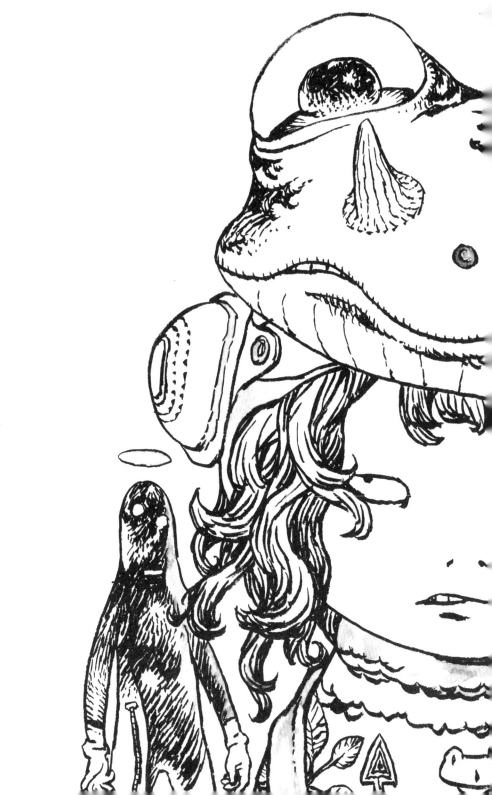

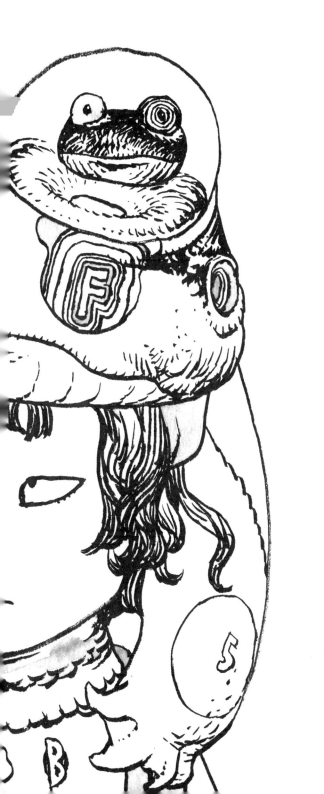

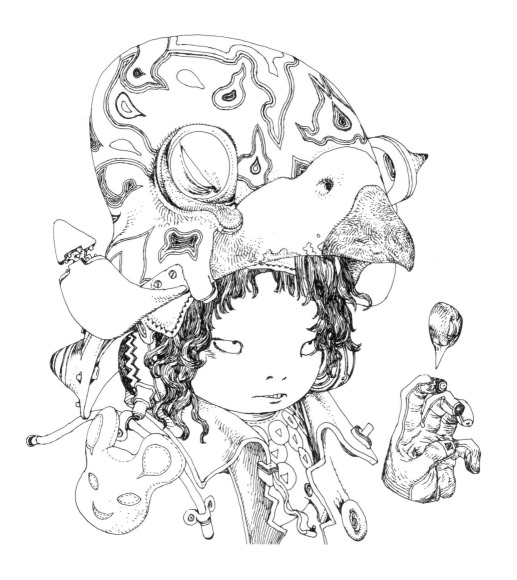

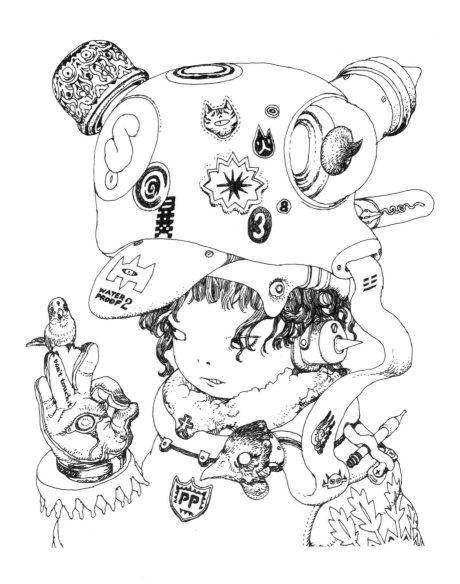

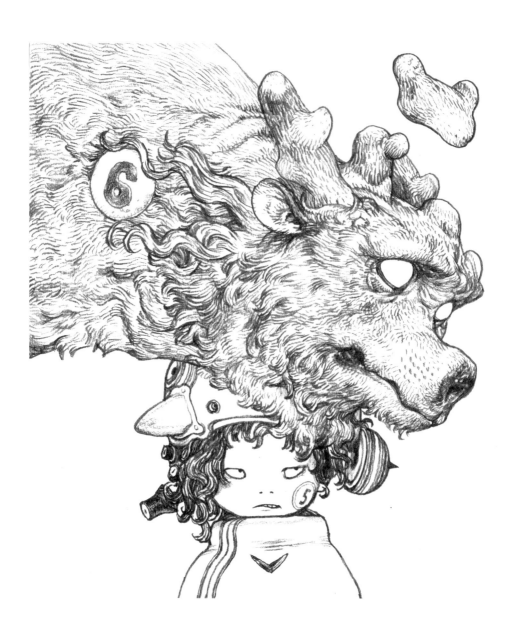

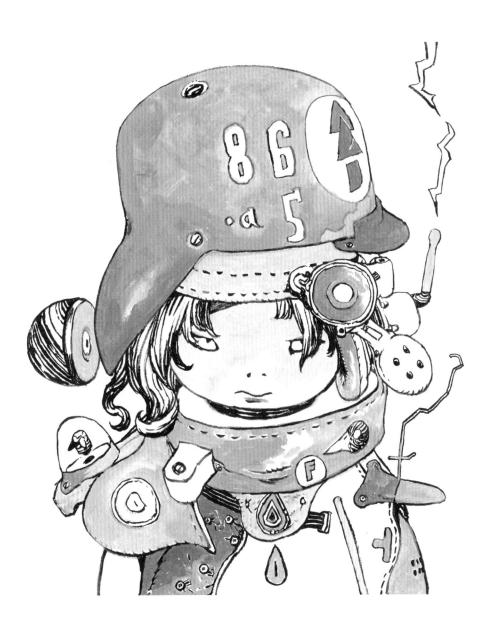

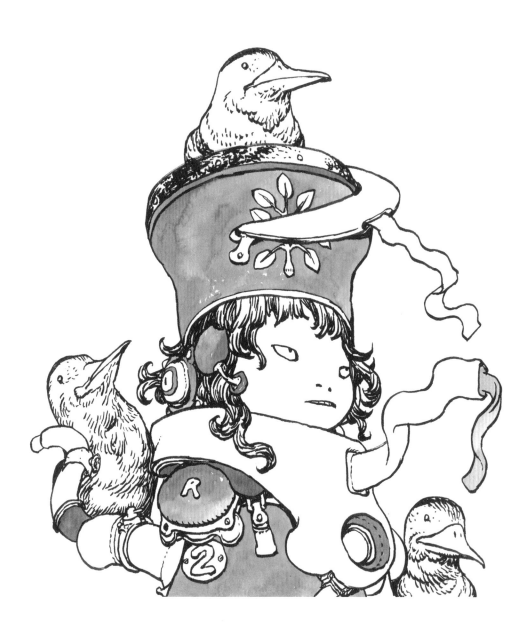

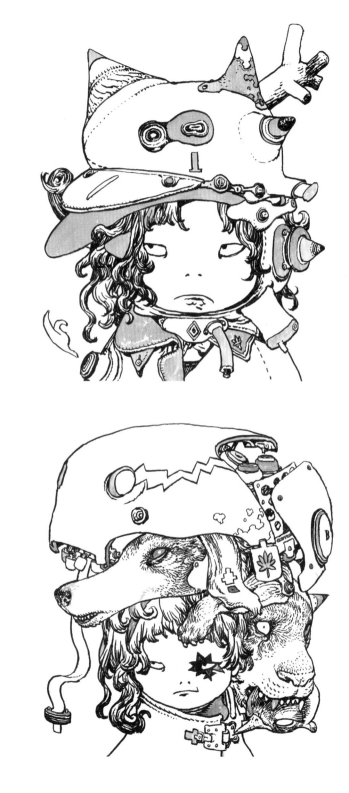

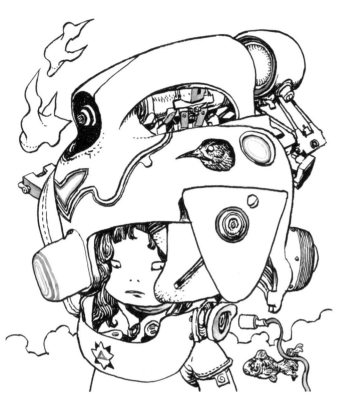

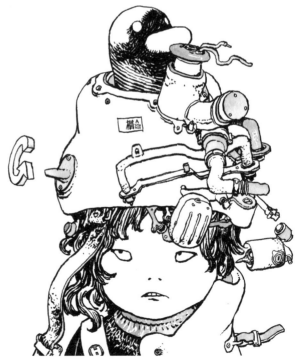

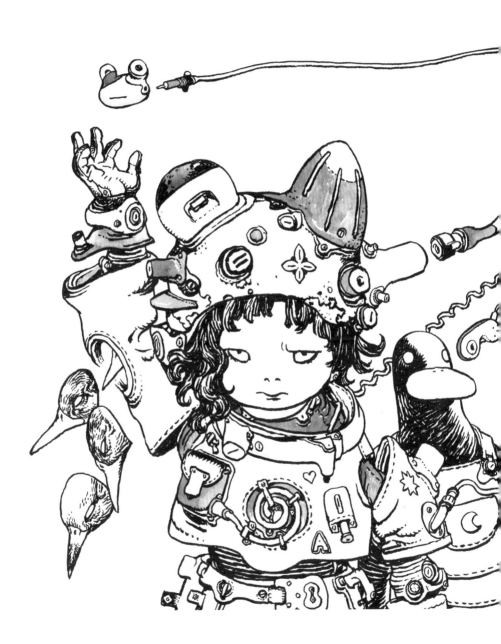

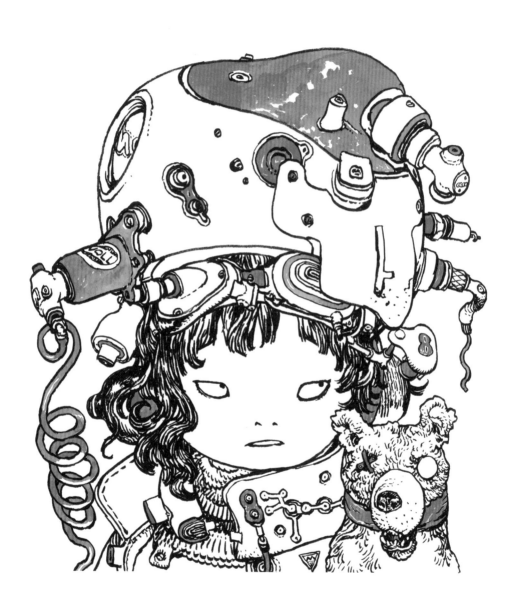

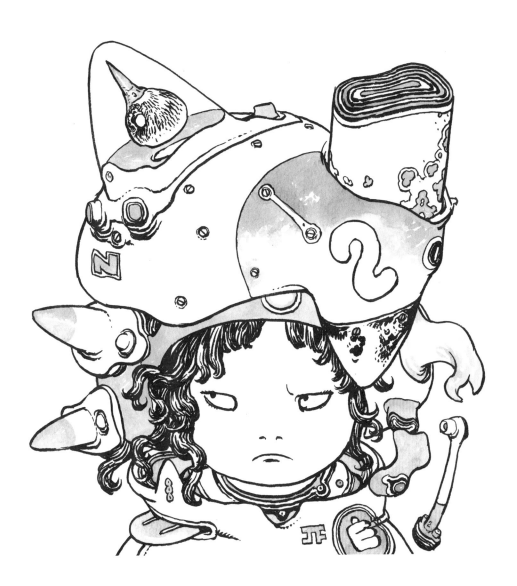

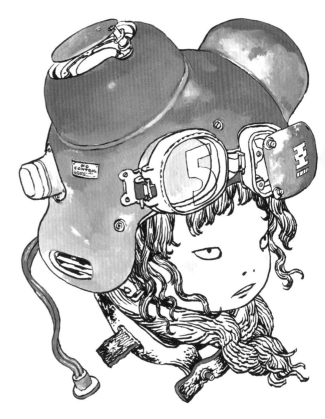
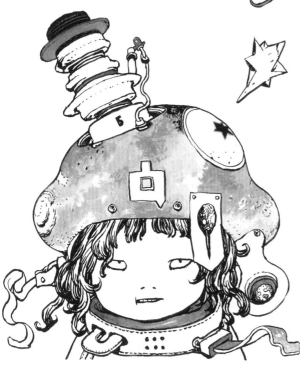

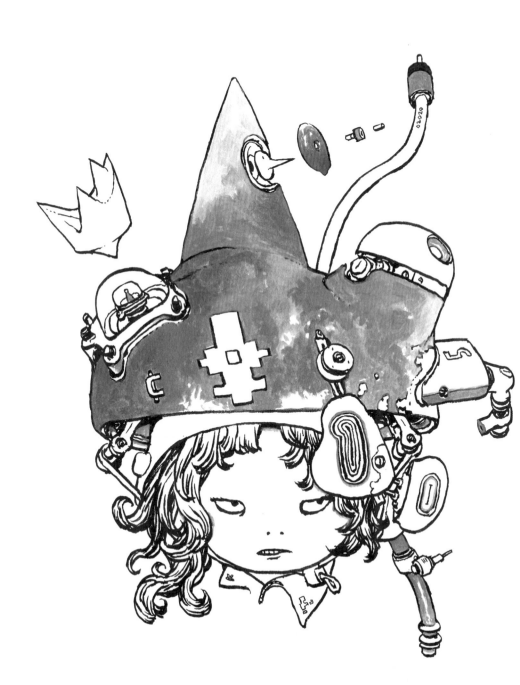

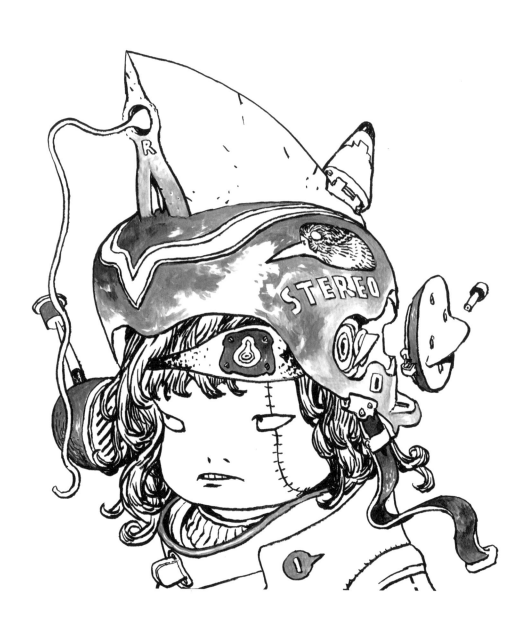

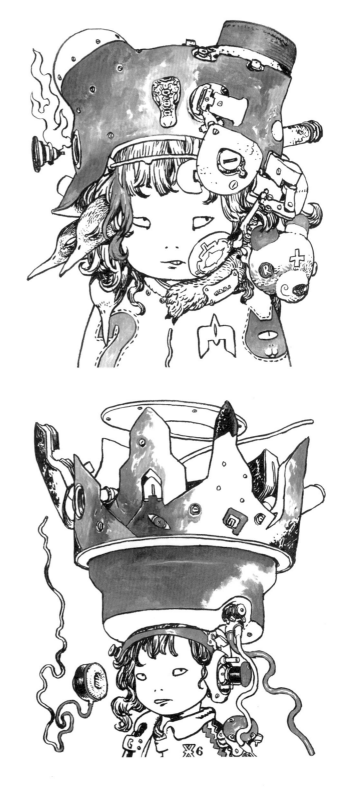

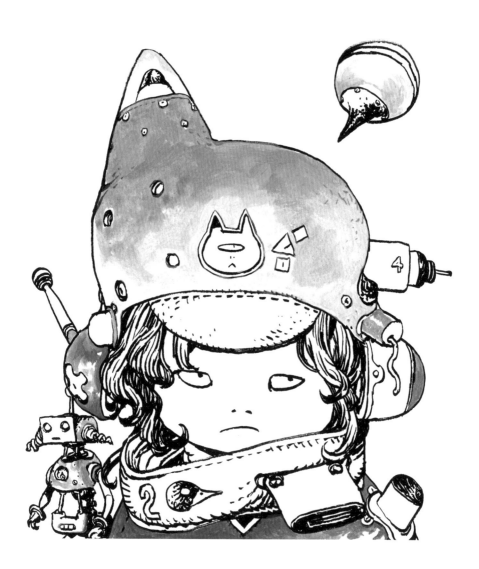

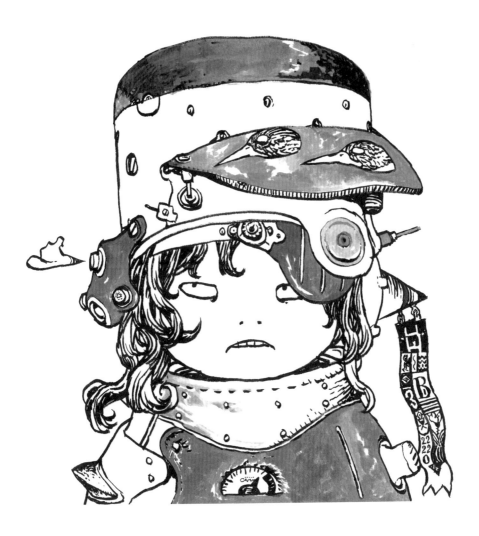

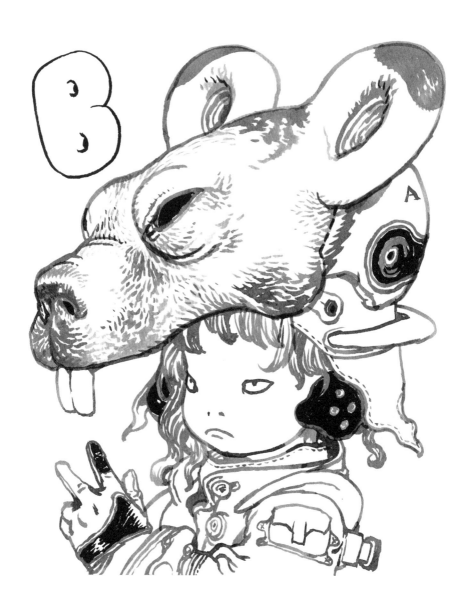

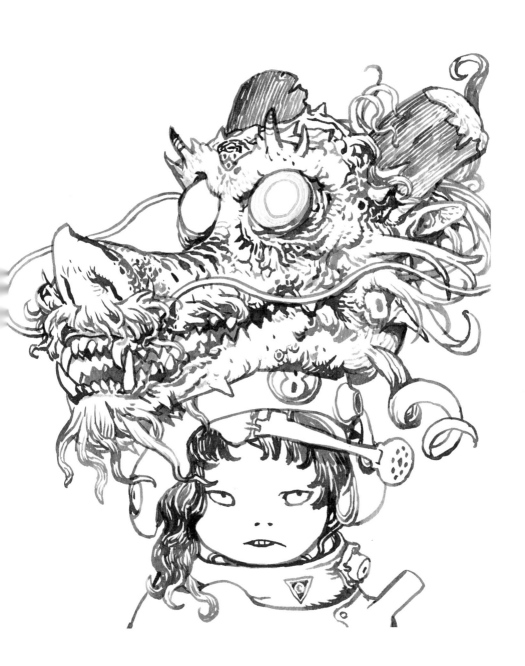

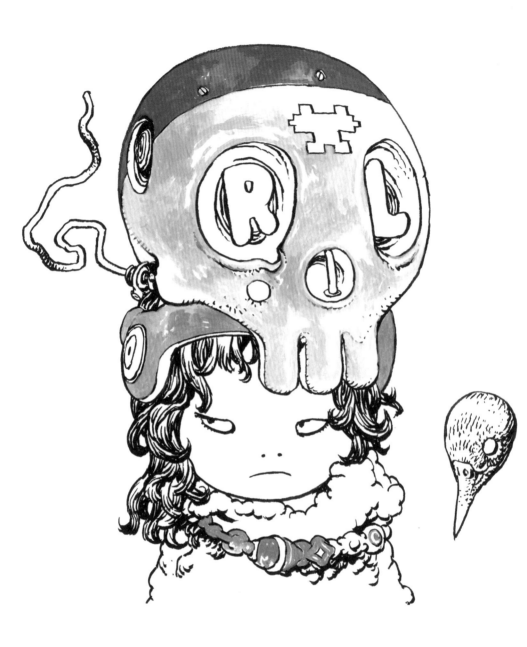

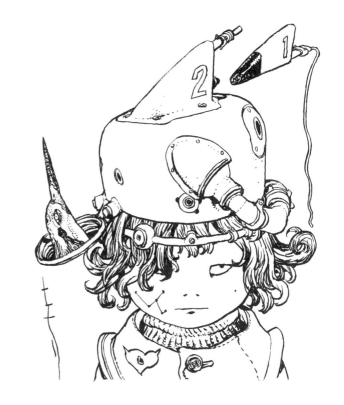

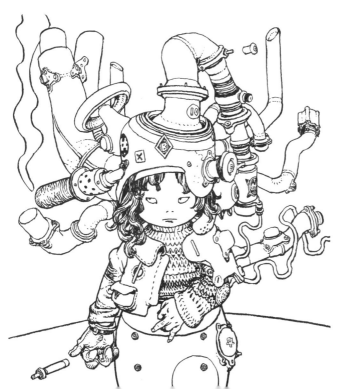

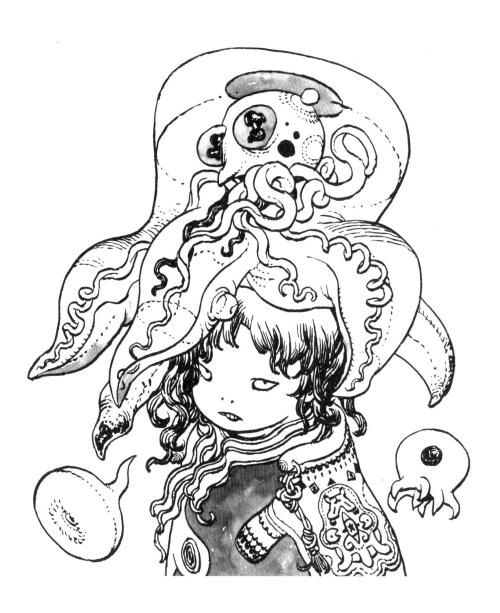

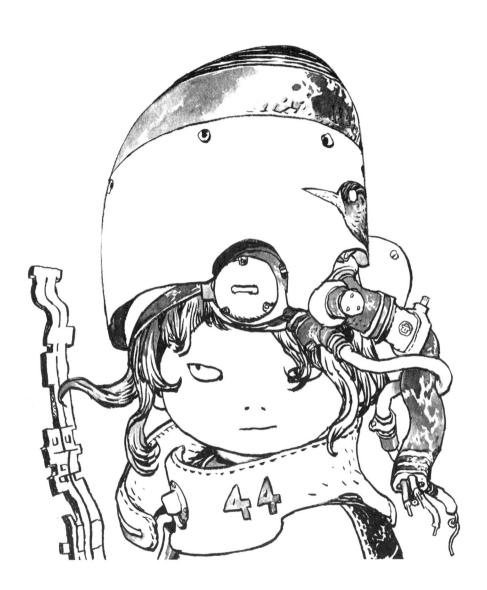

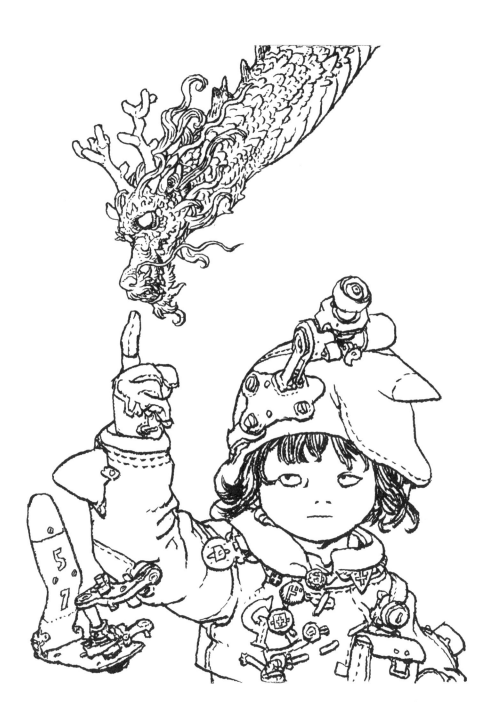

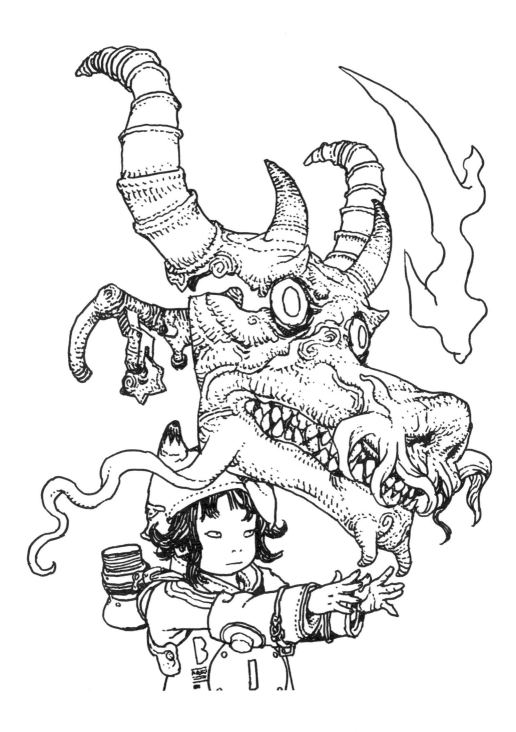

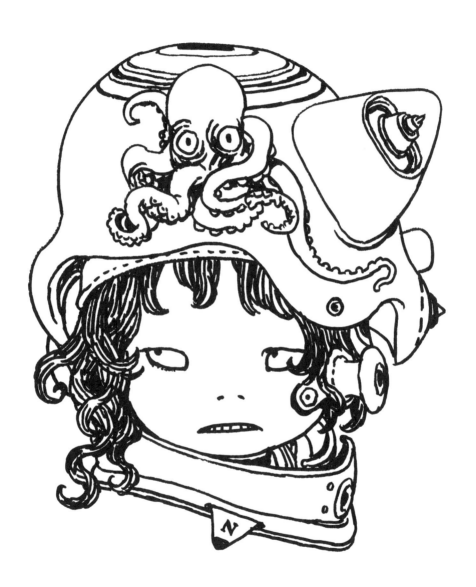

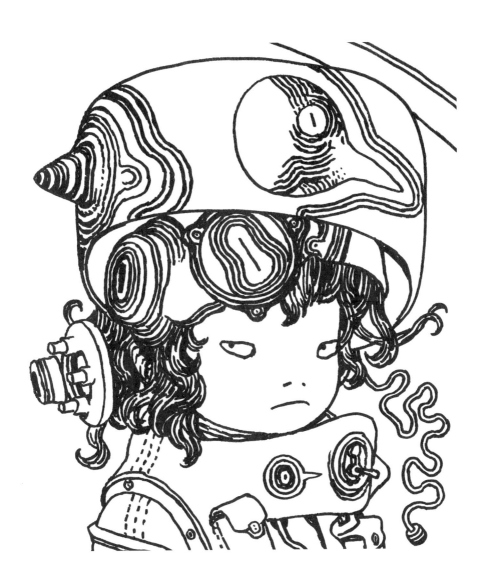

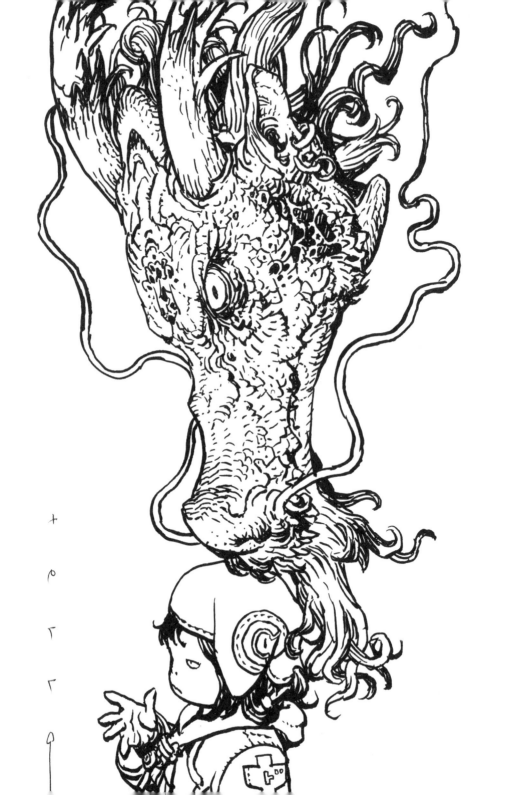

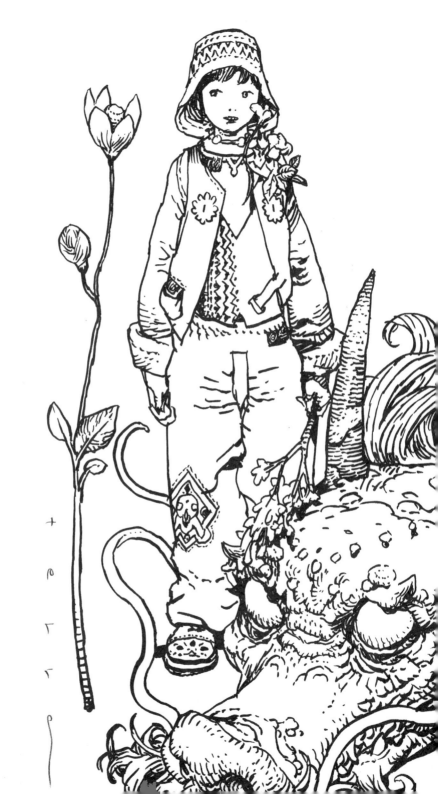

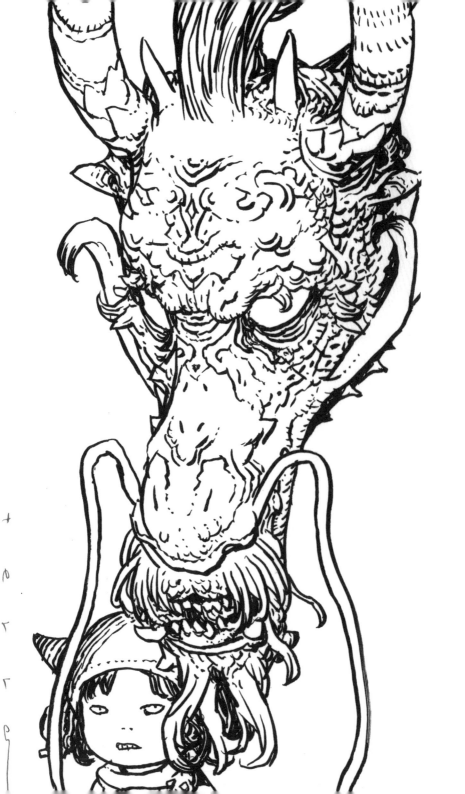

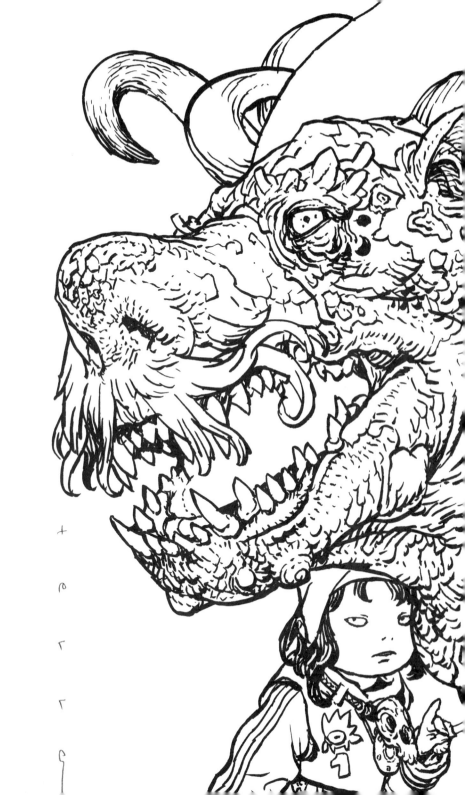

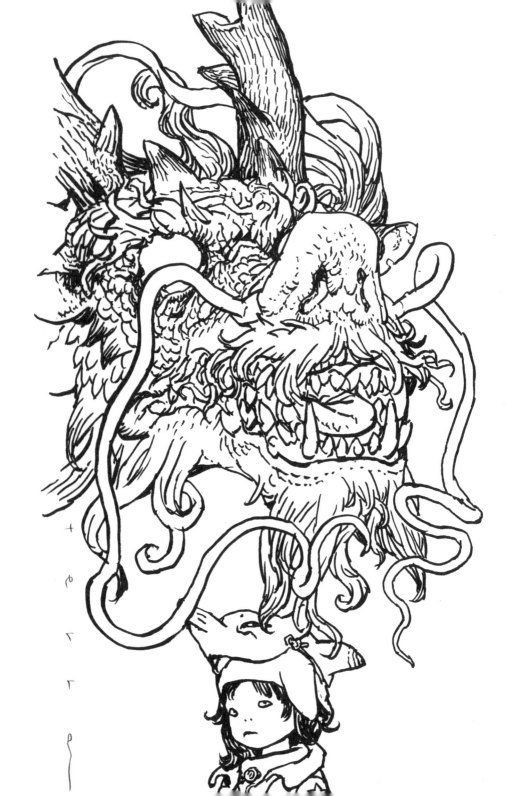

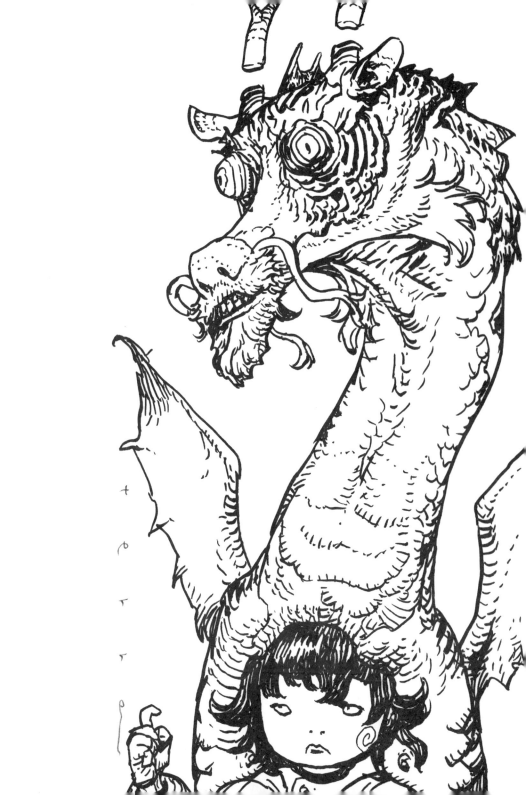

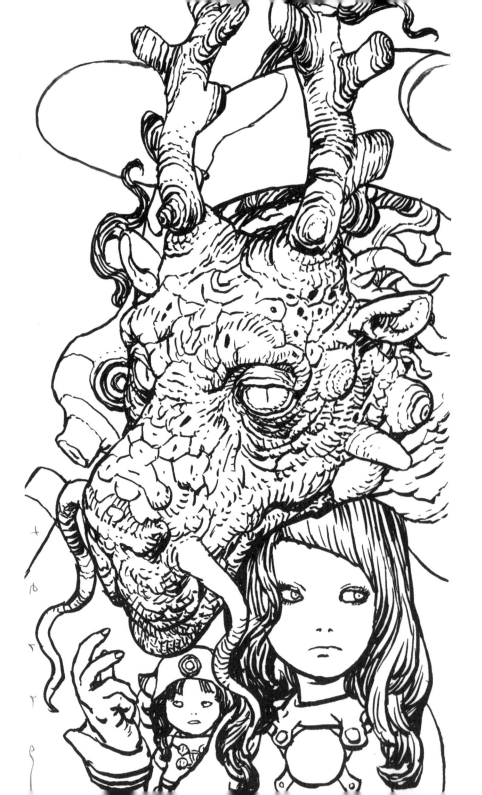

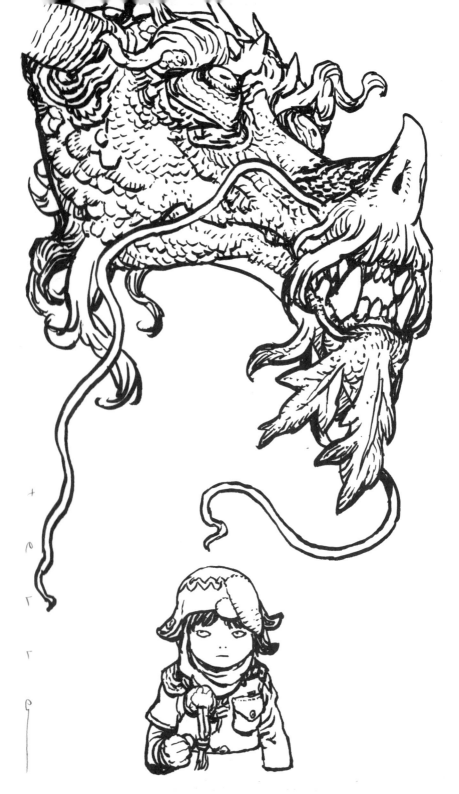

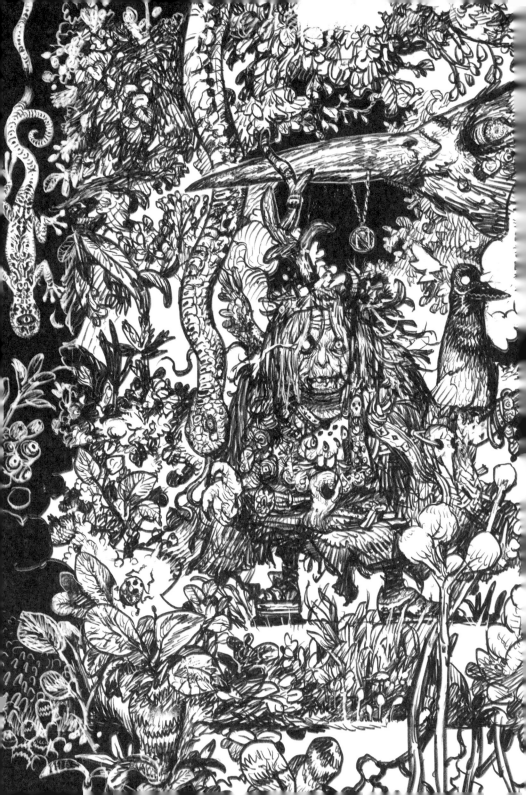

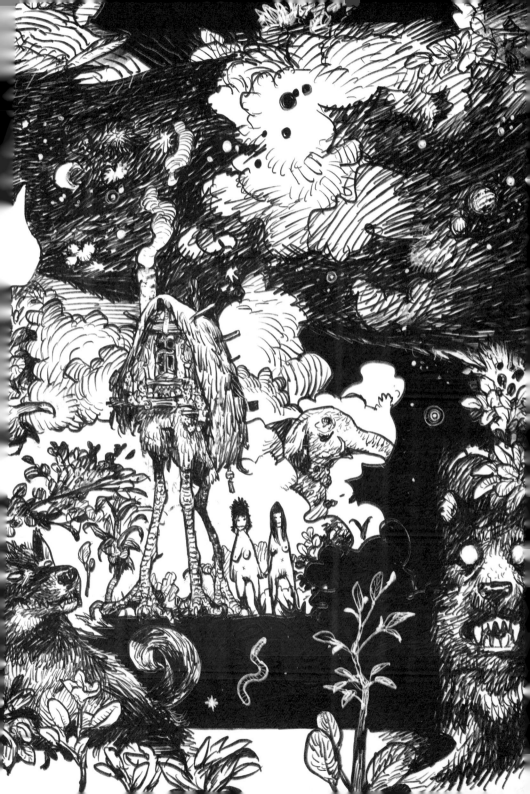

白い紙があると手が疼く病なんですがよく考えると白ければ紙じゃなくてもいい。壁でも襖でもいい。てゆーか平面じゃなくてもいい。描ければいい。

そして毎度描き始めに思うのは「これはオレ史上最高の出来になる」という事です。シゴトでもラクガキでも同じだ。イントロには期待感からの高揚と見えない未来への不安感が共にある。しかしペン先とか筆先とか鉛筆の芯とかアップルペンシルが画面に1本でも線を引いた直後、高揚感は消え失せ、ガッカリと後悔が渦巻き始める。「駄作」「またコレかよ」「ぷぷ」脇腹を抉る言葉が視界を遮る。

目薬で滲む涙を洗い流しながら、それでもと一縷の望みに賭けて手を動かすわけですが、まあ出来上がりは9割が「及第点」レベルに留まる。残りの1割は「凡作」。

いつも他人の審美眼におびえながら描いている。絵を褒めてもらっているのに、責められてるような気持ちになる。まずじぶんでじぶんの絵を褒められないので褒められるとマジきつい。もちろん貶されるとその100倍きつい。

それでもなんでも、オレはオレの絵が好きでもある。うまくなくても好きな絵、というのはあるのだ。じぶんの手が生み出した線が好きなのであります。

だから描き続けていられるのだった。

じぶんの線とはなにか。

それはオレが物心ついてから、好んできた絵の記憶だ。武部本一郎の線の色気。ハヤカワの「キャプテン・フューチャー」シリーズの水野良太郎の線の肉感。手塚治虫の線の愛嬌。大友克洋の線の理性。そしてジャン・メビウス・ジローの、この世界を描ききる事ができる線の自由さ。それ以外にも好きな線が多すぎて枚挙にいとまが無いが、じぶんの線はそれらへの記憶で構成されているのです。だからオレの線が好き、というより正しくは、それを作り上げてくれた線たちへの気持ちを言っているのだ。

人間は単体ではなかなかたいしたものは生み出せない。どんな才能も、そこまでの連綿と続く知識と世界観とセンスの続きを担って開花する。オレは先人たちが描き続けてきた線のはしっこから、すみませんすみませんと低頭しつつ続きを引かせてもらってる。もしもオレの引いたその線から、なにか続いてるものを感じてもらえたら幸せだ。さらにその続きをあなたに引いて描いていってもらえるならば、オレの仕事のほとんどはそこで役目を果たせているということです。

寺田克也

When I see a blank piece of paper, my hand starts to tingle. Actually, when I think about it, as long as it's a blank surface, it needn't even be paper.

It could be a wall or a fusuma sliding door.

Actually, it does not even have to be a flat surface.

As long as I can draw on it.

Then, every time I start drawing, I think, 'This is going to be my best work ever!'

It's the same whether it is for work or just a doodle.

Introductions contain both exaltation from a sense of expectation and anxiety about an unseen future.

However, right after I draw a single line, whether it be with a pen, or a brush, or a pencil lead, or an Apple Pencil, that sense of exaltation disappears and disappointment and regret start to swirl around me. 'What rubbish!' 'Not this again!' 'Ugh!' Words that are a jab in my sides cloud my vision.

Washing away my tears with eye drops, I keep drawing, clinging onto a sliver of hope, but in 90% of cases, the result are barely at a "passing mark" level. The other 10% are mediocre.

I always draw with a fear of the perceptiveness of others. Even when they praise my pictures, I feel as though I am being criticized. When I can't even praise my own work myself, receiving praise is really hard.

Of course, when my work is denigrated, it is 100 times harder. Even so, I like the pictures that I draw. There are pictures that I like even when they are no good. I love the lines that my own hand has produced.

That is why I am able to keep on drawing.

What are my own lines?

They are the memory of the pictures that I have loved for as long as I can remember.
The sensual lines of Motoichiro Takebe.
The carnality of Ryotaro Mizuno's lines in Hayakawa's Captain Future series.
The charm of Osamu Tezuka's lines. The logic of Katsuhiro Otomo's lines. And the freedom of Jean "Meobius" Giraud's , which are able to draw entire worlds. There are more lines that I love than I could possibly list here, but my own lines are made up of my memories of all of those lines. That is why I love my lines. Or, more accurately, I am talking about my feelings toward the lines that have created my own lines.

Humans have a hard time creating anything of real worth on their own. No matter what your talent, when it takes on the knowledge, worldview, and senses that have continued in an unbroken until that point, that is when it will blossom. With my head bowed low, constantly saying, 'Excuse me. Sorry,' even as I have felt unworthy, I have taken the liberty of tacking myself onto the end of the lines that my predecessors have drawn over the years and continuing those lines with my own. When you look at my lines, if they give you a sense that they are a kind of continuation of what has come before, that would make me happy. And, if you were to take over and draw as a continuation of my lines, I would feel that most of my work would have served its purpose.

Katsuya Terada

寺田克也SKETCH

2021年5月19日　初版第1刷発行
2023年2月　7日　　　第6刷発行

著　　　　**寺田克也**
編　　集　田中里奈（ヒヨコ舎）
デザイン　セキネシンイチ製作室
進行管理　大場義行
協　　力　デザインフィル　トラベラーズカンパニー
　　　　　集英社

P246-249
『キマイラ12 曼陀羅変』夢枕 獏（朝日新聞出版）挿絵
P385
『月刊コミックビーム』2015年12月号（KADOKAWA）表紙
P440-442
バロン吉元 画業60年還暦祭『男爵芋煮会』トリビュート バロン.プロ ©Baron Yoshimoto
P496
『ババヤガの夜』王谷 晶（河出書房新社）表紙

発 行 人　三芳寛要
発 行 元　**株式会社パイ インターナショナル**
　　　　　〒170-0005　東京都豊島区南大塚2-32-4
　　　　　TEL 03-3944-3981　FAX 03-5395-4830
　　　　　sales@pie.co.jp

印刷・製本　シナノ印刷株式会社

©2021 Katsuya Terada / PIE International
ISBN978-4-7562-5426-9 C0079 ¥2400

Printed in Japan

Terada Katsuya SKETCH

Author / Katsuya Terada
Editor / Rina Tanaka
Designer / Shinichi Sekine
Managing Editor / Yoshiyuki Oba
Special Thanks / TRAVELER'S COMPANY Designphil Inc.
SHUEISHA Inc.

P246-249
"Chimera 12: Mandalahen" Baku Yumemakura (Asahi Shimbun Publications Inc.)
P385
"Monthly Comic Beam" December 2015 cover (KADOKAWA CORPORATION)
P440-442
Baron Yoshimoto 60th Anniversary Tribute to "Baron Imoni Kai" (Baron.Pro) ©Baron Yoshimoto
P496
"The Night of Baba Yaga" Akira Otani (Kawade Shobo Shinsha) cover

©2021 Katsuya Terada / PIE International

PIE International Inc.

2-32-4 Minami-Otsuka, Toshima-ku,
Tokyo 170-0005 JAPAN
international@pie.co.jp
www.pie.co.jp/english

ISBNISBN978-4-7562-5427-6(outside Japan)

Printed and Bound in Japan by Shinano Co.,Ltd.

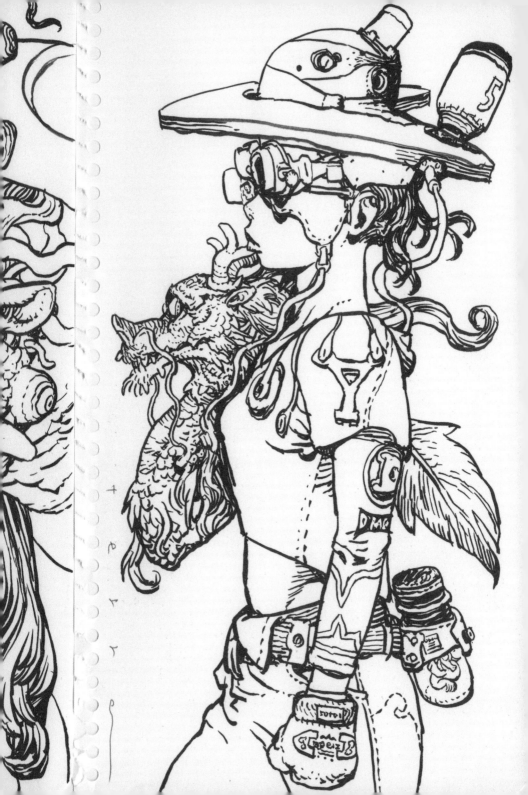

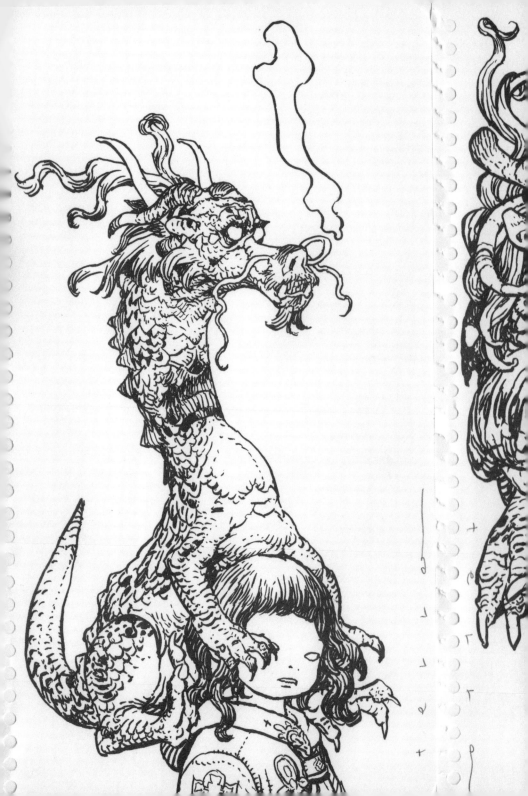

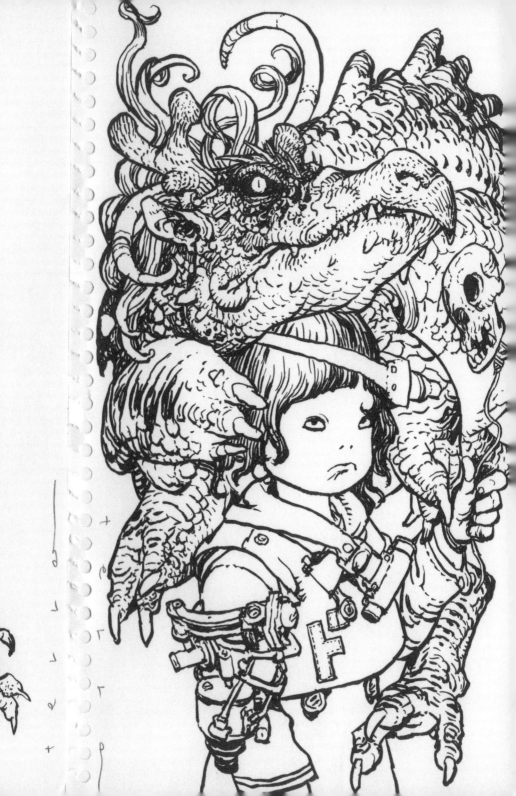

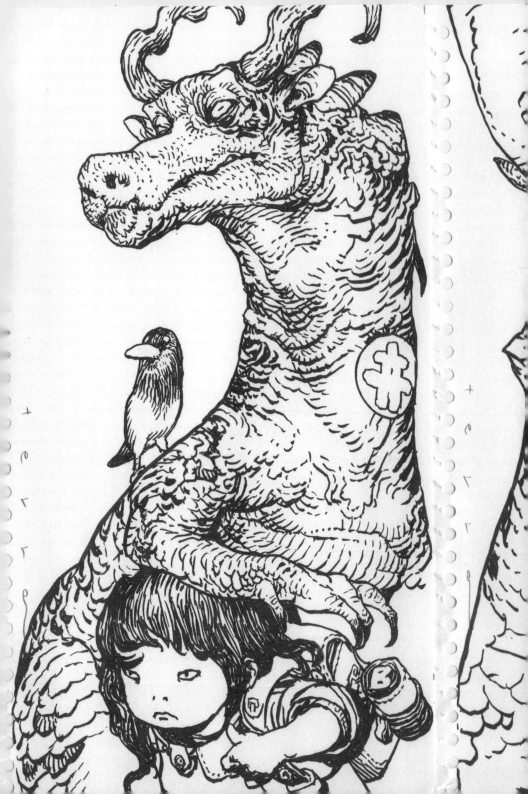

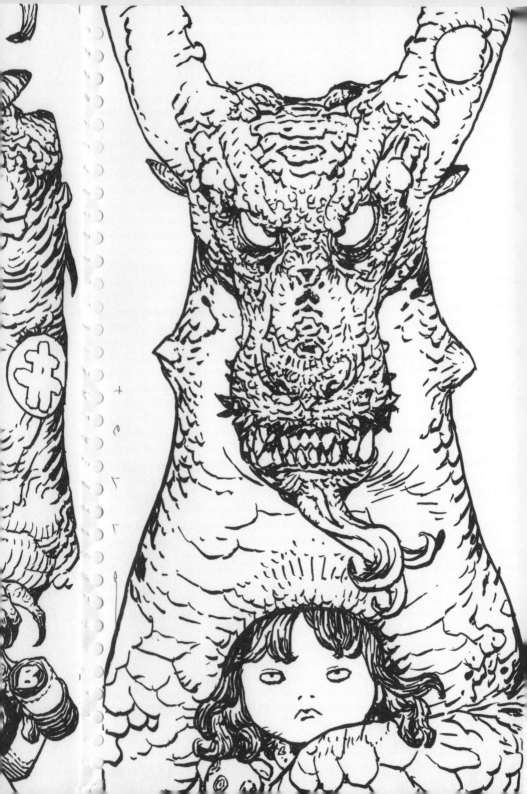

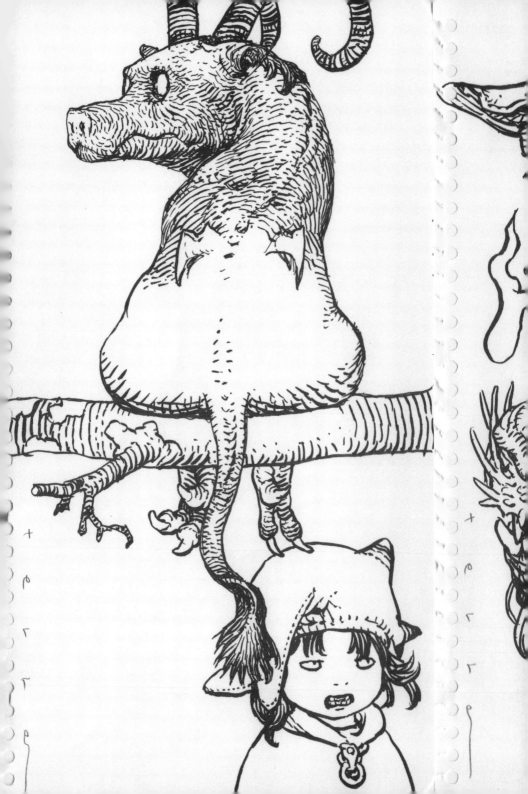

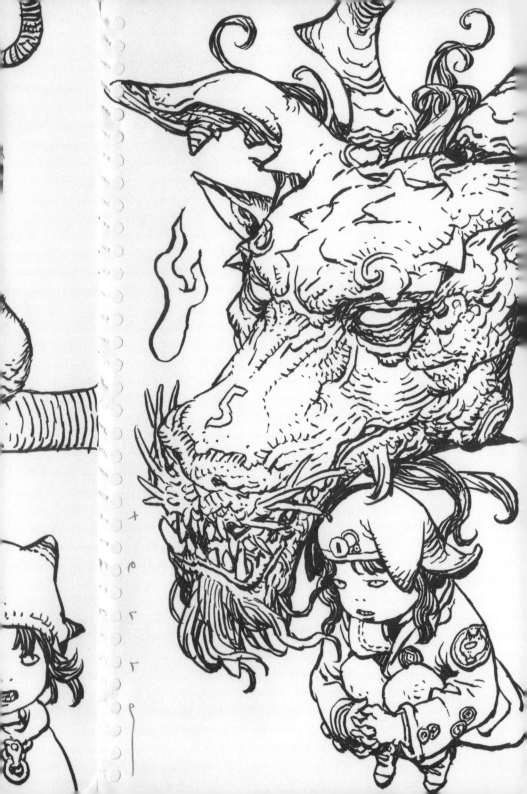